Gilles Néret

HENRI MATISSE

TASCHEN

KÖLN LONDON MADRID NEW YORK PARIS TOKYO

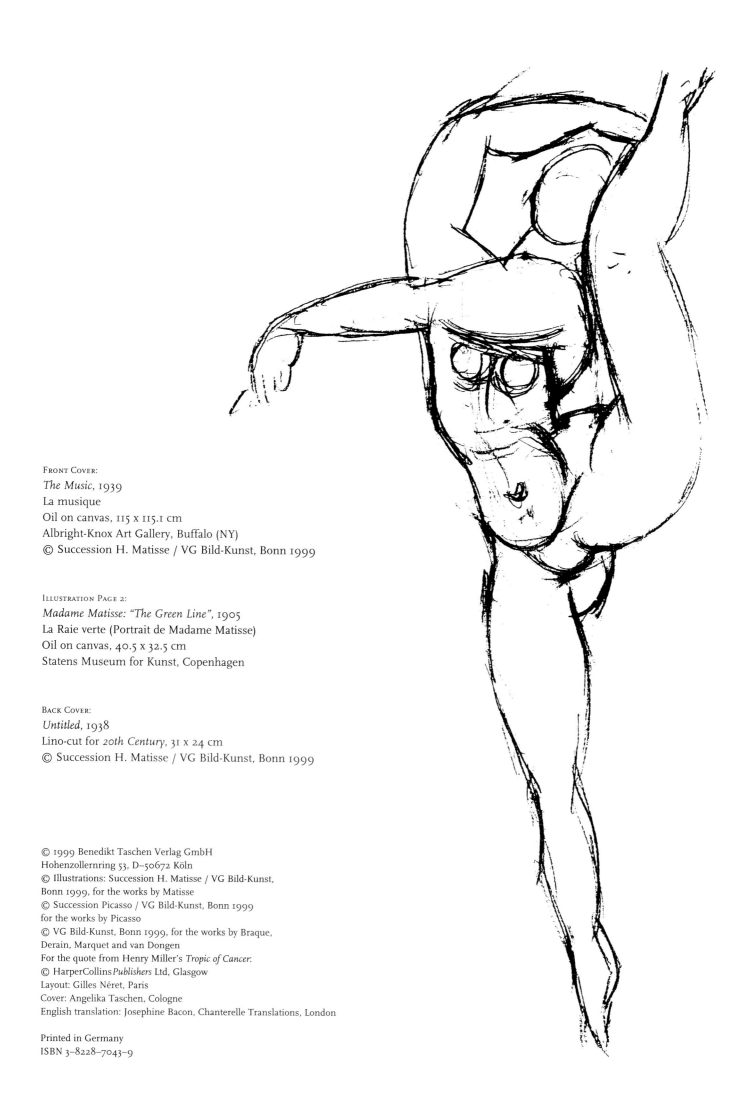

FRONT COVER:
The Music, 1939
La musique
Oil on canvas, 115 x 115.1 cm
Albright-Knox Art Gallery, Buffalo (NY)
© Succession H. Matisse / VG Bild-Kunst, Bonn 1999

ILLUSTRATION PAGE 2:
Madame Matisse: "The Green Line", 1905
La Raie verte (Portrait de Madame Matisse)
Oil on canvas, 40.5 x 32.5 cm
Statens Museum for Kunst, Copenhagen

BACK COVER:
Untitled, 1938
Lino-cut for *20th Century*, 31 x 24 cm
© Succession H. Matisse / VG Bild-Kunst, Bonn 1999

© 1999 Benedikt Taschen Verlag GmbH
Hohenzollernring 53, D–50672 Köln
© Illustrations: Succession H. Matisse / VG Bild-Kunst,
Bonn 1999, for the works by Matisse
© Succession Picasso / VG Bild-Kunst, Bonn 1999
for the works by Picasso
© VG Bild-Kunst, Bonn 1999, for the works by Braque,
Derain, Marquet and van Dongen
For the quote from Henry Miller's *Tropic of Cancer*:
© HarperCollins*Publishers* Ltd, Glasgow
Layout: Gilles Néret, Paris
Cover: Angelika Taschen, Cologne
English translation: Josephine Bacon, Chanterelle Translations, London

Printed in Germany
ISBN 3–8228–7043–9

Contents

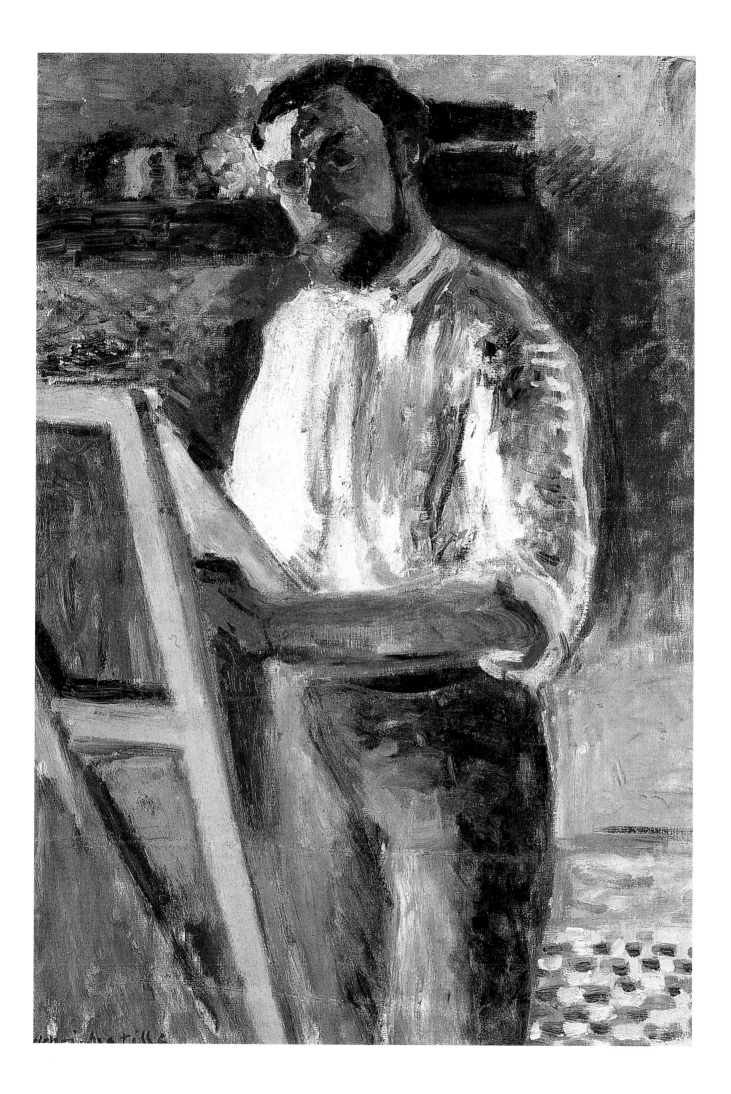

Simplifying Painting...

While Matisse was studying under the painter Gustave Moreau, the latter surveyed Matisse's work and commented, both admiringly and prophetically: "You will simplify painting." Then, after a moment's reflection, he added: "But you won't simplify Nature to that extent, to reduce it to that. If you did, painting would no longer exist...," and finally: "Don't listen to me. What you are doing is more important than anything I am telling you. I am a mere teacher, I understand nothing."

Few people ever possessed such insight into Matisse's work. Few painters have been so misunderstood and treated so unjustly. It began with his initial Fauvist phase, when his paintings caused an uproar and were considered to be "a brightly-coloured daub superimposed on what is, after all, a rather traditional vision – rather like putting up the Christmas decorations in a drawing-room. Once the celebration is over, the room returns to its former drabness... Once you remove the 'fauve', all that remains is the pigeon-fancier." This attitude continued between the Wars, when Matisse became famous, but was still associated with petty bourgeois aesthetics, not quite "fashion illustrator" but almost "interior decorator". "Matisse," commented the critic Pierre Schneider, "is a name that rhymes with Nice. It evokes balconies overlooking the sun-drenched Mediterranean, languishing, lazy odalisques, images of luxury, tranquillity, voluptuousness. In any case, as soon as a painter settles on the Côte d'Azur his work is immediately considered to be some sort of summer holiday picture postcard, a sort of perpetual leisure. Matisse: painter of pleasure, Sultan of the Riviera, an elegant hedonist..."

Matisse himself did much to cultivate this upper-class, even professorial, air (his fellow students even nicknamed him "the doctor"). The nickname stuck, a cross between Socrates and Pasteur, and he even bore a physical resemblance to the latter. When, in 1913, Clara MacChesney expressed surprise that such an "abnormal" work of art had been produced by a man who looked so "ordinary and sane", Matisse replied: "Oh, be sure to tell the Americans that I am a normal person, that I am a devoted father and husband, that I have three beautiful children, that I attend the theatre, ride horses, that I have a comfortable home and a beautiful garden I love, with flowers, etc., just like everyone else." When Joséphin Peladan, who had dubbed himself "SAR" ("Son Altesse Royal – HRH, His Royal Highness") and Grand Master of the Rosicrucians, reproached the Fauves for dressing just like everyone else, so that their presence was no more imposing than that of a floor manager in a department store, Matisse replied: "Does genius depend upon so little? If he is only talking about me, Monsieur Peladan can take comfort. Tomorrow, I'll call myself HRH and dress up like a magician."

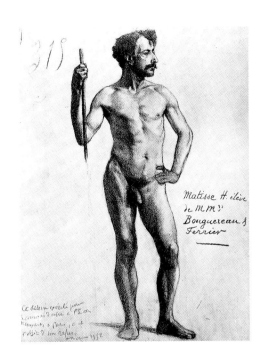

Self-portrait, 1900
Mon portrait
Brush and ink, 23.9 x 8.9 cm
Private collection

Académie d'Homme, 1892
Charcoal, 59.9 x 47.5 cm
Private collection

Matisse studied under the teacher and "pompier" artist, Bouguereau, who told him he "did not know how to draw". He left to become the pupil of Gustave Moreau, a more understanding and enlightened master.

PAGE 6:
Self-portrait in Shirtsleeves, 1900
Autoportrait en bras de chemise
Oil on canvas, 64 x 45 cm
Private collection

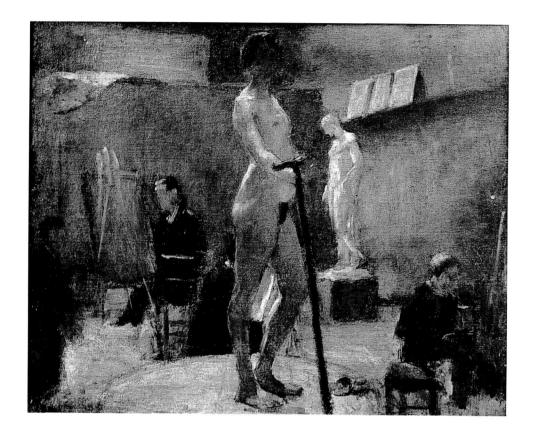

Gustave Moreau's Studio, 1894–1895
L'atelier de Gustave Moreau
Oil on canvas, 65 x 81 cm
Private collection

Matisse added with further mockery: "In the same article, the excellent author claims that I do not paint honestly, and I would be justifiably angry had he not taken care to add the afterthought, 'By honestly, I mean by respecting the ideal and the rules.' Unfortunately, he does not let us into the secret of exactly where these rules to which he refers are to be found. I am happy for them to exist and indeed if it were possible to learn them, what sublime artists we would be!"

Matisse did indeed dream of an "art of balance, purity, tranquillity, devoid of disturbing or disquieting subject-matter which will be for everyone who works with his brain, a businessman or a man of letters, for example, a balm, a soothing influence on the mind, something akin to a good armchair which provides relief from bodily fatigue," but he did not do so with impunity. The distance between these words and his being treated as a diehard, out-of-touch reactionary was but a mere step and one more misunderstanding. For instance, Matisse hotly disputed René Huyghe's attribution of "an exquisite and refined impassivity". "How can one practise one's art dispassionately?" he replied. "Without passion, there is no art. The artist may exercise self-control, to a greater or lesser extent depending on the case, but it is passion which motivates him. Anguish? This is no greater today that it was for the Romantics. One must control all this. One must be calm. Art should neither disquiet nor trouble – it must be balanced, pure, restful." Matisse confided to Gaston Diehl: "I have chosen to put torments and anxieties behind me, committing myself to the transcription of the beauty of the world and the joy of painting." In 1951, he told old Couturier: "My art is said to come from the intellect. That is not true; everything I have done, I have done through passion."

The problem with Matisse is that his painting defies classification, he cannot be slotted neatly into a particular school. Worse still, despite his penchant for discussions of aesthetics and his numerous writings and essays about painting, drawing and colour – on which much of this book is based – he always refused to be a theoretician. He was as wary of his own theories as of the theories of others, and soon distanced himself from the principles or formulas which became the basis for the success of a particular movement or school. Matisse's painting

Albert Marquet: *Fauve Nude*, 1898
Nu fauve
Oil on canvas, 73 x 50 cm
Musée des Beaux-Arts, Bordeaux

PAGE 9:
Nude in the Studio, 1899
Nu dans l'atelier
Oil on canvas, 65.5 x 50 cm
Bridgestone Museum of Art, Tokyo

Six years before the Fauves painters burst onto the scene, creating a scandal, Matisse had anticipated them.

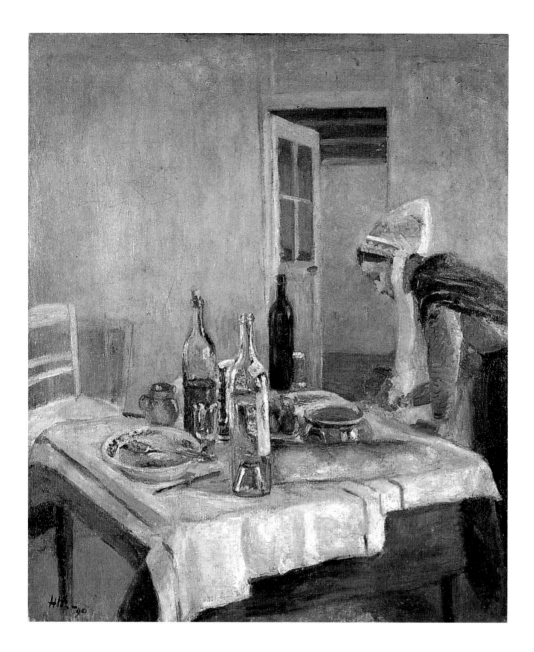

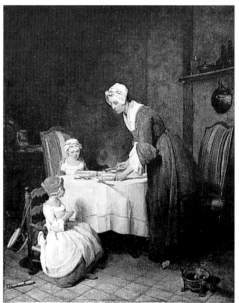

The Breton Serving-girl, 1896
La serveuse bretonne
Oil on canvas, 90 x 75 cm
Private collection

moves quite freely from one style to another, from an almost naturalist, con-
toured technique, in which the play of light and shade is translated into classic
perspective, to a concept in which large flat areas of colour dispense with volume
and offer themselves up for audacious ventures into geometric, even abstract,
forms. In actual fact, these are variations on a single theme, in each of which
Matisse saw advantages and disadvantages. It is thus almost impossible to divide
his work into "periods", that clear segmentation into which a great artist's work
is usually split.

The uniqueness of the art of a great painter lies in the fact that he is never
satisfied with discoveries which he would be entitled to claim as his own, and
immediately launches into new directions. This diversity, which is merely the
continuation of a pattern, a springboard, is often disconcerting. In the case of
someone like Matisse, who uses all the forms of expression – painting, drawing,
sculpture – simultaneously, this creates total confusion. Matisse considered that
any means could be used to embrace the form more tightly, to enhance colour
and thus offer revolutionary solutions disguised as classical views in the great
French pictorial tradition. It is this revolutionary, though seemingly harmless,
aspect of his work which is so difficult to decipher. This art of balance, purity
and mastery, this "joy of painting the beauty of the universe" which exploded on
a world in which the absurd, the disturbing, the "convulsive" reigned supreme.

Jean-Baptiste Chardin: *Saying Grace*, 1740
Le bénédicité
Oil on canvas, 49.5 x 39.5 cm
Musée du Louvre, Paris

This painting by the great master of the still life was
bound to attract the attention of Matisse who appreci-
ated the misty look and very delicate colour scheme
used by him. Under his influence, Matisse tempered
his pallette which he considered to be too bright. He
could have adopted the words of Chardin as his
motto. "I take my time because I have adopted the
habit of never leaving my work until, in my eyes, I see
nothing more in it that I want." There is an import-
ant difference, however. *Grace*, as its title indicates, is
a painting with a religious connotation, whereas *The
Serving-girl* is completely pagan.

"I like to model as much as I like to paint," declared Matisse in 1913. "I have no preference. If the quest is the same, when I am tired of one medium, I return to the other – and 'to nourish myself' I often make a copy in clay of an anatomical figure... I do so in order to express form, I often devote myself to sculpture which makes it possible for me, instead of just confronting a flat surface, to move around the object and thus get to know it better... But I sculpt like a painter. I do not sculpt like a sculptor. What sculpture has to say is not what music has to say. These are all parallel paths but they cannot be confused with one another..."

Perhaps Matisse's mastery, which is evident from his earliest work, can be explained in part by the fact that he is a rare example of a late developer since there was nothing in his youth or his family background to indicate the route he was to take. Matisse was working as a lawyer's clerk in 1890 when, at the age of 21, he was given a paintbox while recovering from appendicitis. This triggered a sudden and unhesitating change of direction. He abandoned the law for the Académie Julian, where he studied under Bouguereau, the high priest of the "pompiers", the banal but highly popular artists of the time who were so despised by the Impressionists. Bouguereau reproached Matisse for "not knowing how to draw". "Tired of faithfully reproducing the contours of plaster casts, I went to study under Gabriel Ferrier who taught using live models. I did my utmost to express the feelings which the sight of a woman's body aroused in me." Matisse

The Dining Table (The Preparations – Still Life),
1896–1897
La desserte (Les préparatifs – nature morte)
Oil on canvas, 100 x 131 cm

Still under Chardin's influence, colour regains the upper hand in this still life. The carafes are very prominent and his teacher, Gustave Moreau, who admired his student, claimed that one could "hang one's hat on the stoppers. That is the main thing."

would find his ideal master in the "charming" Gustave Moreau, a painter whose outlook was broader and who welcomed him into his studio, where he would meet his future companions in the Fauvist venture – Manguin, Camoin, Derain, Marquet and Rouault. "He, at least, was capable of enthusiasm and even of passions."

In 1894, Matisse married Amélie-Noémie-Alexandre Parayre. Life was so hard for them that she had to open a milliner's shop to help them survive. This did not stop Matisse from buying some major works of art from the dealer Ambroise Vollard, works which he retained his whole life and which profoundly influenced his own work at the time. These included *Naked Man – the Serf* (p. 14), *Carmelina* (p. 17) or the first sketches for the series of sculptures entitled *Nude, Backview* (pp. 20–21). He hung the following paintings at home so as to be able to admire them at his leisure: Cézanne's *Three Bathers* (p. 20), a painter he defined as "the father of us all", a plaster bust of Rochefort by Rodin, *Head of a Boy* by Gauguin, and a drawing by van Gogh. Matisse's selection says a great deal about his taste in art and what influenced him in his early stages.

André Marchand reported that in 1947, Matisse said about a landscape which he had painted 40 years earlier. "I was very young, you see, I thought that it was no good, poorly executed, not well-constructed, an insignificant daub, but look at it reduced in the photo; everything is there, it is well-balanced with the tree leaning slightly to the right. Look at this other photo, an enlargement. Basically,

First Orange Still Life, 1899
Première nature morte orange
Oil on canvas, 56 x 73 cm
Musée National d'Art Moderne, Centre Georges Pompidou, Paris

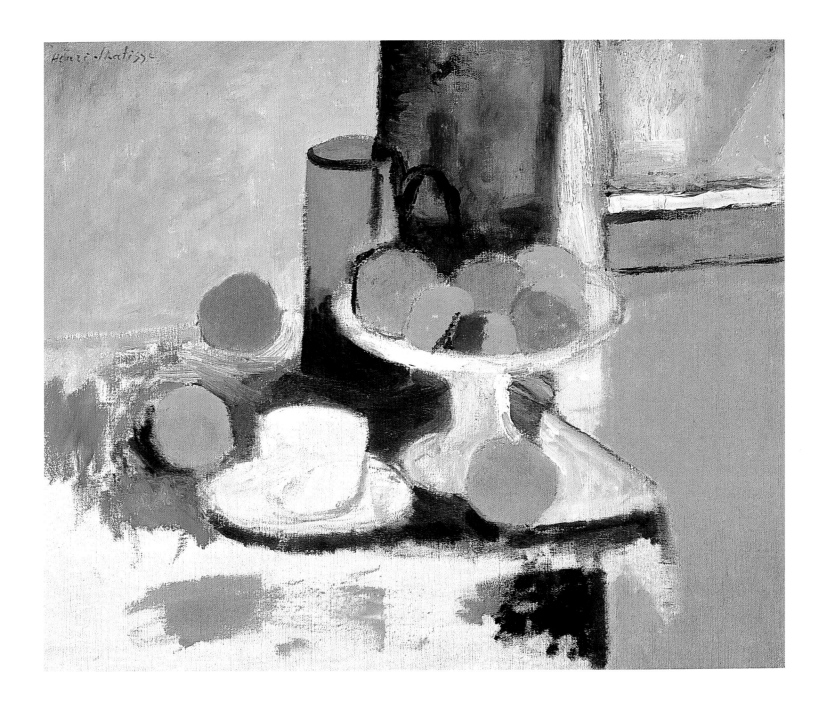

Still Life with Oranges (II), 1899
Nature morte aux oranges (II)
Oil on canvas, 46.7 x 55.2 cm
Washington University Gallery of Art, St. Louis (MO)

all I have done is to develop this idea, you know when one has an idea one is born with it, one develops one's 'idée fixe', one's whole life, one breathes life into it." To other people, he said: "I don't draw any better nowadays, I draw differently." Or: "Not a single attribute of mine is lacking in this picture although they are here in embryonic form."

Matisse's words are applicable to all his early paintings, in which there is really no such thing as the work of a "beginner". From the outset, the composition is in place, colour already emerging in all its splendour. Gustave Moreau, an indulgent, yet excellent critic, commenting on *The Dining Table*, painted in 1897 (p. 11), reveals what is revolutionary in this essay and declares: "Leave it as it is, those carafes are well-balanced on the table and I could hang my hat on the stoppers. That is the main thing." The first *Dining Table* was exhibited by Matisse at the Salon de la Société Nationale des Beaux-Arts and he was counting on it heavily to make his name. It is an everyday scene of the type he used to paint in his early years, reminiscent of a work by Chardin (p. 10). There is nothing more traditional than a maid leaning over a set table, arranging flowers in a vase. On the white tablecloth, the well-ordered array of dessert dishes, carafes and crystal

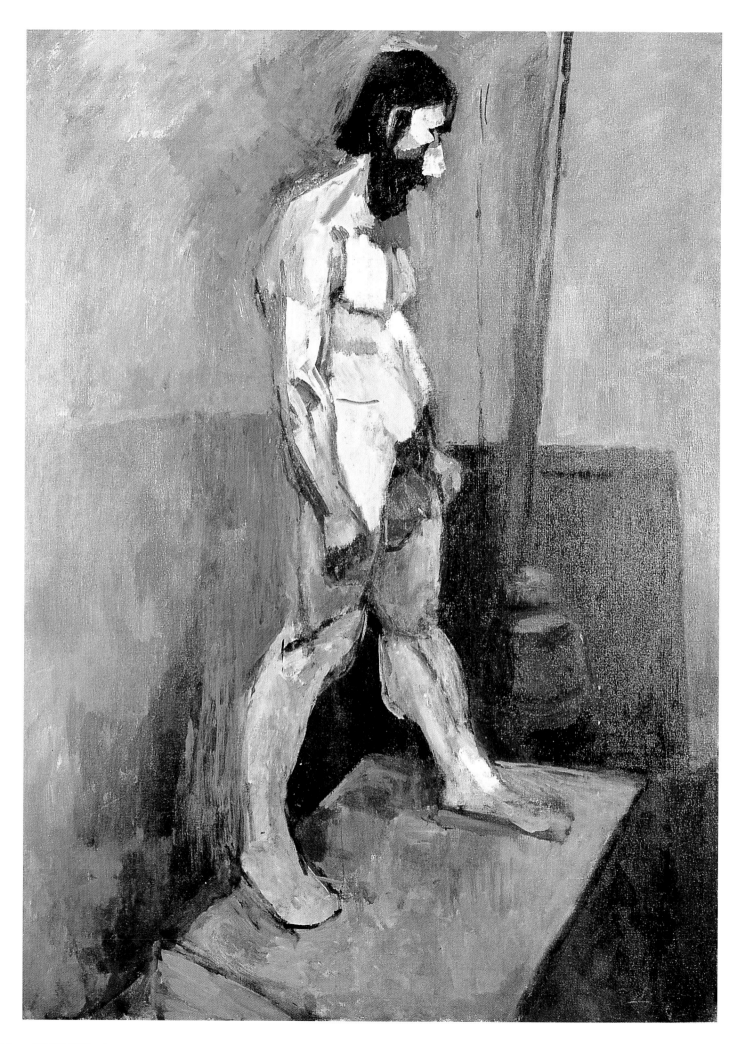

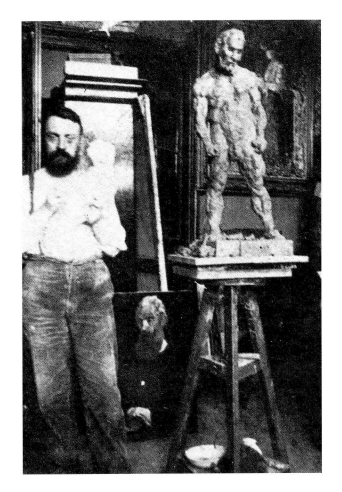

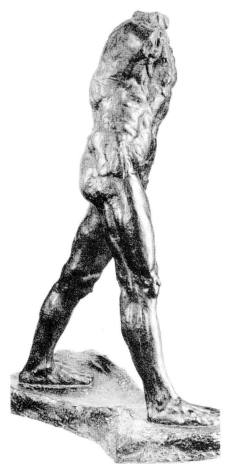

Matisse considered that only weak individuals were incapable of accepting the teaching and influence of the Old Masters. Since he considered himself to be strong, he did not hesitate to immerse himself in an in-depth study of those painters whose sensibilities he considered to be close to his own, including Poussin, Chardin, Watteau, Manet, Cézanne and Rodin. All of them were part of the true tradition of French painting in their art as well as in their personalities. "For my part, I have never avoided the influence of others," Matisse once told Apollinaire. "I would have considered such avoidance as cowardice or a lack of sincerity. I think that the personality of an artist is strengthened through all his struggles. One would have to be pretty silly to avoid studying how other people work. I am surprised at how some people can be so self-confident as to believe that they have understood the truth of their art right from the outset. I have accepted influences from time to time. But I think I have always known how to bring them under control."

This choice says much about Mattisse's artistic tastes and the influences which he adopted from his very beginnings. Despite the extremely difficult times he endured, to the extent that he was forced to let his wife, Amélie, open a milliner's shop in order to provide a livelihood for the couple, he got into debt in order to buy works of art from the dealer Vollard. He kept these works for a long time and hung them in his home in order to study them and admire them at his leisure. They included Cézanne's *Three Bathers* (p. 20), a plaster bust by Rodin entitled *Bust of Rochefort*, a canvas by Gauguin entitled *Head of a Boy*, and a drawing by van Gogh. He even collected the famous sayings of these artists. "I love this phrase of Chardin's: 'I add colour until it bears a resemblance.' And this one by Cézanne: 'I want to make the image', and this by Rodin: 'Copy nature.' Da Vinci said: 'If one knows how to copy one knows how to do.'"

The Serf, 1900–1903
Le Serf
Bronze, height: 92 cm

Matisse in 1903–1904, standing next to his sculpture *The Serf* before he decided to remove the arms.

Auguste Rodin: *The Walking Man, Study for "John the Baptist"*, 1877
L'homme qui marche
Bronze, height: 85 cm
Musée Rodin, Paris

PAGE 14:
Nude Man – the Serf, 1900
Homme nu, le serf
Oil on canvas, 99.3 x 72.7 cm
The Museum of Modern Art, New York

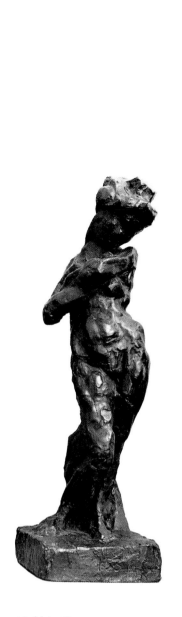

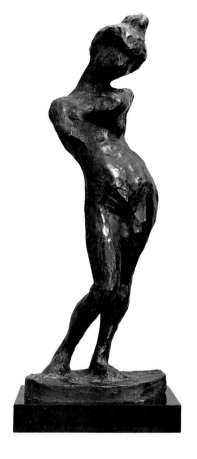

Madeleine II, 1903
Bronze, height: 59 cm

Madeleine I, 1901
Bronze, height: 59 cm

Standing Model – Blue Academy, 1900–1901
Modèle debout – Académie bleue
Oil on canvas, 73 x 54 cm
Tate Gallery, London

Another example of Matisse's unique way of studying shapes and seeking out the reliefs and the hollows by treating the same subject in painting and in sculpture.

PAGE 17:
Carmelina, 1903
Oil on canvas, 80 x 64 cm
Museum of Fine Arts, Boston (MA)

glasses create a still life to which the painter has devoted all his skill, so that one can find no fault. But Matisse *qua* Matisse, is already there – in the white of the tablecloth which is bright but heavily shaded, in the intensity of the splashes of orange and in the carefully studied hues of the shadows. It is there in the "modernist" manner, à la Degas, of representing the scene as if viewed from above, in the Japanese style.

These same elements are expanded upon, simplified of course, and consequently even more "Matisse" in *Harmony in Red – The Red Dining Table* painted in 1908 (p. 50), which hangs in the Hermitage in St. Petersburg. The scene is obviously exactly the same but this time the colours are no longer used to add bright touches; they play a much more active role in relation to each other. This is no longer an intimate household scene, it is a battle. The window, a constant theme in Matisse's work, has become the green rectangle of a framed landscape which contrasts with the red expanse filling the rest of the canvas. In a manner typical of Matisse, the maid has been turned into a sketch, the array of glasses and bottles has disappeared. The baroque contortions of the arabesques and garlands have become all-invading and are now the true subject of the picture. This essentially graphic theme would appear in all of Matisse's work. It would return as a leitmotif, as one of the main manifestations of his personality, as one of his obsessions.

"North Pole, South Pole," is how Picasso – who thought as highly of Matisse's work as the "charming" Moreau did – is said to have defined the contrast between

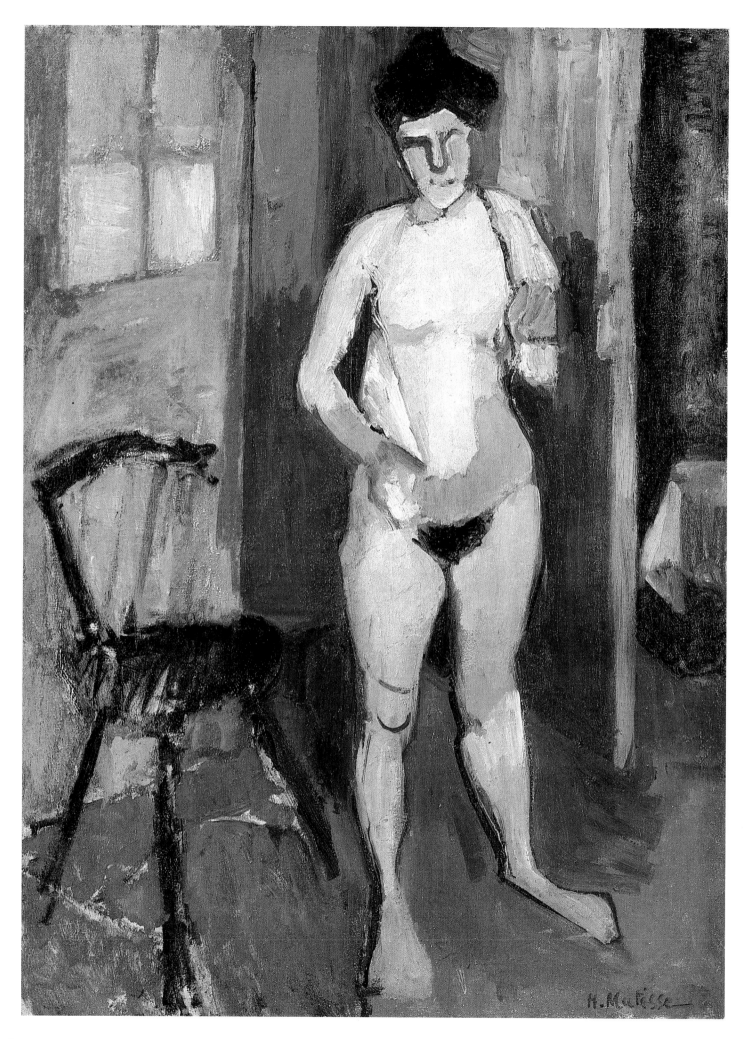

himself and Matisse, the two most illustrious and influential painters of the 20th century. Matisse and Picasso, the two great rivals, in fact, had a relationship which lasted for half a century and which was based on a discreet, almost complicitous, friendship. The one exhalted colour, echoed the other, who smashed form into pieces. "I feel through colour," professed Matisse, "so it is through it that my canvas will always be organised. Yet the feelings ought to be concentrated and the means used brought to their maximum expression."

PAGE 18:
Nude with White Towel, 1902–1903
Nu à la serviette blanche
Oil on canvas, 81 x 59.5 cm
Collection Mr. & Mrs. Gifford Phillips, New York

This version of *Carmelina* is more minimalist, almost abstract, yet another treatment of the subject in two different ways.

Still Life with Blue Jug, 1900
Nature morte à la cruche bleue
Oil on canvas, 60 x 65 cm
Private collection

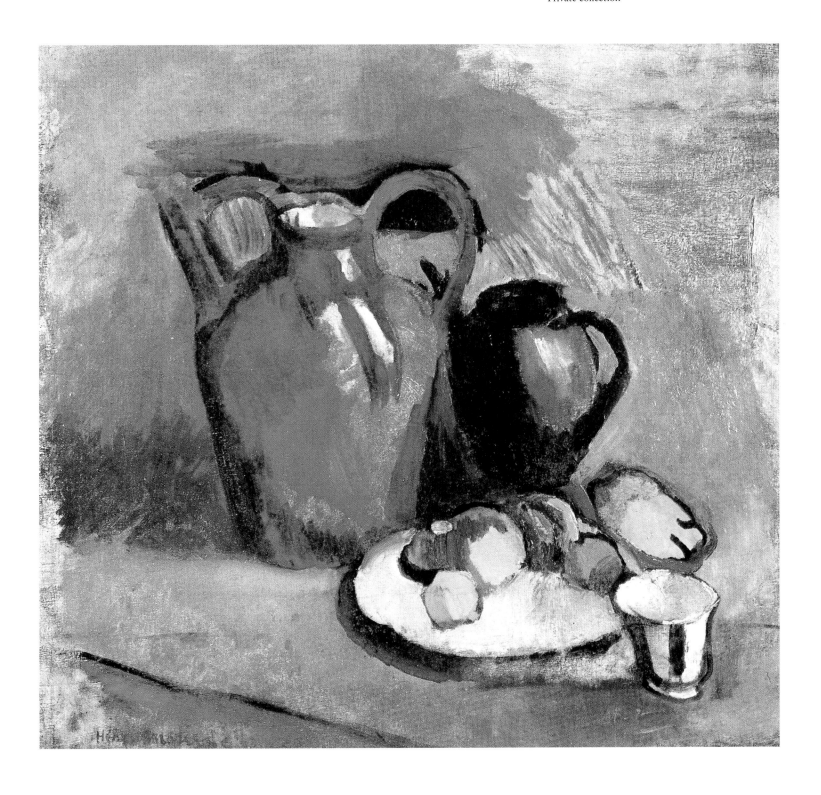

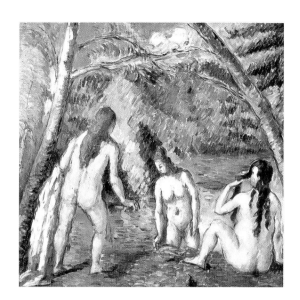

Paul Cézanne: *Three Bathers*, 1879–1882
Trois baigneuses
Oil on canvas, 58 x 54.5 cm

"If Cézanne was right, I am right." Matisse bought this painting from the dealer Ambroise Vollard in 1899 for the sum of about 1300 francs at the time. In 1936, Matisse donated it to the Musée de la Ville de Paris. It was the inspiration for a whole series of drawings and sculptures of the backview of nudes.

Nude, Backview, 1907–1909
Nu de dos
Pencil, 31.5 x 24.4 cm
Private collection

Nude, Backview, 1907–1908
Nu de dos
Ink, 29 x 18 cm
Matisse Archives

Study of Female Nude, Standing. Back, 1901–1903
Etude de femme nue, debout, de dos
Pen and black ink, 27 x 20 cm
Musée de Peinture et de Sculpture, Grenoble

The Red-headed Girl, 1906
La fille rousse
Ink
Private collection

Untitled (Nude, Backview), 1907–1908
Sans titre (Nu de dos)
Reed and Indian ink, 38.6 x 18.6 cm
Musée National d'Art Moderne, Centre Georges Pompidou, Paris

Back I, 1908–1909
Dos I
Original plaster, height: 190 cm
Musée Matisse, Cateau-Cambrésis

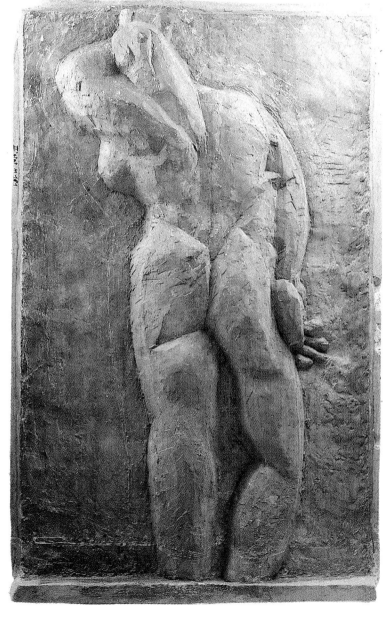

Back II, 1913
Dos II
Original plaster, height: 188 cm

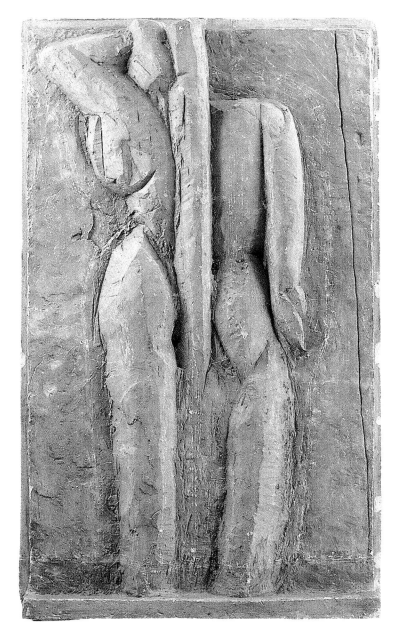

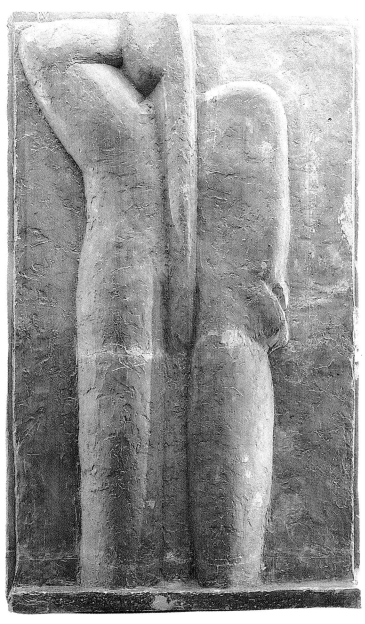

Back III, 1916–1917
Dos III
Original plaster, height: 190 cm

Back IV, 1930–1931
Dos IV
Original plaster, height: 190 cm

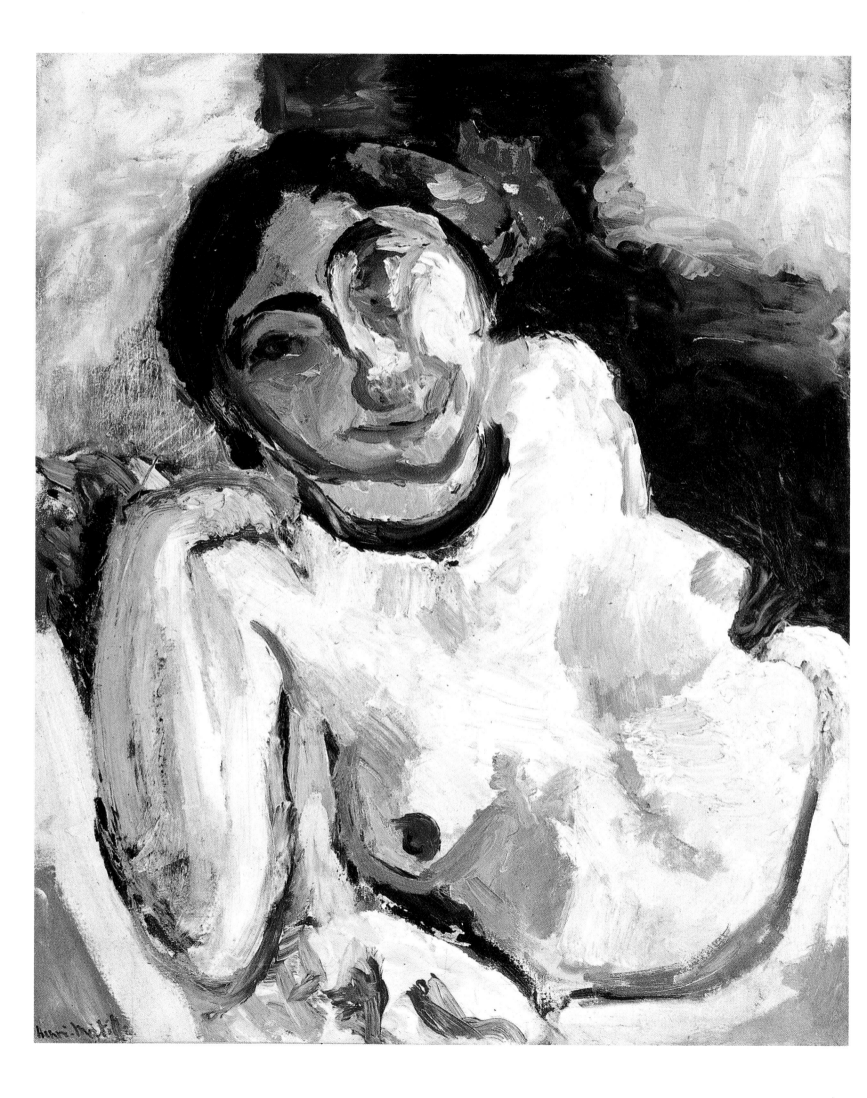

A Fauve in Paradise

This passion for colour was to turn Matisse into the reluctant leader of a school of painting – the Fauves, just as, some 40 years earlier, Manet had found himself the involuntary leader of the Impressionists. Matisse, who was supremely reticent by nature, middle-class by habit and totally opposed to fuss of any kind, found himself promoted to standard-bearer of the Fauves (a nickname which translated means "wild beasts") and the number one butt of the critics. At one point, an inscription in chalk, of which Utrillo was the suspected author, appeared on the walls of Montparnasse in Paris: "Matisse drives one mad… Matisse is worse than absinthe."

Yet far from wishing to shock, Matisse merely dreamed of recreating paradise and imposing it upon his contemporaries of the 20th century, a century which was devoted to massacres and violence, and this is by no means the least paradoxical aspect of his work. *Pastoral* (p. 25), *Luxe, Calme et Volupté* (p. 27), an evocative title borrowed from Baudelaire's *Invitation au Voyage* and *La Joie de Vivre* (pp. 28–29) invoke an Arcadian idyll of shepherds and shepherdesses in a dreamlike Garden of Eden. The critics swiftly extended the concept of a "medical paradise" – referring to the prescriptions of "the good Dr. Matisse" who wanted his painting to act as a "tranquiliser" – to the rest of Matisse's work. Are not the two versions of *The Dining Table* (p. 11 and p. 50) allusions to gourmet heaven? And doesn't *The Boules Players* painted in 1908 (p. 60) belong in bowling heaven? As for the various paintings based on the theme of *Music* (pp. 60, 191) or *The Piano Lesson* (p. 93) painted between 1907 and 1923, do they not evoke certain heavenly pleasures of hearing? The *Nudes* surely evoke Adam and Eve being evicted from Paradise when they became ashamed of being naked? Are not *The Odalisques* the houris who live in Allah's paradise? In each of the themes used by Matisse a direct relationship can be sensed with the painter's avowed aim, "To awaken the ancient deep-seated sensuality of man." The multiple versions of *The Dance* (pp. 58–59, 150–151, etc.), one of the artist's obsessions, were yet another aspect of this avowed aim.

Surely this wild beast, this "Fauve", contrary to what he was considered to be in his day, was a gentle lamb or, rather, a sort of benevolent psychiatrist determined to cure our ills. The way in which Matisse translated this heavenly happiness through his use of intense colours must indicate that Matisse was no "Fauve", if being a Fauve implies violence, since his colour scheme belongs to light and is non-violent by nature. Colour had been a revelation to Matisse from the outset, and he now sought how best to control it totally, to allow it to explode freely all over the canvas in joyous proliferation. As the forerunner of the Minimalists, Matisse was attempting to "simplify painting" just as his teacher, Gustave Moreau, had predicted and he now sought to reduce it to the essentials – the minimum of resources used to produce the maximum results. In this respect, he

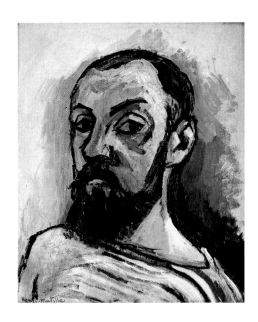

Crouching Nude, Profile with Black Hair, 1906
Nu accroupi, profil à la chevelure noire
Lithograph, 39.5 x 21.5 cm
Bibliothèque d'Art et d'Archéologie, Paris

Crouching Nude with Downcast Eyes, 1906
Nu accroupi, les yeux baissés
Lithograph, 39.6 x 21.3 cm
Baltimore Museum of Art, Baltimore (MD)

Self-portrait, 1906
Autoportrait
Oil on canvas, 55 x 46 cm
Statens Museum for Kunst, Copenhagen

PAGE 22:
The Gypsy, 1906
La gitane
Oil on canvas, 55 x 46 cm
Musée de l'Annonciation, Saint-Tropez

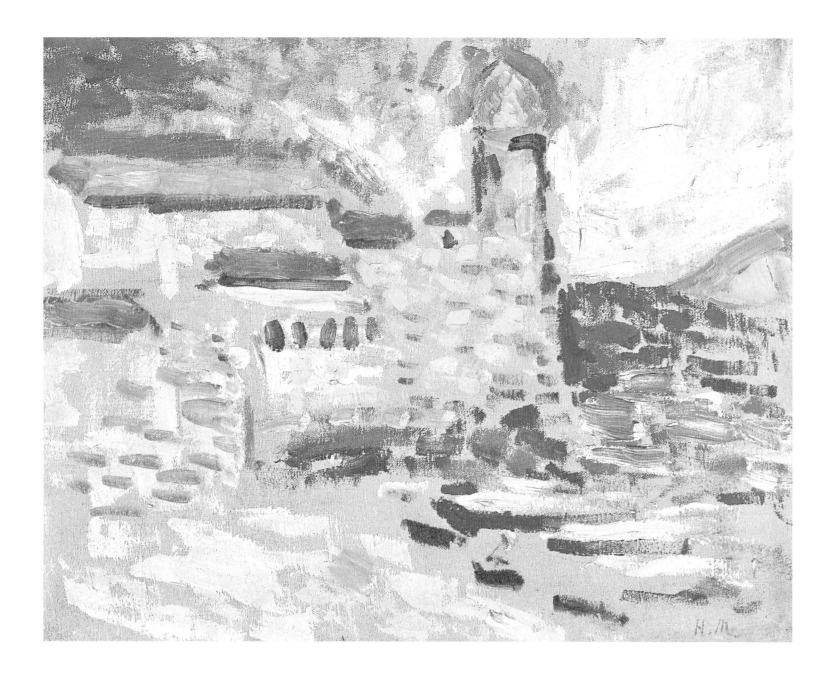

View of Collioure (The Bell Tower), 1905
Vue de Collioure (Le clocher)
Oil on canvas, 32.9 x 41.3 cm
Private collection

André Derain: *Boats at Collioure*, 1905
Oil on canvas, 47 x 46 cm
Staatsgalerie Stuttgart, Stuttgart

is both the precursor and the accomplice of all the simplifiers of our time, from Malevich to Mondrian.

One of the stages in this final conquest of colour was Matisse's encounter with Signac, with whom he spent the summer of 1904 at Saint-Tropez. The flamboyant colours and brilliant light with which the Midi is so generously endowed hastened this development. Matisse first experienced the shock of Mediterranean light after a short trip with his wife Amélie to London, where he discovered Turner. It was in the South of France that he found his true climate, the one to which he would remain faithful his whole life, the reflection of the sun "in his belly" as Picasso put it.

Signac's Pointillist technique, which made the colours sing on the canvas and impregnated them with light in a continual play of scintillating reflections, was to be used in a painting which marks a turning-point in the history of modern art, a painting which Matisse contemplated long and hard and which was preceded by numerous sketches and preparatory studies. This was *Luxe, Calme et Volupté* completed in 1905 and exhibited in the spring of the following year at the Salon des Indépendants.

Matisse put his all into this painting, using his skill and talent to the utmost. The composition was undoubtedly inspired by the Cézanne painting which Ma-

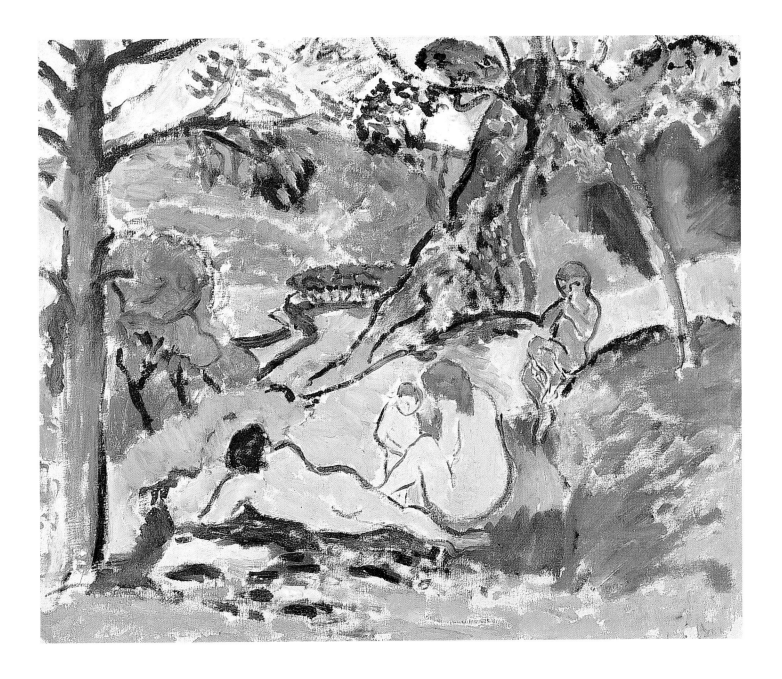

tisse owned (p. 20), and in fact he first called it *Bathers*, in homage to the original model. But there is also something of Poussin in this work, especially the position of the semi-reclining nude in the foreground; it may be based on the *Bacchanale* in the Louvre which Matisse had once copied. The way in which the theme of the Golden Age is dealt with shows an affinity with artists who had tackled the same subject in the recent past, especially Puvis de Chavannes (*Doux Pays*, 1882), Cross (*Air du Soir*, 1902) and Signac (*Au Temps d'Harmonie*, 1893–1902). The way in which contrasting elements, both real and symbolic, are placed in relation to each other is also, to a certain extent, reminiscent of Manet's *Déjeuner sur l'Herbe*, and especially Cézanne's violently expressive variations on that theme in the 1870s. In this painting, Matisse sought to measure himself against the great names in painting. This includes Ingres' *Turkish Bath* in which the figures also adopt a variety of poses, though in the painting by the neo-classical Old Master, the inhabitants of the harem are incarcerated within it, whereas Matisse's nymphs are free to roam in a mythical Eden whose totally decorative composition combines the soft curves of the hills with the sinuous diagonal which marks the shoreline and the strong vertical counterpoint of the tree on the right.

Signac and Cross applauded the performance and enjoyed the strong and dominant contrasts. Yet Cross accurately predicted: "It is good, but you will not

Pastorale, 1905
Oil on canvas, 46 x 55 cm
Musée d'Art Moderne de la Ville de Paris

Georges Seurat: *Bathing at Asnières*, 1883–1884
Une baignade à Asnières
Oil on canvas, 201 x 301.5 cm
Tate Gallery, London

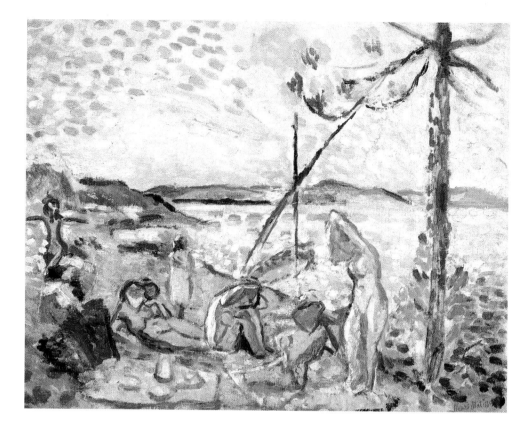

Study for "Luxe, Calme et Volupté", 1904
Etude pour "Luxe, calme et volupté"
Oil on canvas, 32.2 x 40.5 cm
The Museum of Modern Art, New York

The Gulf of Saint-Tropez, 1904
Golfe de Saint-Tropez
Oil on canvas, 65 x 50.5 cm
Kunstsammlung Nordrhein-Westfalen, Düsseldorf

remain with it..." In fact, the techniques of Seurat, Signac and company did not completely satisfy Matisse who disassociated himself from them, making the cogent point: "Neo-Impressionism, or rather the offshoot called Divisionism, was the first attempt to order the techniques of Impressionism, but the process was an ordering of a purely physical nature, a medium which was often mechanical and which corresponded to purely physical emotion. The fragmentation of colour caused a fragmentation of form and shape. Result: a disjointed surface. There is a retinal sensation but it destroys the tranquillity of surface and form. Objects are only differentiated by the degree of luminosity allotted to them. Everything is treated in the same way. In the end, there is mere tactile animation, comparable to a 'vibrato' of the voice or the violin... I have not kept to this path; I have painted in large expanses seeking the quality of the painting through a harmony between the flat expanses of colour. I have tried to replace the 'vibrato' by a more expressive, more direct harmony, a harmony whose simplicity and sincerity would enable me to achieve calmer surfaces." Matisse concluded with this damning condemnation: "Fauvism dislodged the tyranny of Divisionism. One cannot live in a household that is too orderly, a home run by aunts from the provinces. So off one goes into the bush, to seek simpler methods which do not smother the spirit. In this instance, the influence of Gauguin and van Gogh are also evident. These are the ideas of their time: construction through coloured surfaces, experimenting with the intensity of colour, the subject matter being unimportant, reaction against the diffusion of localised hues into the light. The light is not removed but is expressed through the harmony of brightly-coloured surfaces."

"The influence of Gauguin and van Gogh..." This is where Matisse places the origins of Fauvism. Van Gogh had just had a retrospective devoted to his work in spring 1905, at the Salon des Indépendants of which Signac was president and a founder-member. Matisse was appointed deputy secretary and in this capacity he took charge of it personally, thus making it possible for him to expand and re-evaluate "the crisis of Pointillism" which he had experienced during the pre-

vious year. As for Gauguin, Matisse saw his latest works from Oceania during his stay in Collioure in the summer of 1905, when, in the company of Maillol, he visited Daniel de Monfreid, the faithful friend of the "madman of the Islands". It was in Gauguin's technique of expanses of colour, that Matisse discovered the instrument of his release from Pointillism. To the future Fauves, van Gogh contributed his dynamism and his ability to translate his feelings into colour. Gauguin contributed his synthesised, intellectual art. Vlaminck expressed it as "The art of van Gogh is human, sensitive, lively; that of Gauguin is cerebral, intellectual, stylised." So it was not difficult to sense which direction each of those embarking on the Fauvist adventure would lean to, and sometimes take, and how the two currents of which Fauvism consisted would establish themselves. On the one hand there were the intellectuals – Matisse, Marquet, Friesz, Dufy and Braque – who were influenced by Gauguin. On the other, there were the primitives – Vlaminck, Derain, van Dongen – who were influenced by van Gogh. The division was not inviolable, of course; for instance, Derain stayed at Collioure in 1905 with Matisse and his work evolved into a decorative style using expanses of colour like Gauguin. Matisse, on the other hand, was by no means indifferent to van Gogh's art and frequently imitated his short brushstrokes.

Luxe, Calme et Volupté, 1904–1905
Oil on canvas, 98.5 x 118 cm
Musée d'Orsay, Paris

In this painting, Matisse chose to measure himself against great works such as Manet's *Le Déjeuner sur l'Herbe* and above all the violently expressive variations of Cézanne in the 1870s. There is also something of Poussin in this work. One is reminded of the *Bacchanale* in the Louvre which Matisse once copied. Finally, in the actual theme of the Golden Age, there is an affinity with those who had recently tackled this subject, the Pointillists Puvis de Chavannes and Cross.

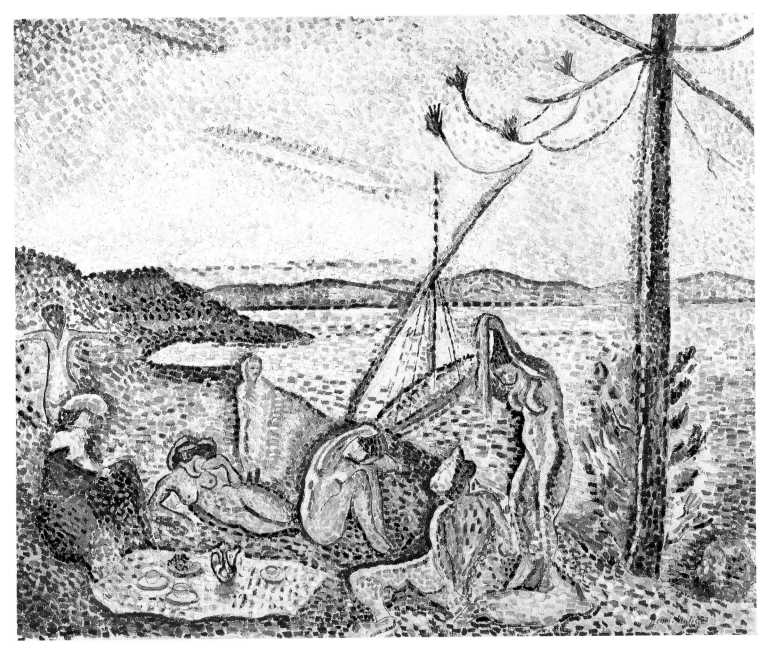

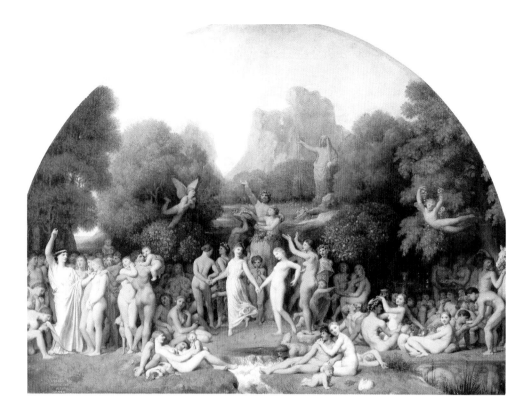

Jean-Auguste-Dominique Ingres: *The Golden Age*, 1862
Oil on paper mounted on a wood panel, 47.9 x 62.9 cm
The Fogg Art Museum, Harvard University Art Museums, Cambridge (MA)

Life (Torso with Head), 1906
La vie (Torse avec tête)
Bronze, height: 23 cm

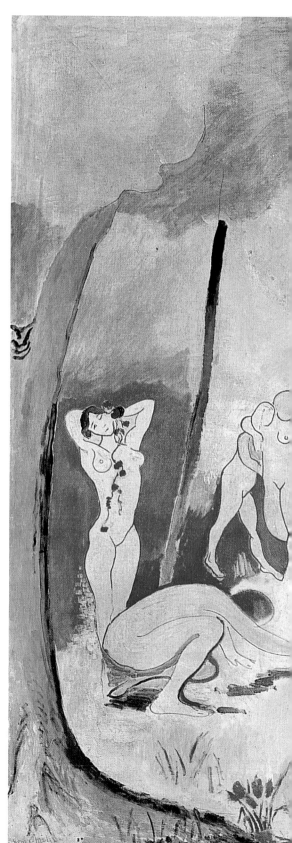

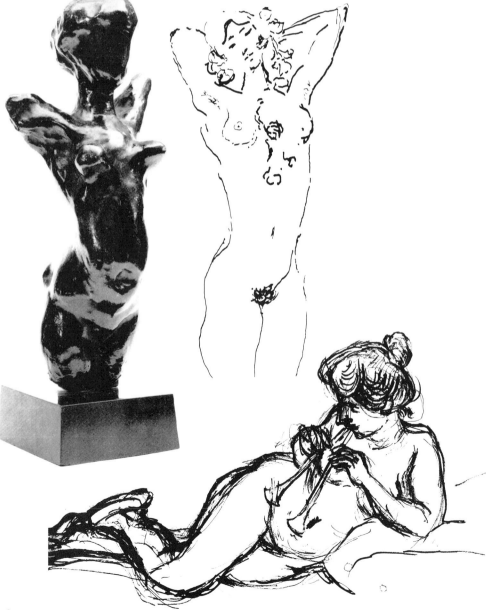

Female Nude (Study for "La Joie de Vivre"), c. 1905
Nu féminin
Pen and Indian ink
Private collection

Reclining Nude Playing the Pipes, 1905–1906
Nu allongé jouant de pipeau
Pen, 45.8 x 60.4 cm
Private collection

La Joie de Vivre, 1905–1906
Oil on canvas, 174 x 238 cm
The Barnes Foundation, Merion (PA)

This is an example of Gauguin's heavy influence in the coloration although there is something of Ingres in the composition. This painting caused "polite society" to burst into gales of laughter, although today it is now generally agreed to be one of the

seminal works of 20th century art, in the same way as Picasso's *Les Demoiselles d'Avignon.* Signac considered it to be an act of betrayal, although there is something of Seurat's *Sunday at La Grande Jatte* in it. However, in his view it had the serious defect of resolutely rejecting any reference to the Pointillist doctrine. According to Matisse, *La Joie de Vivre* marks the true beginning of his work.

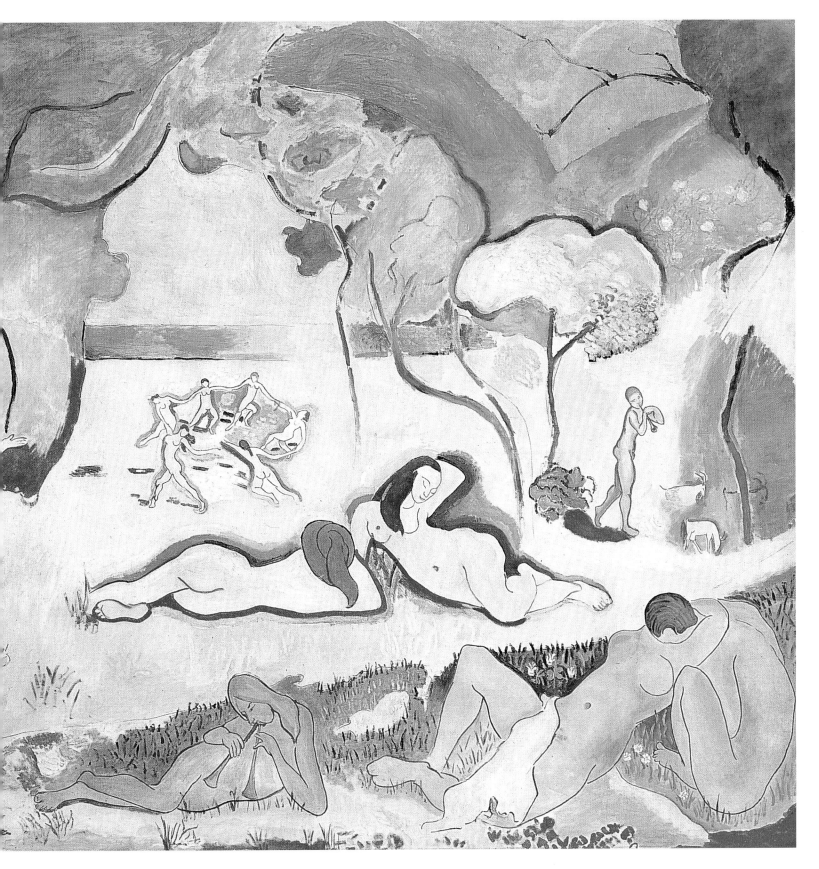

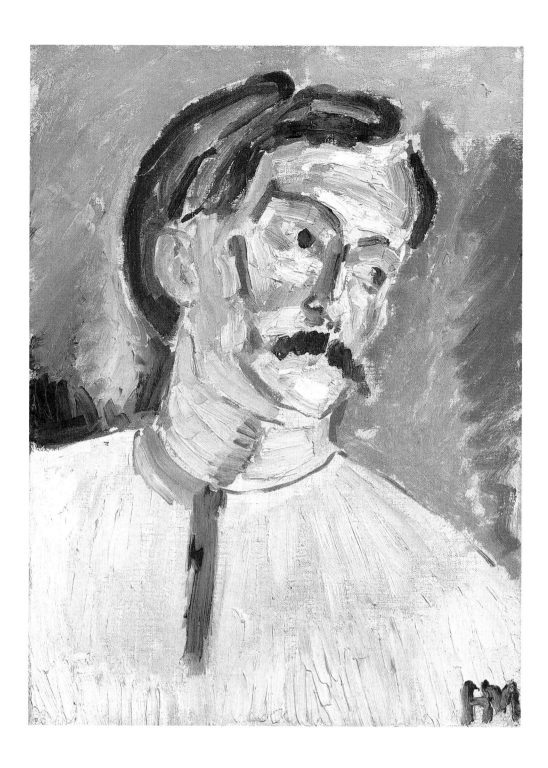

Portrait of André Derain, 1905
Portrait d'André Derain
Oil on canvas, 39.5 x 29 cm
Tate Gallery, London

PAGE 31:
Open Window at Collioure, 1905
La fenêtre ouverte à Collioure
Oil on canvas, 55 x 46 cm
Private collection

"The influence of Gauguin and van Gogh…" This is where Matisse places the origins of Fauvism of which Collioure had been the crucible. It is here that Matisse and Derain, his faithful disciple at the time, produced their most lively paintings. This *Window* is a prime example, combining as it does the Pointillism of Seurat and the flat surfaces of Gauguin.

It was at the 1905 Salon d'Automne that the critic Louis Vauxcelles first uttered his famous line, "Donatello among the wild beasts (fauves)", which gave the movement its name, although it is not known whether this salvo was directed at the small figure of a child by the sculptor Marque, after the Florentine style, or at the voluminous, hairy overcoat worn by Matisse on that cold late October day, which made him look like a bear. Whatever the case, it struck a chord and was to come into vogue. Fierce criticism was unleashed as it had been in the heyday of the Impressionists. Reactions exploded when critics were confronted with these vivid canvasses, painted "tube-to-canvas" as Vlaminck put it. Camille Mauclair, the most reactionary of the critics, dubbed "Faust-le-Honte" by his enemies, burst out in the newspaper *Le Matin*: "A pot of paint has been thrown in the public's face!" he wrote, shamelessly plagiarising the phrase which Ruskin had used in 1877 about a Whistler exhibiton in London. The famous but no less respectable and usually more objective magazine *L'Illustration* devoted a whole double page spread to the event in its issue of 4 November 1905 (p. 33), while

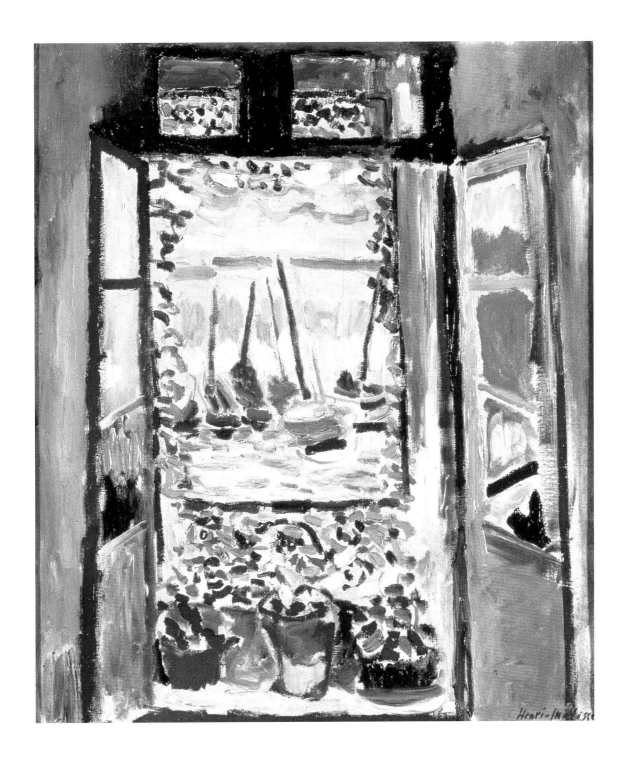

taking the precaution of explaining to its readers: "We are devoting these two pages to reproducing as best we can a dozen of the most notable paintings of the Salon d'Automne. Unfortunately, the colour is lacking, but one can at least judge the drawing and composition. If a few of our readers are surprised at some of the subjects we have chosen, they should read the lines printed beneath each painting. These are the evaluations of the leading writers on art, and we bow to their authority. We would merely remark that if critics once reserved their paeans of praise for established celebrities and all their sarcasm for beginners and experimenters, things are very different today."

Thanks to *L'Illustration* we know that Matisse's contribution consisted of *Woman with Hat (Madame Matisse)* (p. 32), *Open Window at Collioure* (p. 31), *The Japanese Dress, The Promenade*, etc. The scandal was to benefit the newly-dubbed "Fauves" because shrewd dealers as well as enlightened collectors began to take an interest in them and help extricate them from their penury. That is what happened to Vlaminck who feared he had "tricked" the dealer Ambroise Vollard.

PAGE 32:
Woman with Hat (Madame Matisse), 1905
Femme au chapeau (Madame Matisse)
Oil on canvas, 81 x 65 cm
Private collection

PAGE 33:
The article in the 4 November 1905 issue of *L'Illustration*. Matisse, Manguin, Rouault, Derain, Valtat, Puy – the Fauves.

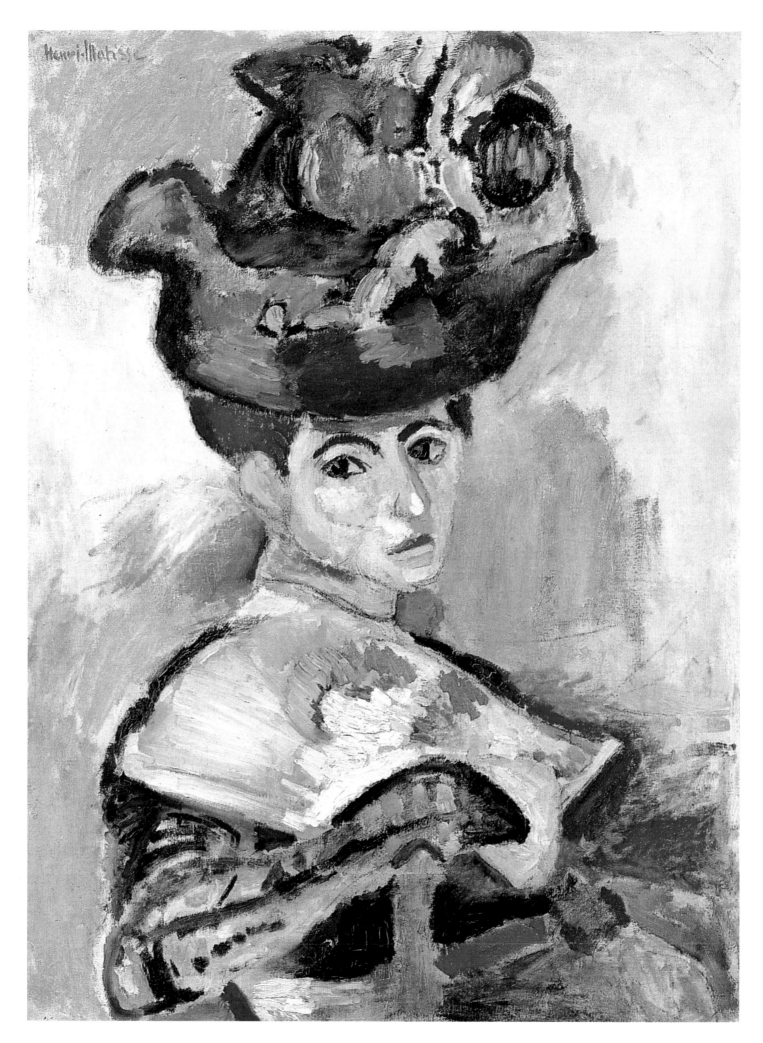

HENRI MANGUIN. — La Sieste.

M. Manguin : progrès énorme ; indépendant sorti des pochades et qui marche réso-
lument vers le grand tableau. Trop de relents de Cézanne encore, mais la griffe d'une
puissante personnalité toutefois. De quelle lumière est baignée cette femme à demi
nue qui sommeille sur un canapé d'osier!

Louis Vauxcelles, *Gil Blas.*

GEORGES ROUAULT. — Forains, Cabotins, Pitres.

Il est représenté ici par une série d'études de forains dont l'énergie d'accent et la robustesse de dessin sont extrêmes. Rouault a
l'étoffe d'un maître et je serais tenté de voir là le prélude d'une période d'affranchissement que des créations originales et
des travaux définitifs marqueront.　　　　Thiébault-Sisson, *le Temps.*

M. Rouault éclaire, mieux que l'an passé, sa lanterne de caricaturiste à la recherche des filles, forains, cabotins, pitres, etc.
Gustave Geffroy, *le Journal.*

M. Rouault... âme de rêveur catholique et misogyne.　　　　　Louis Vauxcelles, *Gil Blas.*

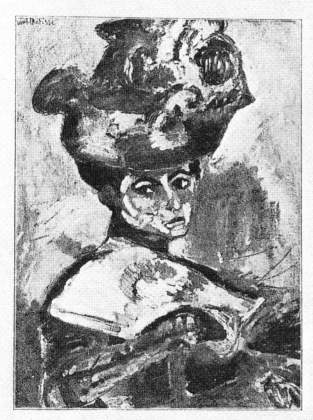

HENRI MATISSE. — Femme au chapeau.

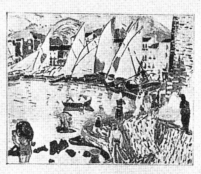

ANDRÉ DERAIN. — Le séchage des voiles.

M. Derain effarouchera... Je le crois plus affichiste que
peintre. Le parti pris de son imagerie virulente, la juxtapo-
sition facile des complémentaires sembleront à certains
d'un art volontiers puéril. Reconnaissons cependant que
ses bateaux décoreraient heureusement le mur d'une cham-
bre d'enfant.　　　　Louis Vauxcelles, *Gil Blas.*

LOUIS VALTA. — Marine.

A noter encore : ... Valtat et ses puissants bords de mer
aux abruptes falaises.　　Thiébault-Sisson, *le Temps.*

M. Louis Valtat montre une vraie puissance pour évoquer
les rochers rouges ou violacés, selon les heures, et la mer
bleue, claire ou assombrie.

Gustave Geffroy, *le Journal.*

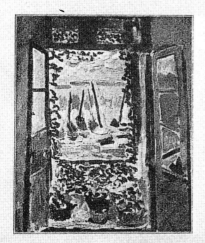

HENRI MATISSE. — Fenêtre ouverte.

M. Matisse est l'un des plus robustement doués des
peintres d'aujourd'hui. Il aurait pu obtenir de faciles bravos,
il préfère s'enfoncer, errer en des recherches passionnées,
demander au pointillisme plus de vibrations de luminosité.
Mais le souci de la forme souffre.

Louis Vauxcelles, *Gil Blas.*

M. Henri Matisse, si bien doué, s'est égaré comme d'autres
en excentricités coloriées, dont il reviendra de lui-même, sans
aucun doute.

Gustave Geffroy, *le Journal.*

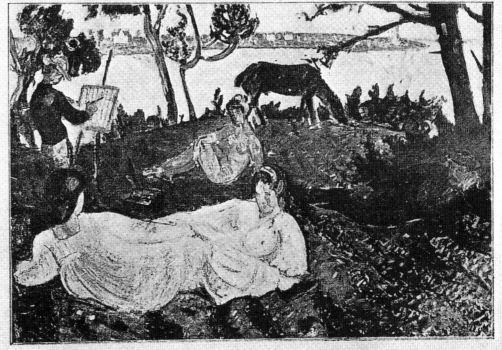

JEAN PUY. — Flânerie sous les pins.

... M. Puy, de qui un nu au bord de la mer évoque le large schématisme de Cézanne, est représenté par des scènes de plein air où les volumes des
choses et les êtres sont robustement établis.　　　　Louis Vauxcelles, *Gil Blas.*

Vollard removed all the canvasses stacked in Vlaminck's studio for what the painter considered to be the "excessive" sum of 6,000 francs. Matisse also began to earn money from his paintings, his best works being bought regularly at the time by the collectors, Léo and Gertrude Stein.

One very young critic, at the outset of his career, distinguished himself from the others by defending the new art. His name was André Gide and in his *Promenade au Salon d'Automne* he wrote: "I lingered in this room (in which the Fauves were exhibiting), listening to people as they walked by and when I heard them exclaim at a Matisse painting, 'That's madness!' I was very tempted to reply, 'No, Monsieur, quite the opposite. It is the product of theories.' Everything can be deduced and explained from it, all that one needs to do is use one's intuition. No doubt when Monsieur Matisse paints the forehead of that woman in apple green and this tree trunk in bright red, he can tell us, 'It is because…' Yes, this art is reasonable, it is even reasoned." These were intelligent and sensitive comments amidst a storm of abuse.

Collioure was the centre of the enterprise. It was there that Matisse and Derain, his faithful disciple at the time, created their most lively canvasses; in particular the *Open Window at Coullioure* (p. 31) in which Matisse combines Seurat's Pointillism and the expanses of colour used by Gauguin in his impression of the trip to Monfreid. It was a magnificent beginning to a theme which was to be further enriched and become fundamental to his art. When Matisse returned to Paris this inclination became even more pronounced and he began using Gauguin's technique alone, starting with the portrait of his wife wearing a flowered hat. *Woman with Hat* (p. 32) was to enrage a large number of visitors to the Salon d'Automne. The colour scheme of the face ranges from yellow to green, opts for red for the hair, then tends to mauve or violet for the hat, yet it has a "pastel",

Blue Nude (Souvenir of Biskra), 1906
Nu bleu (Souvenir de Biskra)
Oil on canvas, 92 x 140 cm
Baltimore Museum of Art, Baltimore (MD)

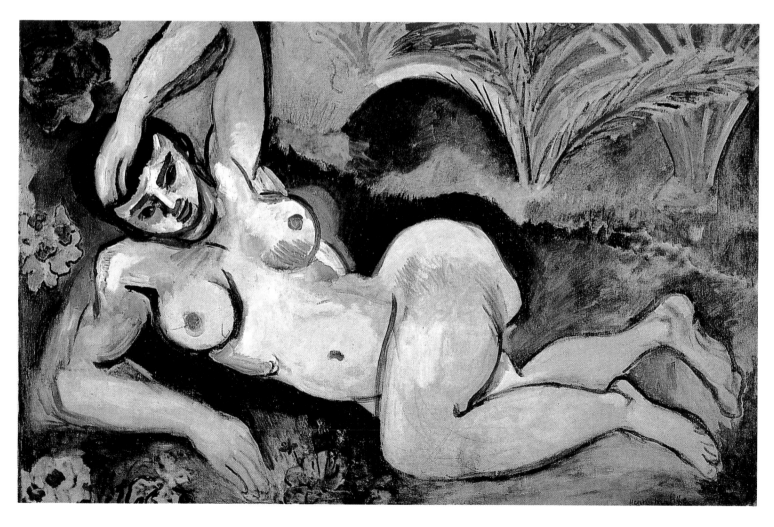

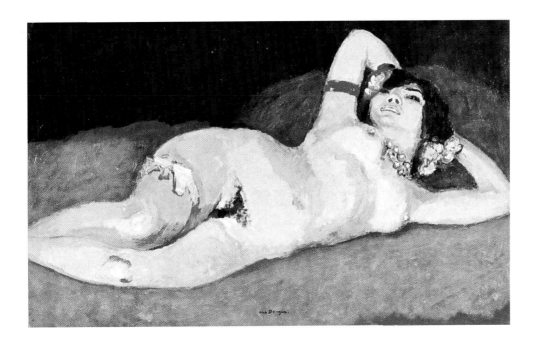

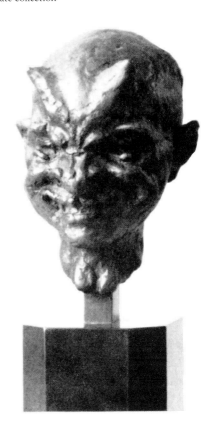

Kees van Dongen: *Nude Wearing a Garter*, 1905
Oil on wood, 81 x 100 cm
Private collection

Head of a Faun, 1907
Tête de faune
Bronze, height: 14 cm

Reclining Nude I (Aurora), 1907
Nu couché I (Aurore)
Bronze, length: 50 cm

The Fauvist used very similar themes – landscapes,
nudes, etc. Thus the pose of "reclining nude" treated
by Matisse in painting and sculpture, to which he
would frequently return, is very close to other nudes
by van Dongen, Derain, and even Modigliani. But
the eroticism of Matisse is less aggressive than that of
van Dongen.

Nude, Backview, 1906
Nu de dos
Lithograph, 41.4 x 27.5 cm
Bibliothèque Nationale, Paris

Seated Nude, Backview, 1906
Nu assis de dos
Lithograph, 43.5 x 24.5 cm
Bibliothèque Nationale, Paris

Idol, 1906
Idole
Lithograph, 44.6 x 22.2 cm
Bibliothèque Nationale, Paris

Henri-Matisse

The Red Carpets, 1906
Les tapis rouges
Oil on canvas, 89 x 116.5 cm
Musée de Peinture et de Sculpture, Grenoble

This is almost a Cézanne, had he painted in the Fauvist style. Yet what interested Matisse were both the contrasts of colours and a brushstroke which summarises and coordinates the essential lines. Throughout his life he sought to achieve this combination. His love of carpet patterns is also evident here, as are the fabrics which mark the start of Matisse's decorative art phase which show the recent influence of the Islamic art he had seen. This painting is a precursor of *The Red Dining Table* of 1908 (p. 50) in which the wall seems to become an extension of the table and a unique and stylised decoration. For the moment, Fauvism predominates over Cézanne's false perspectives.

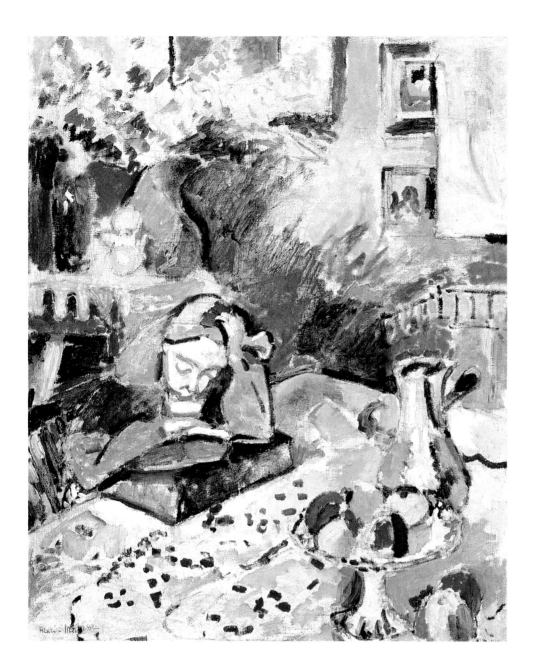

bright note, and is never brutal or elemental as it might have been if painted by Vlaminck. Today, the painting looks like a harmonious rainbow, an attractive bouquet of wild flowers. Perhaps the other portrait of Madame Matisse by its very simplification is more provocative; a green line (hence the title of the painting *Madame Matisse: "The Green Line"*, p. 2) cuts the face in half. The small size of the painting (40.5 x 32.5 cm) is surprising in view of the effect it produces. It is typically Fauvist, based solely on the use of colour, with the "green line" defining the areas of light and shade. Thus, just as Matisse had intended, an impression of tranquility emanates from the portrait despite the intensity of the colour. Even though the lines of the subject have been reduced to basics, this has not prevented the artist from seeking to create a likeness, because unlike Cézanne, or, rather, going beyond Cézanne, Matisse is not content with studying views and structures, he tries at the same time to present a faithful and genuine likeness.

According to Matisse, *La Joie de Vivre* (pp. 28–29) – nowadays considered to be one of the seminal works of 20th century art, in the same way as Picasso's *Les Demoiselles d'Avignon* – marks the true beginning of his work. Signac considered it to be pure treason, although the composition is similar to Seurat's *Bathing at Asnières* (p. 25). However, as far as Signac was concerned, the work had one major defect: it had resolutely rejected any reference to the Pointillist technique. "Ma-

Interior with a Young Girl Reading, 1905–1906
Intérieur à la fillette – La lecture
Oil on canvas, 72.7 x 59.4 cm
Private collection

Untitled (Study of a Head), 1906–1907
Sans titre (Etude de tête)
Graphite pencil, 20.3 x 17.3 cm
Musée National d'Art Moderne, Centre Georges Pompidou, Paris

Head with Necklace, 1907
Tête au collier
Bronze, height: 15 cm

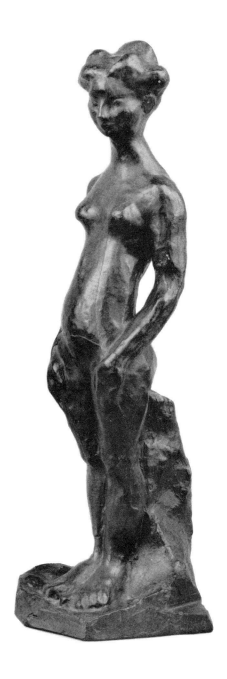

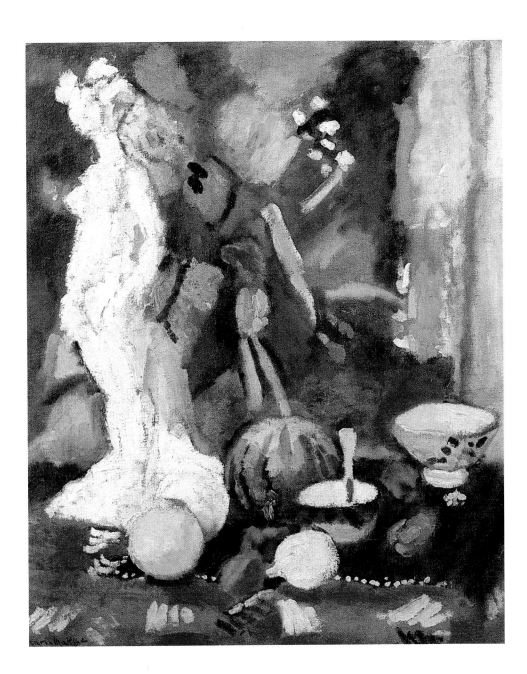

Nude Standing, 1906
Nu debout
Bronze, height: 48.3 cm

Still Life with Statuette, 1906
Nature morte à la statuette
Oil on canvas, 54 x 45.1 cm
Yale University Art Gallery, New Haven (CT)

With his love of ambiguity, bringing together flesh
and clay, Matisse would amuse himself on several
occasions by depicting his own sculptures as if they
were figures in a still life. Here again, Cézanne's work
is a constant presence.

tisse," he declared, "whose experiments I liked hitherto, seems to me to have gone
completely off the rails. On a two-and-a-half metre canvas he has edged the
figures with an outline as thick as a thumb. Then he has covered everything with
flat washes, clearly defined, which, pure as they are, look disgusting…Ugh, those
pale pink hues. They resemble the worst of Ranson (from the 'Nabi' period), the
worst 'cloisonné' work of the late Anquetin – and the brightly-coloured shop
signs used by ironmongers."

The dealers and collectors were not as sharply critical. The Steins, in particular,
were undeterred and immediately bought *La Joie de Vivre* as, in fact, they bought
many of Picasso's works (p. 47). The two beacons of modern art shared the du-
bious honour of each having caused a scandal in their day, and they maintained
their long-distance friendship, which went from strength to strength. They even
exchanged canvasses. Malicious gossip insinuated that each of them would select
what he found most dislikeable in the other in order to show it to his friends. For
instance, André Salmon even claimed that the portrait of *Marguérite* (p. 43)
which Matisse gave to Picasso was used by Picasso's visitors to the Bateau-Lavoir
for target practice, firing at it with a Eureka pistol which shot arrows fitted with
suction-cups: "a Marguerite bullseye!" In fact, the two men kept a close check
on the other but had nothing but admiration for each other. All that Matisse

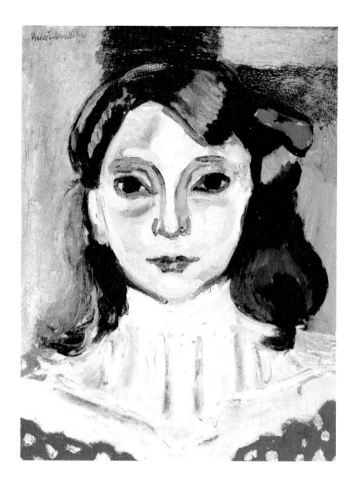

Marguerite, 1906
Oil on canvas, 31.8 x 24.1 cm
Marion Smooke Collection

Portrait of Marguerite, 1906
Portrait de Marguerite
Pen and ink, 39.7 x 52 cm
Private collection

PAGE 43:
Portrait of Marguerite, 1906–1907
Portrait de Marguerite
Oil on canvas, 65 x 54 cm
Musée Picasso, Paris

would say was: "Picasso is a Spaniard and I am a Frenchman. It is as if you were to ask me the difference between an apple tree and a pear tree. It is in the heart." Wassily Kandinsky, whose book *On the Spiritual in Art*, published in 1912, constitutes the fundamental theory of abstract art and contrasted the two artists: "MATISSE: colour, PICASSO: form. Two great tendencies, one great goal."

Although he kept himself at a distance, Matisse also played a role in the creation of Cubism which was to displace Fauvism. It was he who initiated Picasso into African art (*l'art nègre*) of which he was a collector and of which there are traces in such paintings as *Blue Nude, Standing Nude* or *Nude in Pink Slippers*. *Blue Nude (Souvenir of Biskra)* (p. 34) was painted at Collioure after a trip to Algeria. The only sign of the location are the palm-trees in the background, while the nude is inspired by the reclining figure in *Luxe, Calme et Volupté* and *La Joie de Vivre*. Matisse's sculpture *Reclining Nude I* (p. 35) is in the same pose, in a style reminiscent of African art. In this painting, he plays with the volume of the female form, emphasized by the flatness of the background, a thick shadow separating the two worlds. "What interests me most", he would say, "is not the still life nor the landscape either. It is the human figure. This is what makes it possible for me to best express the almost religious feeling which I have about life." In the case of both Matisse and Picasso, one is at a transitional stage, what Alfred Barr called "Cézanne or the crisis of 1907–1908", which affected everyone, not only the Fauves, but Matisse, Derain, Dufy, Vlaminck and even Picasso. It was the period when, for example, Braque moved straight from Fauvism to Cubism without a transition.

This "crise cézanienne" which Matisse and Picasso experienced for various reasons, drew on such fertile soil that the two contrasting styles were both able to feed from it. The style chosen by Picasso gave rise to Cubism. The other, Matisse's choice, evolved into a more synthesised construct, using larger and larger expanses of flat colour and a tendency towards geometric shapes, so that his art ceased to be subservient to emotion in order to become one of contem-

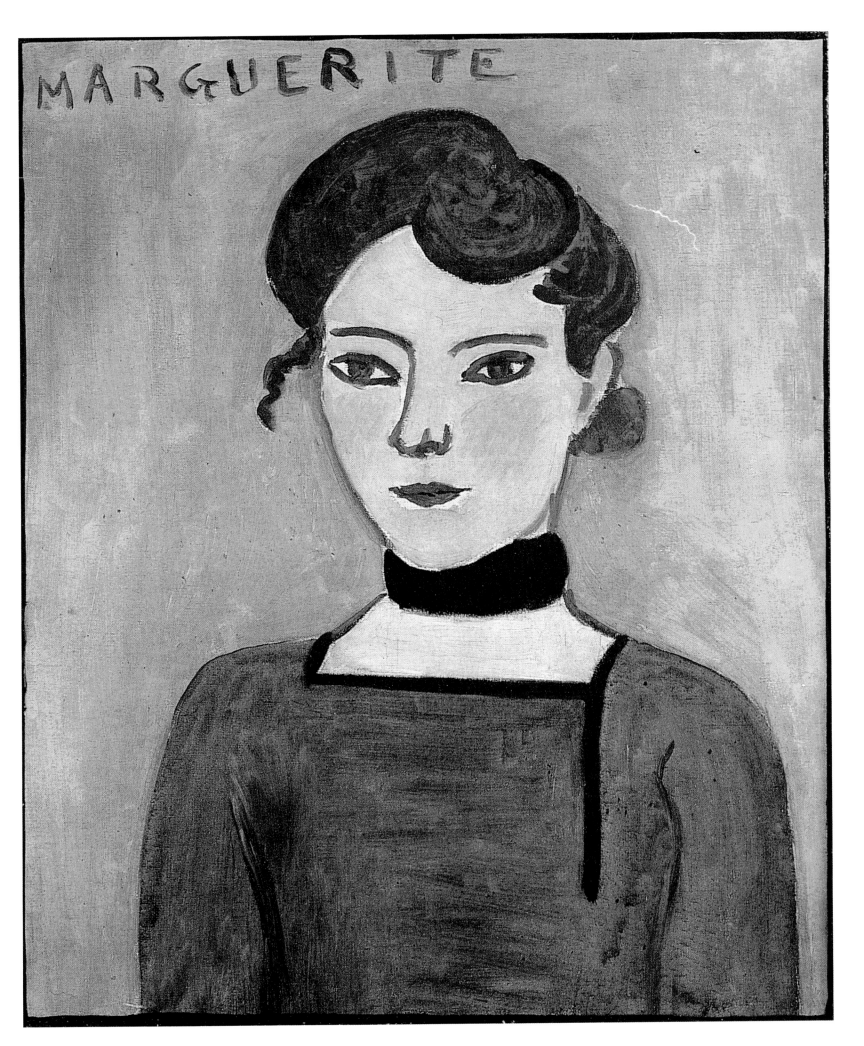

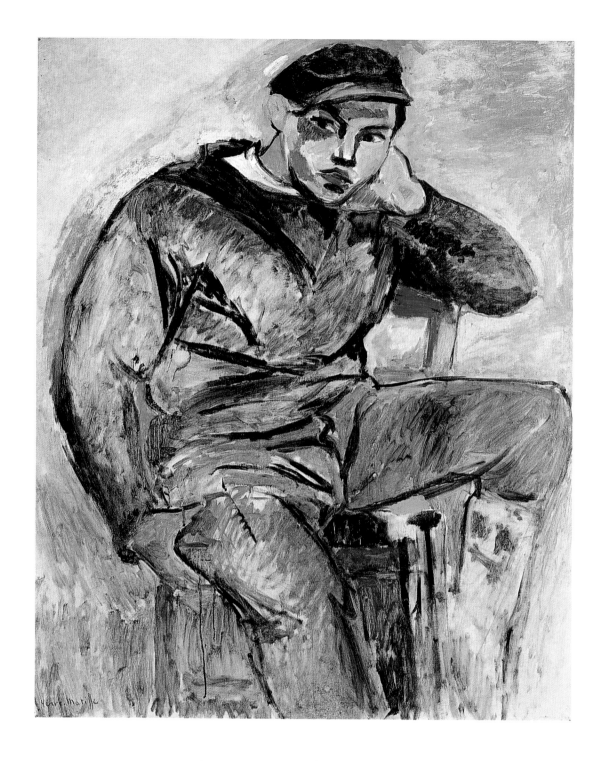

Sailor I, 1906
Marin I
Oil on canvas, 99 x 77.5 cm
Private collection

plation. However, a faint hint of Fauvism was to linger permanently in the background.

Of Matisse's paintings on the borderline between these two influences, whether they are as apparently different as *The Red Carpets* (pp. 38–39), the *Portrait of Marguerite* (p. 43) or *The Sailor* (pp. 44 and 45) – what interested Matisse, and what all these paintings have in common, is contrasting tones and a line which summarises and coordinates the basic composition. In the case of the two successive versions of *The Sailor*, there is an almost "schizophrenic" duplication of these two contrasting yet complementary preoccupations. One might consider the first version, *The Sailor I*, which concentrates on the outline of the face, the clothing, and the general silhouette as the "Dr. Jekyll" aspect of the painting, whereas the second version *The Sailor II*, which avoids anything that might look like bags under the eyes, and only uses the triumphal flat surface, represents the "Mr. Hyde" aspect of the same painting. Everything would return to normal and Matisse would be "cured" when this struggle between the two

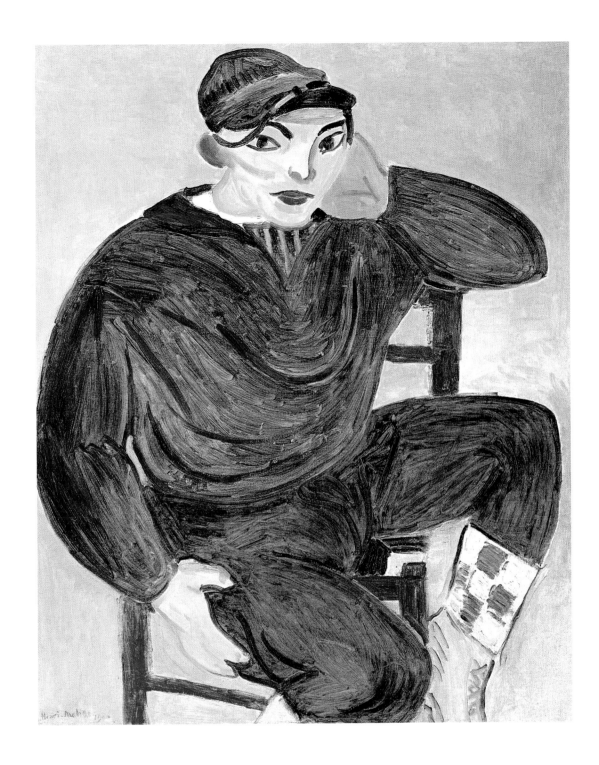

Sailor II, 1906–1907
Marin II
Oil on canvas, 100 x 80 cm
Private collection

All of Matisse's work, from start to finish, contains a
duality, the confrontation between shape and colour
which makes him into a sort of "Dr. Jekyll and Mr.
Hyde". He would often produce two versions of the
same painting, sometimes concentrating on form
(Sailor I) sometimes on colour *(Sailor II)*, until he
managed to achieve the perfect combination with his
gouache cut-outs.

halves of the same whole, contouring on the one hand and colour on the other,
fused together in the magical combination of the gouache cut-outs which "cut
directly into colour". Matisse was very conscious of the dilemmas which divided
him. In 1925, he said: "By being more assiduous and consistent, I learned to push
each study in a certain direction. The concept was gradually imposed whereby
painting is a means of expression and the same thing can be expressed in various
ways. 'Exactitude is not truth,' Delacroix was fond of saying. Note that the
classical painters constantly repainted the same picture but always in a different
way."

Two years after the scandal sparked off by the 1905 Salon d'Automne, Fauvism's
destiny was fulfilled. In its two or three years of existence, it had helped to show
young painters one of the ways in which it was possible to achieve the freedom
of expression which lies behind the achievements of modern art. Each of the
Fauves then went his own way, but the lesson they had imparted, as a group, in
such a short space of time, left deep impressions which can be found among the

Standing Nude (Nude Study), 1907
Nu debout (Etude de nu)
Oil on canvas, 92.1 x 64.8 cm
Tate Gallery, London

It is generally not realised that it was Matisse who gave Picasso his first African art statuette which eventually caused him to produce his seminal *Demoiselles d'Avignon*. Both artists were subject to the same influence in the same year, though each expressed it differently.

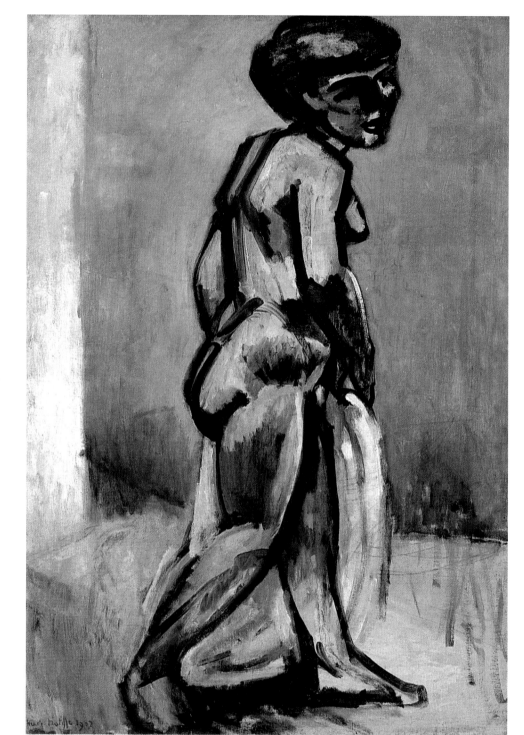

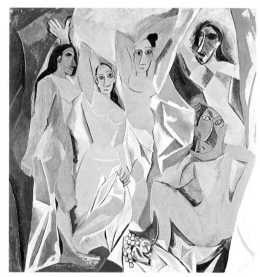

Pablo Picasso: *Les Demoiselles d'Avignon*, 1907
Oil on canvas, 243.9 x 233.7 cm
The Museum of Modern Art, New York

German Expressionists, the Russian painters such as Malevich and Kandinsky, in Soutine, in Klein, in Tapiès and right up to certain currents of American abstract art of the post-World War II period, as well as in some less prominent movements such as "Support-Surface" in France, that is to say, among all those who believed or who still believe in the opportunities afforded by colour. As Matisse said to Georges Duthuit: "Fauvism is not everything but it is the foundation of everything." Jean Leymarie noted that with *La Joie de Vivre*, Matisse had succeeded in surpassing the traditional opposition between Ingres and Delacroix, the Western alternative that assigns line to the intellect and colour to the emotions. This Matisse victory is by no means the least of his revolutions.

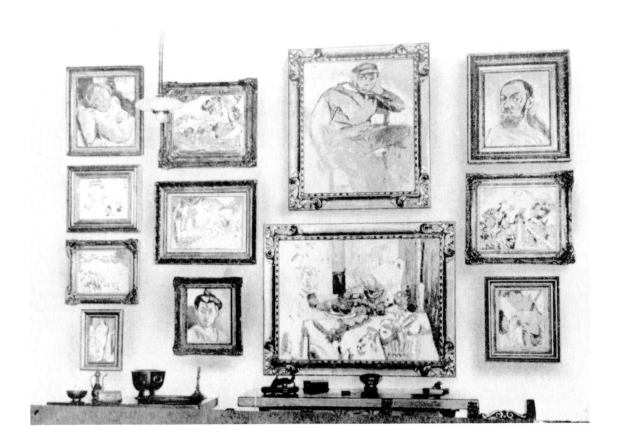

The Paris home of Léo and Gertrude Stein at 27, Rue de Fleurus, in 1907. A whole wall is covered with Fauvist paintings by Matisse from the period 1905–1907. The other wall is a mixture of Matisse's work and paintings by Picasso, Manet, Renoir and Daumier.

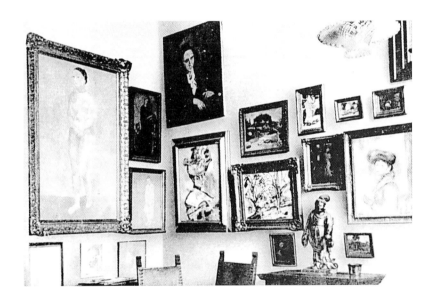

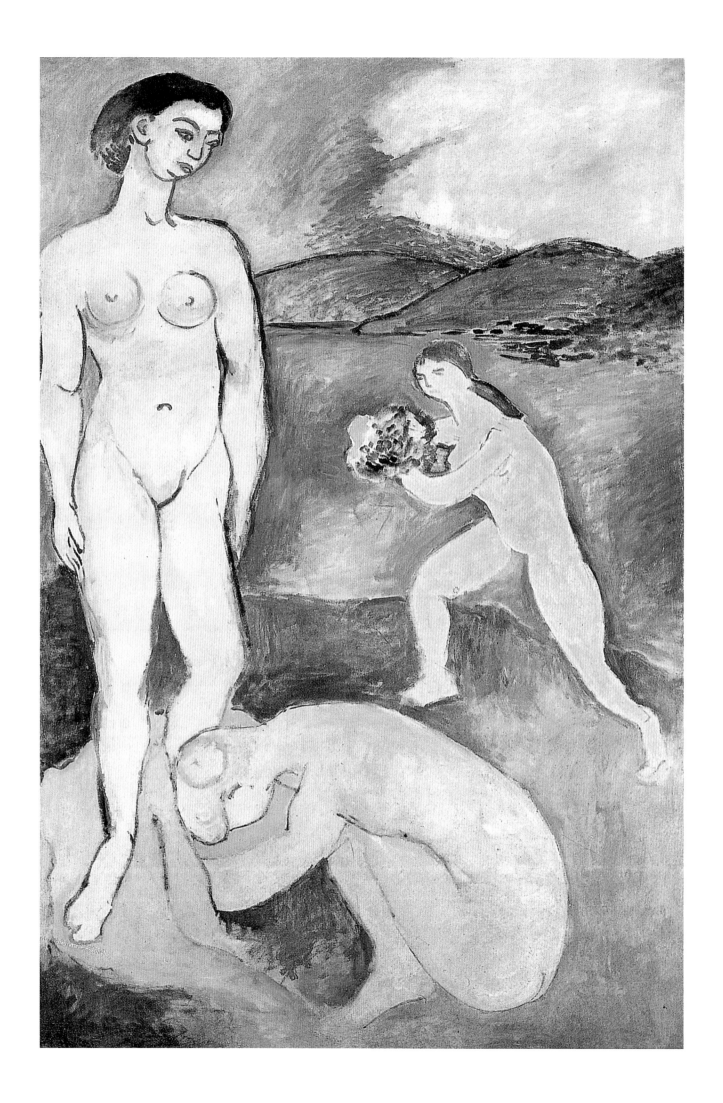

Dr. Jekyll & Mr. Hyde

"If Cézanne was right, I am right," Matisse would reassure himself, determined to discover the secret of his art. "In moments of doubt," he explained in 1925 to Jacques Guenne, "when I was still seeking myself, sometimes frightened by my discoveries, I knew that Cézanne had not been mistaken. You see, in Cézanne's work there are laws of architecture which are very useful to a young painter. Of all the great painters, he had the merit of wanting – giving his work as a painter its greatest mission – shades of colour to be the strength of a painting. It is hardly surprising that Cézanne hesitated for so long and so constantly. Personally, each time I stand in front of my canvas, it seems as though I am painting for the first time. There were so many possibilities in Cézanne who, more than anyone else, felt the need for an orderly mind. Cézanne, you see, is a sort of God of painting. Is his influence dangerous? What if it is! So much for those who are not strong enough to be able to withstand it! Not to be robust enough to be able to sustain an influence without weakening is proof of impotence."

"Let colours be the forces in a painting…" All of Matisse's work, from start to finish, is a record of artistic duality. The "Dr. Jekyll and Mr. Hyde" aspects of his work, have already been encountered . The phenomenon is particularly evident in the confrontation between shape and colour in the two versions of the *Sailor* (pp. 44–45). Yet this art still appears to be based on the equivocal and the implied. Such confrontations can also be diversified and change their nature. Is there a painter in the history of Western Art, who has produced more delightful, impromptu and amusing variations on the theme of duality as has Matisse? Is there a painter who leaves so much to the viewer to fathom his most mysterious messages? This is where the difference lies between a Matisse painting and any other object. One can love – or hate – the former without penetrating the miracles of refinement, the fertility of invention, the often dissimulated depth of technique, implied by this elliptical method so full of allusions which are the only way in which the painter can demonstrate his extraordinary gifts. His talents are as extensive as they are original and they are the result of a dual attribute. On the one hand, there is his amazing sense of the rhythm of line, a rhythm which is both continuous and incredibly flexible, that is capable of abandoning itself to the strangest variations without ever breaking its continuity and thus giving itself the ability to follow the theme throughout its meanderings. On the other hand, this infallible feeling for the harmony of colour which is not content with a complete accord but which constantly adds an element of surprise, an unexpected juxtaposition, causing one to exclaim: "Where on earth did he find this colour which happens to be so exactly right!"

In 1928, Roger Fry remarked that this note of unexpected colour "gives a great

Study for "Luxe I", 1907
Etude pour "Le Luxe I"
Pencil, 20.7 x 13 cm
Musée National d'Art Moderne, Centre Georges Pompidou, Paris

Luxe II, 1908
Le Luxe II
Caseine paint on canvas, 209.5 x 138 cm
Statens Museum for Kunst, Copenhagen

PAGE 48:
Luxe I, 1907
Le Luxe I
Oil on canvas, 210 x 138 cm
Musée National d'Art Moderne, Centre Georges Pompidou, Paris

Diego Velázquez: *Christ in the House of Martha and Mary*, 1680
Oil on canvas, 60 x 35 cm
National Gallery, London

Harmony in Red – The Red Dining Table, 1908
La desserte rouge
Oil on canvas, 180 x 200 cm
Hermitage, St. Petersburg

The Russian collector, Shchukin, had bought a *Blue Dining Table* from Matisse at the Salon d'Automne, but instead received the same canvas entirely re-painted in red. Matisse had completely changed the colour of the painting because the blue harmony did not give him the contrast he sought with the spring-time background visible through the window. Matisse, "the painter of windows", found the inspiration in Velázquez. But whereas the painter from Seville who was so fond of depicting *bodegones* associated food with Christ, Matisse used it merely as a decorative element.

The Serpentine, 1909
La serpentine
Bronze, height: 56.5 cm

The decorative element, the ultimate feminine shape is the curve or arabesque. Here, as the title indicates, the body is serpentine, with arms and feet intertwined as if they were the coils of a braid. This representation of free movement is a forerunner of the theme of *The Dance* painted for Shchukin in the same year.

Illustration from a so-called "art" magazine which was the starting-point for the sculpture entitled *The Serpentine*. Matisse would take his source material from wherever he found it.

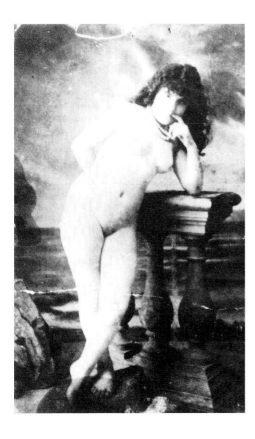

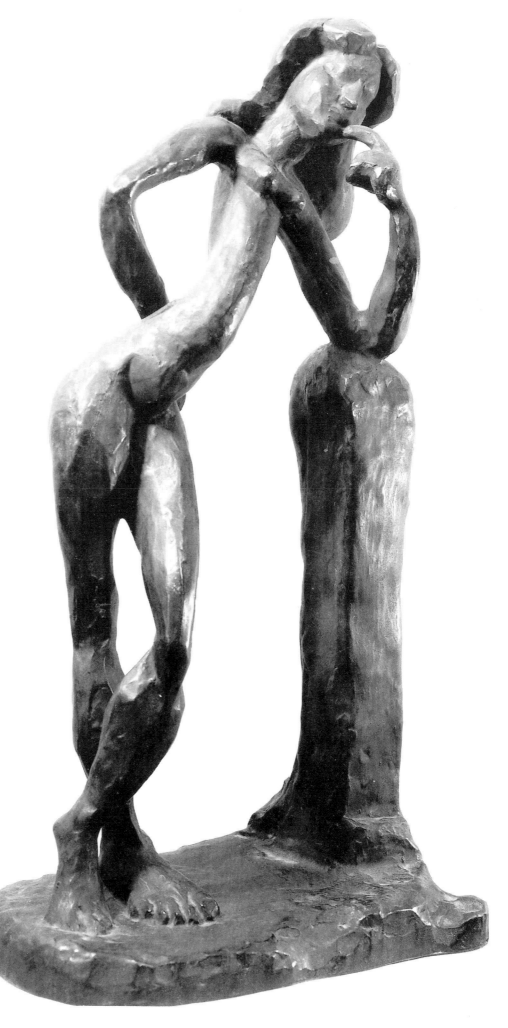

deal of freshness and life to his works, even if one only sees them as simple decorative patterns like those of Persian carpets… The miracle is that Matisse can interpret the colours of nature in a way that is absolutely personal to him – for example by painting bright red a bridge that is seen in the distance, without this spoiling the perspective. The power of his work is thus much greater than that of a mere decorator, and the Persian carpets he shows us are also the image of a three-dimensional world in which the equivocal gains a new power of evocation."

Pursuing this fundamental quest to combine his gifts and his goals, Matisse

Photograph representing two Tuareg women published in an ethnographic magazine, which inspired Matisse's sculpture *The Two Negresses*.

The Two Negresses, 1908
Les deux négresses
Bronze, height: 47 cm

did his best to transform his studio into a sort of "artificial paradise" and continued to pursue the "totality" of his aspirations as represented by the "Golden Age" which had already been at the centre of the works of Titian, Poussin, Watteau, Puvis de Chavannes and even, in a more exotic form, Gauguin. This was a fine idea, but in the middle of the 20th century it required a certain amount of courage to re-establish contact with the almost forgotten tradition of a mythology which the "Pompier" painters had been the last to celebrate so regrettably: an earthly paradise inhabited by gods in human form and naked creatures in godlike attitudes could raise a smile. Gaston Diehl compared the patiently nur-

The Music (Sketch), 1907
La musique
Oil on canvas, 73.4 x 60.8 cm
The Museum of Modern Art, New York

Bather, 1909
Baigneuse
Oil on canvas, 92.7 x 74 cm
The Museum of Modern Art, New York

tured work of Matisse on the theme of "Paradise" to that of Rodin in *The Gates of Hell* since Rodin also took an element from his *Gates* and created a completely separate sculpture from it. According to his needs, Matisse would take various motifs provided by *Blue Nude (Souvenir of Biskra)* (p. 34), *Luxe* (pp. 48–49), *The Dance* (pp. 58–59) and *The Music* (p. 60).

Thus, the three female nudes in *Luxe* become a separate element in *Luxe, Calme et Volupté* (p. 27). The influence of Puvis de Chavannes is present, the same Puvis de Chavannes who painted *Young Girls by the Sea* which Matisse may have admired at the Salon de la Société Nationale in 1895. By assigning to mural painting a decorative and strictly clear function, Matisse considered that Puvis de Chavannes had given it a new impetus. That is precisely what Matisse himself was seeking to do, as he strove to create something monumental, by introducing the gigantic bright yellow of his painting like Venus rising fully-formed from the waves. One feels that the two other, smaller, creatures, the pink one and the green one, are only there to pay homage to this goddess by kneeling at her feet or offering her flowers.

The first version, *Luxe I* (p. 48), dates from the same year, 1907, in which Picasso's *Demoiselles d'Avignon* (p. 46) was painted. Like *Sailor I* and *Sailor II*,

there was a sequel to *Luxe I*, *Luxe II* (p. 49). As in the case of *Sailor*, Matisse started with a strict analysis of reality using the same technique of small, sweeping brushstrokes and almost the same harmonies. Simplification is taken further and is greater, despite the fact that the first version corresponds fairly closely to the sketching style practised by the Fauves which caused critics and the public to describe their work at the time as ugly daubs. On the other hand, in the second version, *Luxe II*, as in the case of *Sailor II*, there are various interlocking coloured grounds which are so strictly, carefully and purposefully arranged that, as Matisse recounted later with a smile, he noticed too late that the right foot of the large figure at the left-hand side of the composition only has four toes. He had considered adding a fifth, but gave up the idea for fear of spoiling the whole arrangement. The technique of gouache cut-outs which Matisse invented 40 years later may well have had its origins in the great gulf which Matisse had created in perception with his *Luxe II*. This dual work also raises the following ambiguous query: should these three figures be interpreted in terms of plasticity as a single body divided into three poses and three different harmonies of colour, or in more symbolic terms as the depiction of three states of being – passive, active and contemplative?

Bathers with a Tortoise, 1908
Baigneuses à la tortue
Oil on canvas, 179 x 220 cm
City Art Museum, St. Louis (MO)

Matisse liked to change from the "dynamic" to the "static". Thus *The Music* is a response to *The Dance*. Both panels complement each other in their contrast and form a complete artistic whole. In this painting, the *Bathers with a Tortoise* are closer to the "static".

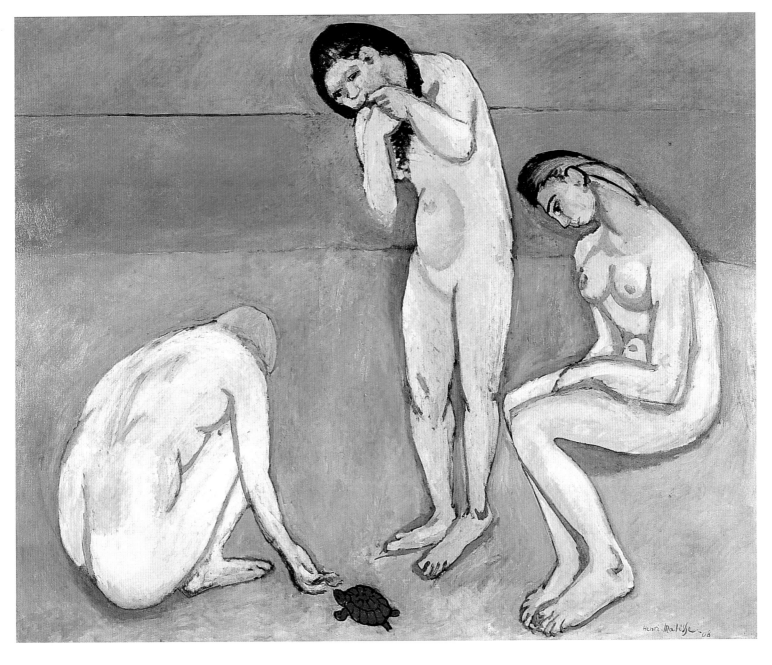

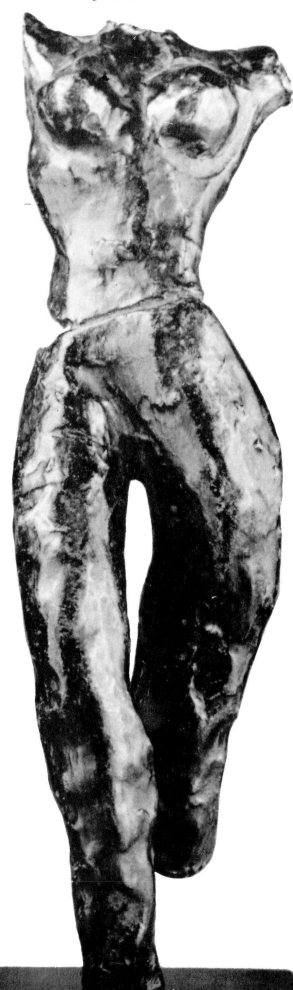

Torso Standing (Fragment), 1909
Torse debout (Fragment)
Bronze, height: 25 cm

Despite appearances, nothing is simple in Matisse, and there is enough to disconcert anyone who is unaware of the complexity of the interests which were guiding Matisse along the path of his best syntheses. Although the painter took the precaution of speaking of a "sketch" when, in fact, he was referring to a finished work, when he entered *Luxe I* for the Salon d'Automne in 1907 it is not surprising that Félix Vallotton had strong reservations. All he saw in this large panel (210 x 138 cm) "which caused quite a lot of discussion…" was a canvas in which "three women stand out against a marine background of greens, browns and violet-blues. One is tall, and stands facing forwards, dominating the second who is crouching in profile at her feet, and in the distance, a third women has her legs spread in a sort of suspended gallop; all this without any particular relationship between the shapes or volumes. It is drawn in outline, that hypnotic, shaky outline adopted by Monsieur Matisse, the only one, no doubt, which can record without betraying the vagaries of his sensitivity; the colour scheme is pleasant although flat, and the relationships happy though elemental. The impression created is a strange one; one is drawn to the painting from a distance because these waves of colour without definite representation make an attractive play on the wall, but as soon as one moves closer the charm evaporates instantly, thus causing disappointment… I have dwelt at some length on this case because it is representative and seems to be the rule. No one takes his art more seriously than Monsieur Matisse, and no one denies that he will achieve greater things, he is above all an honest worker; he deserves to be given some credit."

C. Lewis Hind, who wrote a study of the Post-Impressionists in 1911, wrote more harshly about a visit he made to the Rue de Fleurus, the home of the Steins who were then the proud owners of *Luxe I*. "In Paris," he writes, "I had occasion to drink the Matisse cup to the dregs… Mr. and Mrs. Stein are passionate about Matisse, they do not preach but they try to share their enthusiasm… My first reaction was consternation, almost horror. This group of nudes, those flat expanses of colour – the sort of colour wash used for the exterior of buildings – a green nude, a pink nude, a pale yellow nude. These monsters born of female forms, these caricatures of nudes!"

Of the two versions of the same subject, one emphasised the line, the other the tones. Matisse, as Dr. Jekyll and Mr. Hyde, resisted all attempts at systemisation even if the system in question was of his own making. Worried by his own

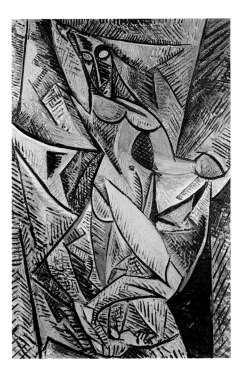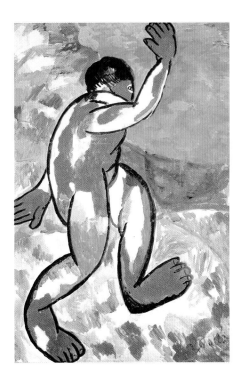

rigid quest or simply, as he himself said, tired of painting, he turned to sculpture. Here he applied the same preoccupations as those which had guided him in painting. The change from painting to sculpture always took place with the constantly affirmed concern to "organise oneself". "It was always in order to organise," he confided in Pierre Courthion, "it was to order my sensations, to seek a method that was totally suited to me… It was always with a view to possession of my brain, a sort of hierarchy of all my sensations which would have permitted me to reach conclusions."

Sometimes he would start not from a model but from a photograph from an erotic magazine (for *The Serpentine*, p. 51) or a postcard on an anthropological subject (for *The Two Negresses*, p. 52). Matisse quickly subordinated these natural elements to an expressive rhythm. In for *The Two Negresses* and even more so in *The Serpentine*, rhythm is a decorative element: a renegade from painting, the curve, the arabesque. As the title indicates, the body is snake-like, the arms and legs intertwined as if braided together. Far from being Fauve or even Expressionist, *The Serpentine* has already been stripped of the decoration and reduces the painting to a series of flat expanses. *The Serpentine* is a radical departure from the classic tradition to which the subject and the pose are so strongly tied that it was originally considered to be a cartoon, whereas today it is considered to be a decisive "event" in the history of modern sculpture. *The Serpentine* could be more than a representation of free movement, the theme of *The Dance* (pp. 58–59) painted in the same year, with the difference, however, that *The Serpentine* is a figure "arrested" in a languid pose whereas *The Dance* is a painting of movement. Yet the rhythmic intent is the same, namely to "skimp" on the shapes and compose them in such a way that movement can be viewed from all its angles.

The sculpture frequently preceded the painting. *Reclining Nude I* (p. 35) was done at Collioure before *Blue Nude (Souvenir of Biskra)* was painted. Alfred Barr deduced the exceptional importance which Matisse attached to *Reclining Nude I* because for many years it figured in many paintings as a major element of the composition, thus closing the circle between sculpture and painting. It was even to be found in a new version, *Reclining Nude II* (p. 69), and it appears omnipresent in a number of compositions in such a way that it is difficult to ascertain where painting ends and sculpture begins. The visual result which was sought has been achieved, namely a strongly expressed tension which is clearly evident in

André Derain: *The Dance*, 1905
La danse
Oil on canvas, 185 x 230 cm
Private collection

Georges Braque: *Nude Standing*, 1907–1908
Nu debout
Oil on canvas, 142 x 102 cm
Private collection

Pablo Picasso: *Nude with Drapery*, 1907–1909
Nu à la draperie
Oil on canvas, 150 x 100 cm
Hermitage, St. Petersburg

Kasimir Malevich: *Bather*, 1911
Baigneur
Gouache, 105 x 69 cm
Stedelijk Museum, Amsterdam

Apparently, the Fauves and the Cubists tried to convey the movement and dynamism of the dance at exactly the same time. In particular, it was under the influence of Matisse's *The Dance* which he had seen in Moscow that Malevich claimed to have painted his *Bather*.

PAGES 58/59:
The Dance, 1909–1910
La danse
Oil on canvas, 260 x 391 cm
Hermitage, St. Petersburg

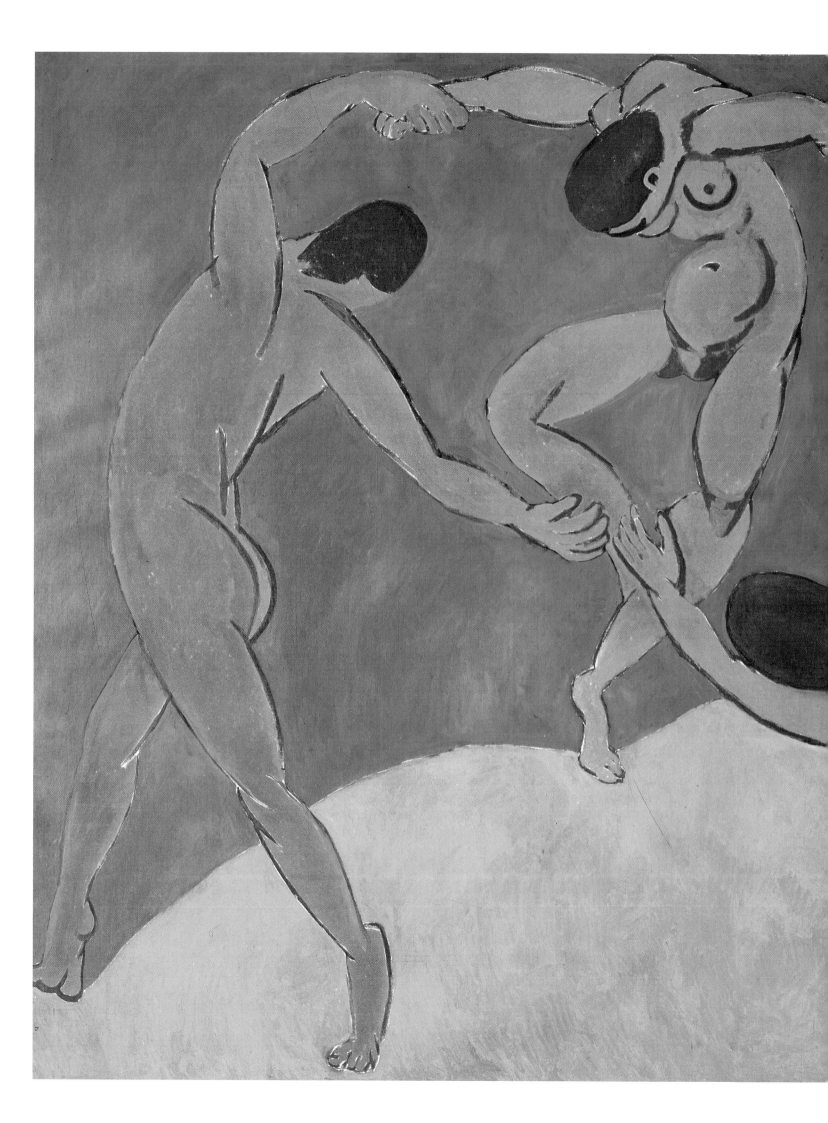

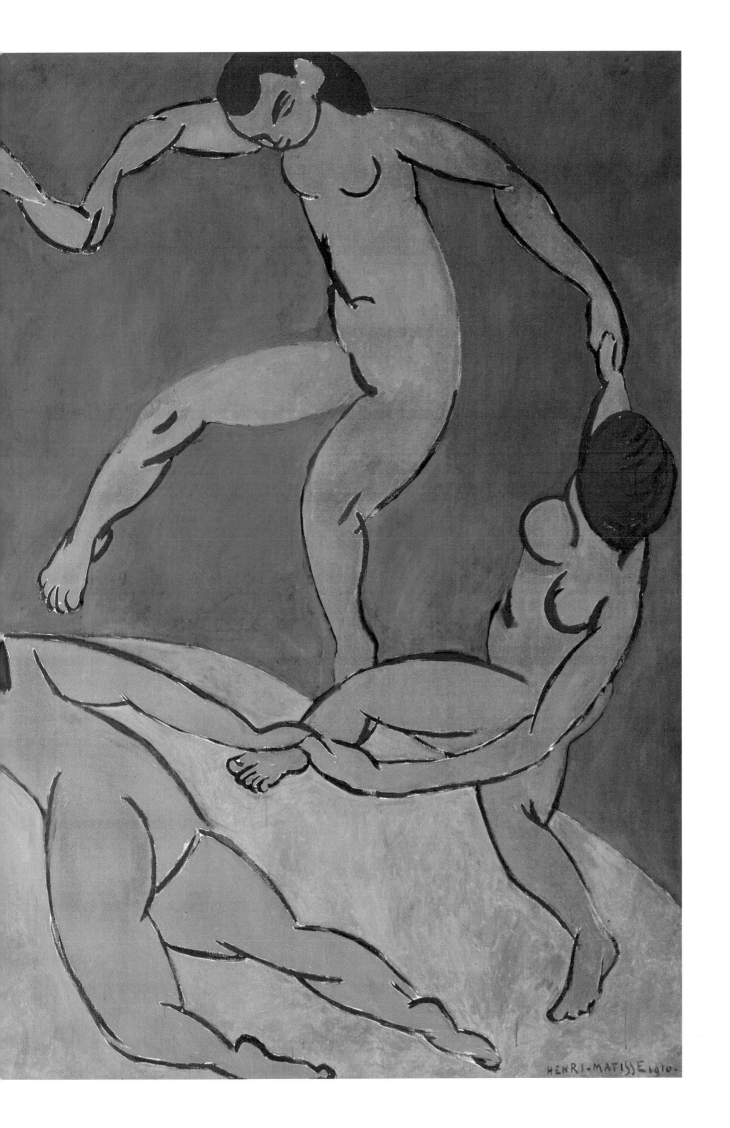

such paintings as *Goldfish and Sculpture* (p. 68) or *The Goldfish* (p. 69), the red colour of the fish reinforcing the ambiguity. The reclining, half-living, half-sculpted figure is painted in a rose-ochre which is as evocative of the flesh tint of a living body as it is of terracotta, or a green which could be that of marble, and it seems to be watching the goldfish in the same way as many female figures would gaze at objects in the paintings and prints created by Matisse in the 1920s (pp. 112–113).

For Matisse, sculpture seems to be one more means of attempting to simplify through distortion. Each of the five versions of *Head of Jeannette* (p. 66) constitutes a stage on the road to the significant distortion in the same way as *Nudes, Backview* (pp. 20–21), inspired by Cézanne and covering a period of more than 20 years, from 1909 to 1930, are "progressive distortions" which are as much as successive stages in a gradual process of simplification and concentration. This evolutionary process was notoriously slow and Matisse spent a lot of time in contemplation between each stage as if the painter wanted to give himself time for thought. This gradual settling of *Nudes, Backview* needed more than two decades, from distortion to simplification, to attain the simplification which in the last stage, enabled the long hair to melt into the head and take on its meaning, so that in the final version one can see that it has become all-pervasive and plays the principal role in relation to the rest of the back. It is possible that this fourth state, which is contemporaneous with Matisse's first trials for the large mural for the Barnes Foundation, could be one of the stages of that work.

The fame which brought Matisse material comforts gave him the freedom he

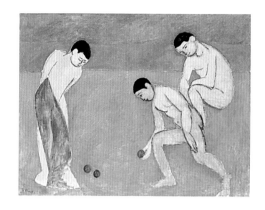

The Boules Players, 1908
Les joueurs de boules
Oil on canvas, 113.5 x 145 cm
Hermitage, St. Petersburg

BOTTOM:
The Music, 1910
La musique
Oil on canvas, 260 x 389 cm
Hermitage, St. Petersburg

PAGE 61 TOP:
Portrait of Sergei Shchukin, 1912
Portrait de Sergueï Chtchoukine
Charcoal, 49.5 x 30.5 cm
Private collection

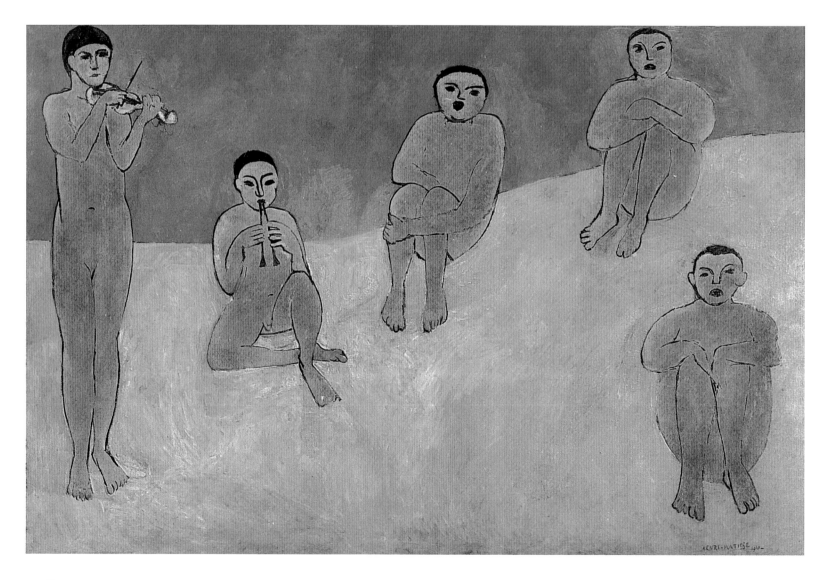

craved in order to paint. In 1909, he moved from the Quai Saint-Michel to Issy-les-Moulineaux, where he bought a house and had a studio built. This is where some of his major works were painted. When showing his father the large garden, which boasted a pond, a flowerbed and a shrubbery, he thought that he was securing his future. Dealers, and particularly private collectors, had done much to make this comfortable life possible. There was Marcel Sembat, the blond, bearded replica of Léon Blum, who became Minister of Public Works in 1916 and whose favourite fauve was Matisse. He bought *Still Life on the Carpet*, the *Portrait of Marguerite, Pink Nude* and others. The Steins were an extraordinary couple. According to Vollard: "She has the air of a housewife whose horizons are bounded by her relationship with the greengrocer, the milkman and the grocer." If Gertrude Stein paid 500 francs for *Woman with Hat*, she paid a lot less for the Picassos and the cubist Braques. Happiness – followed by a few setbacks – resulted from Matisse's relationship with Dr. Barnes, the inventor of "Argyrol", a powerful antiseptic which made him a huge fortune. This American multimillionaire bought lorryloads of the most avant-garde art, though he did so less from personal preference than from a desire to shock his fellow-countrymen. He began by buying up Léo Stein's collection to build up a reserve and continued by buying dozens of paintings by Matisse. The Wall Street Crash enabled him to buy major works at knock-down prices from ruined American collectors. He thus became the proud owner of no fewer than 120 Cézannes, 200 Renoirs, 95 Picassos, 75 Soutines and more than 100 Matisses. These included *La Joie de Vivre* and, in 1933, a second version of *The Dance*, especially commissioned for the library of

The "Matisse Room" in the Moscow home of the Russian collector, Shchukin, who owned no fewer than 37 major works by the artist, including *The Dance* and *The Music*.

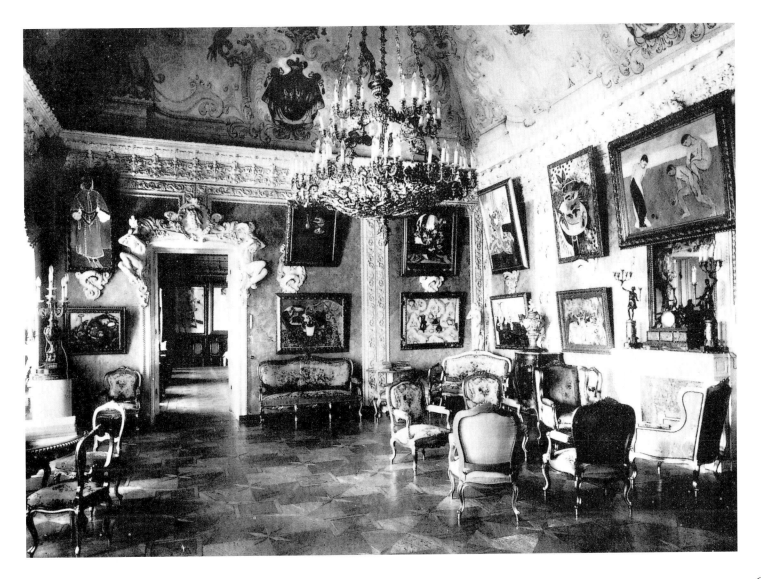

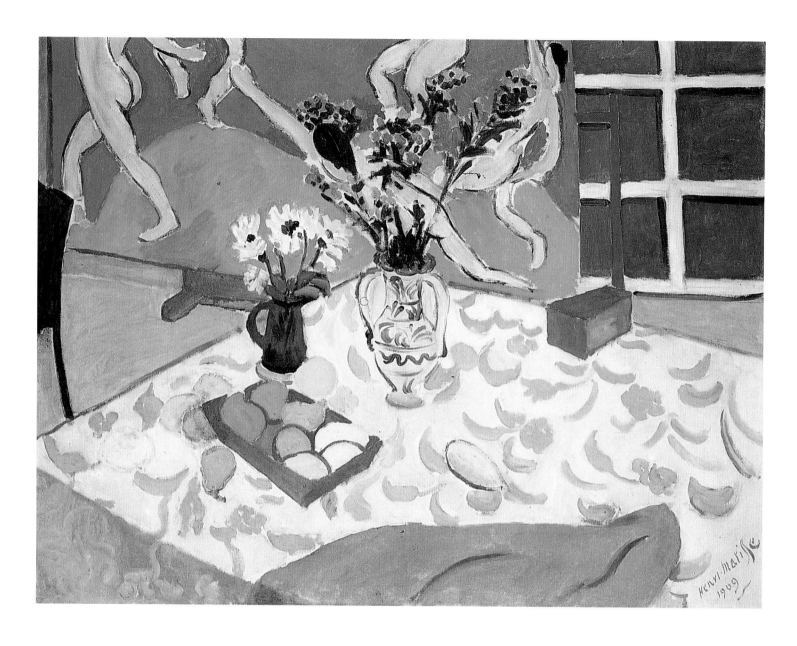

Still Life with "The Dance", 1909
Nature morte à "La danse"
Oil on canvas, 89 x 116 cm
Hermitage, St. Petersburg

Barnes's Renaissance-style chateau which he built for himself at Merion, near Philadelphia. The genesis and avatars of this painting will be discussed later.

Unfortunately for Matisse, Barnes decided to wreak vengeance on his fellow-Americans and on the press in particular, which treated him as a *nouveau riche* and a madman, a sort of Citizen Kane as portrayed by Orson Welles. He bequeathed his whole collection to a foundation he had created for only 200 art students, forbidding visits by the public (except for black people...), and even prohibiting loans or reproductions. That is why about 100 of the most important of Matisse's works have remained hidden for so long, and *La Joie de Vivre* was always reproduced in black-and-white because photographing it in colour was prohibited. The Foundation eventually contested the will made by the eccentric collector and won the law suit, since when the masterpieces in the Barnes Collection have been shown around the world, and *La Joie de Vivre* has been revealed in all the magic of its colours.

Two wealthy Russians, known in Moscow as "the merchant-princes", Morosov and Shchukin, had a very different approach. Morosov, a more sober individual, acquired his Matisse paintings one at a time. Shchukin, on the other hand, was crazy about Fauvism and Cubism and bought them by the dozen. In 1909, he commissioned Matisse to paint two large murals, *The Dance* (pp. 58–59) and *The Music* (p. 60), for which he paid 25,000 gold francs and which Matisse himself went to Moscow to hang. Shchukin was a magnanimous and understanding man

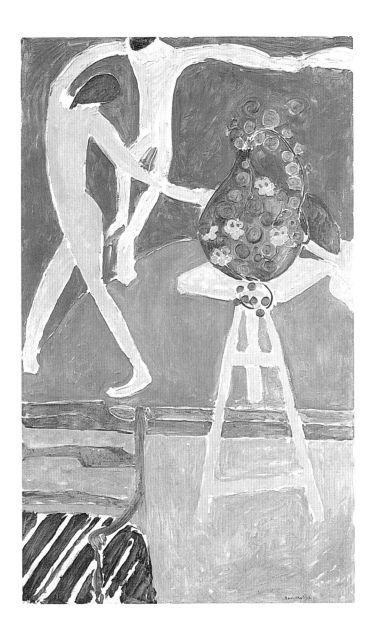

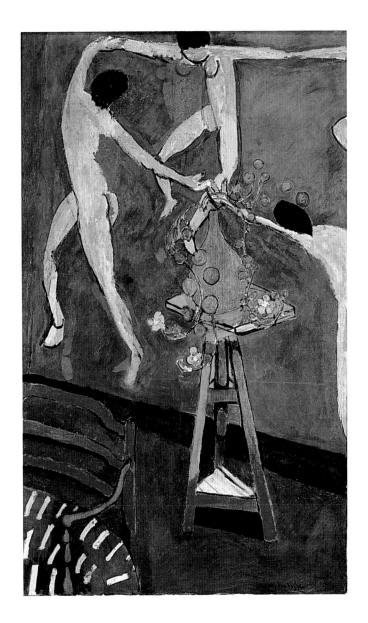

and was not in the least perturbed by the fact that he had bought a *Blue Dining Table* from Matisse at the Salon d'Automne, but what he actually received was the same canvas totally repainted in red. This was the famous *Red Dining Table* of 1908 (p. 50), whose colour had been completely changed by Matisse, because the blue harmony, which was, in fact, almost green, did not give him the contrast he wanted with the spring landscape visible through the window, an idea which had been inspired by the Velázquez painting *Christ in the House of Martha and Mary* (p. 50). Shchukin, whose portrait was sketched in charcoal by Matisse (p. 61), also owned a Matisse Room which was the pride of his Moscow home, yet he was not bitter when the Soviets despoiled him of his collection which, together with that of Morosov, was then used as the basis of the Pushkin Museum. When he fled to Paris after the October Revolution, he declared: "Well, I intended to leave my collection to the state anyway. I'm only sorry that I was not able to enjoy it for a little while longer."

Thanks to the commission to paint *The Dance* and *The Music*, Matisse was able to give new expression to his "religion of happiness". "I have to decorate a studio," he explained to the journalist Estienne (*Les Nouvelles*, 12 April 1909), "there are three storeys. I imagine the visitor entering from outside. He is confronted by the first storey, one has to obtain an effect, give him a feeling of lightness. My first panel represents the dance, a ring of dancers on a hilltop in the full throes of the dance. On the second storey, one is right inside the house;

Nasturtiums in "The Dance" (I), 1912
Capucines à "La danse" (I)
Oil on canvas, 191.8 x 115.3 cm
The Metropolitan Museum of Art, New York

Nasturtiums in "The Dance" (II), 1912
Capucines à "La danse" (II)
Oil on canvas, 190.5 x 114 cm
Pushkin Museum, Moscow

PAGE 62 BOTTOM:
Movement Study for "The Dance", 1909–1910
Etude de mouvements pour "La danse"
Pencil, 27.6 x 22.6 cm
Matisse Archives

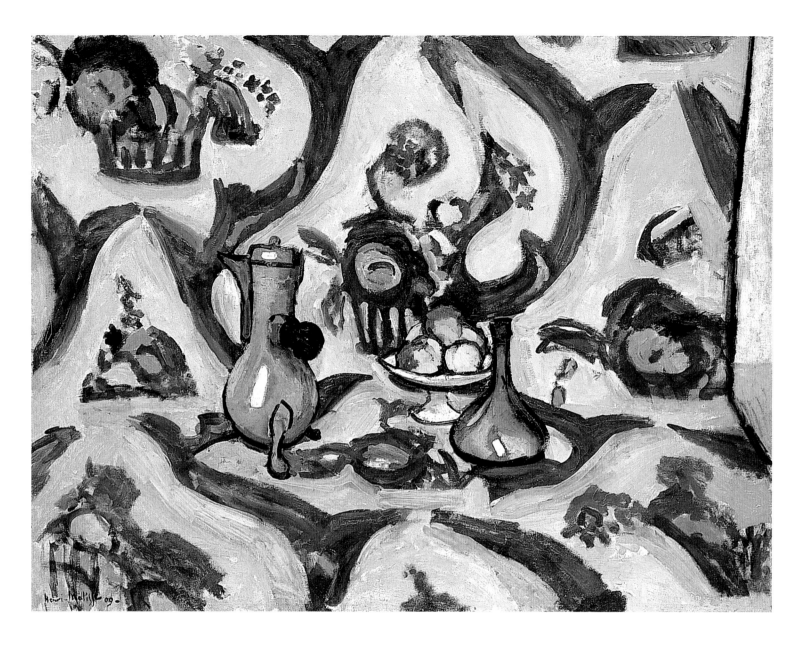

Still Life with Blue Tablecloth, 1909
Nature morte, camaïeu bleu
Oil on canvas, 88 x 118 cm
Hermitage, St. Petersburg

PAGE 65 BOTTOM:
The Painter's Family, 1912
La famille du peintre
Oil on canvas, 143 x 194 cm
Hermitage, St. Petersburg

in its spirit and its silence, I see a musical performance with figures who are listening attentively. Finally, on the third storey, there is complete calm and I am painting a restful scene, people lying on the grass, chatting or dreaming. I will attain this by using the simplest and fewest resources, those which make it possible for a painter to express all his inner vision most relevantly." He listed the resources which were simplification taken to the ultimate. "Three colours for a vast panel of dancers; blue for the sky, pink for the bodies, green for the hill."

In the version of *The Dance* owned by Shchukin, Matisse repeats the central theme of *La Joie de Vivre*. Memories of the farandoles danced in Montmartre in the artist's youth or the sardanes danced in Collioure have been evoked. In reality, it is the very concept of dance which is treated as a sacred rite, just as the drawing defines the shapes which are not only those of human beings but which also prance, twirl and leap, the very movement of dance itself. Whether dancers or bathers, it is the movement in the line which counts, the movement which one finds in *The Bather* in the Museum of Modern Art in New York (p. 54), in *The Boules Players* (p. 60) and even in *Torso Standing (Fragment)* (p. 56). Ultimately, it is this same sense of movement which animates the figures in paintings by Derain, Braque, Picasso and Malevich (pp. 56–57) created at almost the same period, but which in Matisse is conveyed by the three saturated shades which seem to have reduced the painting to the bare essentials, a basic harmony which would appear to have discovered the very principle of colour. This dislocation

Portrait of Pierre Matisse, 1909
Portrait de Pierre Matisse
Oil on canvas, 40.6 x 33 cm
Private collection

of the human form is shared by Fauvism and Cubism. As Jean-Claude Marcadé notes in his book *Malevich*: "Nudity is no longer the expression of a beautiful harmony of the human form as in Academism, of human truth as in Realism, but is a means by which the plastic virtues may be expressed in a combination of elements, making it impossible to produce a faithful reproduction of the model... A flash (of Matisse) can be seen in the forerunners of early 20th century Russian art, in the liberation of the line from any function other than that of expressing the shape of objects... One of the principle lessons learned by Malevich from the art of the French master is that line and colour need to be released from any mimicry of nature. His gouaches of *The Bather* (p. 57) or *Fruit* with their rounded forms and their decorative techniques are directly derived from this teaching."

The panel of *The Music* presents greater problems than that of *The Dance*, since it is based not on irresistible movement but on a subtle balance of stationary bodies, closed in upon themselves and dotted about like notes on a stave. It has much more in common with *Bathers with a Tortoise* (p. 55) and, of course, the sketch for the painting itself (p. 53) both of which are more static. At the time, *The Music* was considered to be an inferior painting to *The Dance* and Shchukin took advantage of this fact in order to pay less for it. Today, the way in which these two panels complement each other perfectly in their dynamic and static aspects and create a complete whole is better understood.

Jeanette III, 1910–1913
Bronze, height: 60 cm

Jeanette IV, 1910–1913
Bronze, height: 61.5 cm

The Red Studio, 1911
L'atelier rouge
Oil on canvas, 191 x 219.1 cm
The Museum of Modern Art, New York

PAGE 67:
The Conversation, 1911
La conversation
Oil on canvas, 177 x 217 cm
Hermitage, St. Petersburg

Portrait of Madame Matisse, 1912
Portrait de Madame Matisse
Oil on canvas, 145 x 97 cm
Hermitage, St. Petersburg

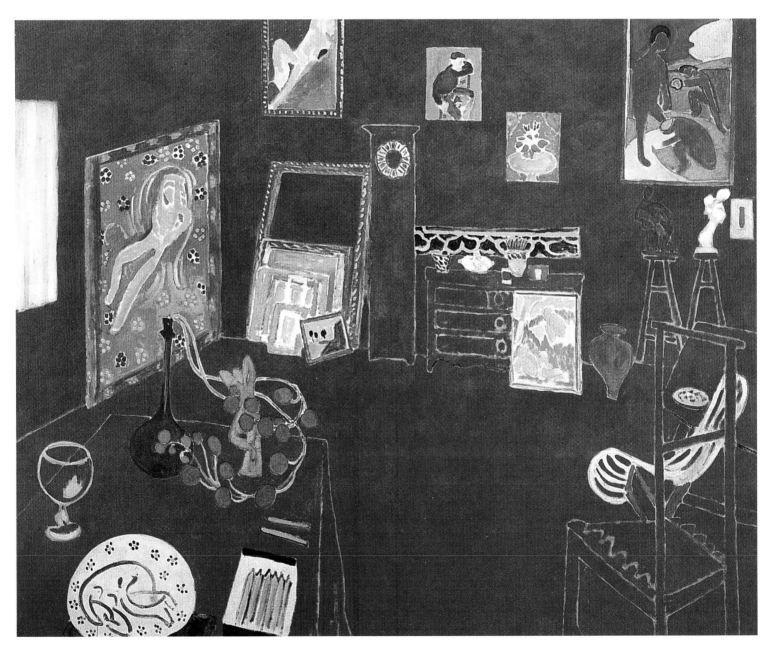

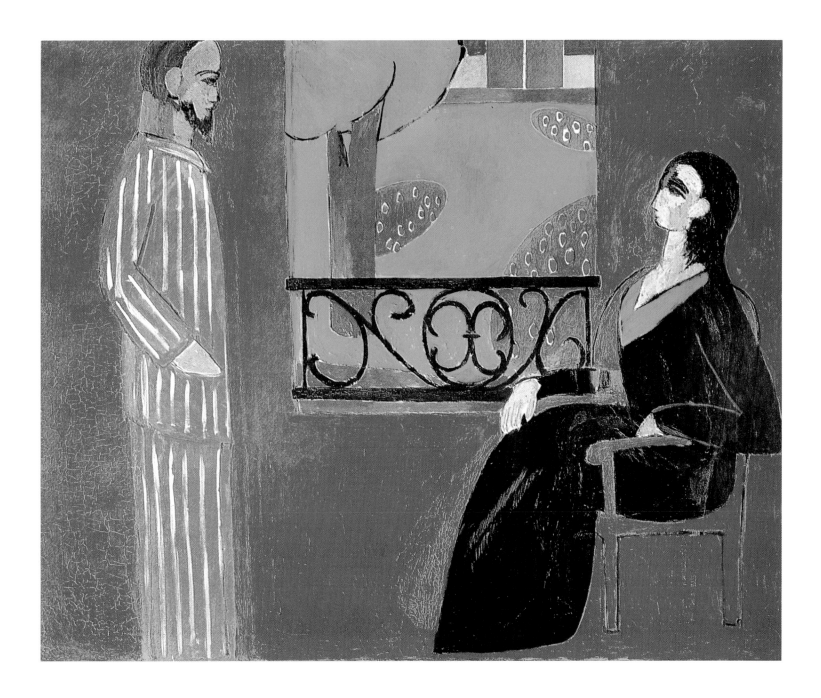

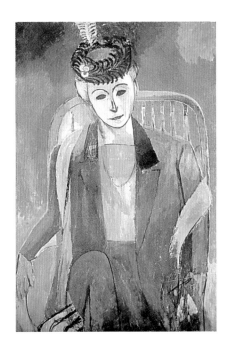

The technique of delightful and effective virtual monochrome of *The Dance* and *The Music* owned by Shchukin, was no sooner adopted by Matisse than he did a complete about-face. He considered that if he reduced his subjects too heavily to the bare essentials, he ran the risk of being led into an evanescent form of art or even into pure abstraction as practised by Rodchenko or Klein. He moved swiftly to restore the authority of graphism and outline at the same time as he launched into a period of searching to re-establish more varied colour and texture to his work and to thoroughly investigate the problem of space. The *Still Life with "The Dance"* (p. 62) series seems to be a veiled cross-reference to three other paintings, *Still Life with Blue Tablecloth* (p. 64), *The Painter's Family* (p. 65) and *Portrait of Madame Matisse* (p. 67), even though this monochromism reappeared in full force in the red of *The Red Studio* (p. 66) or the blue *The Conversation* (p. 67).

In the accentuation of certain heavily-ornamented parts Gaston Diehl sees an echo of the collages or insertions of newsprint used by the Cubists. Yet every painting in the tradition of *The Red Dining Table* – the major forerunner of this almost monochromatic colour scheme, which in this case changed from green to red, which Shchukin preferred – uses the whole area, covering the entire

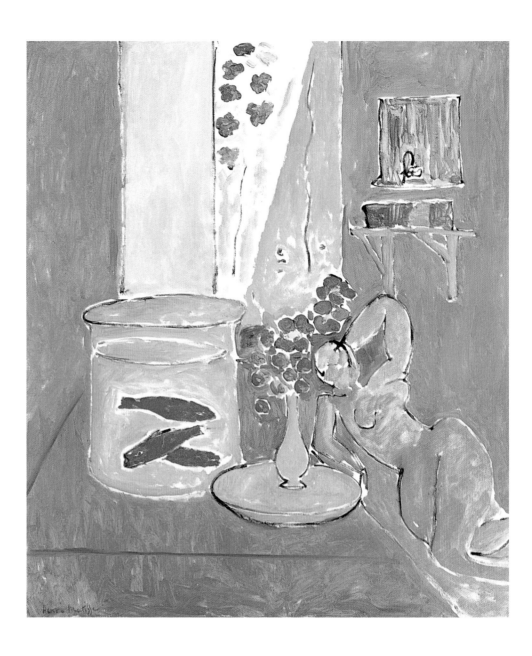

Goldfish and Sculpture, 1911
Poissons rouges et sculpture
Oil on canvas, 116.2 x 100.5 cm
The Museum of Modern Art, New York

canvas with a pattern designed to give an impression of space. The pattern is as elaborate as a Persian carpet. This concept of the "oriental rug", so dear to Roger Fry, which dominates this series of paintings, is sometimes reminiscent of a Persian miniature on a larger scale and sometimes there is a resemblance – as noted by Georges Duthuit – to the Chinese paintings of Cheou Wen-Kin, whom the artist admired. After visiting the exhibition of Moslem Art in Munich and studying oriental art in the Louvre, Matisse absorbed a whole new aesthetic which brought him "confirmation" of his theories, which completely agreed with his systematic experimentation, and which is found in later work, especially that based on his visits to North Africa. In fact, it could be asked whether his obsession with the blue of the Moroccan landscape, the very concept of this unfailing dominant, may not predate his discovery of Tangiers, as is evidenced in paintings of the period which precede his trip to Morocco. This premonition is not unlike that of Gauguin whose Breton peasants have something of the Tahitian *vahines* and whose landscapes of Arles contain a sort of artificial look of Polynesia.

According to Gaston Diehl: "Matisse borrowed from the oriental aesthetic, right down to the smallest detail: the principle of a continuous pattern, evenly covering whole surfaces and divided into vertical and horizonal registers, linear combinations or repeated flower and roseate motifs which he also used on his ceramics. There is a tendency to superimpose objects and figures, and scenes

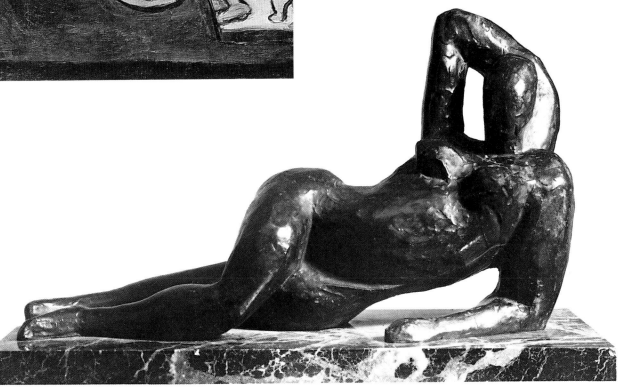

The Goldfish, 1912
Les poissons rouges
Oil on canvas, 82 x 93.5 cm
Statens Museum for Kunst, Copenhagen

appear to be viewed from above; the composition is essentially ornamental and there is a tendency to use geometric forms and sometimes interlaced plant forms."

Yet so great is Matisse's freedom of interpretation that he does not reject influences as soon as he has mastered them, he knows how to adapt them to his own concepts with remarkable ease. It is like a game which he is playing with the firm intention of "winning". He is perfectly capable of giving this ornamental exuberance, in his own "oriental carpet" style, an ordered elegance and a truly monumental stature. What interests him, above all, is that, in his own words "through these accessories, this art suggests a wider space."

Reclining Nude II, 1927
Nu couché II
Bronze, height: 28 cm

Another of Matisse's ambiguities which consists of featuring his sculptures in his paintings. Thus the omnipresent *Reclining Nude* appears in many of his compositions. The colour actually reinforces the ambiguity. Painted in a pink which is closer to the human skin colour than to the actual colour of terracotta or a greenish-grey that looks more like penumbra than marble, the reclining figure seems to be gazing at the goldfish while asking herself whether she is not also a prisoner.

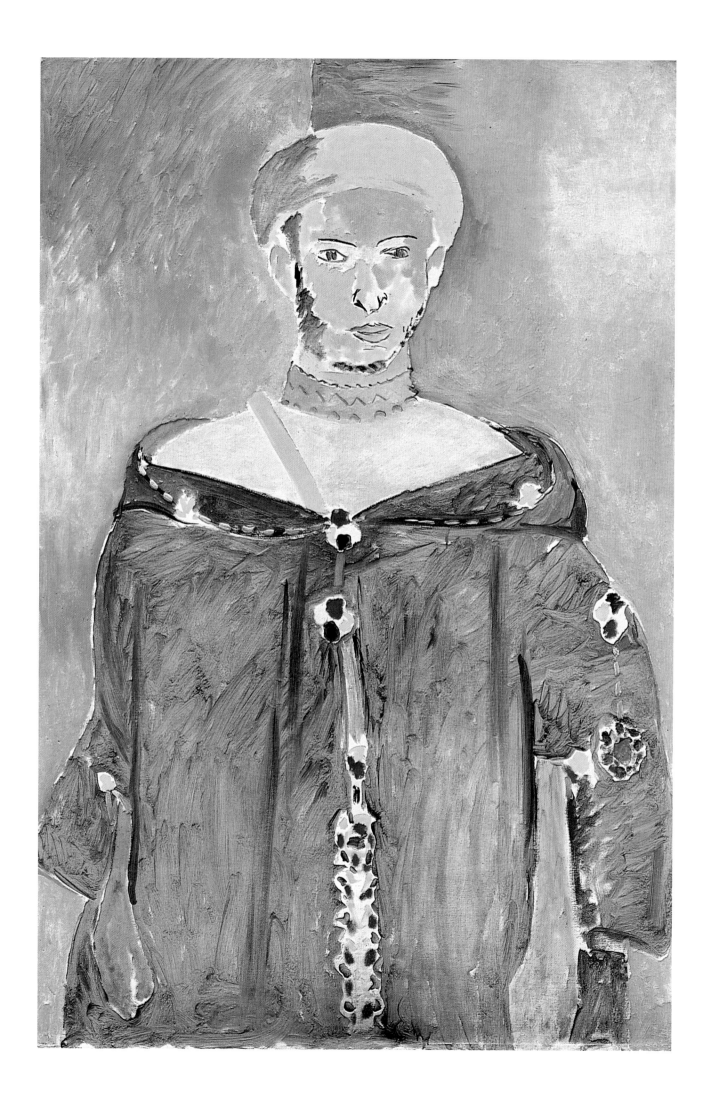

The Oriental Carpet

Henri Matisse by Himself, 1912
H. Matisse par lui-même
Pen and ink, 19.3 x 25.3 cm
Private collection

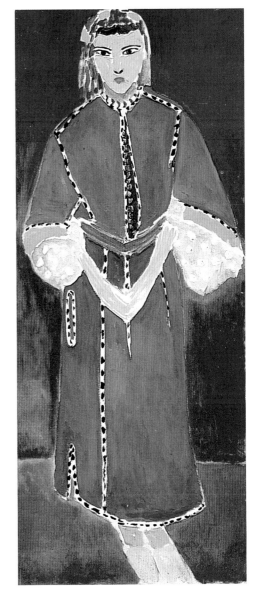

"The revelation came to me from the Orient," noted Matisse when, in 1947, he looked back over the road he had travelled. Rembrandt, in his day, had collected a whole property store of bric-à-brac – carpets, weapons, helmets, fabrics, multicoloured jewellery and china which he acquired from second-hand clothes dealers and which he used as costumes and head-dresses for his *Lucretia*, his *Danaeids*, his *Suzanna* and *Bathsheba*, as in a Shake-speare play. In the same way, Matisse came back from Morocco with a crateful of ceramic wall-tiles decorated with stylised floral or geometric patterns, as well as fragments and small ornaments which he thought he would use "to emerge from the painting of intimacy". Once again, he took Gauguin's advice: "O painters who ask for a technique of colour, study carpets. There you will find everything that is sincere." Yet in doing so, Matisse rediscovered his old demons, this tearing apart, this "eternal conflict" caused by two opposing influences, that of Cézanne who urged him to exaggerate volume and that of Oriental art which tended to eradicate it.

For Matisse, Morocco was a fabulous garden in which he picked his flowers one by one. *Amido* (p. 73), *Fatmah the Mulatto Woman* (p. 73), *Zorah on the Terrace* (p. 74), *Zorah Standing* (p. 71) are all human flowers. *The Standing Riffian* (p. 70) has the colouration of the plains. The six figures in the *Arab Café* (p. 72) wearing the white head-dresses are like flowers growing on the floor of the Arab café which the pale Veronese tonality has transformed into yet another garden. Matisse once told Louis Aragon: "There are flowers everywhere for those who wish to see them."

In Issy, Matisse said the same thing, one wonders why he needed to travel unless it was to store up souvenirs and emotions. He talked about his garden to a visitor, saying: "I also have a wonderful garden there with lots of flowers which are the best lesson in colour composition for me. Flowers give me impressions of colour which remain marked indelibly on my retina as if branded there. So one day when I find myself, palette in hand, faced with a composition and I have only a hazy idea of what colour to use first, this memory resurfaces from deep within me and comes to my aid to give me the impulse."

Marquet was responsible for Matisse's trip to Morocco after he had returned from Russia. In 1911, he wrote to Manguin: "I have just ridden from Tangiers to Tetuan on horseback, a distance of 70 kilometres. The Arabs are sprightly and my backside is a purée. Old Matisse has been beaten!" According to Pierre Schneider, Matisse was constantly trying to convey his passion for horsemanship to his Fauvist friends, generally without success. The master took up the "challenge" of his pupil next year and also rode from Tangier to Tetuan.

What Matisse sought in Morocco was not the picturesque, the sort of thing Delacroix had found when he declared: "The picturesque abounds here. At each

Zorah Standing, 1912
Zorah debout
Oil on canvas, 146 x 61 cm
Hermitage, St. Petersburg

PAGE 70:
The Standing Riffian, 1913
Le riffain debout
Oil on canvas, 145 x 96.5 cm
Hermitage, St. Petersburg

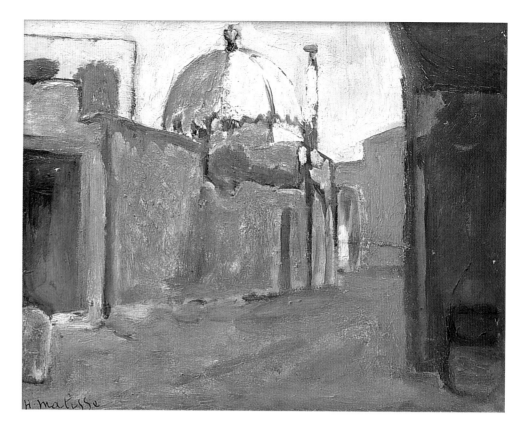

Self-portrait, 1912–1913
Autoportrait
Pen and ink, 21 x 13.5 cm
Private collection

Le Marabout, 1912–1913
Oil on canvas stuck to wood, 21.5 x 27.5 cm
Private collection

Amido, 1912
Oil and pastel on canvas, 146.5 x 61.3 cm
Hermitage, St. Petersburg

The Arab Café, 1913
Le café arabe
Glue painting on canvas, 176 x 210 cm
Hermitage, St. Petersburg

Entrance and Minaret, Mosque in the Casbah, 1912–1913
Portail et minaret, mosquée de la casbah
Pen and ink, 25.7 x 17.1 cm
Private collection

Fatmah the Mulatto Woman, 1913
Fatmah la mulâtresse
Oil on canvas, 147 x 61 cm
Private collection

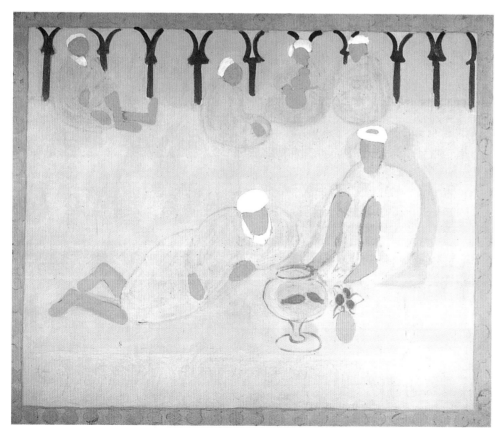

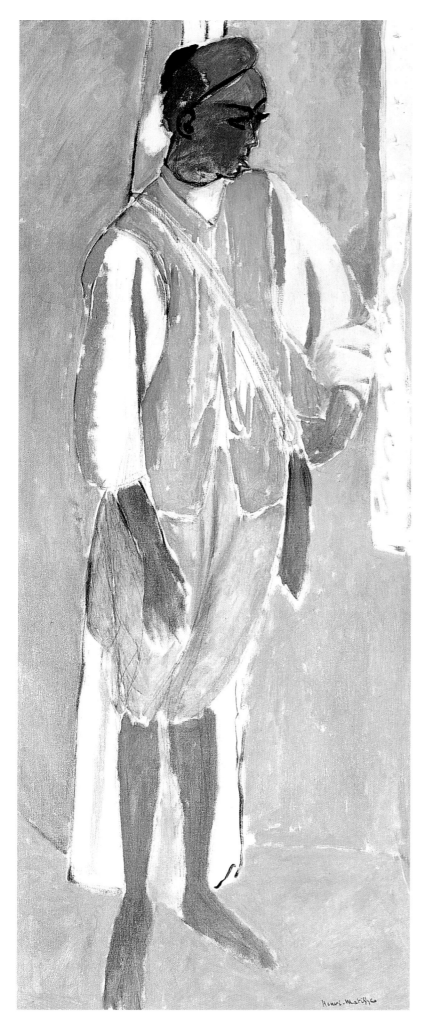

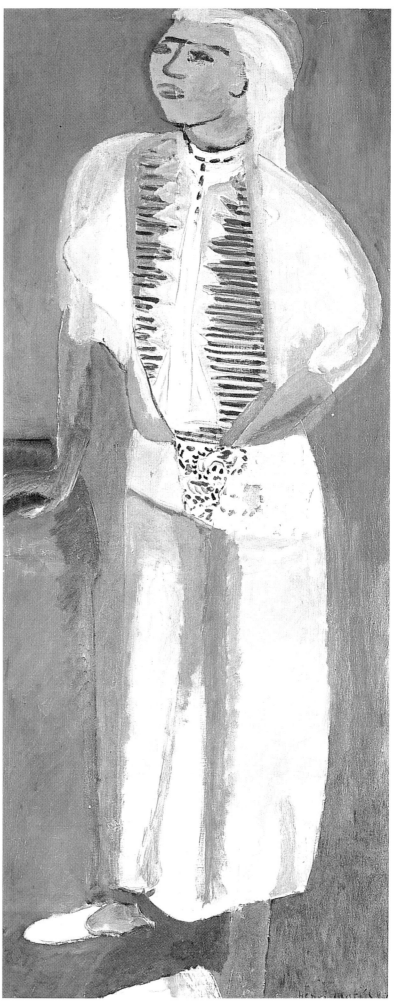

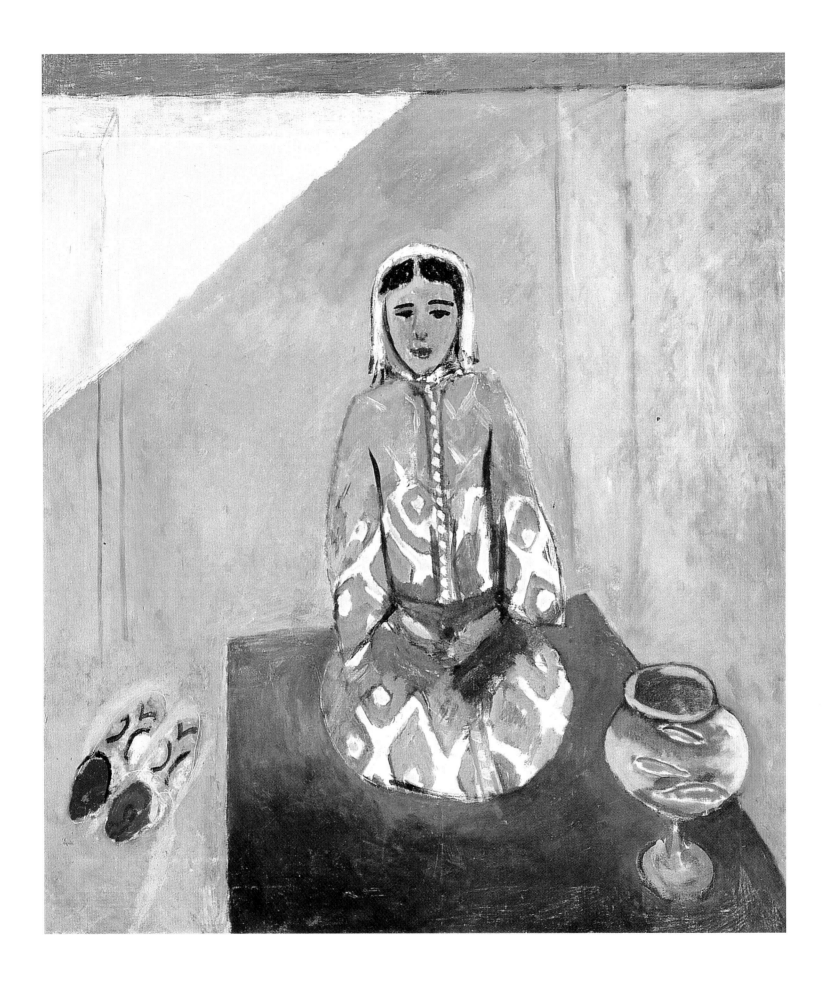

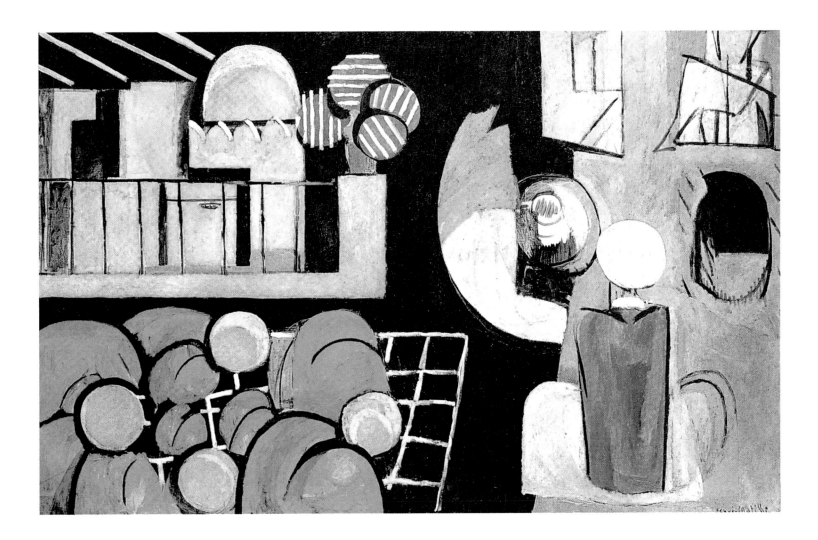

step, there are ready-made scenes which would make a fortune and achieve glory for twenty generations of painters." Matisse judged his illustrious predecessor quite harshly. "Delacroix's imagination in relation to a subject remains anecdotal, it's a pity; it's due to the quality of his intellect because Rembrandt under the same conditions is noble." Matisse resisted the charms of exotica. He explained to Camoin: "I will probably surprise you if I tell you that I have made plans to spend several months in Paris considering that for the moment I need to concentrate and that travel, the change of climate and the excitement of new experiences, of which the picturesque is the most affecting, would to lead me into too great a diversification…"

Matisse was probably being rather unfair to Delacroix because he wrote in his diary twenty years after his Moroccan expedition: "I only started to produce something reasonable from my trip to Africa when I had begun to forget the little details and only remember the striking and poetic side in my pictures; hitherto I had been pursued by the love of accuracy which most people take for truth." This "filtering by memory" is exactly the way in which Matisse worked from that time and for the rest of his life.

Matisse applied to Morocco, as to all the other subjects he tackled, the very antithesis of a "ready-made scene", what the critic Maurice Denis described as "Remembering that a painting, before it can be considered as a warhorse, a naked

The Moroccans, 1916
Les marocains
Oil on canvas, 181.3 x 279.4 cm
The Museum of Modern Art, New York

PAGE 74:
Zorah on the Terrace, 1912
Zorah sur la terrasse
Oil on canvas, 116 x 100 cm
Pushkin Museum, Moscow

For Matisse, travel was a way of accumulating memories which he would later use as inspiration and would continue to verify the research he was doing and his "prescience". This "filtering through memory" applied to Morocco, as it would apply to Tahiti and would enable him to "put it into the form of a memory" several years thereafter and to decant reality into an abstraction in such paintings as *The Moroccans*, *Bathers by a River* and the famous *Zulma* produced as much as forty years later.

Bathers by a River, 1916
Les demoiselles à la rivière
Oil on canvas, 261.8 x 391.4 cm
The Art Institute of Chicago, Chicago (IL)

woman or the depiction of some story or other is essentially a flat surface covered in colour, assembled in a particular order." The various trips made by Matisse to North Africa ought to have offered him the opportunity of spending a long time applying the formulae and themes of which he had been made aware and which he had only just perfected. Yet this was not the case. Matisse has already accustomed us to the abrupt changes of course he would make after his most decisive achievements which caused him to delay any repetition as if, seized with scruples and almost disconcerted by the success of his audacity, he granted himself a respite and gave himself time to evaluate the possibilities and in some way "to get the memory into shape."

The Moroccans (1916, p. 75), *Bathers by a River* (1916, p. 76) right up to the famous *Zulma* (1950, p. 77) are examples of how Matisse used his memory as a filter to strain out the actual and create an abstraction, this abstraction which we will soon see appear deliberately and systematically in later paintings and which he would use again later when he visited Tahiti and brought back his *Souvenirs of Oceania*. For the moment, interested no doubt in the progress of geometric and abstract art of which Picasso's *Harlequin* is one of the most outstanding examples, Matisse was seeking to create what he loved most, "doing two things at the same time", that is to say, in this case, merging abstraction with reality.

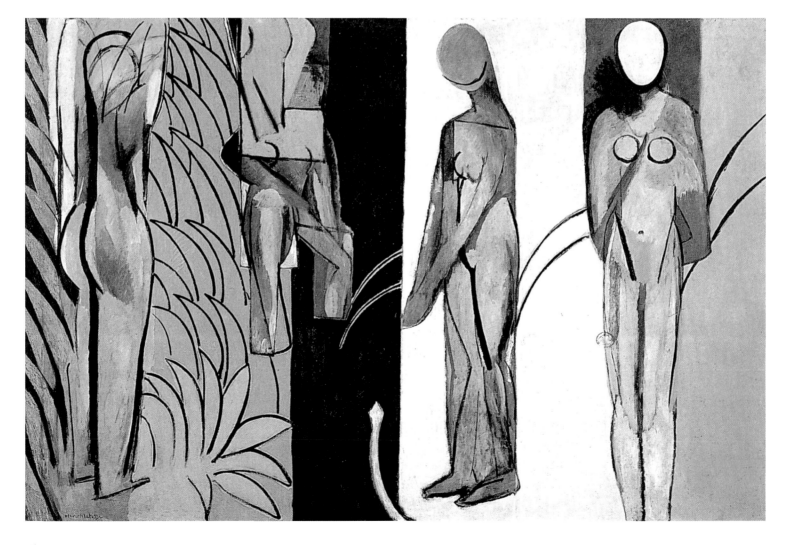

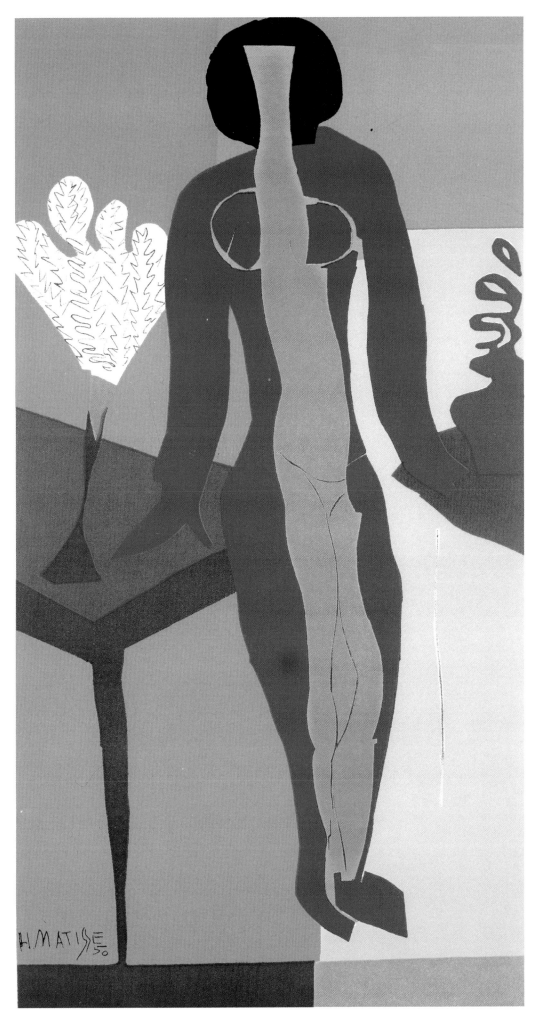

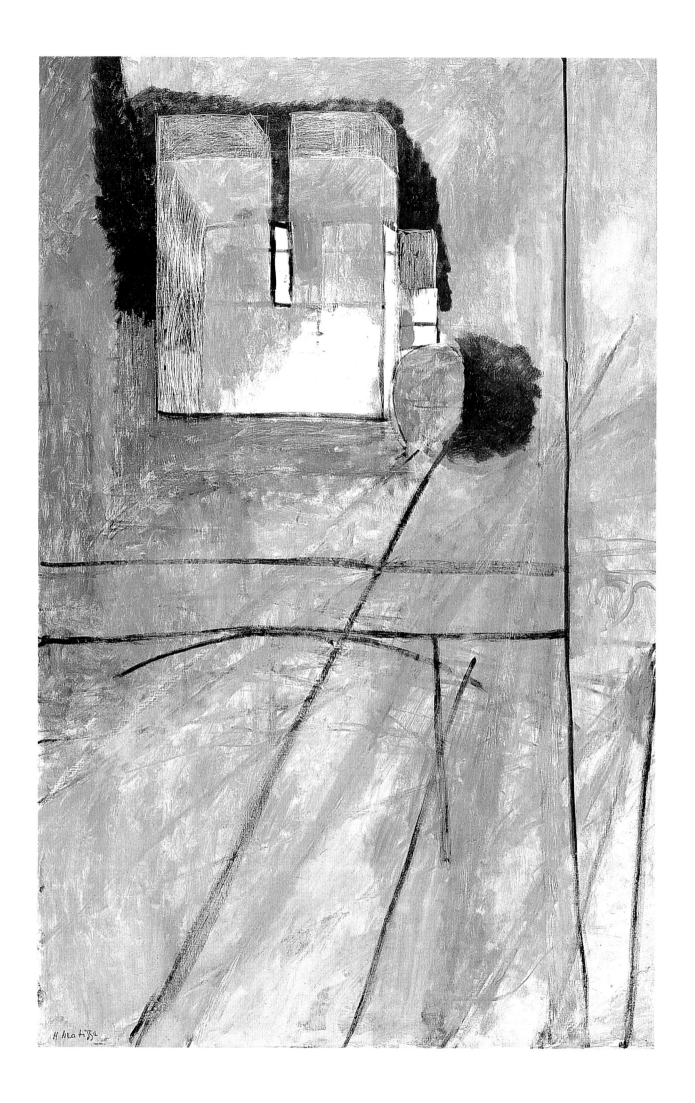

The Temptation of Abstraction

Matisse was haunted by problems of construction and space. He began working on the "geometric combination" which is already perceptible in his so-called "Moscow works", such as *The Dance* and *The Conversation* and which was such a triumph in *Bathers by a River* and *The Moroccans*, both painted in 1916. He might have empathised with the Cubist doctrine, although it should not be forgotten that, with the exception of Juan Gris, the Cubists were not colourists. Matisse learned from Cézanne to concentrate on form as well as the use of colour. He wanted to continue both the severity of reasoned elaboration and the grace of his enchanting colours and lines enchantments. As André Warnod wrote later: "We are here in the presence of one of the turning points in French painting."

The year 1914 saw the outbreak of war and all its inherent atrocities, smashing Matisse's paradise to smithereens. Two factors should be borne in mind. A French painter felt a crucial need to give a meaning to every painting he produced, even an abstract. There was also the inevitable impact of external events upon art, even if it were created in the remotest and most protected ivory tower. Painters do not paint in the same way in times of euphoria and prosperity as they do in times of tragedy and deprivation. Goya's *The Horrors of War* and Picasso's *Guernica* are there to remind us. Matisse wrote to Purrmann: "This war will have its compensations – what gravitas it will have bestowed even on the lives of those who did not participate in it, even if all it does is to enable them to share the feelings of an ordinary soldier who gives his life without really knowing why, though he has the innate feeling that such sacrifice is necessary."

The *View of Notre-Dame* (1914, p. 78) in which geometrical simplification is taken to its extreme was not a chance composition. Diagonals create the depth, while the verticals and horizontals form an abstract structure against a blue background accentuated by the green blob (the interplay between blue and green which one finds constantly in Matisse). It is as if the painter, instinctively, through the geometry of the church, was cutting himself off from the real world. This view of Notre-Dame only represents a fleeting moment in Matisse's work, but it is a moment which can be dated, specified and singled out by its general context. It was to be followed by a whole series of less austere, less extreme works painted from the window of the building in which he lived at 19, Quai Saint-Michel, while he continued to keep his home at Issy-les-Moulineaux.

In 1914, Matisse first began using black as a colour. At the time, black performed the same function as had almond green during his stay in Morocco. In *French Window at Collioure* (p. 82), black covers most of the surface of the painting, leaving only a green strip and a blue strip, Matisse's two favourite colours which, for once, are separated by a hiatus, a gap between these two supreme colours of peace. What separates them is the tragedy which is unfolding. In this

Flowers and Sculpture, 1913
Fleurs et céramique
Oil on canvas, 93.5 x 82.5 cm
Städelsches Kunstinstitut, Frankfurt

TOP:
Greta Prozor, 1916
Pastel, 55.5 x 37 cm
Musée National d'Art Moderne, Centre Georges Pompidou, Paris

Study for "Portrait of Sarah Stein", 1916
Etude pour "Portrait de Sarah Stein"
Charcoal, 48.5 x 32.1 cm
Museum of Modern Art, San Francisco (CA)

PAGE 78:
View of Notre-Dame, 1914
Vue de Notre-Dame
Oil on canvas, 147.3 x 94.3 cm
The Museum of Modern Art, New York

Coup de Soleil, 1917
Oil on canvas, 91 x 74 cm
Private collection

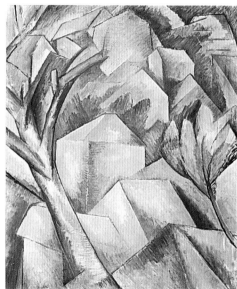

Georges Braque: *Houses at l'Estaque*, 1908
Maisons à l'Estaque
Oil on canvas, 73 x 60 cm
Hermann and Margrit Rupf Foundation,
Kunstmuseum Bern, Berne

Paul Cézanne: *View of Château Noir*, 1894–1896
Vue du Château noir
Oil on canvas, 81 x 65 cm
Private collection

PAGE 81:
Study of Trees (Group of Trees at Estaque), 1915–1916
Etude d'arbres (Groupe d'arbres à l'Estaque)
Charcoal, stumpwork and graphite pencil,
62.1 x 47.5 cm
Musée National d'Art Moderne, Centre Georges
Pompidou, Paris

respect, the painting acquires greater significance from what Louis Aragon wrote about this painting in his book *Henri Matisse, a Novel:*

"Matisse's *French Window* (1914), the most mysterious painting ever painted, seems to create from this 'space' a story which the author has begun but of whose outcome he is still unaware, like this life, in this house of darkness, its inhabitants, their memories, their dreams, their suffering... The mystery of the *French Window* seems to me to lie largely in the difference between it and all those open windows which occur so frequently in Matisse's work and that of many other painters of his time or later, windows which open on to a bright exterior. Here, the opposite is happening, it opens into darkness, outside there may be a garden or what we see at a later date in *The Silence Living in Houses* (p. 225). Furthermore, whether Matisse was aware of it or not, when I look at the date of the painting, 1914, and realise that it must have been painted in the summer, I have an uncomfortable feeling of impending doom. Whether or not the painter wanted it to be so, the French window opens on to the blackness of the unknown. It is opening on to war, an event which suddenly turns the lives of unknown men and women into darkness, the black future, the inhabited silence of the future."

This appraisal might well provoke the remark that what is true of French artists always wanting a painting to have meaning is also true of French writers. But just as Aragon says, we are "at the time when violence is already growling at the doors of this country and it envelops us in the monstrous shadow which attempted to smother the French light of Manet and Matisse forever, and even beyond 'degenerate art' as those who have already ruled over us would call it. When I went to Cimiez to seek the blue outlook which gave me confidence in the future after the storm, the outlook of one who, at Issy-les-Moulineaux in 1914 had opened this French window onto the war from which I can not detach myself." This *French Window* is probably the nearest Matisse ever came to abstract painting, since the geometric shapes almost coincide with the plane of the picture. It is reminiscent of American Abstract Expressionism and particularly the Pacific School and its principle of the "Color Field". These are expanses of black or very dark colour with jagged edges, large strips or rectangles of colour as used by Barnett Newman, Mark Rothko and Clyfford Still or the "all over" colour washes such as those of Sam Francis, resulting in such canvases as *Saturated Blue* (1953), in which the space is filled with blue, the intense blue which Matisse was trying to achieve in *The Dance* and *The Music*. The only difference between Matisse and these American artists is that his painting was attracted to abstraction as one might be drawn to a precipice yet it continues to represent an actual French window.

Another of Matisse's masterpieces also attains a degree of abstraction rarely equalled. This is another painting whose subject is a window, but this time it is ablaze with colour, in which one finds the harmony of blue and green added to the yellow which underlines a red curve. The painting has been wrongly entitled *The Yellow Curtain* (1914–1915, p. 83) because the curtain is red whereas the yellow symbolises the landscape visible outside. Here again, the abstract juxtaposition of flat expanses of colour is reminiscent of the gouache cut-outs he was to produce in the future, a true hymn to colour. In contemplating this painting, one can better understand what Aragon mean by "this blue outlook which gave me confidence".

The Yellow Curtain, 1914–1915
Le rideau jaune
Oil on canvas, 146 x 92 cm
Stephen Hahn Collection, New York

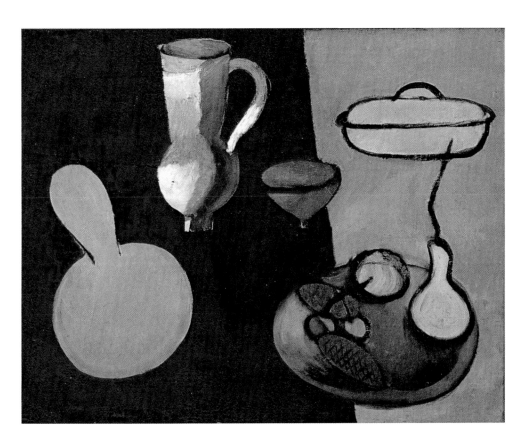

The Gourds, 1916
Les coloquintes
Oil on canvas, 65.1 x 80.9 cm
The Museum of Modern Art, New York

PAGE 82:
French Window at Collioure, 1914
Porte-fenêtre à Collioure
Oil on canvas, 116.5 x 88 cm
Musée National d'Art Moderne, Centre Georges Pompidou, Paris

This is the most famous of Matisse's depictions of French windows. This is the one which Aragon considers to be opening on to the 1914–18 War. It also opens on to all of the abstract American school of Expressionism, and in particular, the Pacific School which created the theory of the "Color Field" these flat expanses of all-over colour, which sometimes result in canvasses saturated with blue, that intense blue which Matisse tried to achieve in *The Dance* and *The Music*. However, there is a difference, in that even if Matisse's painting tends to abstraction as one might be drawn to an abyss, it still continues to represent an actual French window.

Apples on the Table against a Green Background, 1916
Les pommes sur la table, sur fond vert
Oil on canvas, 114.9 x 89.5 cm
The Chrysler Museum, Norfolk (VA)

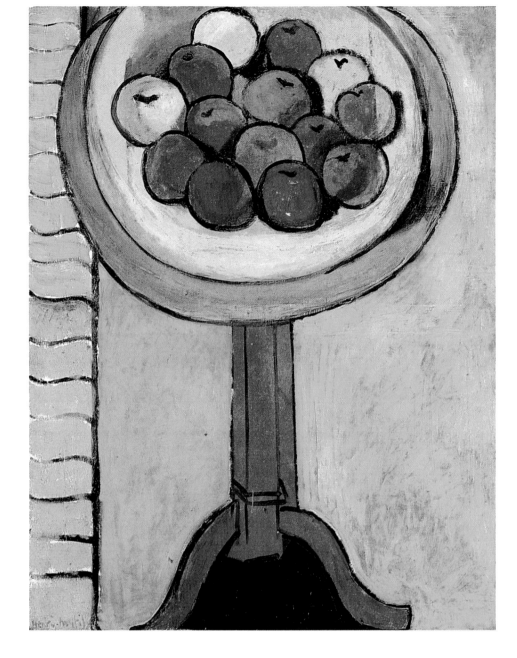

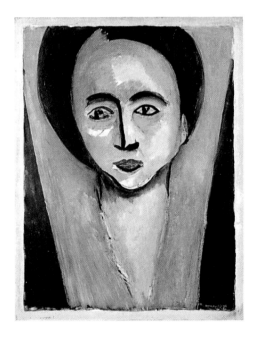

Portrait of Sarah Stein, 1916
Portrait de Sarah Stein
Oil on canvas, 72.4 x 56.5 cm
Museum of Modern Art, San Francisco (CA)

Whereas for the Cubist, the geometry is an end in it-
self to which everything else is required to be subordi-
nate, including colours, for Matisse geometry is the
paradoxical expression of emotion, and it is merely a
means of release from this emotion. "Sentimental geo-
metry", "dramatic geometry", all bend to Matisse's
will. There are still lifes, portraits, landscapes…
One can be both the master of the curve and "draw
constant benefit from the use of the plumbline"
(*Jazz*).

Having decided to leave Paris shortly before the Battle of the Marne, Matisse
took Marquet with him when he went to visit his daughter, Marguérite, in Tou-
louse. From there he travelled on to Collioure where he stayed with his family
and Marquet until November 1914. Matisse cemented a friendship with his fellow
painter Juan Gris, a Cubist who, according to Apollinaire, was obsessed with
logic, and who had found refuge with his children's tutor. Matisse and Gris
enjoyed long discussions. This meeting at the height of the war with the only
great Cubist colourist would often be quoted as one of the factors which
influenced Matisse's research. Fear, aroused by the terrible events, had brought
together the Fauvists and the Cubists who had previously been divided by artistic
dissent. Perhaps it was after this interlude that Matisse found an additional reason
to reinforce his move towards geometric simplification. One thing is certain:
when confronted with those tragic times, it was then that Matisse devised the
lasting basis for his art. If in *The Moroccans*, Matisse had made good use of black
as a colour, those colours which are forever associated with Matisse are still in
evidence. Matisse was not one to remain morose for long; happy, bright, and
highly-coloured thoughts soon emerge against the background of the dark days.
For the moment, all that counts is that the composition is typified by sharp

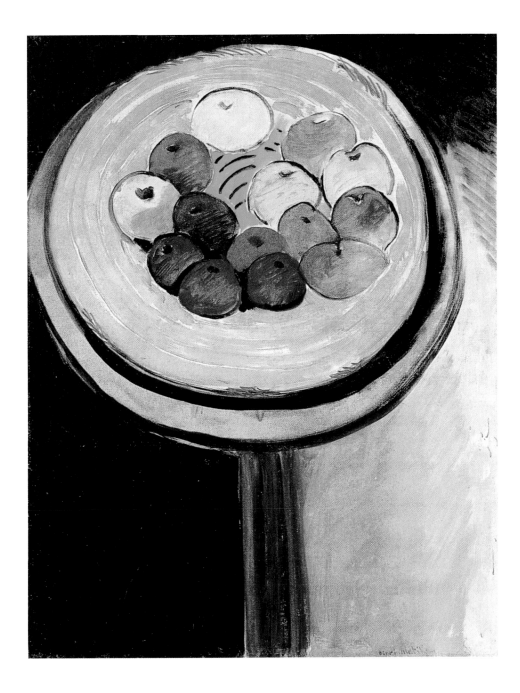

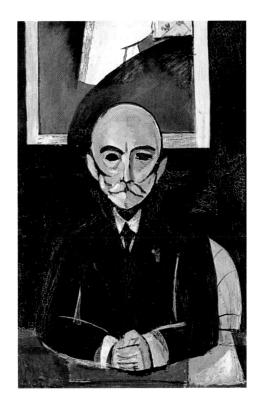

Apples, 1916
Les pommes
Oil on canvas, 116.9 x 88.9 cm
The Art Institute of Chicago, Chicago (IL)

Auguste Pellerin II, 1916
Oil on canvas, 150.2 x 96.2 cm
Musée National d'Art Moderne, Centre Georges
Pompidou, Paris

contrasts between straight and curved lines, a tension to be found in the new interiors and geometric still lifes which Matisse was then painting. It cannot be claimed by any stretch of the imagination that *The Gourds* (p. 83), *Apples on the Table Against a Green Background* (p. 84), *Apples* (p. 85), *Portrait of Sarah Stein* (p. 84) and *Auguste Pellerin II* (p. 85) are influenced by Cubism. Geometry had always been very important in Matisse's work long before the advent of Cubism. Even in his first *The Dining Table*, painted in 1897, Gustave Moreau was delighted to discover the long necks of the carafes whose alignment emphasised the perspective of the table and the way in which the maid's body bent over it. Matisse told Rouveyre: "I have come to possess the feeling of the horizontal and the vertical in such a way as to make the resulting diagonals expressive, and that is no easy task. One can possess mastery of the curve and draw 'constant benefit' from the use of the plumbline. The vertical is in my mind. It helps me to specify the direction in which lines should go and when I make rough sketches I never indicate a curve, such as that of a branch in a landscape, without being conscious of its relationship with the vertical." (*Jazz*)

For the Cubists, geometry was an end in itself to which everything else had to be subordinated, even colour. For Matisse, on the other hand, geometry has the

PAGES 86–89:
Study for "Portrait of Yvonne Landsberg", 1914
Pen, 22 x 16 cm
Private collection

Portrait of Yvonne Landsberg, 1914
Oil on canvas, 145.5 x 95.5 cm
Philadelphia Museum of Art, Philadelphia (PA)

Portrait of Madame Josette Gris, 1915
Pastel, 29.3 x 24 cm
Private collection

Marguerite in a Leather Hat, 1914
Marguerite au chapeau de cuir
Oil on canvas, 46 x 38 cm
Private collection

White and Pink Head, 1914
Tête blanche et rose
Oil on canvas, 75 x 47 cm
Musée National d'Art Moderne, Centre Georges
Pompidou, Paris

The "Dr. Jekyll and Mr. Hyde" side of Matisse again offers two versions of the portrait of his daughter, and a choice between colour or shape, or perhaps both. But only the velvet band and the pendant at the neck are identical.

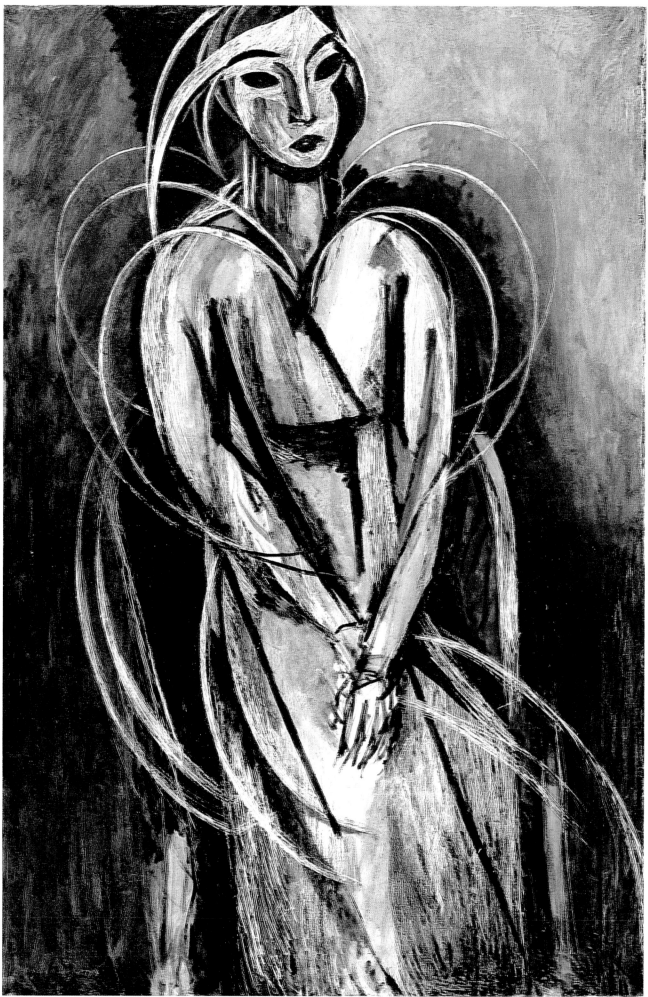

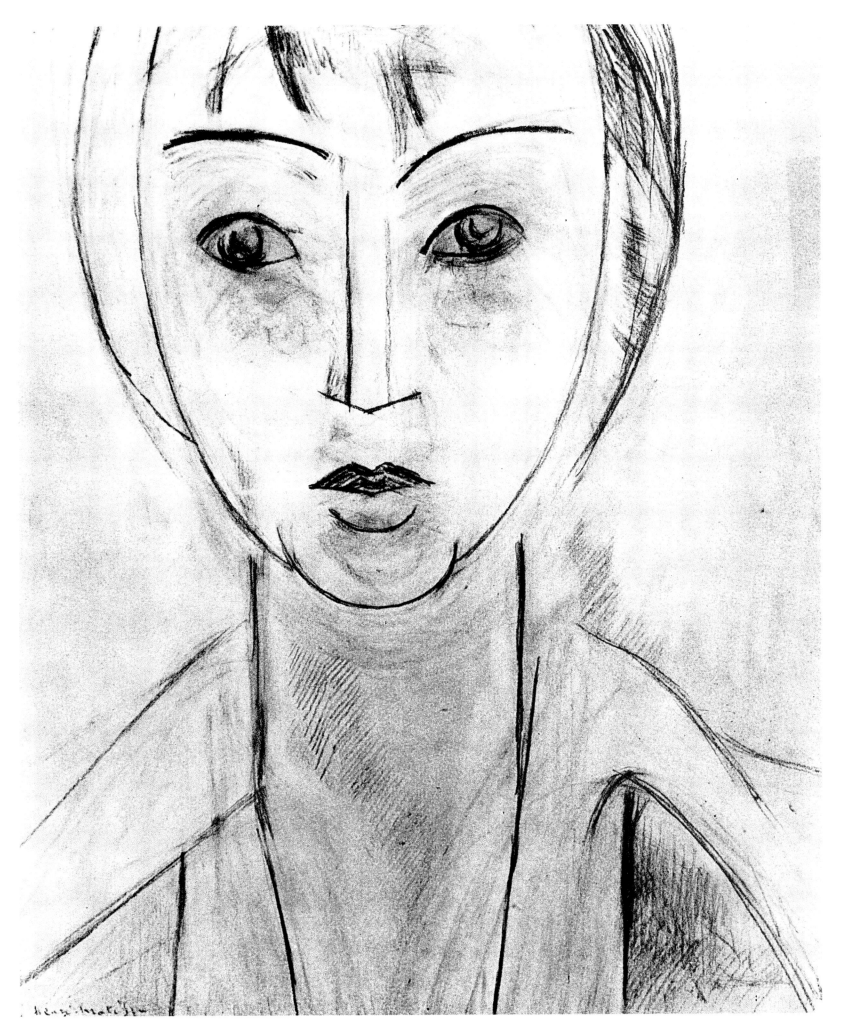

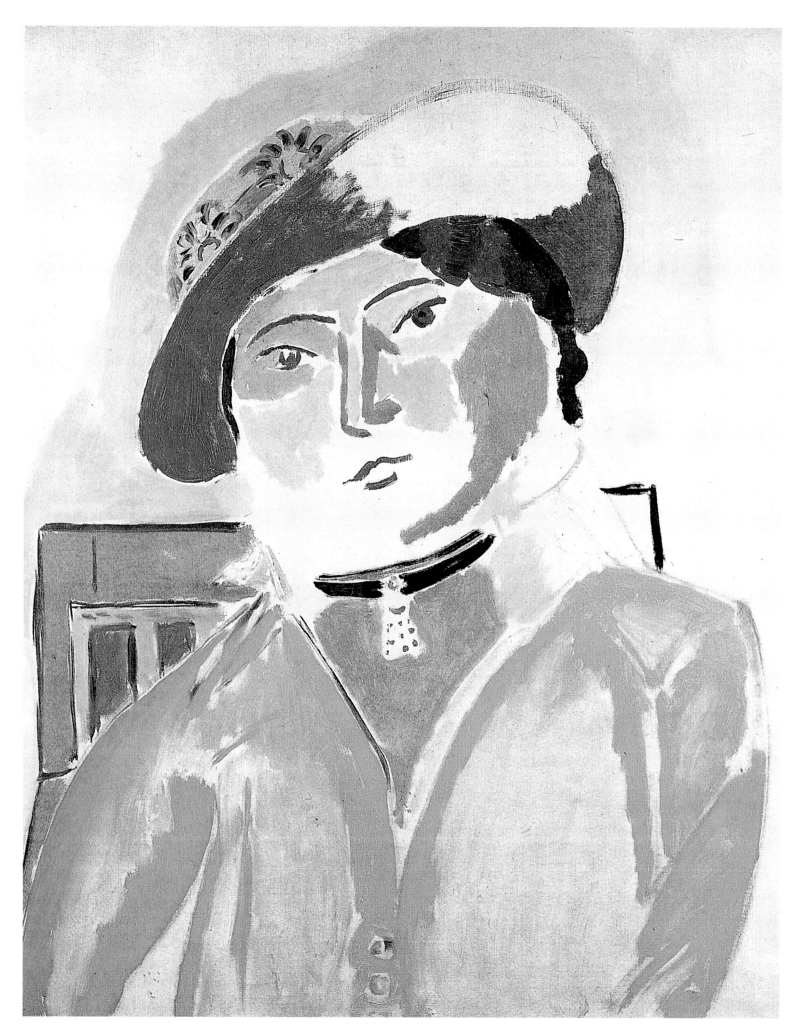

THE TEMPTATION OF ABSTRACTION

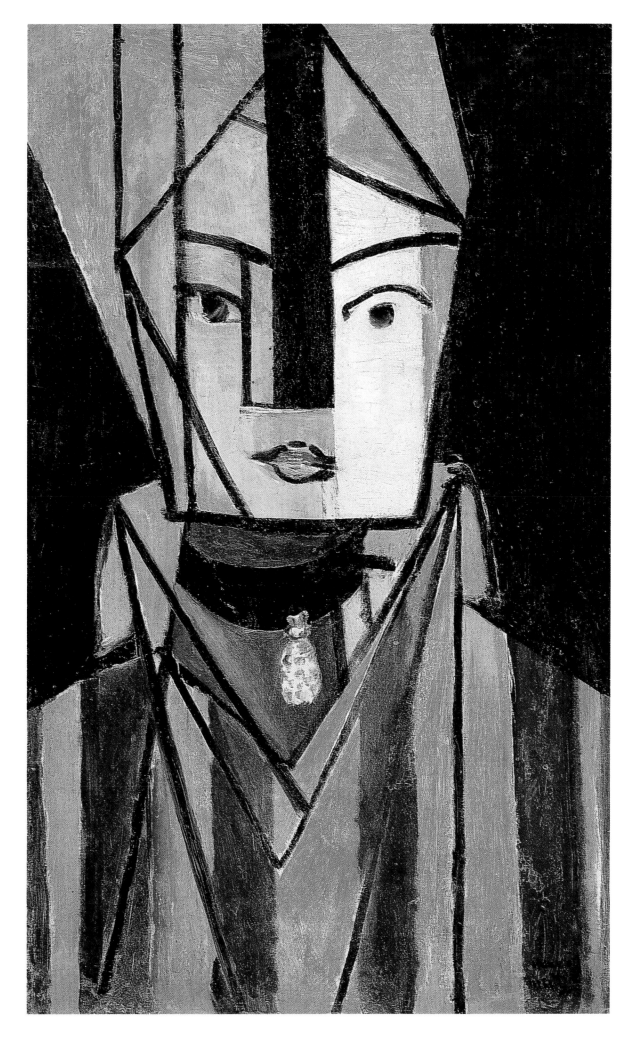

paradoxical task of expressing emotion and is only a means to an end – one which would culminate in his gouache cut-outs – which is that of the release of emotions. The war years emphasized this dialectic even further. Pierre Schneider, for example, mentions both "sentimental geometry" and "dramatic geometry". Everything is subjugated to Matisse's will: still lifes, landscapes, portraits. *Coup de Soleil* (p. 80) that extraordinary painting, as abstract as it is geometrical, introduces a third dimension with which Matisse often plays, while disguising it under apparent superficiality, that of mystery. Is this a landscape or an abstract composition? It looks like a battlefield on which both confront each other without reaching a decisive conclusion yet retaining the attention of the spectator who is supposed to interpret the canvas according to his mood. Anyone who is aware of the admiration Matisse had for Cézanne will find this picture to be closer to *View of Château Noir* by Cézanne (p. 80) than to Braque's *Houses at l'Estaque* (p. 80).

As for the numerous portraits Matisse painted during this period using the technique to which he has accustomed us, one often has the impression that he is taking a step backwards in order to make a greater leap forward. He returns to an attenuated form of Fauvism in order to launch himself further into geometric designs. Just as his sculptures tend to successive simplification, the faces appear to progressively lose their flesh so that all that is left is the bone structure. They remain attractive, thanks to the magic of Matisse's paintbrush, just as the Cheshire cat's grin remained in *Alice in Wonderland* although the cat himself had dis-

Photograph of Greta Prozor at the period when Matisse painted her portrait.

Study for "Portrait of Greta Prozor", 1916
Etude pour "Portrait de Greta Prozor"
Charcoal, 37.5 x 56 cm
Private collection

Untitled (Portrait of Greta Prozor), 1916
Thick pencil, 56 x 37.3 cm
Musée National d'Art Moderne, Centre Georges Pompidou, Paris

PAGE 90:
Greta Prozor, 1916
Oil on canvas, 147 x 93 cm
Musée National d'Art Moderne, Centre Georges Pompidou, Paris

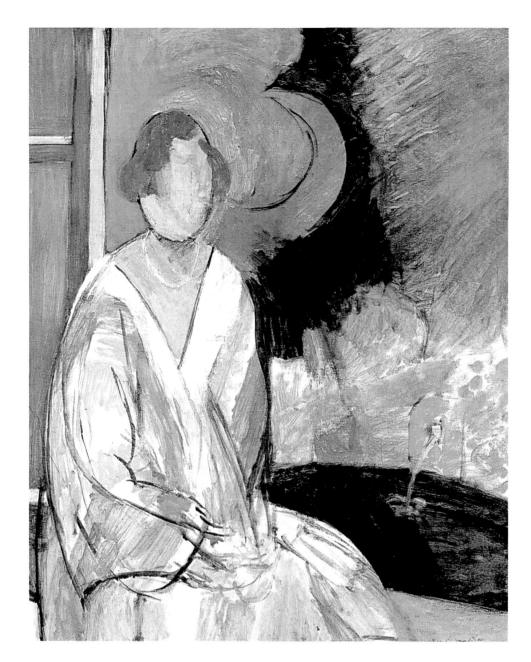

Woman at the Fountain, 1917
Femme à la fontaine
Oil on canvas, 81 x 65 cm
Private collection

Violin Player at the Window, 1917
Le violiniste à la fenêtre
Oil on canvas, 149 x 97.5 cm
Musée National d'Art Moderne, Centre Georges
Pompidou, Paris

PAGE 93:
The Piano Lesson, 1916
La leçon de piano
Oil on canvas, 245.1 x 212.7 cm
The Museum of Modern Art, New York

appeared. In contrast to the portraits of ladies in flowered hats, such as *Marguerite in a Leather Hat* (p. 88) which have the "set piece" look of carefully-posed photographs taken on special occasions by a provincial photographer, there are *White and Pink Head* (p. 89) or the *Portrait of Yvonne Landsberg* (p. 86) which looks more like an x-ray. There is an intermediate stage, in the shape of the portraits of Sarah Stein, Auguste Pellerin and Greta Prozor (p. 90).

True to his "Dr. Jekyll and Mr. Hyde" habit of offering two versions of the same painting (*The Sailor, Luxe, The Dance, Notre-Dame,* etc.), Matisse applies the same formula to his portraits and one can only be amazed at the results when one knows, for example, that *Marguerite in a Leather Hat* and *White and Pink Head* are two twigs from the same branch. Both paintings depict Marguérite, the artist's daughter, who was then twenty years old. The paintings have only one recognizable feature in common, the pendant attached to a black ribbon. The first portrait is incredibly lifelike, the second is the "Cubist" version with its orthogonal grid and the sectioning of the bust into vertical strips. Matisse kindly told his daughter who was posing for him: "This canvas wants to take me elsewhere. Do you agree to it?" This disconcerting work, this landmark painting, is a portrait which, despite the lamination effect of the passage through the

Cubist machine, still retains the grace of the model through the presence of the lightly-sketched mouth and a pure gaze which seems to linger strangely. Matisse would comment on his concept of the portrait: "The almost unconscious transcription of the meaning of the model is the initial act of any work of art and particularly of a portrait. Subsequently, reason is there to dominate, to restrain and to give the opportunity of re-creating while using the first work as a springboard."

The *Portrait of Greta Prozor* (p. 90) is an echo, in its way, of *The Portrait of Yvonne Landsberg* (p. 86). The same pose is used as a play on the ambiguity of a figure presented as seated, but which appears to be suspended in a vertical space which it completely fills. It is the subtle game of a Matisse who seems to be amusing himself when he confides in the model, after a few sittings, "that he had reached a point which did not satisfy him but he could not go any further…" Here again, drawings, drypoints and even etchings come to the rescue of the portrait in order to point it in the direction desired by the painter. However, this ever-increasing, ever more demanding tension would only culminate in the creation of *The Piano Lesson* (p. 93). It represents the zenith of the long process of

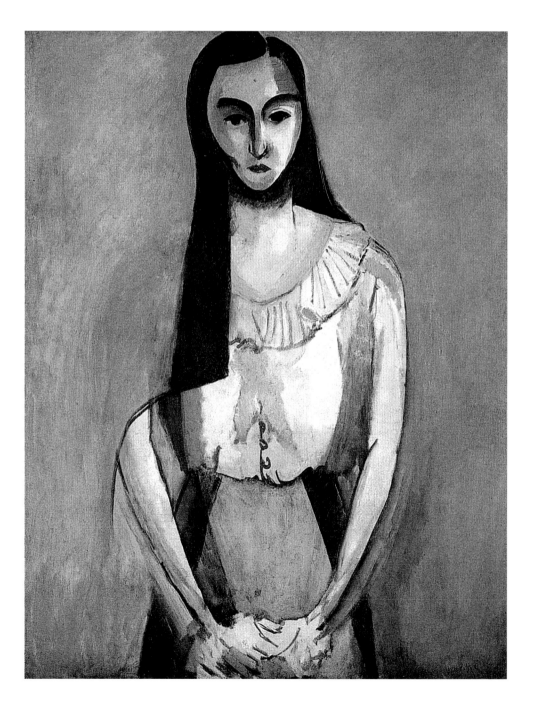

The Italian Woman, 1916
Italienne
Oil on canvas, 116.6 x 89.6 cm
Solomon R. Guggenheim Museum, New York

evolution during this period in which Matisse wrestled with the problems of construction and space.

In *The Piano Lesson*, Matisse had never seemed closer to Cubist doctrine, yet at the same time he had been as faithful to his own aspirations. Gaston Diehl notes in relation to this major work that "the crudity of the geometric distortions and the rigours of a strictly architectural composition are soon forgotten when one is confronted with the persuasive modulations of vertical rhythms which enliven the surfaces, the all-embracing and light-hearted melody of the interlaced palms and the curves of the window grille and the music stand which give space to the living structure. The discipline he imposed upon himself, the slow work of consideration and reworking have all mutated into smiling tranquillity, in a majestic and calm order of things."

This canvas marks the end of a period of change, research and torment, an important turning-point in the development of Matisse's painting which would now open up to influences other than that of Cézanne, which had hitherto predominated. He would consider Ingres, Courbet and even Manet, whose presence can be sensed in the portrait of the *Three Sisters* (p. 97). For relaxation,

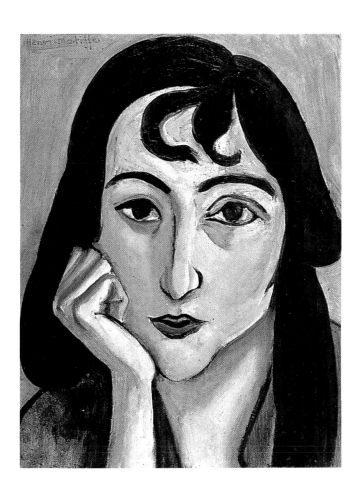

Head of Lorette with Two Curls, 1917
Tête de Lorette aux deux mèches
Oil on wood, 34.9 x 26.4 cm
Private collection

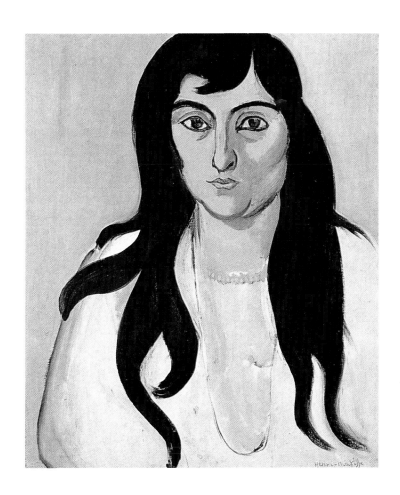

Woman with an Amber Necklace, 1917
La femme au collier d'ambre
Oil on canvas, 55.5 x 46.5 cm
Private collection

The contrast and tension between straight lines and curves which are so characteristic of the still lifes of the period are also to be found in the portraits. Geometry has always played a vital role in Matisse's work, from the long vertical necks of the carafes in his

first *Dining Table*, painted in 1897 and long before the advent of Cubism. Matisse stated on this subject: "I eventually came to possess a feeling for the horizontal in such a way as to render expressive the resulting obliques, and this is something which is not easy."

PAGE 97:
Three Sisters, 1916
Les trois sœurs
Oil on canvas, 91 x 74 cm
Musée de l'Orangerie, Paris

Lorette Reclining, 1916–1917
Lorette allongée
Oil on canvas, 95 x 196 cm
Private collection

Matisse would amuse himself by multiplying the effigies, sometimes dressed, sometimes undressed, in a huge, seemingly hieratic *Tryptich* (Barnes Foundation) and in various preparatory studies.

Matisse is not a painter who bears witness to his time, and yet he has left us some revealing images of women. These three middle-class women in their interior are typical of a certain society. They are not a personal ideal, as the creatures of Botticelli or Veronese might be, but they reflect an era of prosperity when the rich lived a life of luxury, leaving the rest in penury. One can see that these sisters live idle lives and are rather stupid, though pseudo-intellectual, their expressions

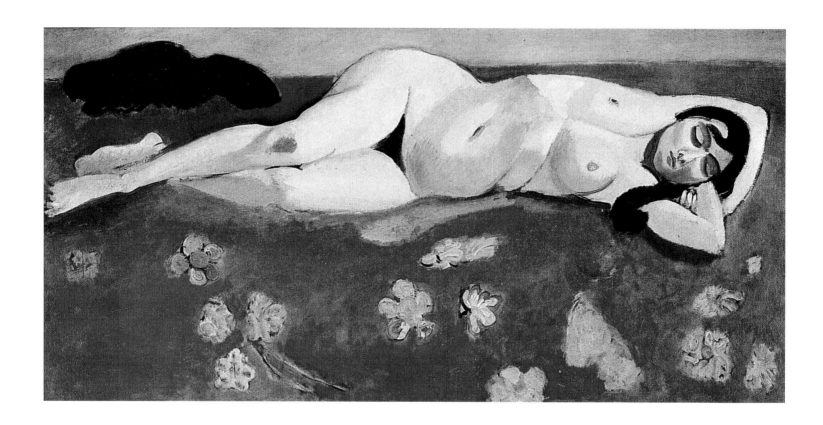

The images of women in Matisse are revealing. This painting of Lorette stretched out indolently, like a courtisan passively awaiting her fate, is a similar pose to that used by Ingres. Then there are these three middle-class women in their interior, are they not typical of a certain class of society? They are above all, under Matisse's paintbrush, design and colour, and nothing more.

lacking any human warmth. They are the daughters of a judge, a banker or a businessman. Happily, under Matisse's paintbrush, they become design and colour and nothing more. Henceforward, Matisse would withdraw from society. He decided to take refuge in Nice, in a more intimate world, one which was more propitious and, above all, calmer than the world which surrounded him and which was being disrupted by war.

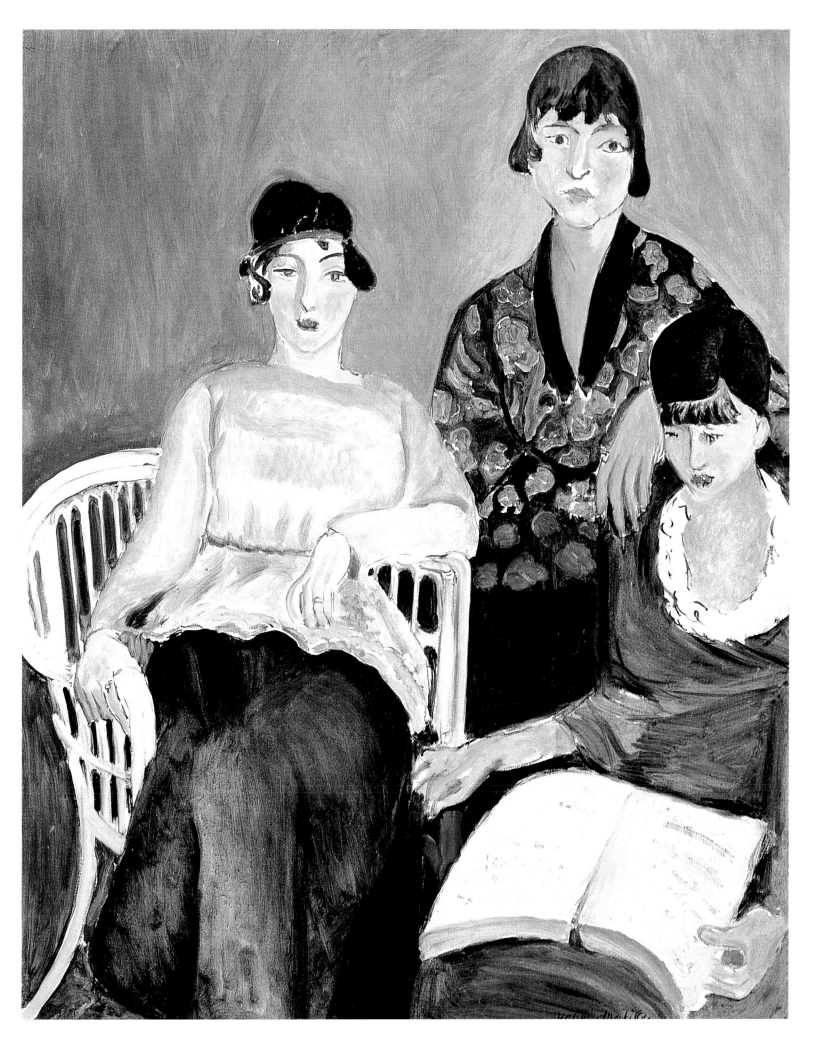

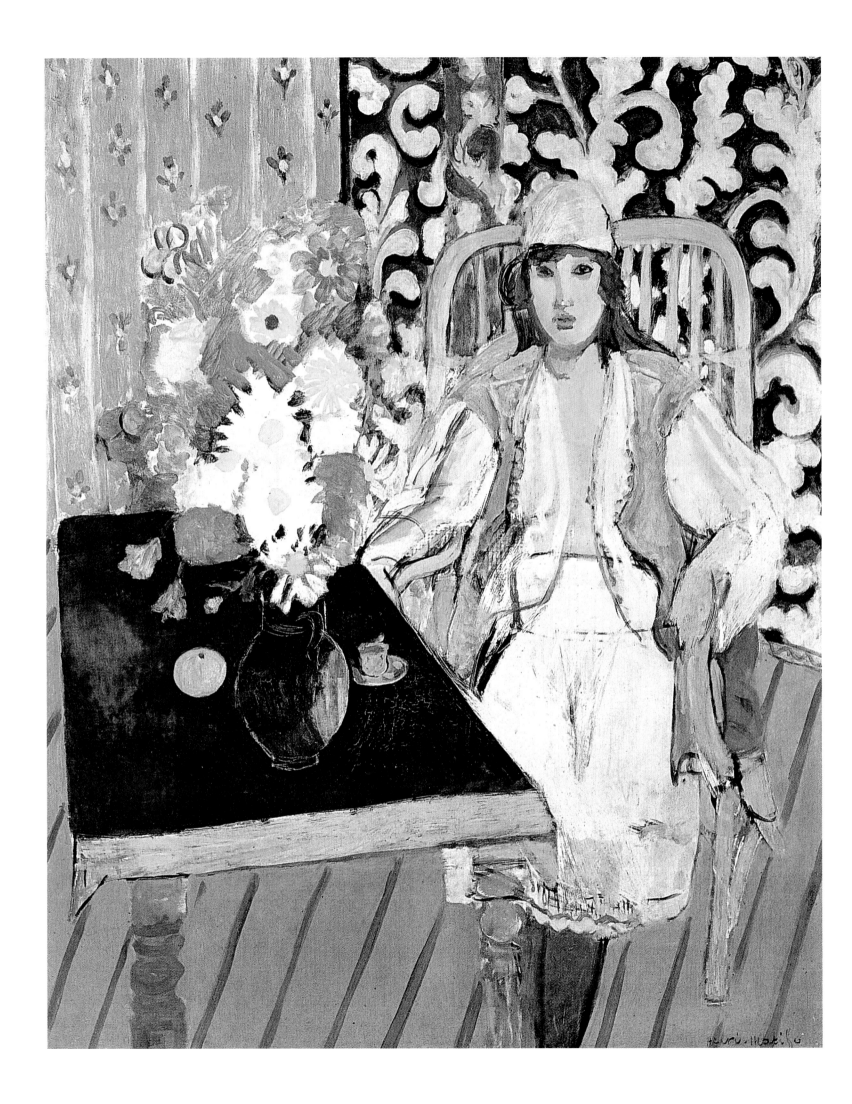

Nice, Base of Operations

" I was just emerging from long and tiring years of experiment," said Matisse, "during which I did all I could, after many internal conflicts, to bring these experiments into line with a creation which I wanted to be without precedent. In any case, some major mural and monumental compositions required it of me. Having started with a certain amount of exuberance, my paintings had evolved into clarification and simplicity itself… A desire for colour abstraction and rich, warm, generous shapes in which the curve wanted to predominate. This duality gave rise to the paintings which, despite some inner qualms, were created through the unification of opposites. Yes, I needed to be able to breathe, to relax and rest while forgetting my cares, far away from Paris…"

Matisse sought solitude and tranquillity and wanted everyone else to be at peace as well. His only desire was to be able to devote himself in complete tranquillity to experimentation with his discoveries and their harmonious application. He was like a musician who wants to practise his scales before performing in concert, like a tennis player between matches who is trying to perfect his backhand or improve his forehand.

It's hard work being a full-time genius. Matisse went to relax in the warmth of the South of France, to pose his models, dressing them up in fancy costumes and surrounding them with quasi-oriental props, as in *The Black Table* (p. 98), the prototype of the genre, which is a forerunner of *The Odalisques* he was to paint later. The scrolls and flowers in the background were inspired by the ceramic tiles which he had brought back from Morocco. By doing so, this apostle of peace unwittingly started another war… All those who aspired to run the art world of the time – Zervos, Raynal and Roger Fry – severely criticised this uncharacteristic self-indulgence, either by refraining completely from even mentioning the new style or treating it with a certain amount of disdain and calling it "baroque".

On the other hand, there was a sudden, concomitant change of heart by the press and the authorities in the painter's favour and an almost official admission that the authorities had been wrong to put so little faith in him. On the one hand, Dadaism, the Surrealists and other abstractionists of the period accused Matisse of flattering the worst aspects of public taste by offering it "modernist" paintings which were limp and lacking in visual or metaphysical depth. On the other hand, the conservative critics congratulated him for "his less redoubtable graces than before" (*Les Arts à Paris*, 1918) and compared him to Ingres, Renoir or Corot, whose worthy successor they considered him to be "the most gifted conjuror and manipulator of decorative shades of our time". The question arises, however, as to what had happened to the militant Fauve, "this dangerous firebrand who only recently maintained the supremacy of the French School throughout the world". Some regretted that he had not kept his promises, that he had betrayed them and

Nude Seated in a Chair (Study for "The Black Table"), 1919
Nu assis dans un fauteuil (Etude pour "La table noire")
Pastel, 33 x 23 cm
Matisse Archives

Hat with Feathers, 1919
Le chapeau à plumes
Pastel, 52 x 36.5 cm
The Detroit Institute of Arts, Detroit (MI)

PAGE 98:
The Black Table, 1919
La table noire
Oil on canvas, 100 x 81 cm
Private collection

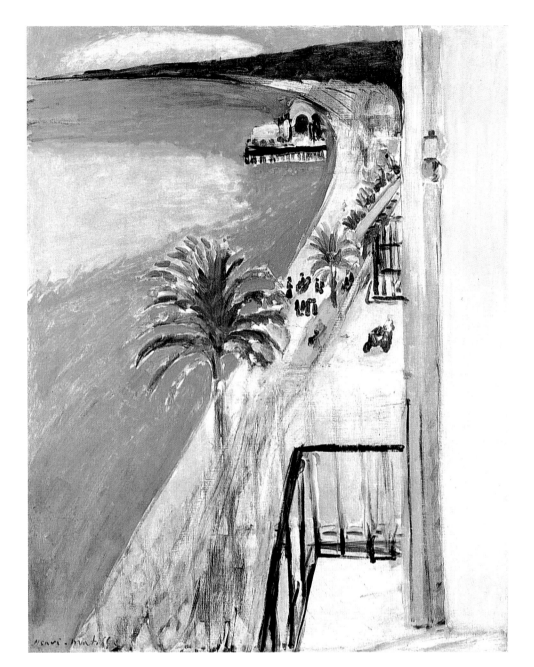

The Bay of Nice, 1918
La baie de Nice
Oil on canvas, 90 x 71 cm
Private collection

The Painter and his Model, 1917
Le peintre et son modèle
Oil on canvas, 146.5 x 97 cm
Musée National d'Art Moderne, Centre Georges
Pompidou, Paris

had descended to the level of a minor Mannerist painter, others, however, congratulated themselves on the return of the prodigal son to the bosom of what Jules Romains called "the dignity of his classicism". He was pardoned for the escapades and pranks of the past, and was soon to be appointed a member of the National Museums Purchasing Commission. In 1925, he was awarded the Legion of Honour. His achievement was recognised on an international level when he won the Carnegie Prize in 1927.

As usual, Matisse had done nothing to provoke this polemic. All he wanted was "to live like a monk, in a cell, just so as I have something to paint with no worries and no disturbance." Was this denial? Too much distraction? Fatigue? It was none of the above. Neither extreme of Matisse's art was understood, consisting as it did of regressions and great leaps forward, resting on the equivocal and the implied, moving between reality and abstraction, in an apparently easy and open manner which actually demanded much more participation and reflection from the viewer than would appear at first sight. Thus, as usual, Matisse merely did whatever came into his head. He saved his breath, recoiled from the springboard. If he could obtain the balance he sought he did not care that the impression he conveyed was

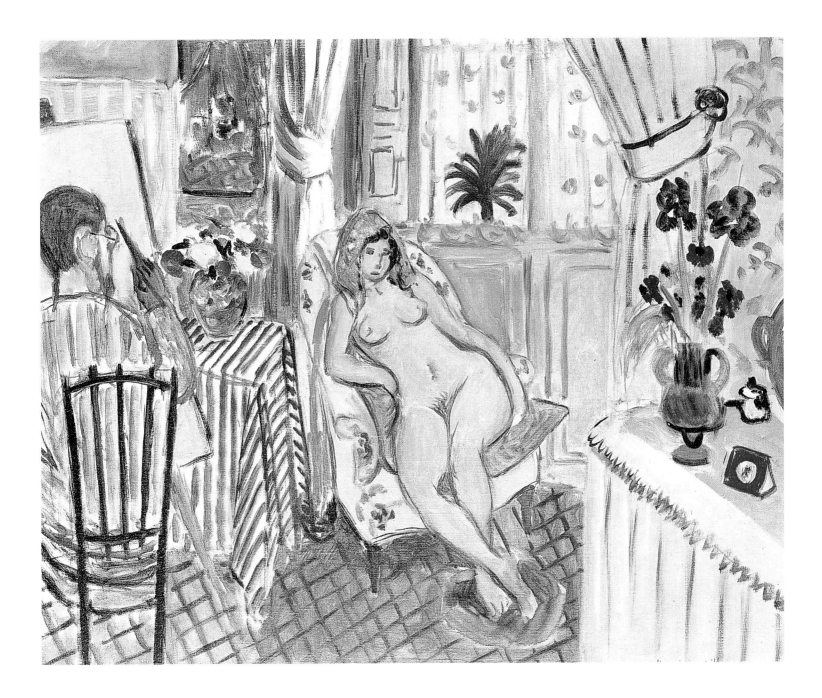

The Artist and his Model, 1919
L'artiste et son modèle
Oil on canvas, 60 x 73 cm
Private collection

PAGES 102–103:
Antoinette in a Feathered Hat, Jewish Costume to the Waist, 1919
Antoinette au chapeau à plumes, robe juive à mi-corps
Pastel, 49 x 37 cm
Baltimore Museum of Art, Baltimore (MD)

The White Plumes, 1919
Les plumes blanches
Oil on canvas, 74 x 61 xm
Art Institute, Minneapolis (MN)

one of regression. "He manages his flows and reflows, tempers his will through his inclination." (Lassaigne). Had not Appollinaire written so perceptively about Manet in 1907 of "an order measured by instinct"? Matisse was seeking "precision" and "distance". His thought process extended into what Bachelard called "reverie" and Poussin called "delectation". He pursued his dialectic through the two-version paintings, choosing, for example, the Intimist subject of *The Painter and his Model* (1917, p. 100) or *The Artist and his Model* (1919, p. 101), and creating a realist version and then a Cubist version two years later, a theme which Picasso would later copy. He used this method so that each version would demonstrate all the aspects of his repertoire and especially the contrasts of which he was so fond, using the model and the portrait, the painting within a painting, the mirror and the window, the interior and the exterior, the colours and the lines, the three-dimensional volumes and the scroll pattern, light and shade, transparency and opacity. These combinations of the artist's favourite themes, these "domestications" of his favourite subject-matter were by no means the least important contribution to this so-called period of "relaxation".

Like a schoolboy on holiday, Matisse was having fun. He boasted of having

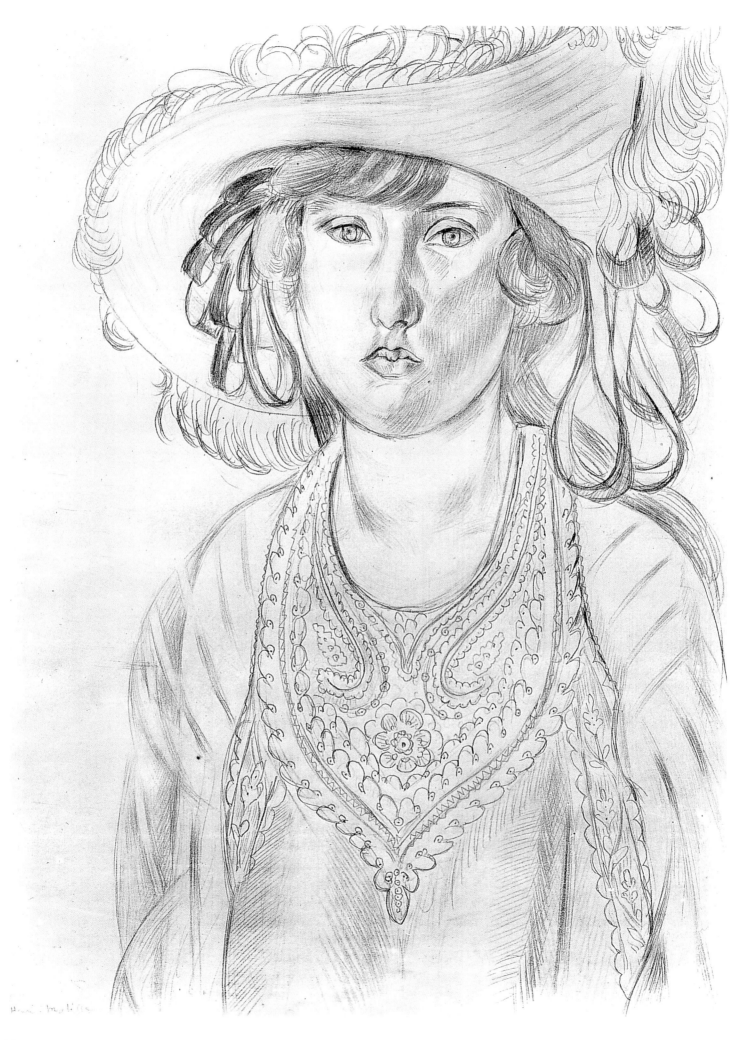

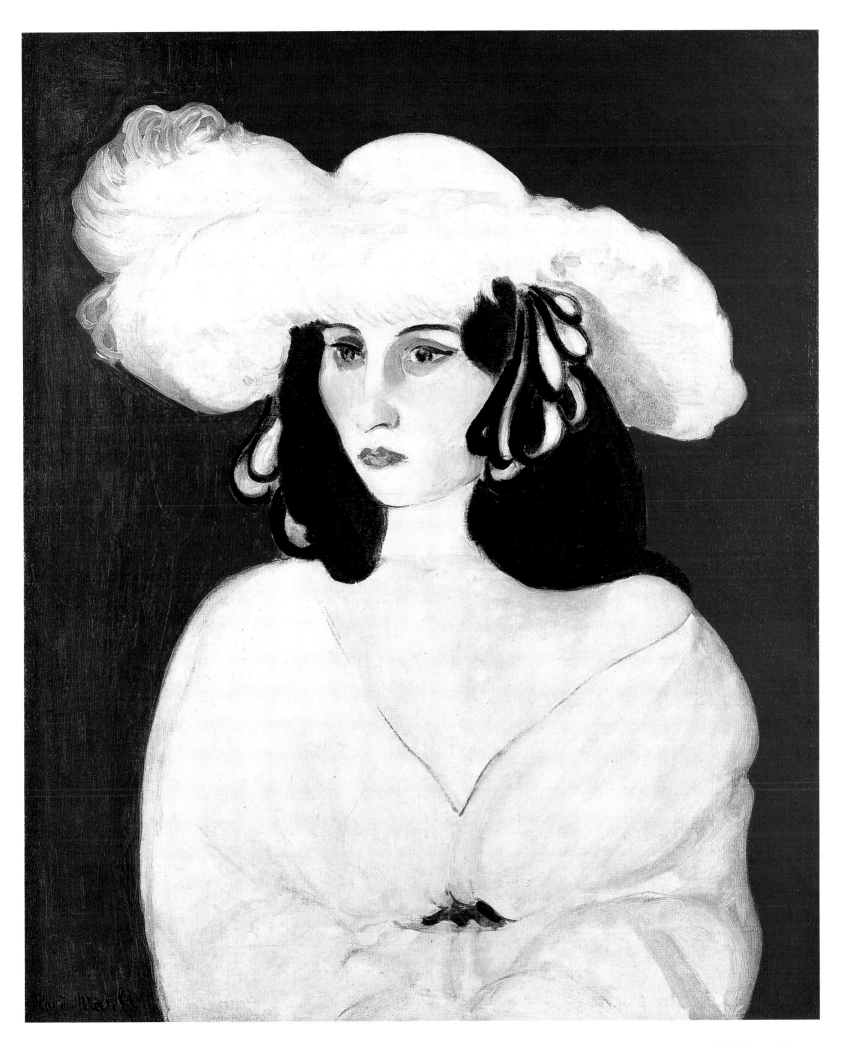

Antoinette in a Feathered Hat, Right Profile, 1919
Antoinette au chapeau à plumes, profil droit
Pen, 26.9 x 36.5cm
The Art Institute of Chicago, Chicago (IL)

Woman in a Flowered Hat, 1919
Femme au chapeau fleuri
Oil on canvas, 58.9 x 49.9cm
Mr. & Mrs. Herbert J. Klapper Collection,
New York

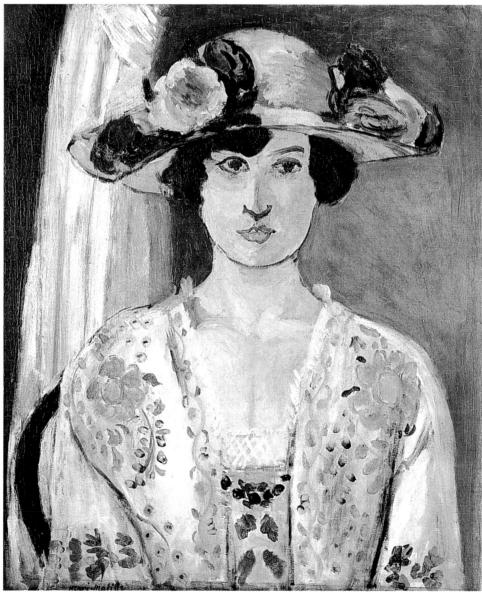

himself designed the extraordinary hat which he placed upon the head of his attractive model, Antoinette, in order to produce a whole series of surprising drawings which either preceded or succeeded the painting *The White Plumes* (p. 103). The drawings were so pure that one cannot help but recall the work of Ingres. He himself collected the ostrich feathers, shaped the woven straw and, having bought too much of the trimming, designed those loops of ribbon which hang down on either side of the face. He amused himself by adorning these beautiful and charming creatures with turbaned head-dresses and Moorish costumes, sometimes only retaining the general look, sometimes insisting on a particularly interesting face such as that of Antoinette which he emphasised with the curls of her ebony tresses coiled into the elaborate hairstyle invented by the painter. Matisse thus devoted himself to infinite variations, always seeking a harmony in the whole, combining decorative elements, reinventing them in order to better subject them to those sets of stripes and patterns of coloured squares and flower and fruit arrangements which he peopled with sumptuous human forms, oozing with sensuality, joy and warmth. Nice had a lot to do with it. "When I realised that each morning I would see this light again, I could not believe my luck." Nice was his home base to which he would return faithfully until his last departure and his last rest.

Influenced by the South of France and the magic of its lifestyle, Matisse

The Feathered Hat, 1919
Le chapeau à plumes
Pastel, 48 x 31 cm
Private collection

Antoinette, 1919
Oil on canvas, 66 x 50 cm
Private collection

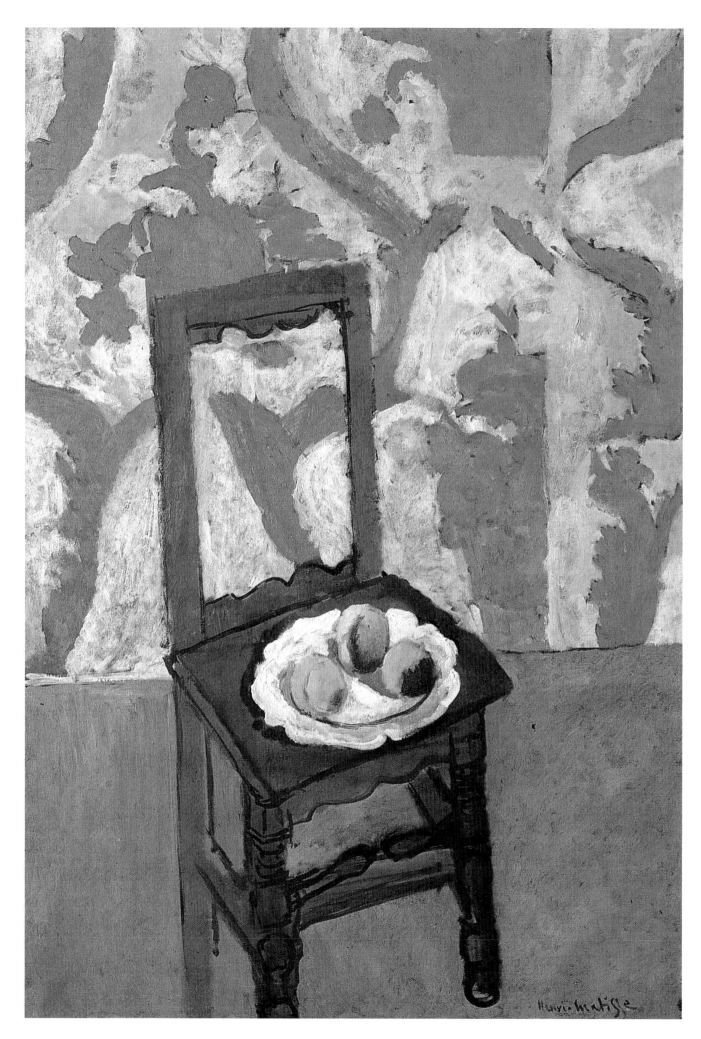

PAGE 106:
The Lorrain Chair (Chair with Peaches), 1919
La chaise aux pêches
Oil on canvas, 130 x 89 cm
Private collection

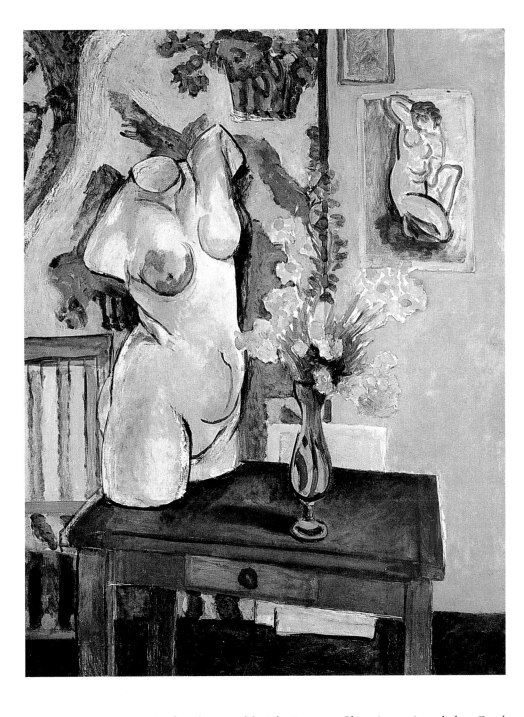

Greek Torso and Bouquet, 1919
Torse grec et bouquet
Oil on canvas, 116 x 89 cm
Museu de Arte, São Paulo

Paul Cézanne: *Still Life with Plaster Cupid*, c. 1895
Nature morte avec l'amour en plâtre
Oil on paper attached to cardboard, 70 x 57 cm
Courtauld Institute of Art, London

seemed to re-create the familiar world. *The Lorrain Chair* (p. 106) and the *Greek Torso and Bouquet* (p. 107), a combination which reconciles Cézanne with the Orient, represents a group of objects assembled in such as way as to cause them to respond, balance and interact, in a form used by Cézanne, and which was less concerned with creating a likeness than with suggesting the shapes to the viewer's imagination. Roger Fry said in relation to Matisse and his previous work, that this was "an art full of implications, which leaves it up to the spectator to understand its most mysterious suggestions."

Still Life with Plaster Cupid (1895) by Cézanne and *Greek Torso and Bouquet* by Matisse (p. 107) are very similar, both being still lives which feature a plaster sculpture. In each case, the sculpture's whiteness focuses attention upon itself. However, there is a subtle play of shapes in response, the echo of the round objects which surround it, the contrast with the straight lines of the tables, the edges of the paintings and the balustrade. The eroticism and sensuality of Cupid (copy of an 18th-century baroque statue) or the female bust which was Matisse's choice, are even more accentuated when contrasted with the suppressed violence of the shapes placed next to them.

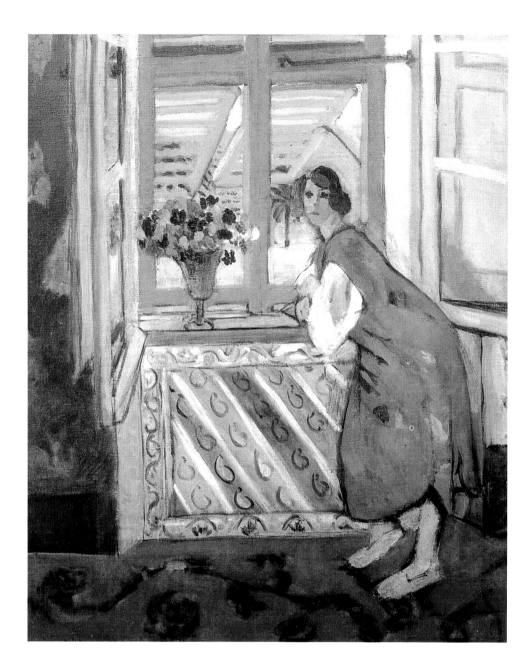

Young Girl in a Green Dress, 1921
Jeune fille à la robe verte
Oil on canvas, 65 x 55 cm
Private collection

Study for "Young Girl in a Green Dress", 1921
Etude pour la "Jeune fille à la robe verte"
Pastel, 30 x 24 cm
Private collection

The Moorish Screen, 1921–1922
Le paravent mauresque (Jeunes filles au paravent mauresque)
Oil on canvas, 90.8 x 74.3 cm
Philadelphia Museum of Art, Philadelphia (PA)

In a realism in which "everything is false", Matisse makes great use of the light in which Nice is bathed and which he generously allows to infiltrate through the shutters. "It is only after having so long enjoyed the sunlight that I tried to express myself through the light of the mind… A cosmic space in which one feels walls no more than does a fish in the sea."

The peaceful and luminous interiors such as *Young Girls with a Moorish Screen* (p. 109), *Interior in Nice, Young Woman in a Green Dress* (p. 108), or the intimate scenes of *Nude, Spanish Carpet* (p. 110) in which the woman emerges glorified, sovereign and triumphant in her feminine curves, are all in the words of André Rouveyre, the "concertos of a colourist". This is where the field of spiritual and visual sensuality begins, these pensive emotions which were to dominate Matisse's world, or rather the "harem" of the *Odalisques*, of which he would say: "I painted odalisques in order to paint nudes. But how can you produce a nude which is not artificial? But then, I happen to know [this world] exists. I was in Morocco. I have seen them. Rembrandt painted Biblical subjects adorned with cheap Middle-Eastern trinkets from the bazaar, but he put all his emotions into them…"

"Where is the charm in your paintings which depict open windows?" This question was often asked of the man who was described as the painter of windows. "Probably," Matisse would reply, "from the fact that my feeling for space only covers the area from the horizon to the interior of my studio room and that a passing ship experiences in the same space only the familiar objects which surround me, and the wall in which the window is set does not create two

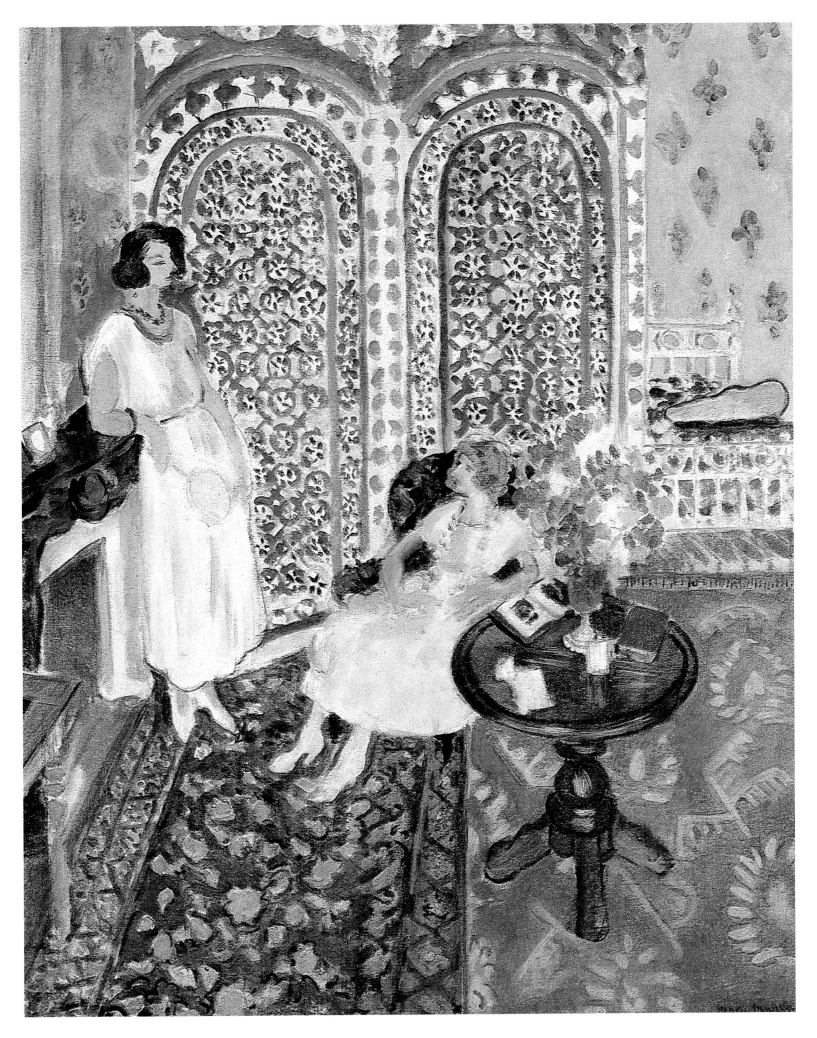

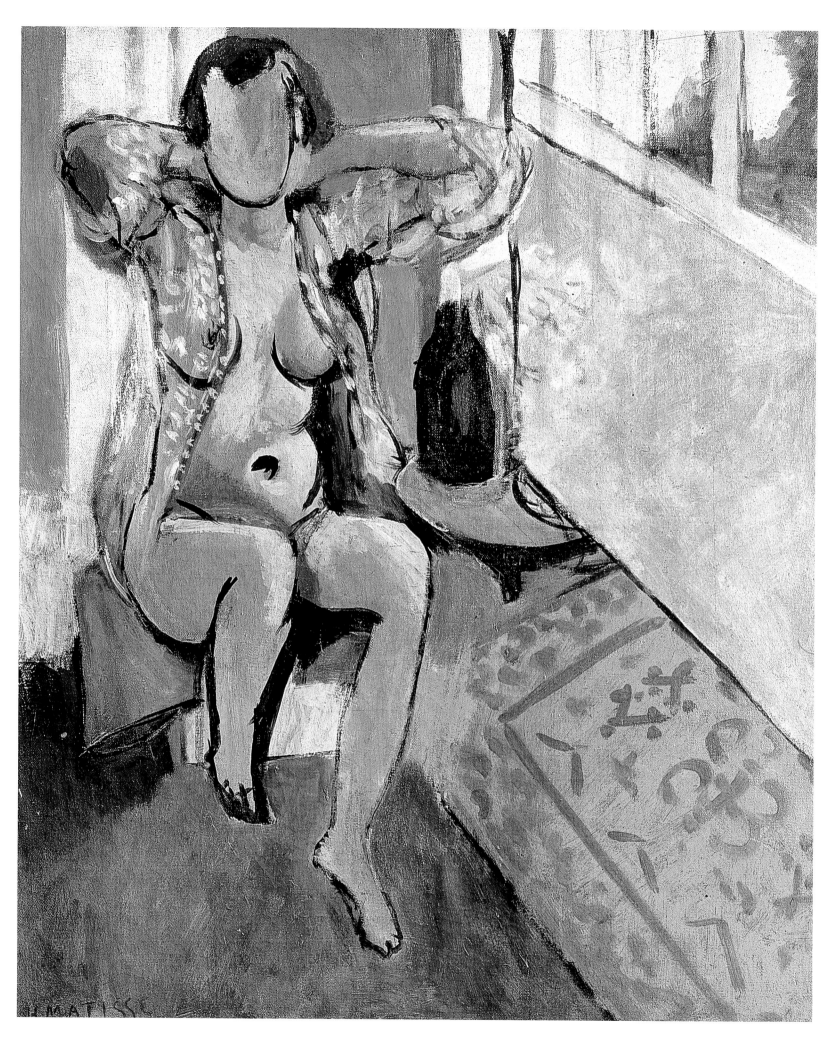

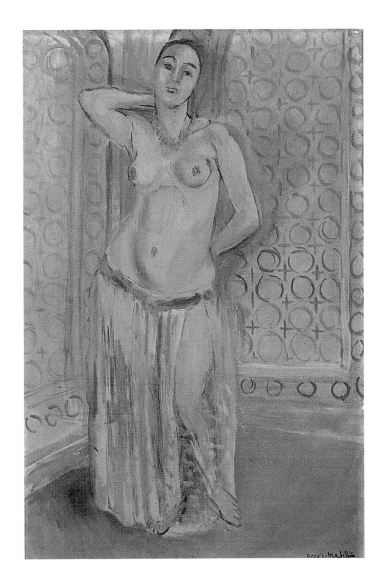

different worlds." In the same way, Matisse wrote: "If I have been able to combine in my painting the exterior, the sea for example, and the interior, which is the atmosphere of the countryside and that of my room into a single whole... I would not need to bring the interior and the exterior together, both are combined in the way I experience them. I can associate the armchair which is near me in the studio with a cloud in the sky, with the quivering of the palm-tree beside the water, without straining to differentiate their localities, without disassociating the various elements in my design which create whole in my mind."

Art experienced a period of uncertainty between the wars, torn as it was between the various excesses of which Expressionism – then causing a sensation in Europe at the time though this was by no means its least or even its last metamorphosis – and the reaction of the constricted "return to order" which certain people advocated in the name of a Neo-Classicism of doubtful lineage. Matisse, in his withdrawal, had chosen a form of wisdom which was to prove particularly fruitful for him. He continued to develop despite what the critics were saying, to sail between dream and reality, avoiding the reefs, cautiously circumnavigating the excesses and above all ensuring that he did not fall into the old precepts of a stultified tradition. On the contrary, he devised clever potions which were also wonderful antidotes. As he himself said, human figures were what interested him the most and while retaining their decorative role, they would become more and more monumental, more and more significant, ever more real. They would take on the fullness of living sculpture, constructed with a firmness which preserved

Face of a Young Woman and Three Goldfish in a Bowl,
1929
Visage de jeune femme et bocal aux trois poissons
Etching, 9.2 x 12.5 cm

Nude with Moroccan Mirror, 1929
Nu au miroir marocain
Etching, 21.7 x 15.3 cm

Nude in Interior with Venetian Lamp and Goldfish,
1929
Nu dans un intérieur avec lampe vénitienne et pois-
sons rouges
Etching, 20.1 x 15.1 cm

Reclining Nude, Interior with Venetian Lamp, 1929
Nu couché, intérieur à la lampe vénitienne
Etching, 9.1 x 12.5 cm
All at the Bibliotèque Nationale, Paris

their essence and which would culminate in *Decorative Figure against an Or-
namental Background* (p. 114), a supreme example of the genre. It is no accident
that such figures are compared with sculpture. As always with Matisse, one
should refer to his experiments in this medium so as to throw light on his deepest
concerns.

If there was too much of an overall sugary quality in his work, if concessions
were accepted in his portraits or his last still lifes, he must have had some doubts,
and Matisse was not a man who could fail to react against this intimate interac-
tion between dream and reality with which he was preoccupied for some time.
It was hardly in his nature to make dramatic U-turns as did Picasso. He preferred
to act without haste, gradually, always careful to preserve his freedom of judge-
ment and above all to make use of the wealth of experience he had acquired. At
this period, when Art Deco began to emit a plethora of circles and squares,
Matisse seems to mock them gently and take one last moment of repose by

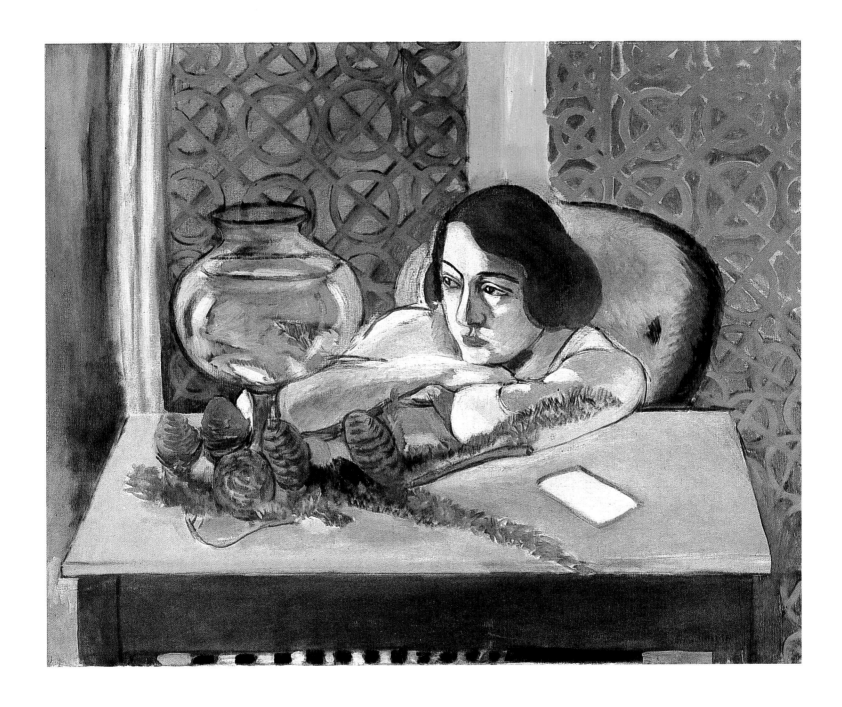

playing with the shapes of *Woman before an Aquarium*, painted in 1921 (p. 113), which in 1929 he would transform into a series of drawings (p. 112). In his own way, he added a touch of philosophical reflection. What is this woman thinking of as she stares dreamily at the goldfish swimming in a bowl? Of her fate? Is she, like them, an unwitting prisoner? She is not only the pretext of yet another contrast between the transparent and the opaque, the curve and the straight line, space and light, echoes and reflections… As for the apparent simplicity of the scene, is it not there to send the viewer into a daydream? Fish, in Matisse's work, are a sort of echo of the odalisque. Both have fluid and languorous bodies and, at a subconscious level, represent both the opposition and the union between the world of water and the world of land.

Woman before an Aquarium, 1921
Femme et poissons rouges
Oil on canvas, 81 x 100 cm
The Art Institute of Chicago, Chicago (IL)

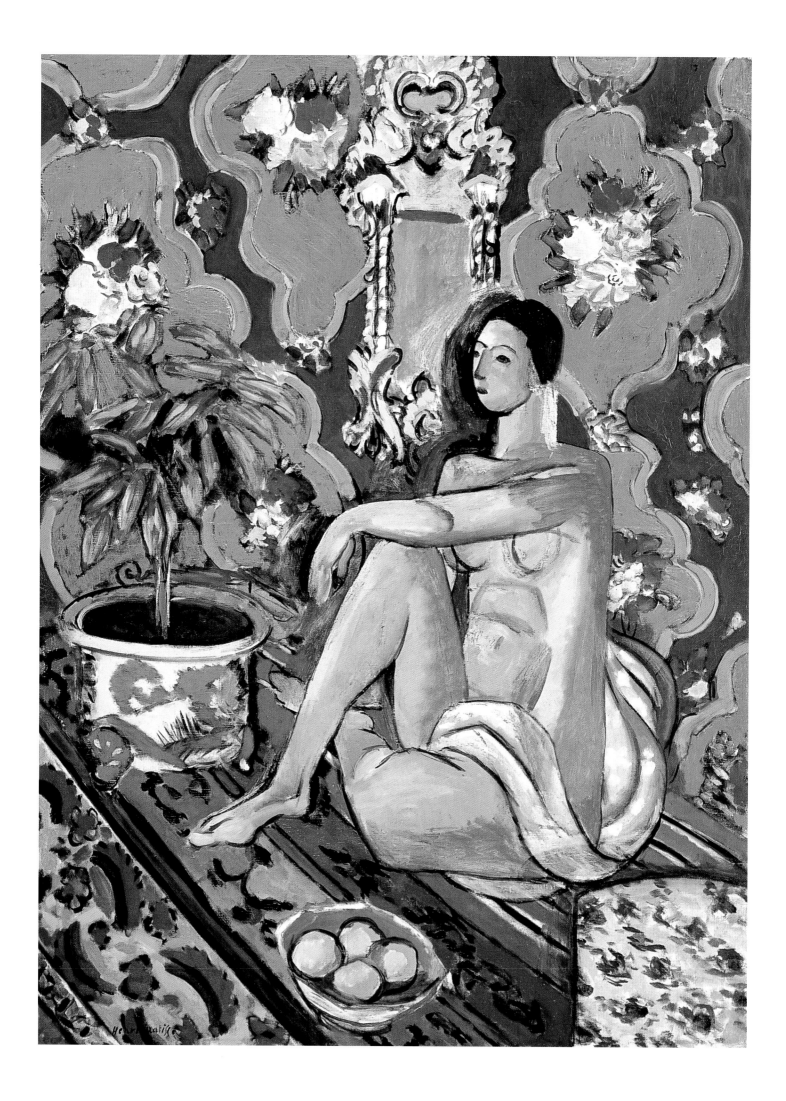

The Harem of the Odalisques

The *Odalisques* was Matisse's own way of extending Fauvism, giving it a more tranquil appearance by the careful use of line. *Odalisque in Red Culottes* (p. 116), often cited as an example of the painter's more classical style, could be considered as the vibrant proof that, for Matisse, the furnace of Fauvism had not yet lost all its heat. The innovation in this painting is that Matisse had installed an oriental background in a corner of his studio. The props included a Moorish screen, Arab drapery and other items brought back from Morocco. The feminine curves emerge in all their splendour, the relationship between the figure and the background predominates. The scroll pattern is an echo of the body, the swags, patterns, flowers, checks and stripes are not mere decoration, they play the role of first violin.

In fact, this series of *Odalisques*, from *Odalisque in Red Culottes*, painted in 1921 and *Odalisque with Magnolias*, painted in 1923–24 (p. 117), to *Reclining Nude, Backview*, painted in 1927 (p. 136) as well as the rest of the series which covers a six-year period is closer in spirit to Persian miniatures – despite the difference in format – than, for example, Delacroix's *Women of Algiers* or even to any "realistic" depiction of the subject in Western art. Matisse devoted his attention less to orientalism and more towards the Orient. And what better way to highlight the sumptuousness of the barely-suggested flesh and the sensual shape of the subject, to the subtle yet so real modelling, than by allowing them to stand out against this theatrical backdrop. It could be said that Matisse is playing a game of chess here and has launched into one of the subtle and complex moves of which he was so fond, with woman as the prize. Her body is an arabesque, her finery a symphony of colour and the decor created is a receptacle for light.

The game almost takes the form of a dual which might be dubbed "Cézanne versus the Orientals" when Matisse paints his *Decorative Figure on an Ornamental Background* (1925, p. 114). This *Decorative Figure*, was first modelled as a large sculpture in his Nice period, when it is called *Large Seated Nude* (1925, p. 120). He launches this hieratic, almost Cubist figure, into the decorative scrolls and swags which appear to be flat and lacking in depth. The mirror in the background is an excuse for a touch of blue amidst the lavish swirls. Between the background and the carpet there are no fewer than half a dozen different patterns. Here is Matisse in fine fettle, juggling curves and volumes, determined to place the two constants of his painting in as sharply contrasting a manner as possible. The "figure" and the "background" are as far removed as possible from each other in spirit yet they are forced to coexist! It is like witnessing a balancing act on the high wire.

"As for the odalisques," commented Matisse, "I saw them in Morocco, which makes it possible for me to paint them now for real…" Of course, but to be able

Night, 1922
La nuit
Lithograph, 25 x 29.6 cm
Bibliothèque Nationale, Paris

Matisse with *Decorative Figure on an Ornamental Background*, 1926–1927
Photo: Keystone

PAGE 114:
Decorative Figure on an Ornamental Background, 1925
Figure décorative sur fond ornemental
Oil on canvas, 131 x 98 cm
Musée National d'Art Moderne, Centre Georges Pompidou, Paris

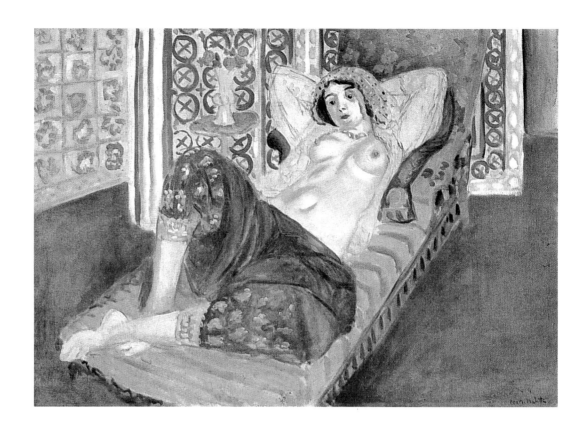

Odalisque in Red Culottes, 1921
Odalisque à la culotte rouge
Oil on canvas, 65 x 90 cm
Musée National d'Art Moderne, Centre
Georges Pompidou, Paris

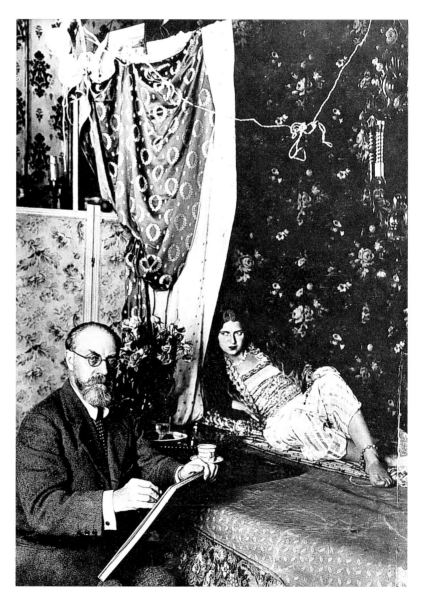

Matisse in a corner of his flat in Nice which had
been decked out with a background, his model
dressed up as one of his odalisques, 1928

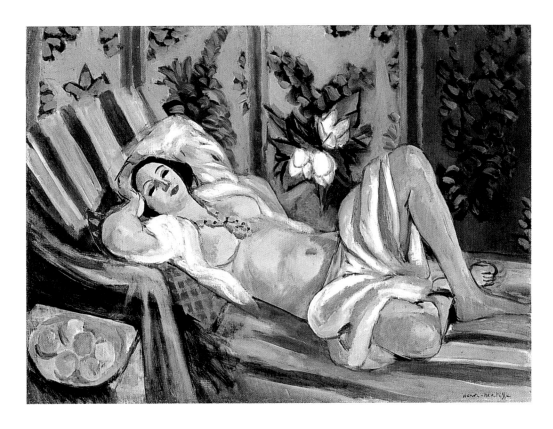

Odalisque with Magnolias, 1923–1924
Odalisque aux magnolias
Oil on canvas, 65 x 81 cm
Private collection

Odalisque in Turkish Trousers, 1920–1921
Odalisque au pantalon turc
Pen, black ink, retouched in paintbrush with
white ink, 27 x 37.4 cm
Musée National d'Art Moderne, Centre
Georges Pompidou, Paris

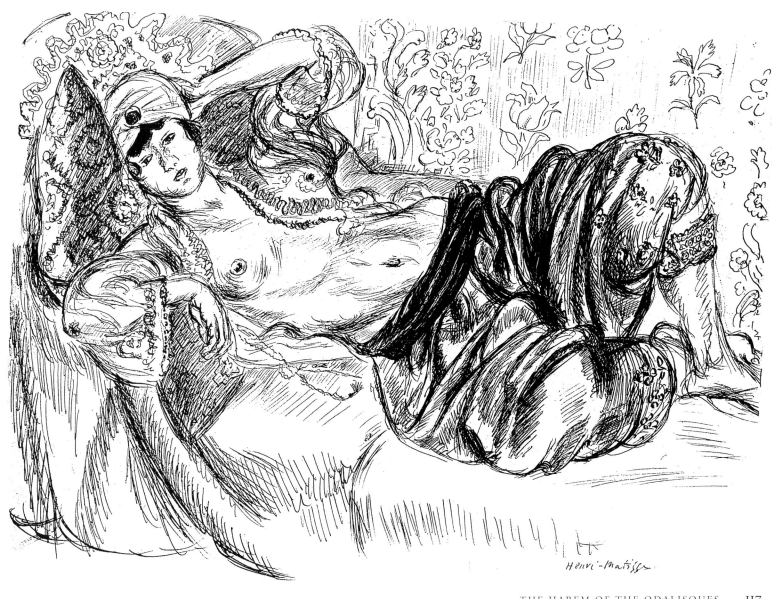

to paint them in this way, one has to be Matisse, Matisse of Nice. He chose to reconstruct the scene in his own way, in the studio, even choosing to use professional models, to re-create this world of houris which inspired him rather than paint it on location. Was Matisse losing his touch? Who was he trying to convince? These artificial paradises are part of his usual magical world, in which, to a greater extent than ever, he manipulates the plastic elements and all the colours. Here again, it is hard to discern where the carpet ends and where the wallpaper begins. Although the lemons are shown in relief, they become part of the composition, as does the mirror. The potted plant is a variation on the pattern of the wallpaper. One fails to notice the unrealistically straight back of the model, a distortion so remote from reality, surrounded as it is by all those curves. Matisse's trap works perfectly and closes in on the viewer.

The painting was exhibited at the Salon des Tuileries in 1926 but did not cause a scandal. However, it did give rise to a host of questions and the provocative distortion between the "figure" and the "background" produced a mountain of written analyses. The word "boldness" was used most frequently in the comments, sometimes as criticism and sometimes to infuriate the painter. He was reproached for using aggressive colours and for the clear lack of academic drawing

Odalisque with a Moorish Chair (Odalisque in Grey with Chessboard), 1928
Odalisque au fauteuil turc (Odalisque en gris à l'échiquier)
Oil on canvas, 60 x 73.5 cm
Musée National d'Art Moderne, Centre Georges Pompidou, Paris

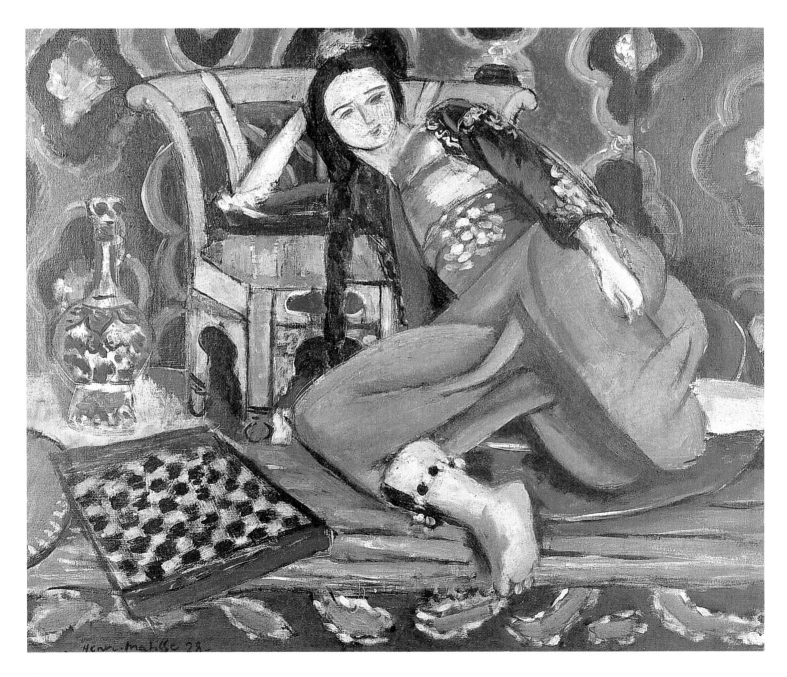

in the depiction of the nude. Even his most favourable critics had their doubts. "Matisse," wrote Georges Charensol, "who for years has made so many pledges to the partisans of hedonism appears to have intended to surprise us. We are not displeased, quite the opposite, that a painter whose skills are so sure and who has accustomed us for so long to perfectly harmonious creations should launch himself yet again into new adventures." Robert Rey, on the other hand, pretended hypocritically to be surprised "that Fauvism is so wise…" and "if it were not for the foreshortening of the thigh… the contouring would be almost academic!" "Does an artist have the right to change key, like a musician, in the middle of a single painting?" asked Henry MacBride in all seriousness. Clément Greenberg, the great theoretician of the American School, wrote more seriously, with hindsight in 1953, in relation to this painting: "The problem of reconciling the illusion of depth with the brutal act represented by the flat surface of the painting is often presented in Matisse's work, like that of the integration of the volume of the human figure against a flat, richly ornamented background. In this outstanding painting, the problem is raised in such a way as to render any solution almost impossible… it seems as though, for once, Matisse has allowed his sculptural concerns to invade his painting. The distortion and simplifications of the anat-

Two Odalisques, 1928
Deux odalisques
Oil on canvas, 54 x 65 cm
Moderna Museet, Stockholm

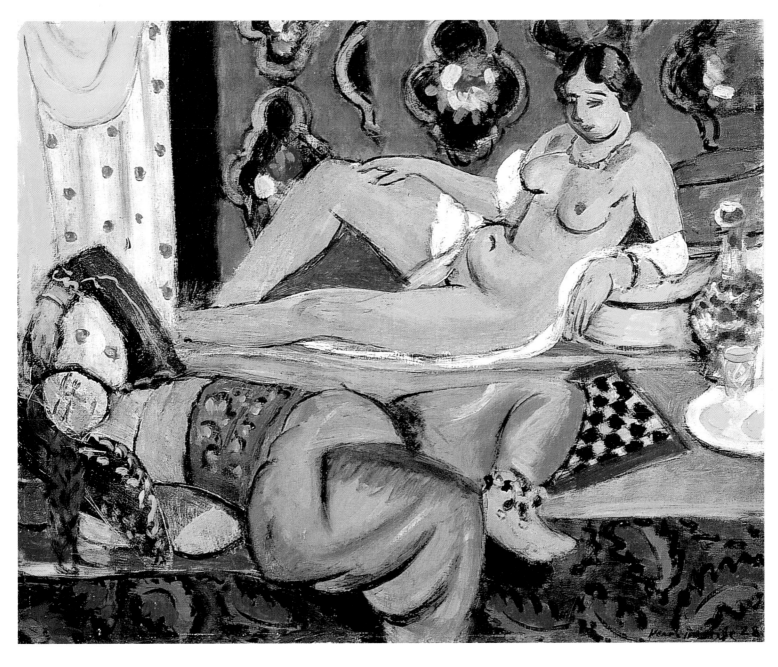

omy of the nude reflect those which emerge in certain of the bronzes of the same period. Matisse had occasionally worked in plaster, clay and bronze. After 1899, and despite his debt to Rodin, he managed to become one of the greatest sculptors of our time."

Those denigrating Matisse's work had wasted their time. If they had dismissed *The White Slave* (p. 111) or *Nude on a Blue Cushion* (p. 122) as the amiable fantasies of a Fauve who had lost his bite, *Decorative Figure on an Ornamental Background* showed them just how wrong they were. This abrupt insertion of a three-dimensional object into a flat space, which is the most "Nice-inspired" of Matisse's paintings, was Matisse's complex response, almost the supreme retort, a genuine challenge!

The same game is being played and the same contrasts and surprising yet complementary juxtapositions of round and square shapes are made in *Still Life on a Green Sideboard* (p. 140) and *Woman with a Veil* (p. 141). Both paintings use the same chequerboard pattern (the check pattern is a recurring theme) and the same contrasts of tones. They are used more subtly in the *Sideboard*, whose colour scheme is the blue and green of which Matisse was so fond and where the two colours are placed as close to each other as possible and yet in many different ways. The contrast is more Fauvist in *Woman with a Veil* (also called *Portrait of Miss H.D.* who posed for *Woman with an Aquarium*), the rather stiff pose being reminiscent of *Decorative Figure on an Ornamental Background*. In his report of the 1929 Salon d'Automne, Jacques Guenne says of the *Sideboard* that it is "one of the most accomplished of Matisse's paintings, a work which the public could place next to a masterpiece by Cézanne and which gives us the salutary joy of being able to hope for a period which possesses such a master…" He emphasises the way colour was used "in the same way as the Old Masters" and concludes

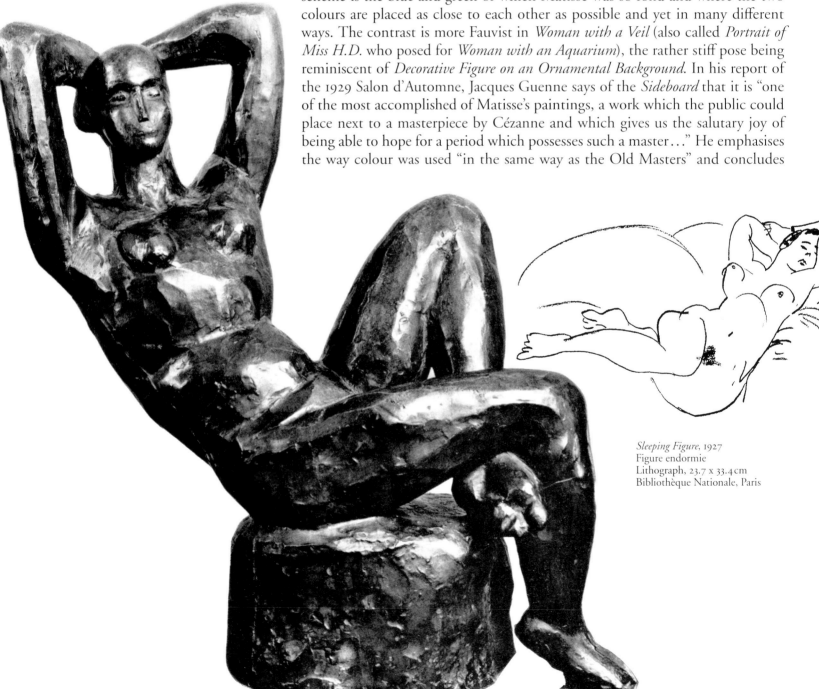

Large Seated Nude, 1925
Grand nu assis
Bronze, height: 84 cm

Sleeping Figure, 1927
Figure endormie
Lithograph, 23.7 x 33.4 cm
Bibliothèque Nationale, Paris

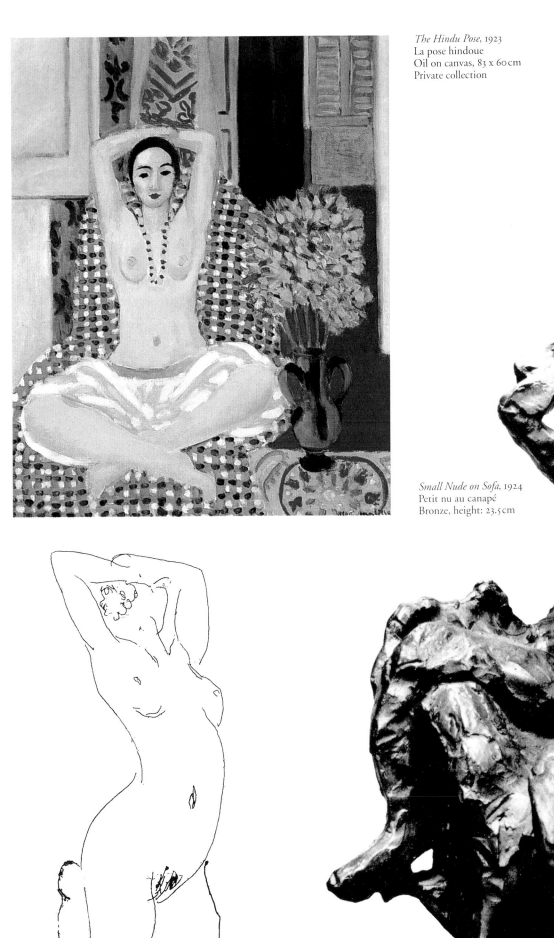

The Hindu Pose, 1923
La pose hindoue
Oil on canvas, 83 x 60 cm
Private collection

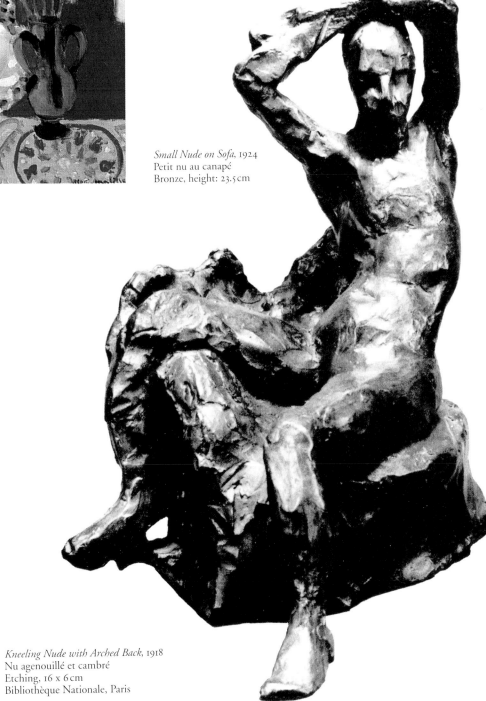

Small Nude on Sofa, 1924
Petit nu au canapé
Bronze, height: 23.5 cm

Kneeling Nude with Arched Back, 1918
Nu agenouillé et cambré
Etching, 16 x 6 cm
Bibliothèque Nationale, Paris

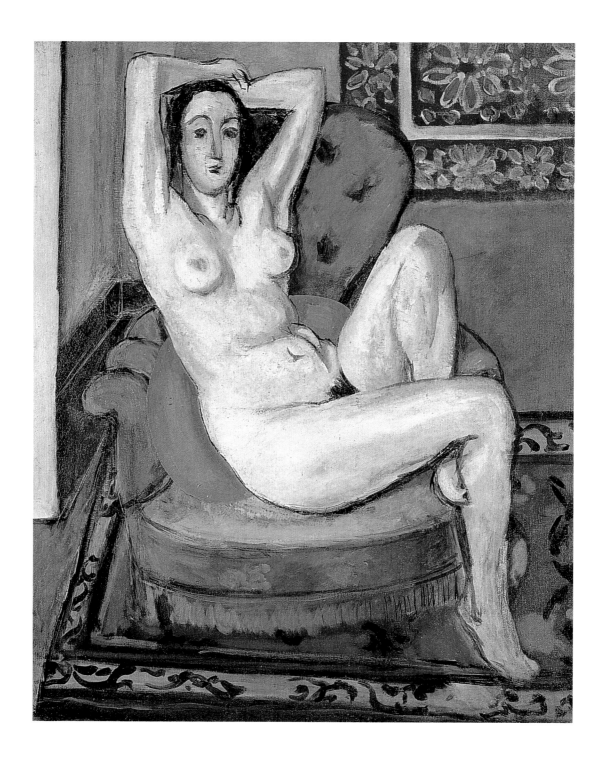

that it would be impossible for "even the most barbaric eye not to be won over" by the "magic of the colour, the nobility of the lines, by all the virtue of joy and security which emanate so intensely…"

The lithographs, as numerous as they are diverse, which Matisse produced on the odalisque theme are all drawn with great care. Here again, there is evidence of a crisis of conscience similar to that experienced by Renoir (in his Ingres-like period which he described as "sour") and Degas. Yet there are signs of great boldness and freedom. More than 300 prints, almost all of which have women as the subject punctuate those happy years peopled with odalisques. "There are drawings," wrote Aragon, "created using a single, continuous line which only ends when they are completed, almost like a confidence (reminiscent of his etchings, drypoints and lithographs entitled *Arabesque*) and then those shaded prints, alive from the shading (see *Large Odalisque in Striped Trousers* (p. 124)) and those in which shade dominates, which are illuminated by rare points of light (as in the 1938 lithographs)."

Nude on a Blue Cushion, 1924
Nu au coussin bleu
Oil on canvas, 72 x 60 cm
Private collection

PAGE 123:
Nude on a Blue Cushion by a Fireplace, 1925
Nu au coussin bleu à côté d'une cheminée
Lithograph, 63.6 x 47.8 cm
Bibliothèque Nationale, Paris

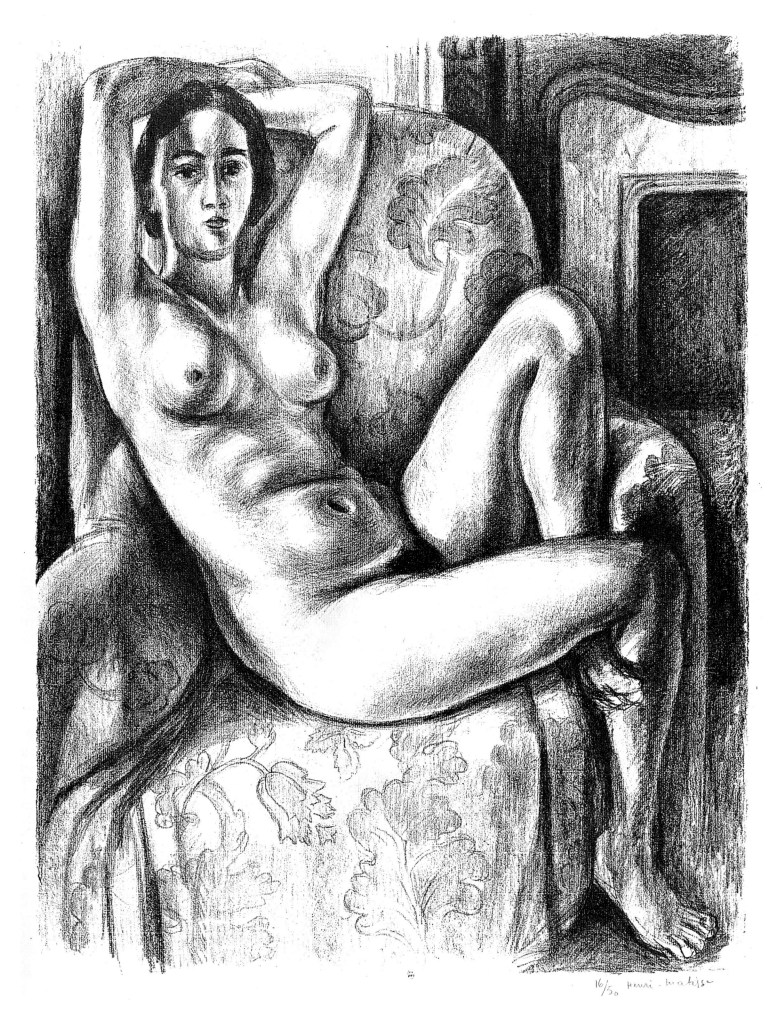

16/50 Henri-Matisse

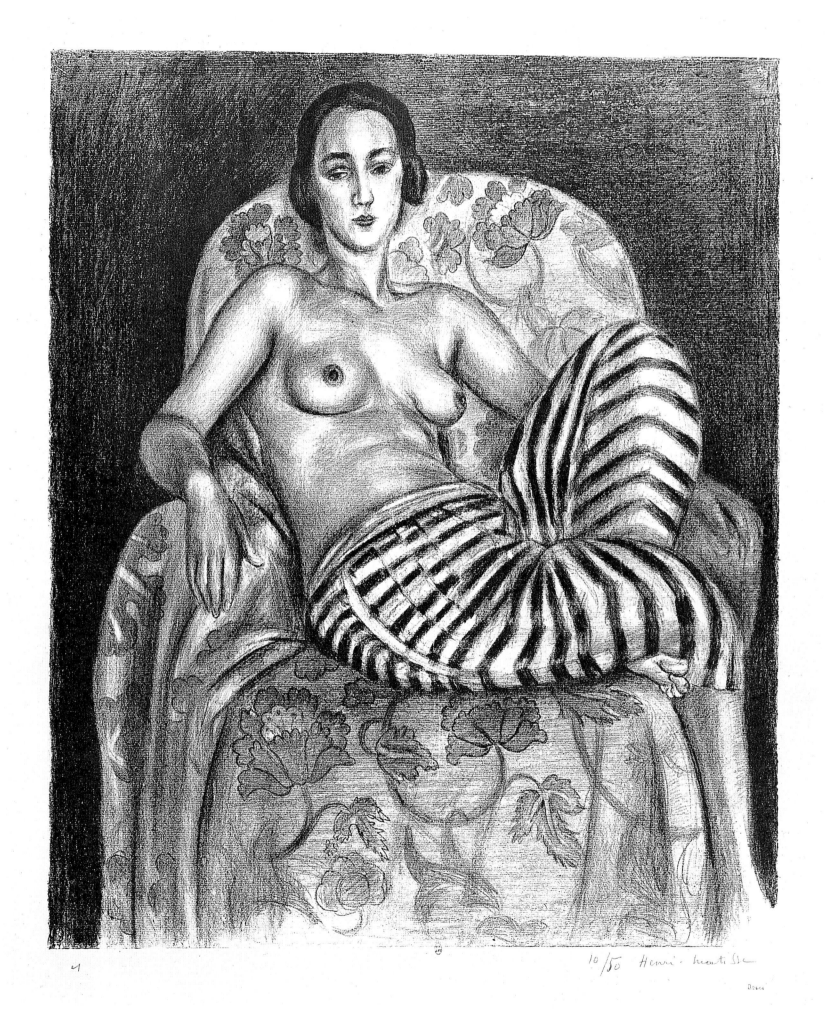

10/50 Henri-Matisse

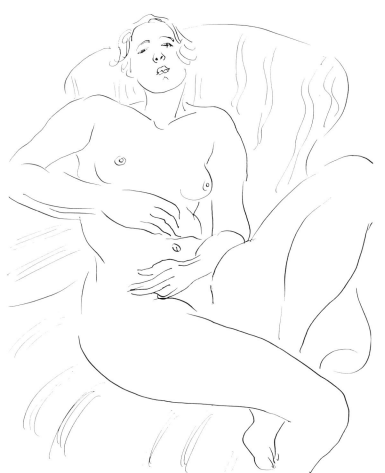

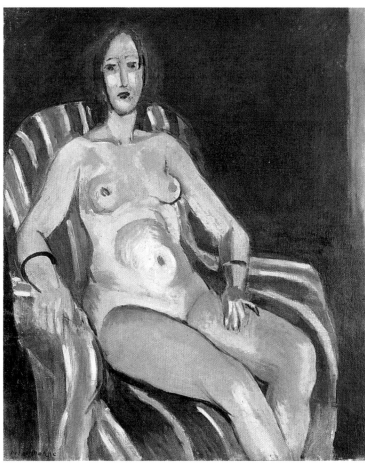

The closer Matisse appeared to be moving towards realism the further away he seemed to be from it. Everything is "artificial" in this reconstructed, transposed graphic realism, which is even more clearly removed from the figurative than his paintings of the same years, which used a very complex yet remarkably well-balanced system of equivalents. Thus from the light, that light in which Nice is bathed and which he generously introduces through the shutters in such paintings as *Young Girl in a Green Dress* (p. 108), is transmuted into a drawing which at first sight appears to be paradoxical in the elaborate tracery of the greenery, in the charcoal stumpwork of mottled grey and black. "Making" light out of darkness is the sort of magic which is performed by alchemists. People were hanged for less in the Middle Ages. "The various lights which I have tasted have made me more demanding in imagining the spiritual light of which I speak, born from all the light which I have ever absorbed," explained Matisse, and he added: "It was not until I had revelled in sunlight for a long time that I tried to express myself through the light of the mind… A cosmic space in which one can feel the walls as little as does a fish in the sea." The term "realism" can be used in connection with such masterpieces as van Eyck's *Adam and Eve*, Cranach's naked, hatted Venuses or the models of Pisanello, Signorelli or Dürer in their elaborate costumes; similarly, there are the still lifes with books produced by the Master of the Annunciation of Aix, Chardin's kitchen tables, Ingres' *Monsieur Bertin* or Matisse's *Odalisques*. One always ends up with a hotch-potch of half-baked ideas. All this goes to show that realism, like everything else, is a matter of great individuality which no code of conduct can attenuate or crush. Baudelaire himself, seeking the typical painter of "modern life", believed at one time that he had found it in Manet's "realism", then, realising his mistake, he had to make do with that of the mediocre Constantin Guys.

The art of giants belongs only to themselves. One cannot grasp the intimate

Nude in an Armchair, 1925–1927
Nu dans un fauteuil
Ink, 34 x 26.8 cm
Private collection

Seated Nude on a Red Background, 1925
Nu assis sur fond rouge
Oil on canvas, 74 x 61 cm
Musée National d'Art Moderne, Centre Georges Pompidou, Paris

PAGE 124:
Large Odalisque in Striped Trousers, 1925
Grande odalisque à la culotte bayadère
Lithograph, 54.5 x 44 cm
Bibliothèque Nationale, Paris

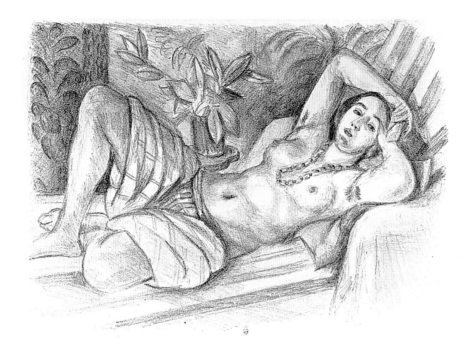

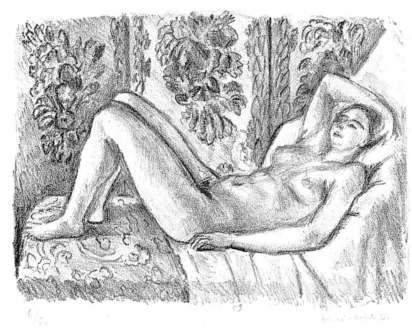

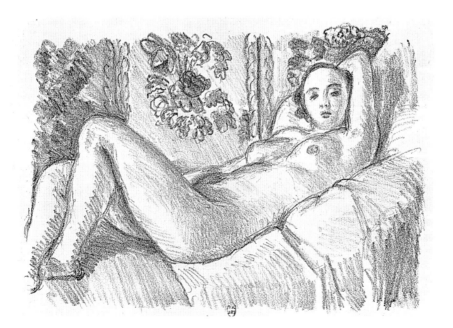

Odalisque with Magnolia, 1923
Odalisque au magnolia
Lithograph, 30 x 40.2 cm
Bibliothèque Nationale, Paris

Reclining Nude with Louis XIV Screen, 1923
Nu couché au paravent Louis XIV
Lithograph, 14.1 x 19 cm
Bibliothèque Nationale, Paris

Petite Aurore, 1923
Lithograph, 13 x 20.1 cm
Bibliothèque Nationale, Paris

PAGE 127:
Nude on a Chaise-Longue against Pierced Screen, 1922
Nu sur chaise de repos sur fond moucharabieh
Lithograph, 49.2 x 40 cm
Bibliothèque Nationale, Paris

PAGES 128–129:
Seated Woman, 1922
Femme assise
Charcoal and stumpwork, 60.3 x 46.6 cm
Baltimore Museum of Art, Baltimore (MD)

Nude Sitting in an Armchair, 1922
Nu assis dans un fauteuil
Charcoal, 63 x 47.8 cm
Musée Matisse, Cateau-Cambrésis

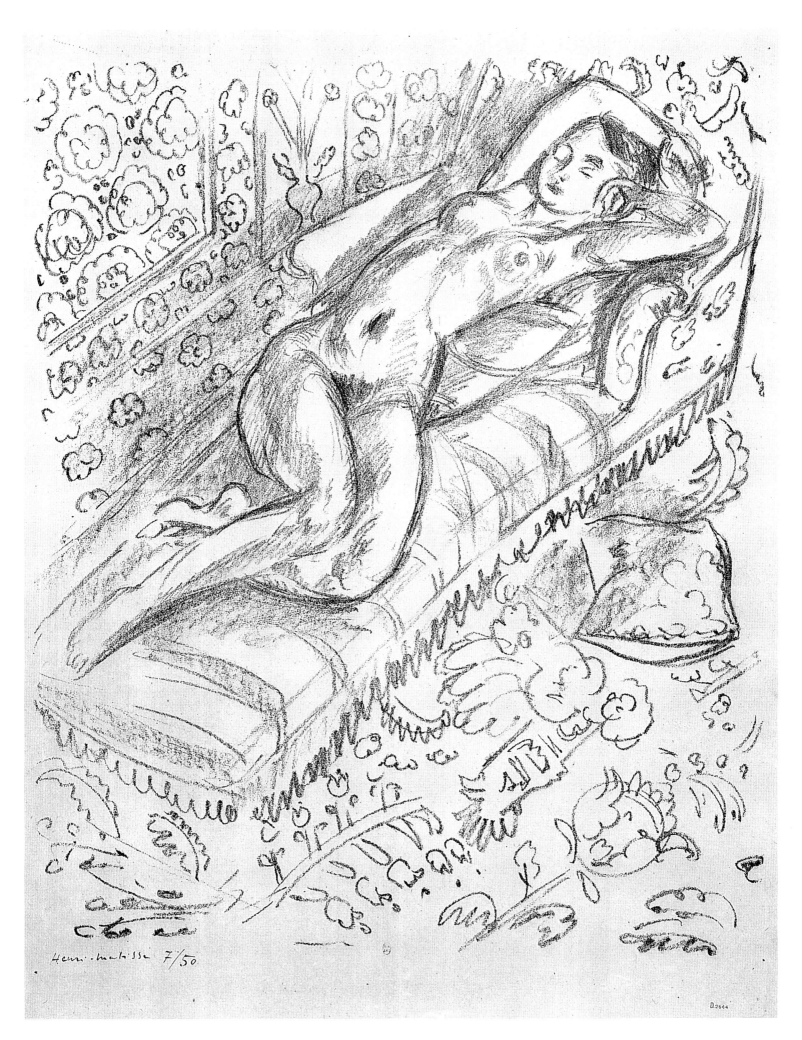

Henri-Matisse 7/50

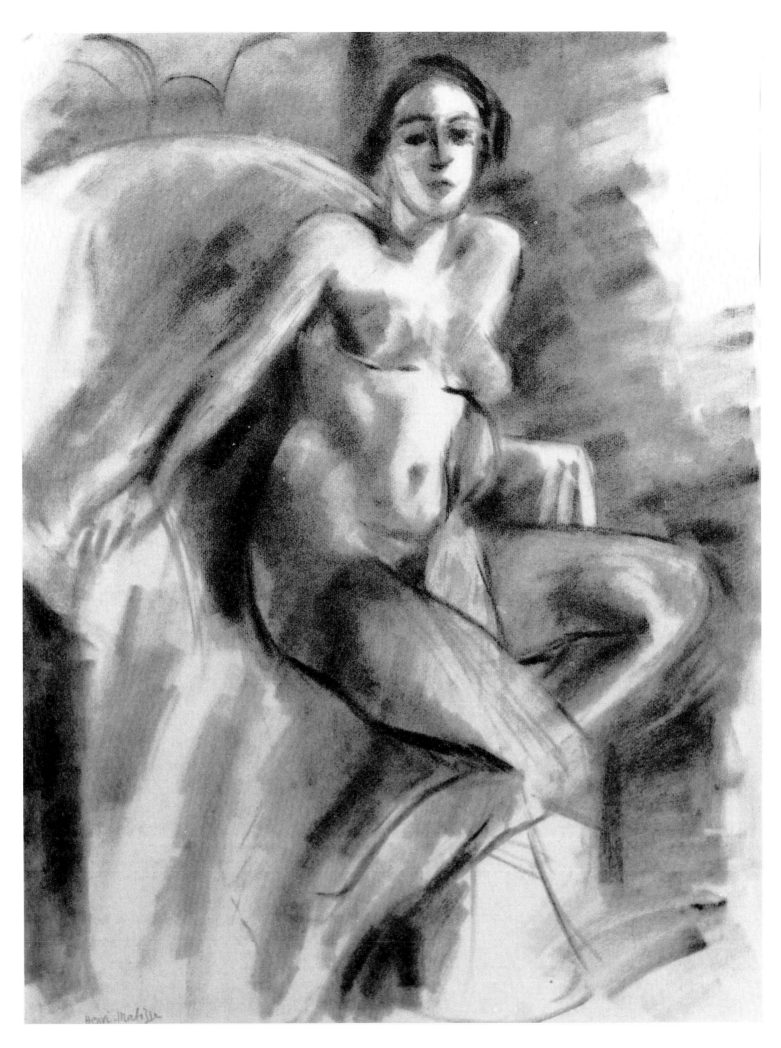

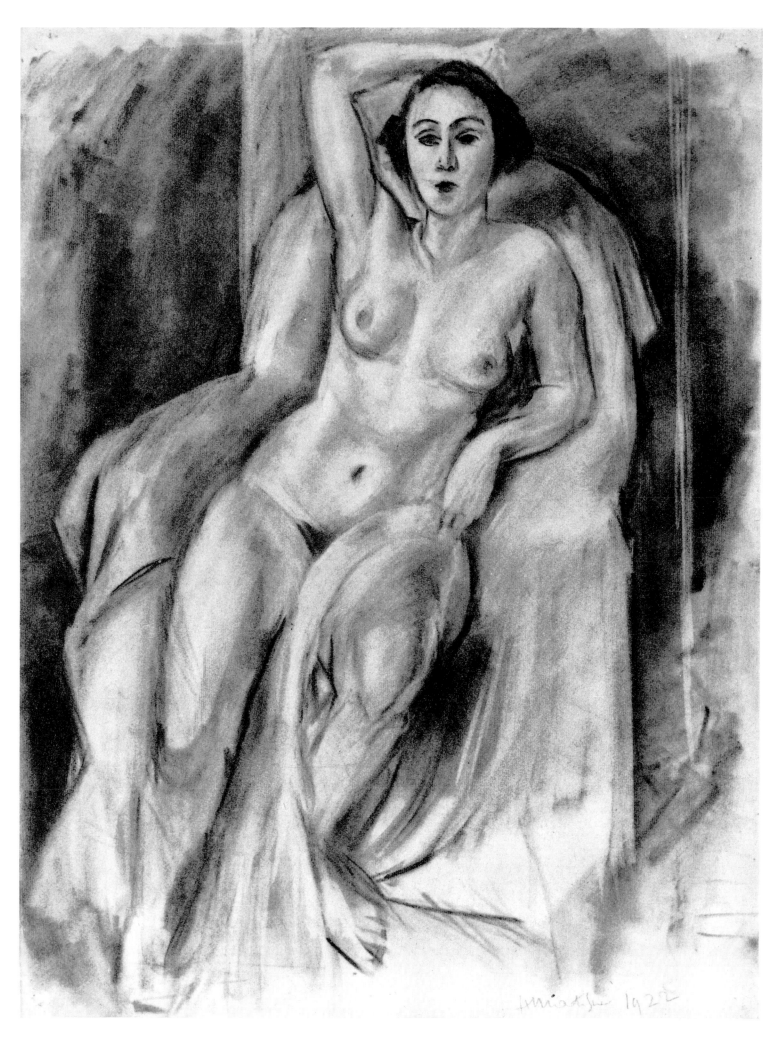

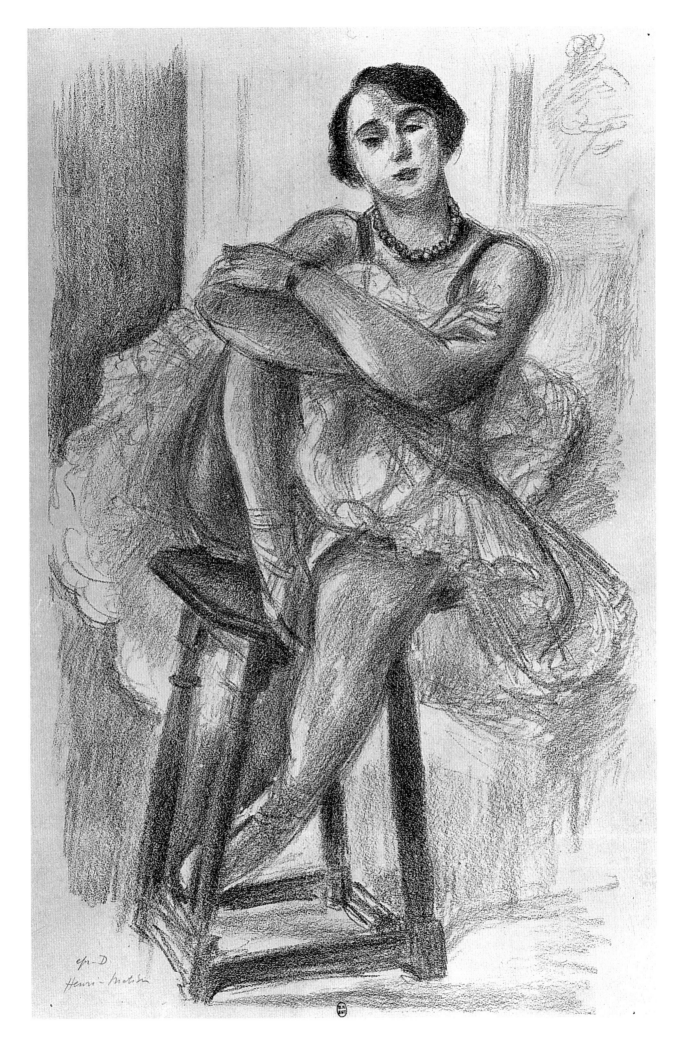

PAGE 130:
Dancer from the Series "Ten Dancers", 1925–1926
Danseuse de la série "Dix danseuses"
Lithograph, 45.7 x 28 cm
Bibliothèque Nationale, Paris

Ballet Dancer, 1927
Danseuse classique
Oil on canvas, 81 x 61 cm
Baltimore Museum of Art, Baltimore (MD)

Dancer Resting, Head Cut Off, 1927
Danseuse cambrée au visage coupé
Lithograph, 45 x 25.5 cm
Victoria and Albert Museum, London

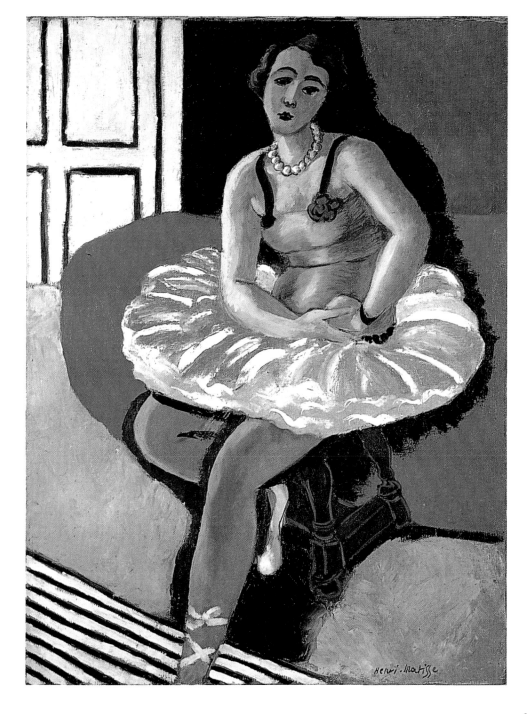

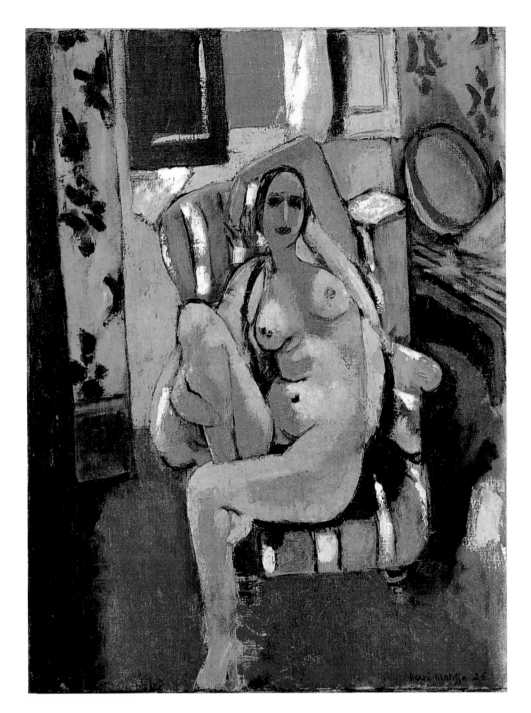

Odalisque with a Tambourine, 1925–1926
Odalisque au tambourin
Oil on canvas, 74.3 x 55.7 cm
The Museum of Modern Art, New York

immensity of Matisse. An American painter of the 1930s, Milton Avery, thought that he could learn from Matisse by placing his figures against flat areas of pure colour without any need other than that of plasticity. He was confusing academicism with simplification of the painting. Similarly, André Lhote confused Cubism and Geometrism without realising that Cubism contains an inherent questioning of the whole system of painting originally created during the Renaissance.

There has been a frequent tendency, *à propos* the inter-war period, only to think of avant-garde art: Bauhaus in Germany, De Stijl in Holland, Futurism in Italy, Constructivism and Suprematism in Russia, Purism in France. This is to forget rather too quickly that the era witnessed the emergence all over the world of a feverish nationalism, which was manifested in official terms by the production of works of monumental realism in the service of the state. Surrealism or Abstract Art, for example, began to be considered as games played by misguided, even traitorous, intellectuals, those who would later be called Deviationists. These were the theories which Messrs. Stalin and Hitler would espouse, the former by ordering that culture must be "proletarian in content, national in form" (Stalin), the

Matisse's flat in Nice in spring 1926 with the sculpture *Large Seated Nude* in the foreground in its earliest stage and behind it *Odalisque with a Tambourine*.

PAGE 133:
Persian with a Cross, 1929
Persane à la croix
Oil on canvas, 73 x 60 cm
Private collection

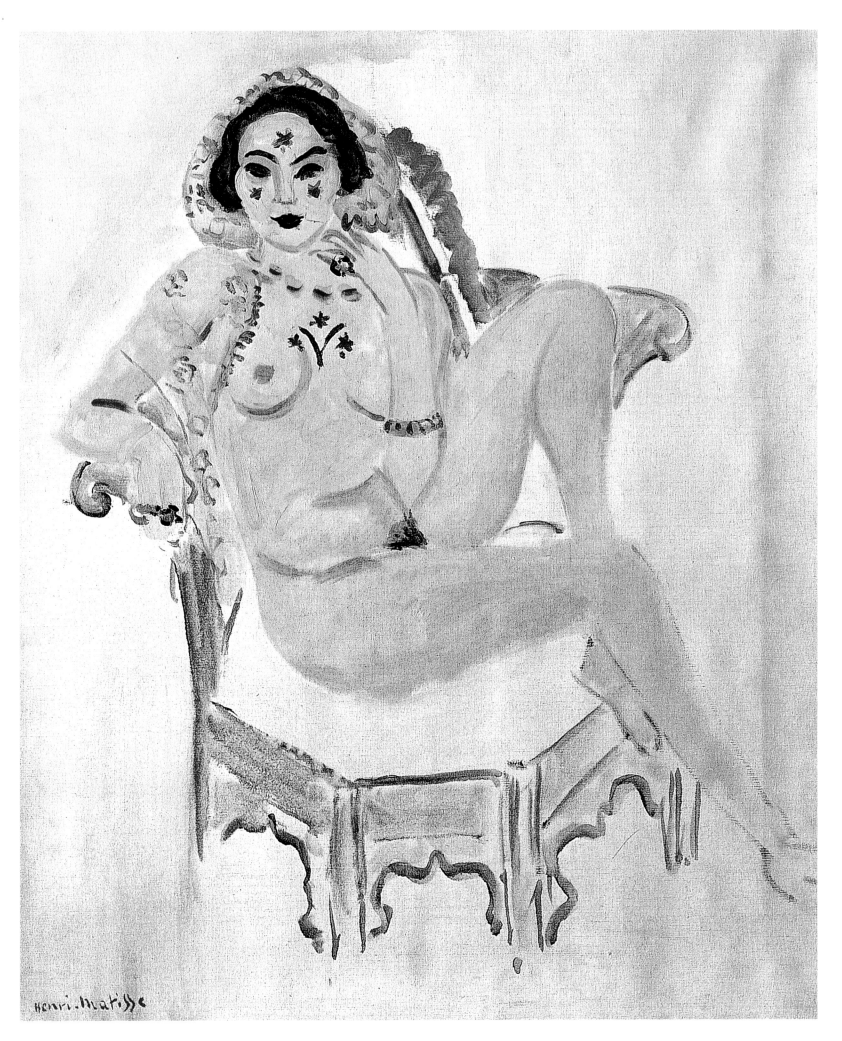

Henri Matisse

PAGE 134:
The Persian Woman, 1929
La persane
Lithograph, 44.8 x 29 cm
Baltimore Museum of Art, Baltimore (MD)

Young Hindu, 1929
Jeune hindoue
Lithograph, 28.5 x 35.8 cm
Bibliothèque Nationale, Paris

Repos sur la Banquette, 1929
Lithograph, 44.5 x 55.5 cm
Bibliothèque Nationale, Paris

Reclining Nude, Backview, 1927
Nu couché de dos
Oil on canvas, 66 x 92 cm
Private collection

latter echoing the former, but in the even more menacing phrase: "There are still painters who see things differently from the way they are" (Hitler).

In the United States there were the Precisionists (forerunners of the Hyper-realists), in Mexico, fresco painters such as Orozco or Rivera. France was not the last country to fall in with the official line. André Derain led the way, assuming as his own the phrase attributed to Jean Cocteau, although in fact it was Lhote and Bissière who invented it, the famous "recall to order" which in retrospect makes one shudder and which sent everyone off to the "museum school", to the Louvre, where Gustave Courbet's *The Painter's Studio*, had just been installed with great ceremony. Jean Laude perfectly summarised this universal trend: "After 1919, a discourse began to emerge and spread throughout Europe (as will be seen, 'the United States' should be added here). It is designed to put an end to the vagaries of the past against which one must be on one's guard. Just as in literature and in music, national cultural values are being rehabilitated, the taste for a job well done, the greatness of skill and tradition. This discourse is showing the way, using as its examples the works of the recent past and favouring the production of other work. It enables them to be seen in a particular way – and from this it draws its legitimacy… Furthermore if through the Neo-Realism movements of France and Germany, the Valori Plastici and Novecento in Italy, institutional Cubism is itself challenged, this is not to skirt around the problem it poses but to return to a system of traditional figurative work, coupled with the technical aspirations to craftsmanship, to retie the knot, beyond Cézanne, with perspective and humanism."

It is not such a giant step from this to the "recovery" of a Picasso then entering his neo-Greek phase when he made gigantic drawings using a single pen stroke, as precise as those of Ingres or Raphael; or a Matisse, now permanently living in Nice, who had "settled down" and at least until 1930, remained the hedonistic painter of *Windows* and *Odalisques*. The period was ushered in by the philosopher Alain, who in 1920, in his *Système des Beaux-Arts* (*A System of Fine Art*) wrote this peremptory phrase which sounds even more absurd now than it did then: "Society needs to be supported by its trappings, just as women need support from their corsets."

The relationship between tradition and invention is constant in Matisse's work. He did not wait for a "return to order" to constantly raise the issue from painting to painting and neither the influence of Courbet – whom he admired and collected – nor the friendship of the aging Renoir, his neighbour at Les Collettes whom he used to visit, nor the general spirit of the age, are adequate to explain this period which is still considered as a step backwards following a great leap forwards. All he needed to have said, like Courbet, although he was too well-bred to do so, was: "I am a Courbettiste, or rather a Mattissian, that's all."

Odalisque with Grey Culottes, 1927
Odalisque à la culotte grise
Oil on canvas, 54 x 65 cm
Musée de l'Orangerie, Paris

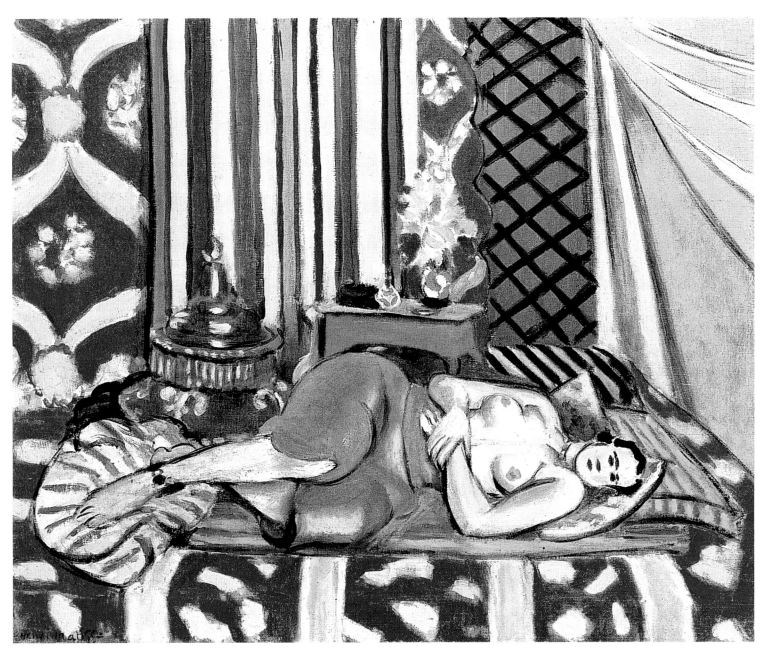

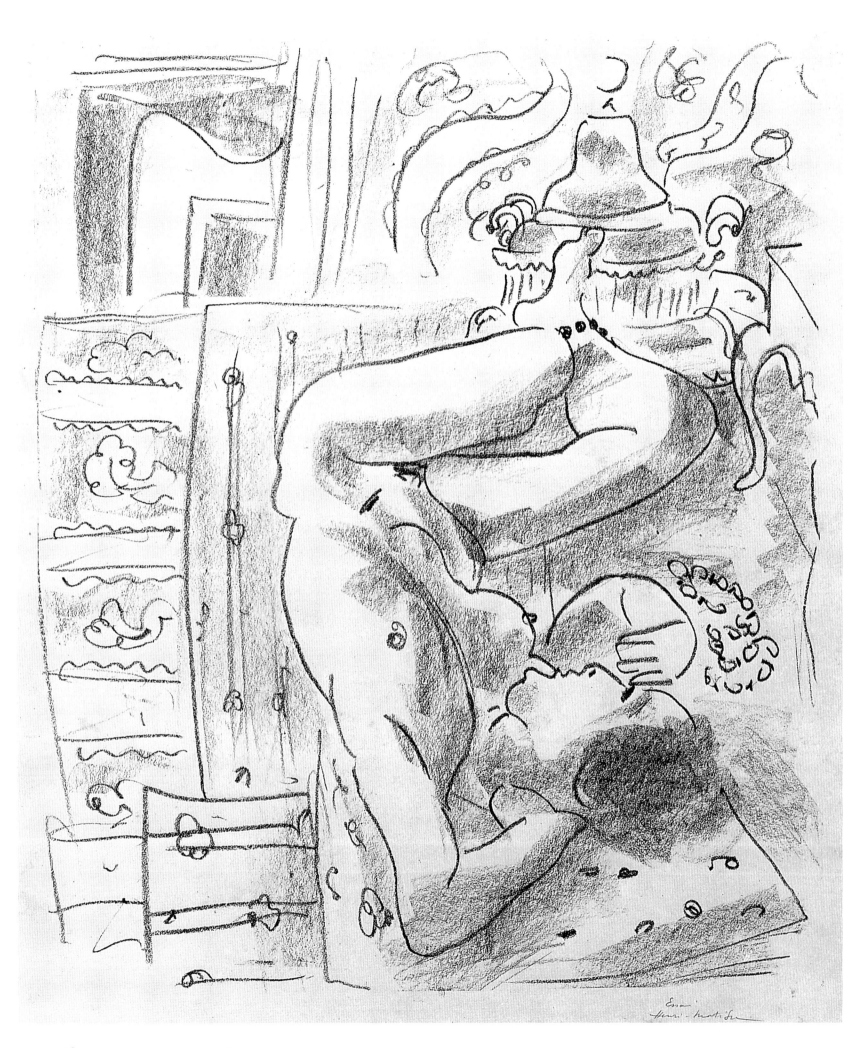

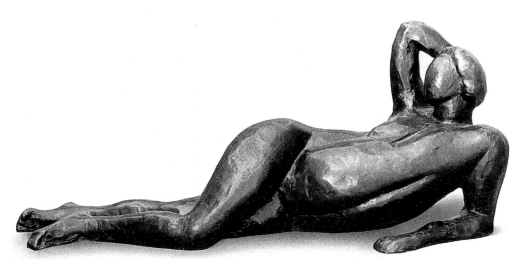

Reclining Nude III, 1929
Nu couché
Bronze, length: 46.5 cm

PAGE 138:
Nude from the Rear with Brazier, 1929
Nu renversé au brasero
Lithograph, 55.7 x 46 cm
Bibliothèque Nationale, Paris

Reclining Nude, Backview, 1929
Nu couché de dos
Lithograph, 46 x 56 cm
Victoria and Albert Museum, London

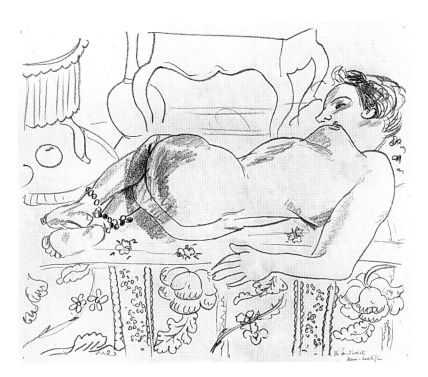

Nude Reclining on Flowered Ground, 1929
Nu couché sur sol fleuri
Lithograph, 46 x 56 cm
Bibliothèque Nationale, Paris

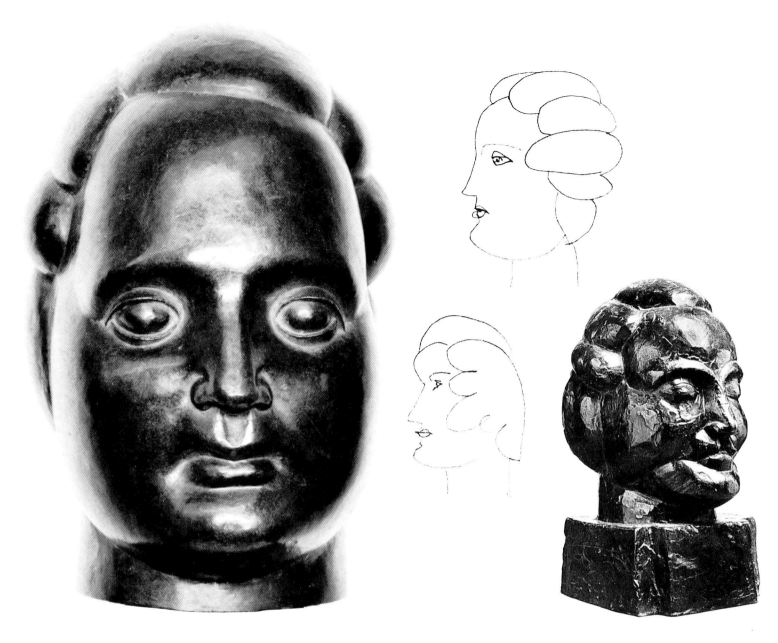

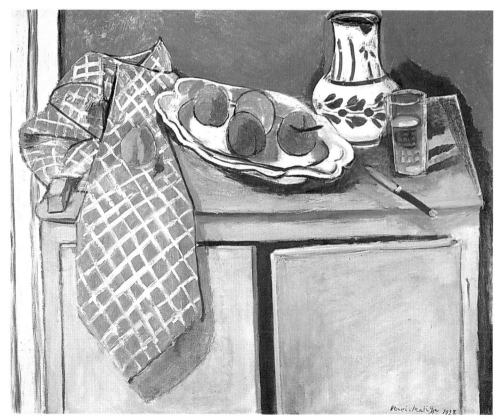

Henriette II, 1927
Bronze, height: 37.5 cm

Designs for "Henriette", c. 1928
Pencil, 23.3 x 21 cm
Private collection

Henriette III, 1929
Bronze, height: 40 cm

Still Life on a Green Sideboard, 1928
Nature morte au buffet vert
Oil on canvas, 81.5 x 100 cm
Musée National d'Art Moderne, Centre Georges
Pompidou, Paris

PAGE 141:
Woman with a Veil, 1927
La femme à la voilette
Oil on canvas, 61 x 50 cm
Private collection

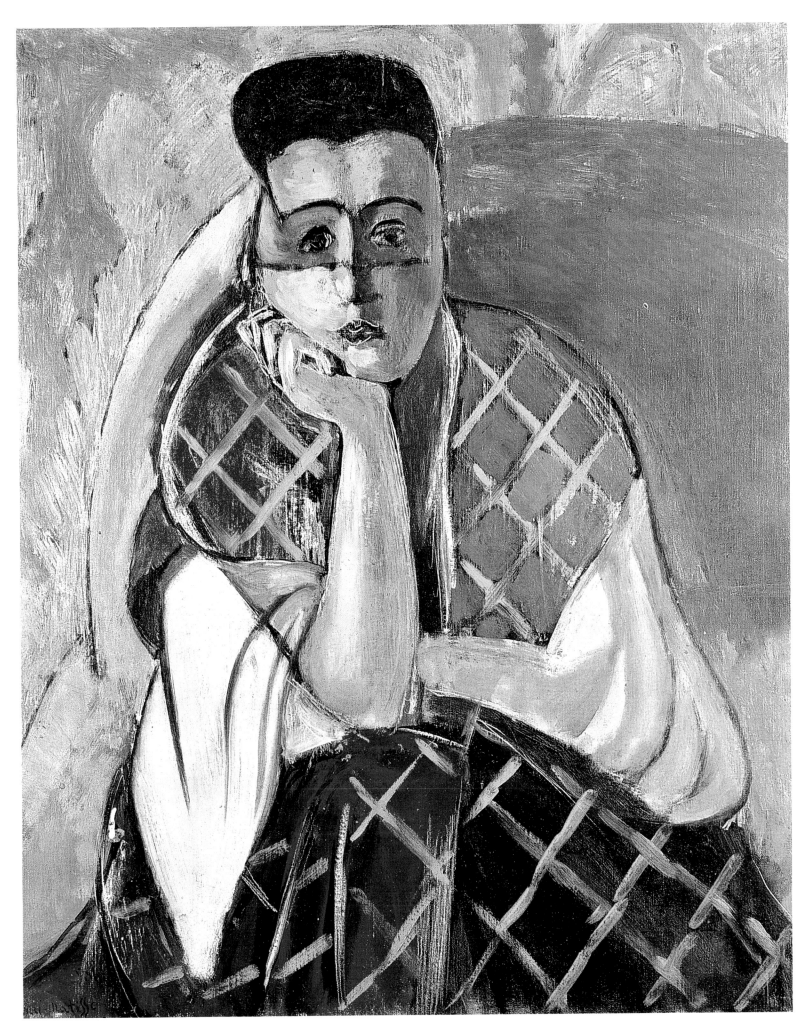

The Monumental Architecture of *The Dance*

Famous, showered with honours and now financially secure, Matisse began travelling. In 1927, he won the most prestigious of international prizes, the Carnegie Prize, which was awarded the following year to Picasso, when Matisse was on the jury. Matisse was invited to Pittsburgh to receive the prize, but before going he decided to take a trip to the Pacific, in the wake of Gauguin, via New York and San Francisco. He spent a three happy months in Tahiti, although he was very slightly disappointed at the negative aspect which Westerners so often retain of their encounter with this dreamlike world. Matisse brought a great deal with him, especially memories of the work he had done. He would tell Tériade that his travels had made it possible for him to consider the work he had done and to find solutions to current problems, through this disorientation. "This proves that my work is the split personality of the life of my brain. It may also be the *idée fixe* of an old fool who travels around the world only to come home to look for the tobacco pouch which he had mislaid before he left."

Having worked for forty years in "European light and space", Matisse dreamed of other proportions which might perhaps be found in "the other hemisphere". "I have always been conscious of another space in which the objects of my reverie were forming. I was looking for something other than real space. Hence my curiosity for the other hemisphere, where things might happen differently." Unfortunately, according to Matisse, this "something else" was not to be found in the South Pacific, or rather, as was his custom, not until it had passed through his "filtering". "That is why," he said, yet again paradoxically, "when I was in Tahiti, I drew back to seek views of Provence and contrast them bluntly with those of the landscape of the South Pacific."

It may well be partly for the same reasons that Gauguin painted a snowy Breton landscape shortly before his death under the sun of the Marquesas Islands. "Most painters," commented Matisse, "need direct contact with objects in order to feel that they exist and they can only reproduce them under their strictly physical conditions. They seek an external light to see clearly within themselves. Yet the artist or the poet has an internal life which transforms projects to create a new, tangible, organised model, a living world which is itself the infallible sign of divinity, a reflection of divinity."

The occasion was to offer him the opportunity of finding, or rather constructing, what he was looking for but what the South Pacific had been unable to provide. After his arrival in Pittsburgh, he went to visit the principal American collections some of which already contained works of his, especially those of Cone and Dr. Barnes. The latter commissioned him to create a huge mural in the mansion he had built to house his art collection. The site was fifty-two square metres in size. It was high above the French windows and thus in poor light, and was split into two semi-circles separated by the projecting drop of an overhang supported by a row of pillars. Yet the location was a prestigious one since it made it possible to

Dancer, 1931–1932
Danseuse
Lithograph over red pencil, 43 x 32 cm
Bibliothèque Nationale, Paris

Barnes Collection Version of "The Dance", Sketch to the Scale of the Central Figure, 1931
La danse Barnes, esquisse à l'échelle de la figure centrale
Paintbrush and ink on chalk-coated paper, 335 x 198 cm
Musée Matisse, Nice

PAGE 142:
Unfinished Version of "The Dance" (right-hand panel), 1931
La danse inachevée (panneau de droite)
Oil on canvas, charcoal, 344 x 398 cm
Musée d'Art Moderne de la Ville de Paris

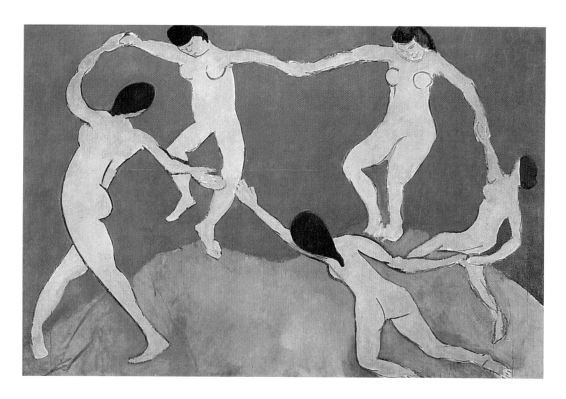

create a peculiar pediment worthy of the works of art which Barnes had accumulated below, without "overwhelming" them. The works in question included Seurat's *The Models*, the large *Card Players* and *Madame Cézanne in a Green Hat* by Cézanne, *The Family* by Renoir and *Seated Riffian* by Matisse himself. Matisse explained to Dorothy Dudley: "My aim was to translate painting into architecture to make a fresco the equivalent of cement or stone. I do not think this is very often attempted nowadays. People who paint on walls now create paintings and not true murals." "But what about Puvis de Chavannes?" she asked. "Yes, he comes close to it but he never reaches perfection in this sense. The walls of the Pantheon, for example, are made of stone. The paintings of Puvis are too sweetly sentimental to render the equivalent of that material. If one had a diamond, one would set it in metal, not in rubber." "So has your painting really corrected architecture?" Matisse admitted that he considered this to have been an imperative; if the proportions had been different he would not have developed the particular theme and would have done something else on the surfaces. "Now, one would be happy to call this place a cathedral," proudly proclaimed Barnes as he viewed the result.

"This dance," confided Matisse to Gaston Diehl, "is something I have long had inside me and I had already put it in *La Joie de Vivre* (p. 145), and subsequenty in my first large composition (the version created for Shchukin, pp. 58–59). However, this time, when I wanted to do sketches on three one-metre canvases I was unable to do so. Finally, I took three five-metre canvases, which were the actual size of the wall, and one day, armed with a piece of charcoal attached to a length of bamboo, I began to draw the whole thing in one go. It was inside me, like a rhythm that carried me along. I had the surface in my head. But once the drawing was finished, when I started to apply colour, I had to change all the shapes I had planned. I had to fill in all this area in such a way that the whole would remain architectural. Furthermore, I had to work closely with the masonry so that the lines would withstand the massive projecting blocks of the springing of the arches; they even had to project beyond them and have enough impetus to link up with each other. Having all this to contend with when composing it, the attempt to create a living, singing composition could only be the result of trial and error, a constant variation on the colour sections and the blacks."

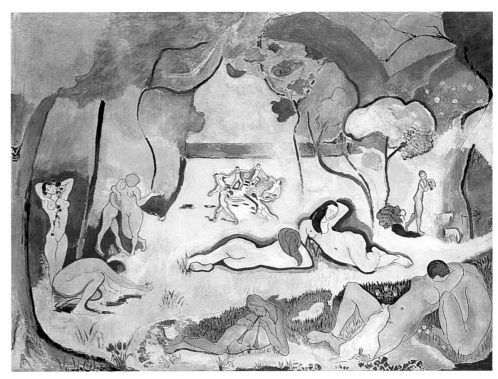

Matisse drawing the *Unfinished "Dance"*, 1931

TOP RIGHT:
La Joie de Vivre, 1905–1906
Oil on canvas, 174 x 238 cm
The Barnes Foundation, Merion (PA)

The first attempt was a failure. Started in April 1931, this *Unfinished Dance* (pp. 142 and 146) was abandoned at the beginning of the following autumn. By trying too hard to make "the fresco the equal of the cement and stone" Matisse may have pushed the combination too far, hesitated too much between the medium and the design, mastering the contours and the carnal nature of the figures conferring upon them through their colour the mineral quality of stone. In short, he was trying to turn these dancers into hybrids, somewhere midway between the organic and the inorganic or, to quote Baudelaire (whose work Matisse would later illustrate) to make "living pillars". Matisse had once told Aragon that "Renaissance art is decadence – because anatomy, so dear to Michelangelo when hollowing out and hammering the human body, spoils the plane of the painted surface." Nevertheless, Matisse fell into the very trap he wanted to avoid. First of all, as the eulogist of colour he found the grey "pillar" he had created unattractive and to make it worse, it was not even uniform. Using a play of various pale shades, Matisse added some anatomical features to abstract silhouettes – the play of bones and muscles, the tendons with the shadows he gave them – which was contrary to what he was trying to achieve. Begun without enthusiasm, the *Unfinished Dance* perished in the sad realisation of failure. "The reality of the space took precedence over the Apollonian dream."

Matisse went back to work, deeply fatigued, though not discouraged. This time he to tried to "freeze life and bring the pillars to life". "The eternal question of the objective and the subjective", which Matisse never failed to ask himself, confronted him here in the form that tradition in architecture renders as a cruel conflict. However, Giotto's example encouraged him. "When I see Giotto's frescoes in Padua," he noted as early as 1908, "I am worried about which scene in the life of Christ I am witnessing, but then I understand the feeling which emanates from it because it is in the lines, in the composition, in the colour…" A new version of *The Dance* was started and this time it was completed and proved to be a success just as the previous one had proved to be a failure. The human element was attenuated in favour of its translation into architectural terms; the nymphs dance less but the composition dances more. When installed, the canvas could be detached from the painter to become "part of the building".

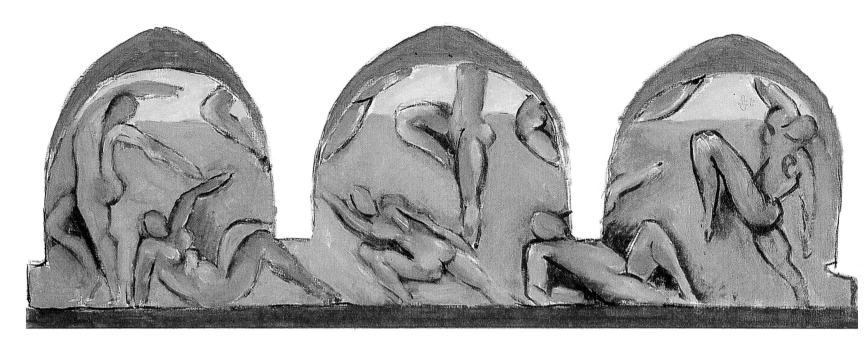

To solve the problem, Matisse conceived the really novel idea of using col-
oured paper cut-outs which could be moved around and substituted at will until
the best position could be found for them. The *Acrobats* in *Jazz* (p. 156) are the
direct descendants not only of the forms thus created but also of the technique
itself which was to raise his unusual individual style to new heights. Unfortu-
nately, a disappointment regarding the size awaited Matisse on his arrival at
Merion in 1932; a mistake had crept into the measurements which had been
supplied to him. Thanks to this mistake, the true original version of *The Dance*
can be viewed in the Musée d'Art Moderne de la Ville de Paris (pp. 150–151). One
year later, a second version was ready (p. 147): "Thus, for three years," commented
the painter, "I had to constantly redesign my work like a film director. When I
work it is really a sort of perpetual cinema. But there I was also bound by the
architecture which was in control."

Matisse insisted that there was a difference between the two completed ver-
sions of the mural commissioned by Dr. Barnes. In 1934, he explained in a letter
to the critic of Russian art, Alexandre Romm: "The second (version) is not a
simple replica of the first, because due to the different pendentives, and the need
for a composition which took account of architectural masses which were twice
as bulky [as he had originally been led to believe], I had to change my design. I
even worked with different feelings. The first (*The Dance* which is now in Paris)
is warlike, the second (*The Dance* which is now in Merion) is Dionysian. The
colours which are the same have, nevertheless, changed. The quantities being

Study for the Paris Version of "The Dance"
(The Dance I), Ochre Harmony, 1930–1931
Etude pour "La danse de Paris" (La danse I),
harmonie ocre
Oil on canvas, 33 x 87 cm
Musée Matisse, Nice

The Unfinished "Dance", 1931
La danse inachevée
Oil on canvas, charcoal, 3 panels: left, 344 x 402 cm;
central, 358.2 x 499 cm; right, 344 x 398 cm.
Musée d'Art Moderne de la Ville de Paris

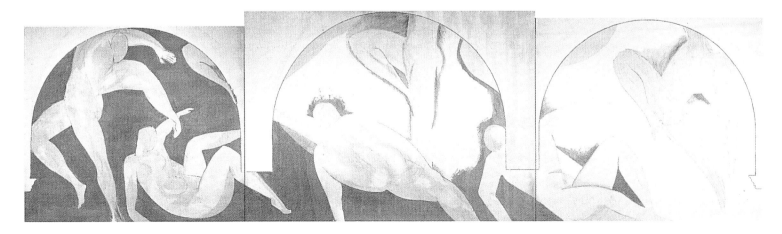

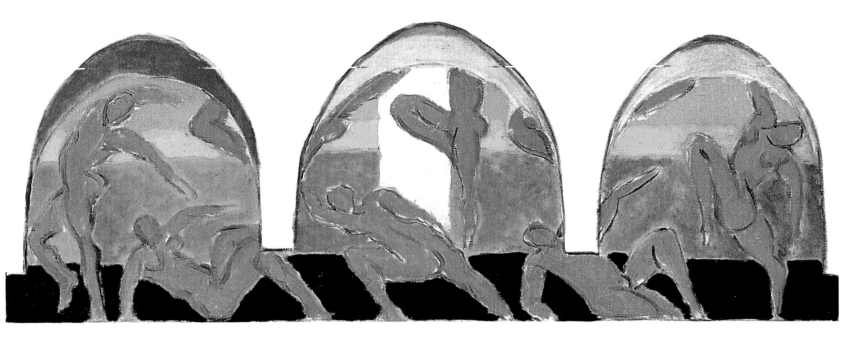

Study for the Paris Version of "The Dance"
(The Dance I), Blue Harmony, 1930–1931
Etude pour "La danse de Paris" (La danse I),
harmonie bleue
Oil on canvas, 33 x 88 cm
Musée Matisse, Nice

different, their quality changes as well; the colours used quite plainly obtain their quality from their relationship to quantity." He ended with a credo which he applied to Manet and which he would often repeat in later years: "A great painter is one who finds personal and lasting signs to explain the spirit of his vision in plastic terms."

The Dance is one of those crucial achievements in Matisse's work from which a whole series of oil paintings and gouaches would later result of which the most notable are *The Dream* (p. 167) and *Seated Pink Nude* (p. 173) in which the arrangement is as bold as it is majestic and seems to burst out of the frame. All of them reveal a distortion in the modelling within a very careful compositional context reminiscent of the original model. The human element is alleviated, tempered or even removed. "If one excludes all the richness of spirit which Raphael and Michelangelo expended in their murals, did they not render their walls heavy by the expression of this human element which always separates us from the whole, especially in *The Last Judgement?*" asked Matisse. He said to Georges Charbonnier in 1952: "I need above all to give a feeling of immensity within a limited space. That is why I put in figures which are not always complete. About half of them are outside it... That is what I did at the chapel in Vence..."

Matisse had the Paris version of *The Dance* in his studio when he executed his first gouaches using paper cut-outs. It was the ideal way in which to re-create "a sort of paradise in which I could make frescoes". It was also his original method of reworking his composition at will without having to constantly repaint it. This

The Merion Version of "The Dance", 1932–1933
La danse de Merion
Oil on canvas, 3 panels: left, 339.7 x 441.3 cm;
central, 355.9 x 503.2 cm; right, 338.8 x 439.4 cm
The Barnes Foundation, Merion (PA)

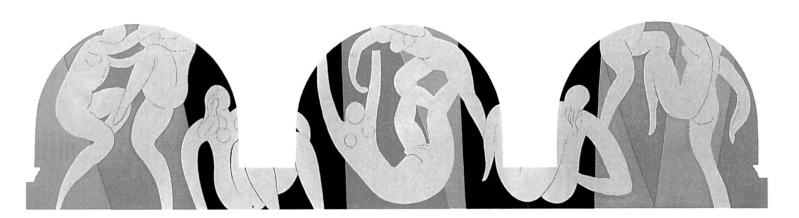

Dancer, 1931–1933
Danseuse
Pastel, 32.2 x 25.7 cm
Musée National d'Art Moderne, Centre Georges
Pompidou, Paris

Auguste Rodin: *Dance Movement*, 1911
Pastel, 31.2 x 20 cm
Musée Rodin, Paris

Auguste Rodin: *Nude Woman Doing a Headstand*,
c. 1900
Graphite and gouache, 32.6 x 22.7 cm
Musée Rodin, Paris

Pablo Picasso: *The Acrobat*, 1930
Oil on canvas, 162 x 130 cm
Musée Picasso, Paris

PAGE 148:
Acrobatic Dancer, 1931–1932
Danseuse acrobate
Lithograph, 38 x 29.7 cm
Bibliothèque Nationale, Paris

is how he created the scenery and costumes for the ballets of Léonide Massine (pp. 152 and 154) or the covers of magazines such as issue No. 1 of *Verve*. What started out as an assemblage of little pieces of paper cut-out and glued, used like the touches of colour applied to a painting with a paintbrush, which would soon become a means of expression in its own right, serving to create a figurative iconography on a large scale. It would be the cut-out gouaches in *Jazz* and the large compositions for which he would carve boldly simplified forms directly out of large sheets of brightly-coloured paper. In the meantime, the experience acquired in executing the decorative panel for Dr. Barnes was the inspiration for the radical transformation to which Matisse's painting was subject in the 1930s, at a time when he was moving towards a new stage in his quest, towards a new balance between drawing and colour. In the summer of 1935, he wrote to his son Pierre that he was "doing some experiments". He felt, he said, that his recent paintings using vivid colours were the inauguration of a new method of working which would make it possible for him to achieve a better combination between line and colour.

As usual, drawings and sculptures alternated with compositions. All of them reflect this tendency towards the architectural, the monumental which at the time constituted Matisse's principal preoccupation. In Matisse's work, even book illustration is primarily a question of architecture. Like Mondrian's squares or the unity of Le Corbusier, a drawing is created first for an "occupant." He identifies the walls of the reader's bedroom or a room in a museum and its narrow confines directly with an open book. "Are not the fourteen Stations of the Cross in the Chapel of the Rosary in Vence the pages of the largest architectural book which Matisse ever produced?" "'This book has caused numerous architectural difficulties,' said Matisse of *Pasiphaé* as if a book had some direct relationship to a building in spatial terms." (Xavier Girard)

Subsequent illustrations for the poet Stéphane Mallarmé (pp. 158–161), Pierre de Ronsard, Charles d'Orléans, James Joyce, Guilleaume Apollinaire, Baudelaire,

*Study for the Left-hand Panel of the Merion Version of
"The Dance"*, 1932
Pastel, 25.8 x 33.2 cm
Musée Matisse, Nice

*Barnes Collection Version of "The Dance", Study of
Whole Set of Panels*, 1930–1931
La danse Barnes, étude d'ensemble
Pencil, 27.7 x 37.7 cm
Musée Matisse, Nice

BOTTOM:
The Paris Version of "The Dance" (first version),
1931–1932
La danse de Paris (première version)
Etching in colours, 29.7 x 80.7 cm
Musée d'Art Moderne de la Ville de Paris

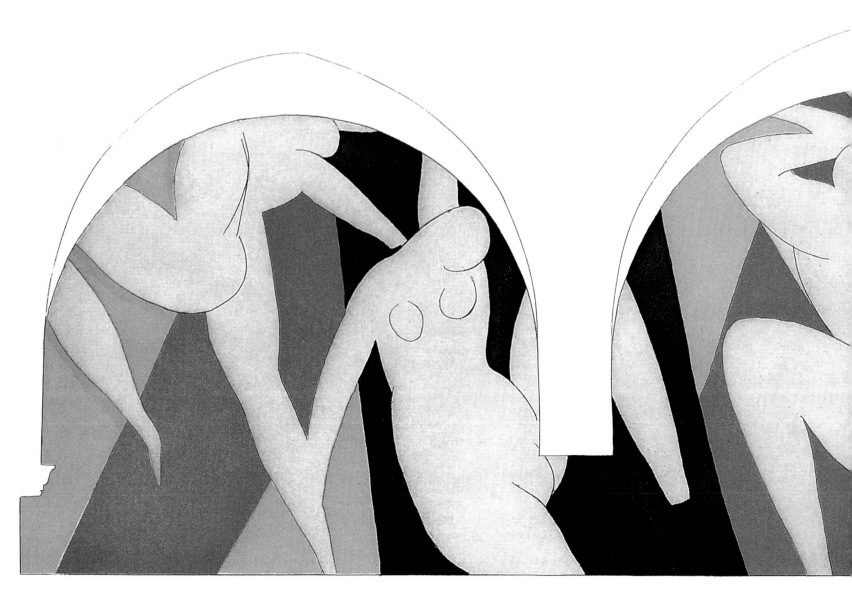

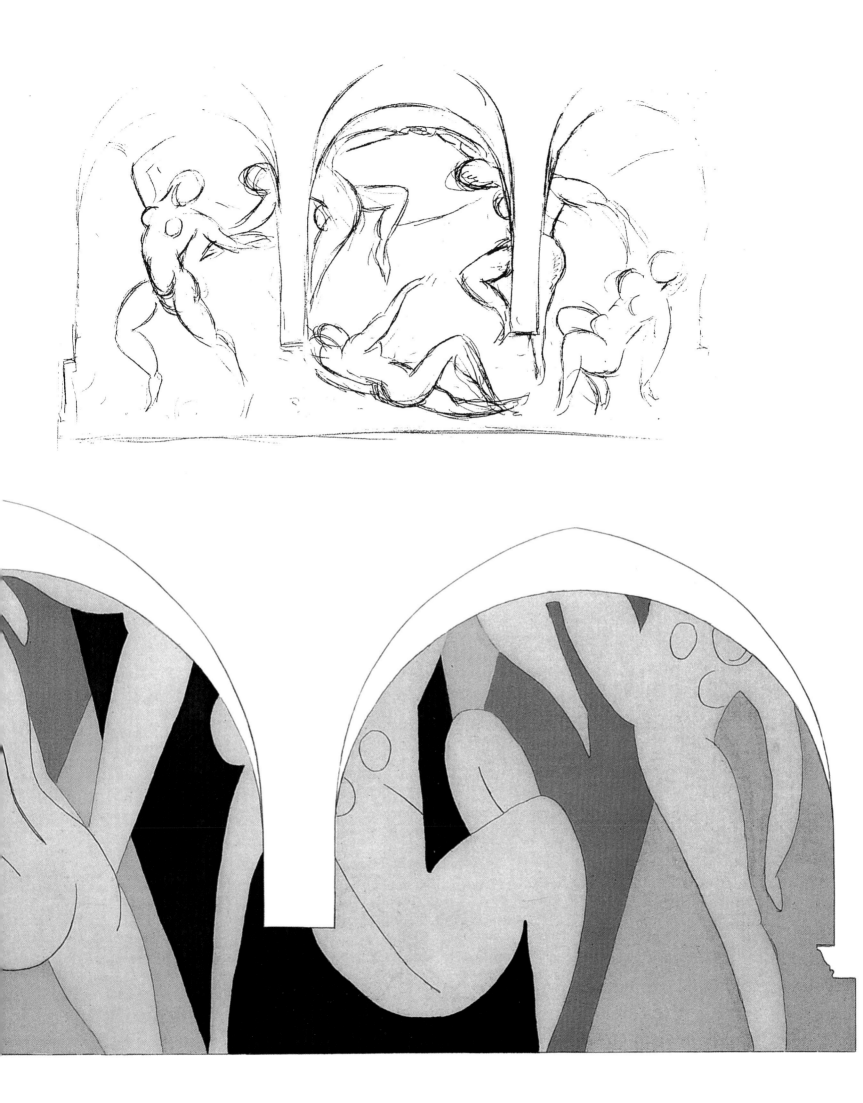

Dancer. Study for the Backdrop of the Ballet "Strange Farandole", 1937
Danseuse
Pastel and gouache cut-out, 58.5 x 69.8 cm
Musée National d'Art Moderne, Centre Georges Pompidou, Paris

The Dance, 1938
La danse
Gouache on paper cut-out, 80 x 65 cm
Musée National d'Art Moderne, Centre Georges Pompidou, Paris

PAGE 153:
Untitled, 1930–1931
Graphite pencil, 28 x 21.6 cm
Musée National d'Art Moderne, Centre Georges Pompidou, Paris

Henry de Montherlant, "architectures on paper", were first and foremost celebration of the splendour of "whites". If it is the blacks which are admired in other artists who produced drawings and engravings, from Redon or Seurat to Rouault or Picasso, in Matisse – perhaps the ultimate simplification? – it is the magical property of white which predominates.

Matisse the engraver is Matisse made whole. The Matisse who said of his work: "Anything that is not useful in a painting is, by virtue of that fact, an irritant." He also said to André Verdet: "The work of art is the emanation, the projection of oneself. My drawings and my canvases are parts of myself. Their whole constitutes Henri Matisse." That is what Aragon would call the Flaubert side. For Matisse, engraving was another sort of drawing, and drawing was always painting. The difference for him between a sculpture and a painting was the way in which he had to "organise" and "order" his feelings, to find a method which would suit him completely. Nor was it by chance that Matisse chose to illustrate those poets who sing, celebrate and revere women and love. This is the "face" which makes it possible for him to best express his feeling "to say everything religious which I possess in life". A swan, a hairstyle, "an acacia at Vesuvius, its movement, its slender grace may have led me to conceive of the body of the dancing woman"

PAGE 155 BOTTOM:
A scene from the ballet "Strange Farandole" was created in Monte Carlo by the Ballets Russes, using the music from Shostakovich's second symphony. The choreography was by Léonide Massine and sets and costumes by Matisse. The subject of the ballet was the eternal internal struggle between the spiritual and the material. Matisse dressed the principal pair of dancers in white, to symbolise the poetic spirit facing the attacks of the black or red characters who symbolised the forces of violence or evil. Man would succeed in dominating them provisionally, but eventually he would suffer his "fate".

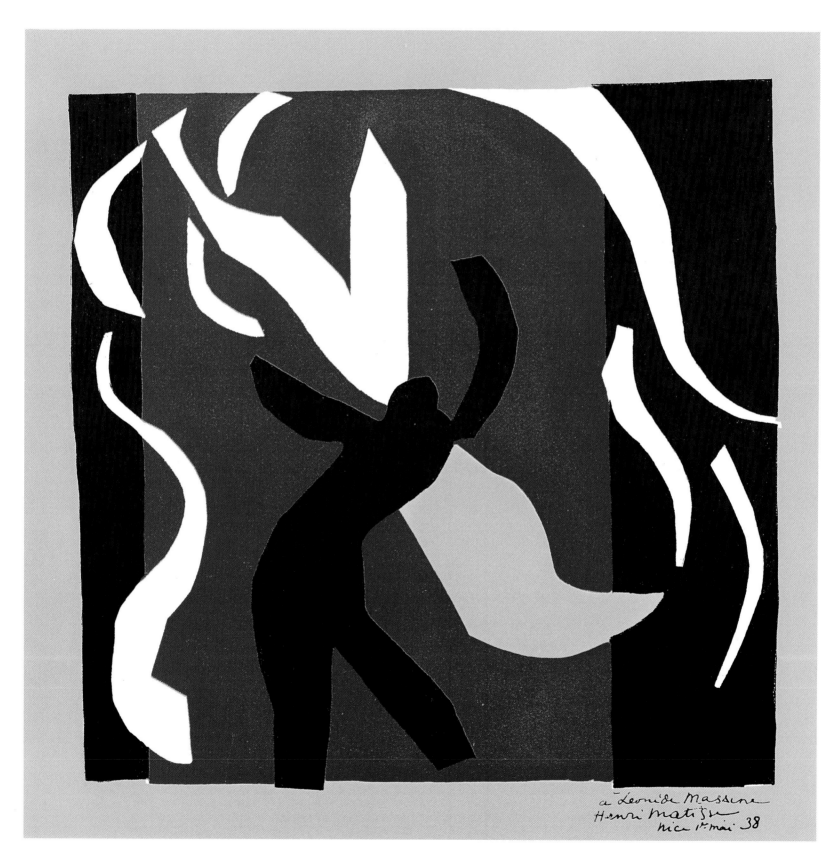

Programme cover for the ballet "Strange Farandole", 1939

Costume designs for "Strange Farandole", 1939

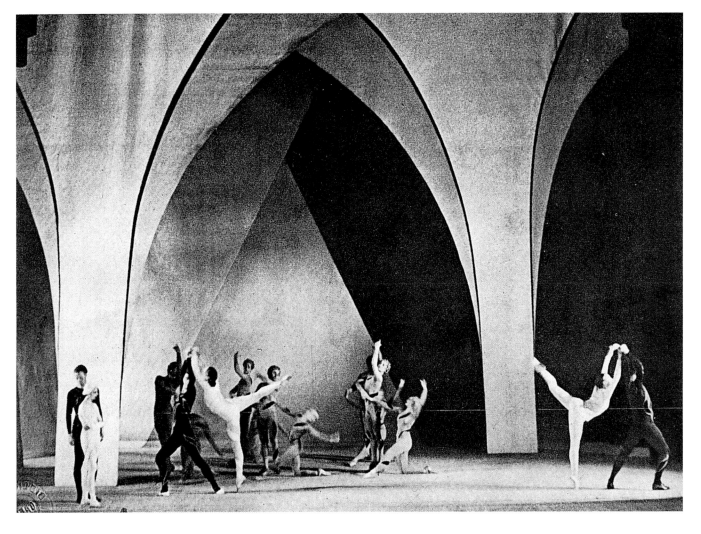

(writing to Tériade), "there is a design which is common to all things, plants, trees, animals, people and it is to this design which we must attach importance" (to R.P. Couturier). When someone told him that he did not see women as he represented them, Matisse replied: "If I encountered women like these in the street I would run away in fright. I do not create a woman, I make a picture. To summarise, I work 'without a theory'. As Chardin said, 'I put on some more (or I remove some because I scrape away a lot) until it is done well.'" In his studio, innumerable drawings were hung on the walls and composed a surprising tapestry but the only ones used in books are those which by the filtering of forms contain more of the flavour and sensitivity to line and light of the poet.

When Matisse made fun of Brancusi and declared: "And there is the phallus!", when he viewed the portrait of *Mademoiselle X* it is because in his eyes, Brancusi had eventually "forgotten" his model, the result being this abstract form which could be interpreted in a variety of ways, including the malicious title which

Acrobats, 1952
Acrobates
Stencil

PAGE 157:
Large Acrobat, 1952
Grand acrobate
Paintbrush and Indian ink, 105 x 75 cm
Musée Matisse, Nice

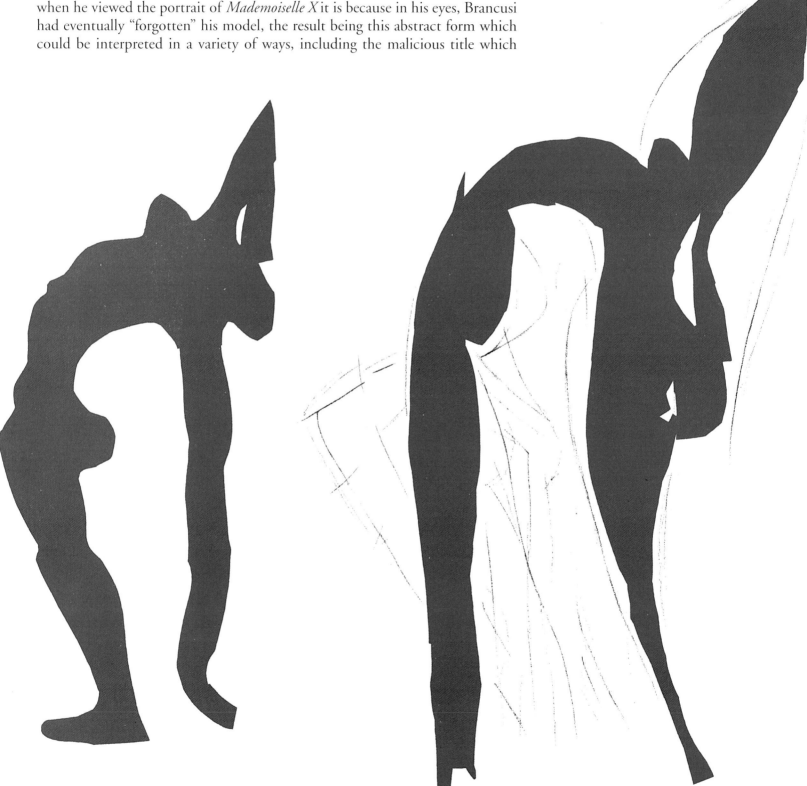

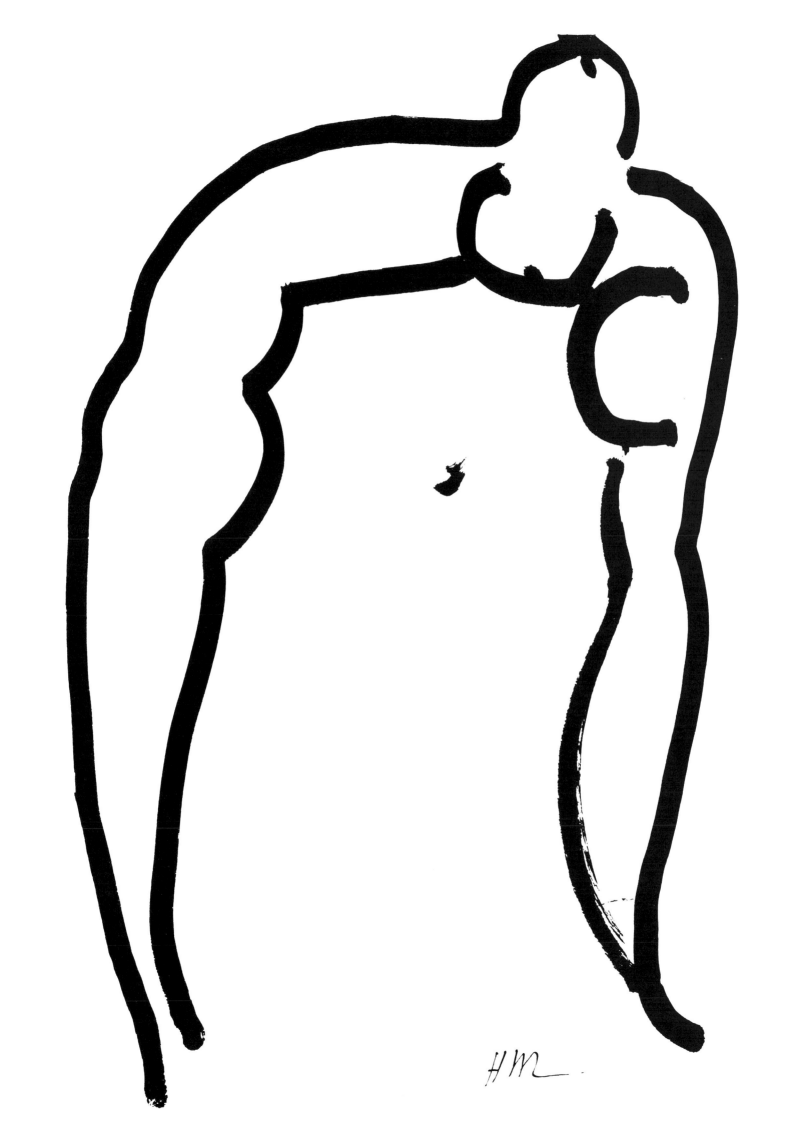

Matisse bestowed upon it. It is also because the paths of Matisse and of Brancusi could not be further apart, the simplification and distortion which both used creating completely different results in each case. Matisse's preoccupations were closely linked to a certain "realistic" continuity, especially through his studies of human figures.

What is surprising is that at the same time, both Matisse and Picasso, as well as others such as Jacques Lipchitz, seem to have made a break with their previous ventures into sculpture which were more tormented, more unreal and more Cubist in order to return to massive, monumental sculpture in the tradition of sculptors of which Rodin would say: "A painter who knows how to draw knows how to sculpt," thus making a decisive contribution to the liberation of forms and materials. Freedom of expression being acquired, it was much more the degree of culture, of intellectual maturity and also of clairvoyance that counted. In the midst of the various currents with which he was confronted, Cubism through Arp, "The Iron Age" through Gonzales or Calder, Figurative Classicism of which Marino Marini was the archetype, Constructivism of the Pevsner type, there existed at the time a Neo-Expressionist current which once again brought

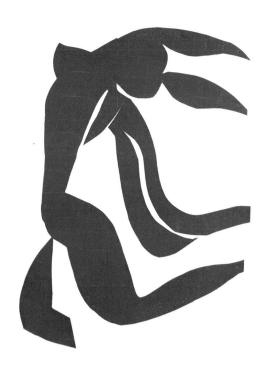

Hair, 1952
La chevelure
Stencil

Matisse drawing a swan in the Bois de Boulogne,
c. 1930
Photo: Pierre Matisse

Hair. Study for the Book of Poems by Stéphane Mallarmé, 1931
La chevelure. Etude pour le "Mallarmé"
Pastel, 31.6 x 23.7 cm
The Baltimore Museum of Art, Baltimore (MD)

PAGE 159:
The Swan. Rejected plate for the Mallarmé book, 1931–1932
Le cygne. Planche du "Mallarmé" refusée
Etching, 33 x 25 cm
The Baltimore Museum of Art, Baltimore (MD)

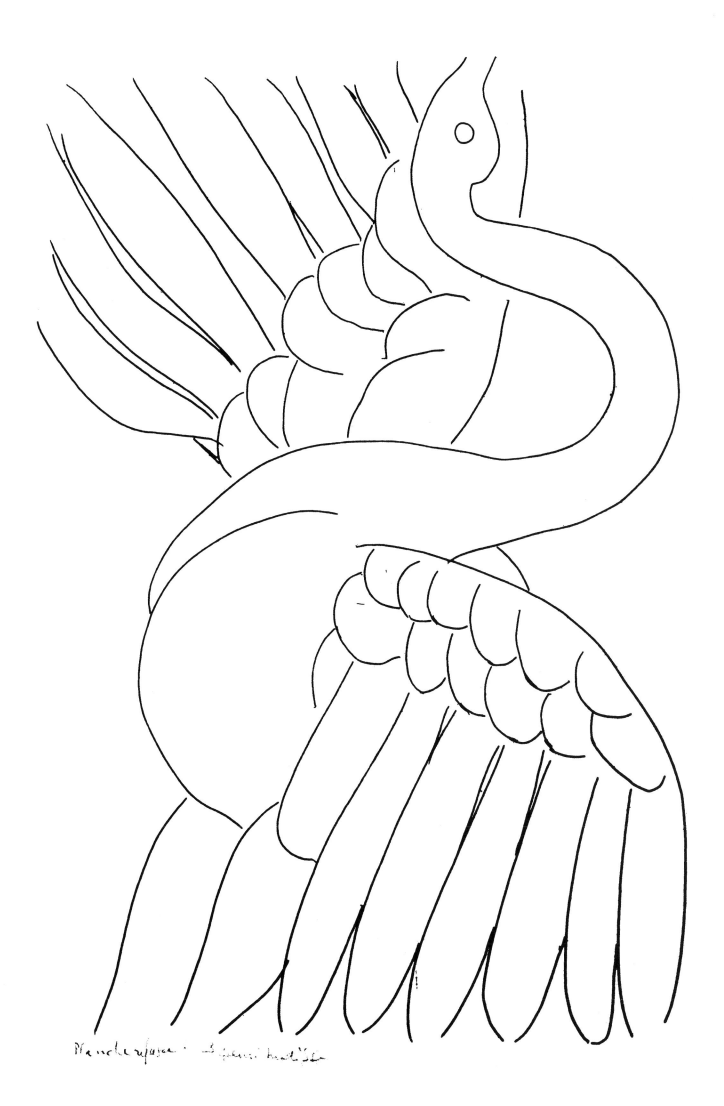

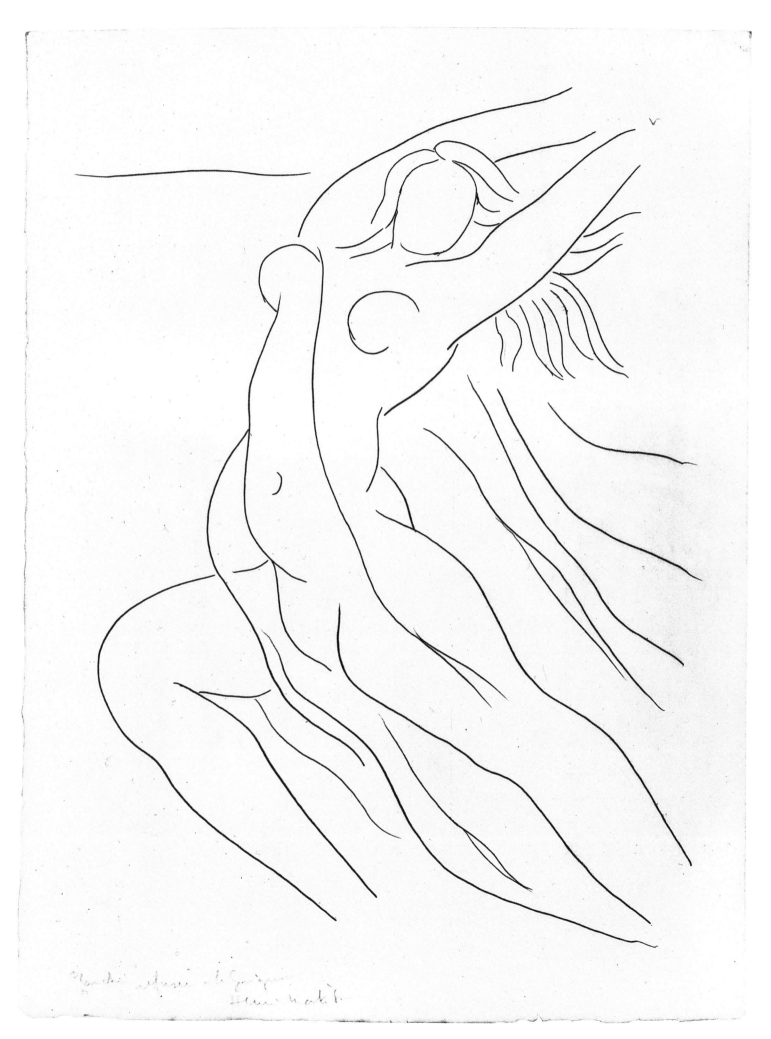

LE GUIGNON

Ce dessus du bétail ahuri des humains
Bondissaient en clartés les sauvages crinières
Des mendieurs d'azur le pied dans nos chemins.

Un noir vent sur leur marche éployé pour bannières
La flagellait de froid tel jusque dans la chair,
Qu'il y creusait aussi d'irritables ornières.

47

The Tiari, 1930
Le tiare
Bronze, height: 20 cm

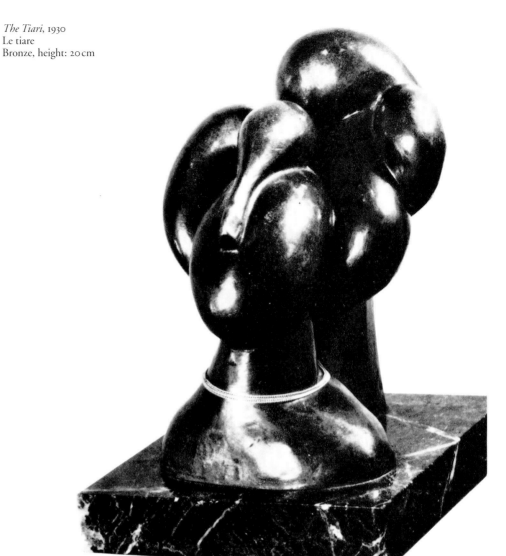

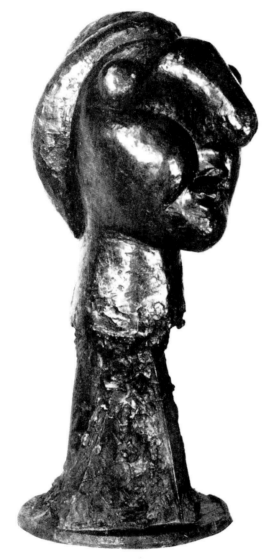

Pablo Picasso: *Head of a Woman*, 1932
Tête de femme
Bronze, height: 86 cm

Matisse and Picasso together. As we know, it only takes one person to yawn in a crowded room for many others to suddenly feel the need to yawn. That is one explanation for the fact that so many artists produce similar works and seem to copy each other whereas in fact, it is merely that there is are converging trends which combine to produce the "spirit of the age". It is this "spirit of the age" to which both Matisse and Picasso were sensitive, which took the form of a sort of renewed but perpetual dispute between "ancients" and "moderns". In this instance it was the defence of Woman in the face of her "massacre" by the destructive representations produced by the descendants of Fauvism or Cubism, whose original exponents happened to be – Matisse and Picasso. Both of them have encouraged us not to become too attached to a particular, strictly defined stylistic tendency and, in painting as in sculpture, they always reserved the freedom to create by suddenly changing course to undertake new ventures. It is significant that they seemed to move at the same time towards a reactionary tendency which could be described as "new realism" which took a monumental form in which Woman occupies a special position, the bust and the nude being the inheritance of the past.

Between 1925 and 1930, Matisse created his last great set of sculptures which began with *Large Seated Nude* (p. 120) and continued with *Venus in the Shell* (p. 163) and the unclassifiable *Tiari* produced in 1930 (p. 162), executed upon his return from a trip to Tahiti, the title taking its name from a tropical flower. Under

the fingers of Matisse, the flower is transformed into the monumental head of a woman relatively similar to the one which Picasso would create a few years later (p. 162), or the last versions of *Henriette* (p. 140). To his students, Matisse then explained: "In this African you can see a cathedral, that is to say a solid, majestic, superb construction resulting from the assembly of numerous elements. But from time to time it is essential for you to remember that he is a negro and not to forget this, or yourself, when creating your construction."

Venus in the Shell, 1930
Vénus à la coquille
Bronze, height: 31 cm

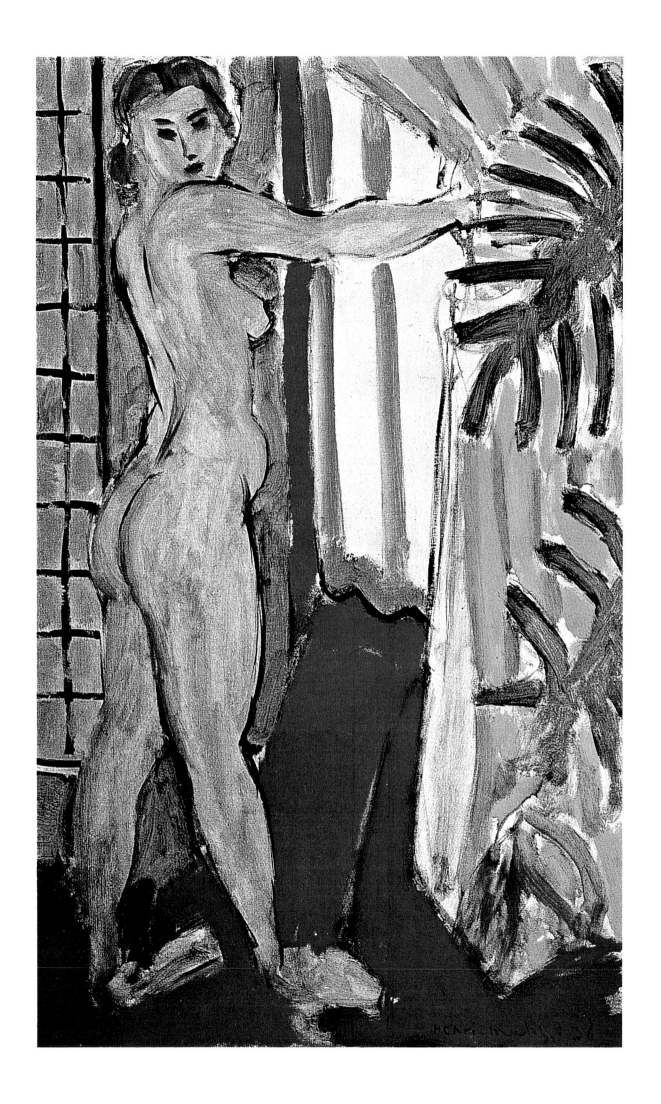

The Wise Old Man and the Young Giantesses

Eroticism, or rather sensuality, which reappeared in 1930 with *The Dance* became the basic motif in Matisse's work. The affectionate identification of the painter with his model was a prime condition for his work. He explained it thus: "A relationship is a kinship between things, it is a common language; rapport is love, yes, love." Unlike Picasso, in Matisse's case love was not linked directly to sexual potency. It meant an internalised emotion which caused him to perceive the world in a positive way. An illustration of this is the *Pink Nude* (p. 170) and the paintings and drawings on a similar theme. They cannot help but affect us as the voyeurs. Matisse expects the viewer's imagination not only to reach beyond the limitations of the canvas itself but even beyond its content. Using his magical zoom lens, Matisse seems to be able to get closer and closer to the model. Thus although the *Pink Nude* has rather small proportions, it gives the impression of being monumental in size. The background is merely a backdrop used to offset the subject, all perspective has disappeared, overwhelmed by the "close-up". The exaggeration of the proportions of the arms and legs, the alternating warm and cold tones, are reminiscent of a fresco. In relation to the colours, Matisse himself speaks of a beautiful "mattness" which is one of the great qualities of a mural. The whole episode of *The Dance* was a turning-point.

Although Matisse has been described as "a charmer who loves to charm monsters", Matisse never considered his creations to be charmed or charming monsters. Nor did his models have the role of mere "extras". "I often keep these young girls for several years, until there is a loss of interest. My plastic signs probably express their state of mind (an expression I do not like) in which I am unconsciously interested, so what should interest me? They are not always perfectly formed but they are always expressive. The emotional interest they inspire in me is not seen especially in the representation of their bodies but often by the special lines or values which are distributed throughout the canvas or the paper and create its orchestration, its architecture. But not everyone can see this. Perhaps it is sublimated desire, which is not perceptible to everyone."

The relationship between the painter and his model generally remain a mystery. Lydia Delectorskaya was first hired as an assistant in 1935, and was then required to pose daily. She has partially raised the veil. Matisse was 65 years old when he met her. Most of the nudes of that period, from *Nude Standing in front of an Open Door* (p. 164) to *Blue Eyes* (p. 166) to the later *The Dream* (p. 167) are her. The *Reclining Nude* (p. 169), the first "realist" and more austere version of *Pink Nude* (p. 170) are her. She wrote a book about the special "artist-model" relationship she had with the painter through his masterpieces between 1935 and 1939. In particular, she published the photographs which either of them took or for which they hired a photographer, of the various stages of the work in progress. Thus she shows us that for *Pink Nude* alone there were 24 stages (p. 171), at the

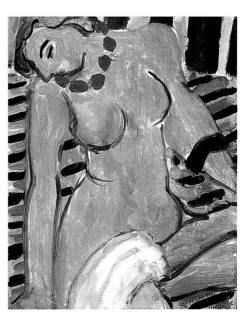

Study for "The Dream", 1935
Etude pour "Le rêve"
Graphite, 28 x 38cm
Private collection

Seated Nude with White Towel, Black Bracelet, 1936
Nu assis au linge blanc, bracelet noir
Oil on canvas, 24.5 x 19cm
Private collection, Cambridge

PAGE 164:
Nude Standing in front of an Open Door, 1936
Nu debout devant la porte ouverte
Oil on canvas, 61 x 38cm
Private collection, New York

same time as a large number of charcoal drawings of the same pose. These document the slow progress towards the removal of anything which the painter considered superfluous and which he was trying to achieve.

Isabelle Monod-Fontaine, in her preface to the book, writes of the various stages: "The way in which the paintings interlock with the time-frame, the permanence of the themes and the way in which they were related to constantly changing goals are clearly visible here. The pose in the early versions – in which the model reclines on a divan, her head resting on a cushion, the left leg crossed over the right, with a bouquet of flowers placed behind her at the level of her knee – is one of Matisse's most familiar themes. He used it in painting, in *Blue Nude (Souvenir of Biskra)*, 1906, and in various versions of *Reclining Nude* which he also sculpted in 1907... This pose is to be found throughout his work. Here is it repeated and, as if internalised, it finds such perfect expression that it almost becomes difficult to hold. 'It is sublimated desire,' Matisse would say... The different moments which were photographed do not record a linear 'progression' but are rather reminiscent of organic growth, with its nascent, dazzling discoveries, followed by periods of thankless toil, in which

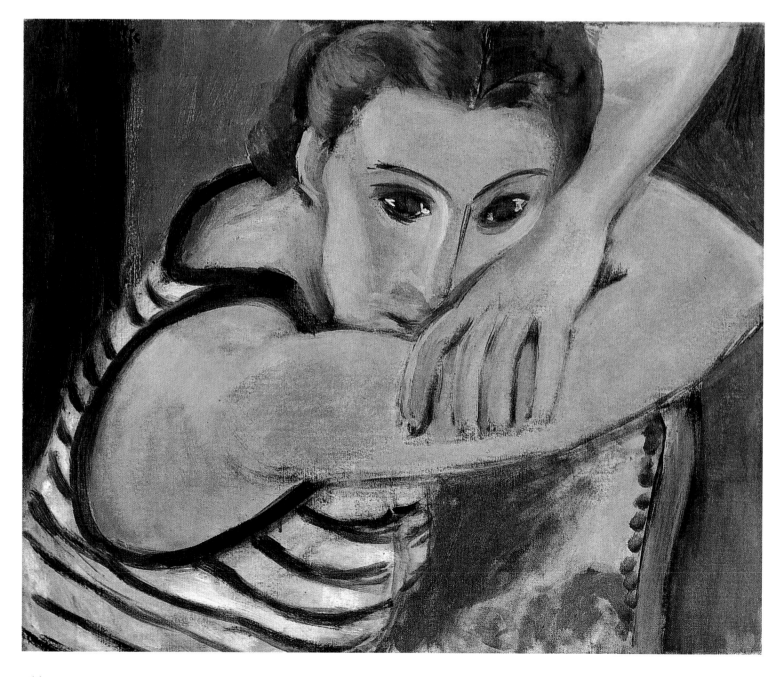

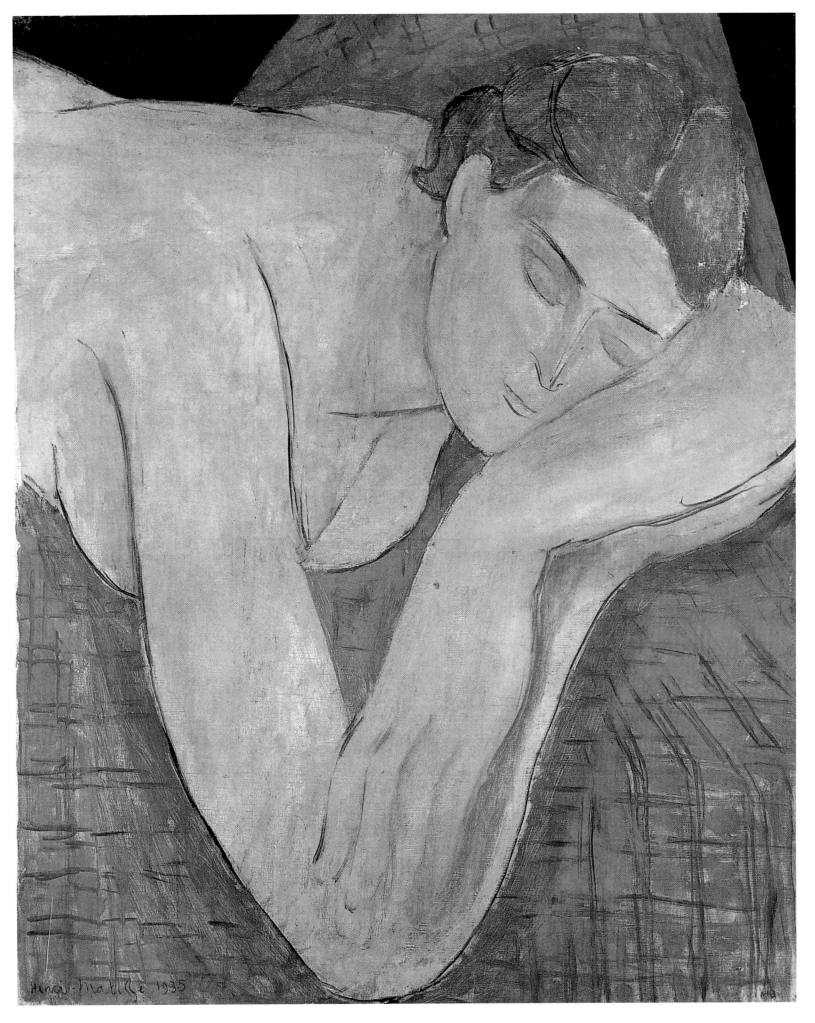

Henri-Matisse 1935

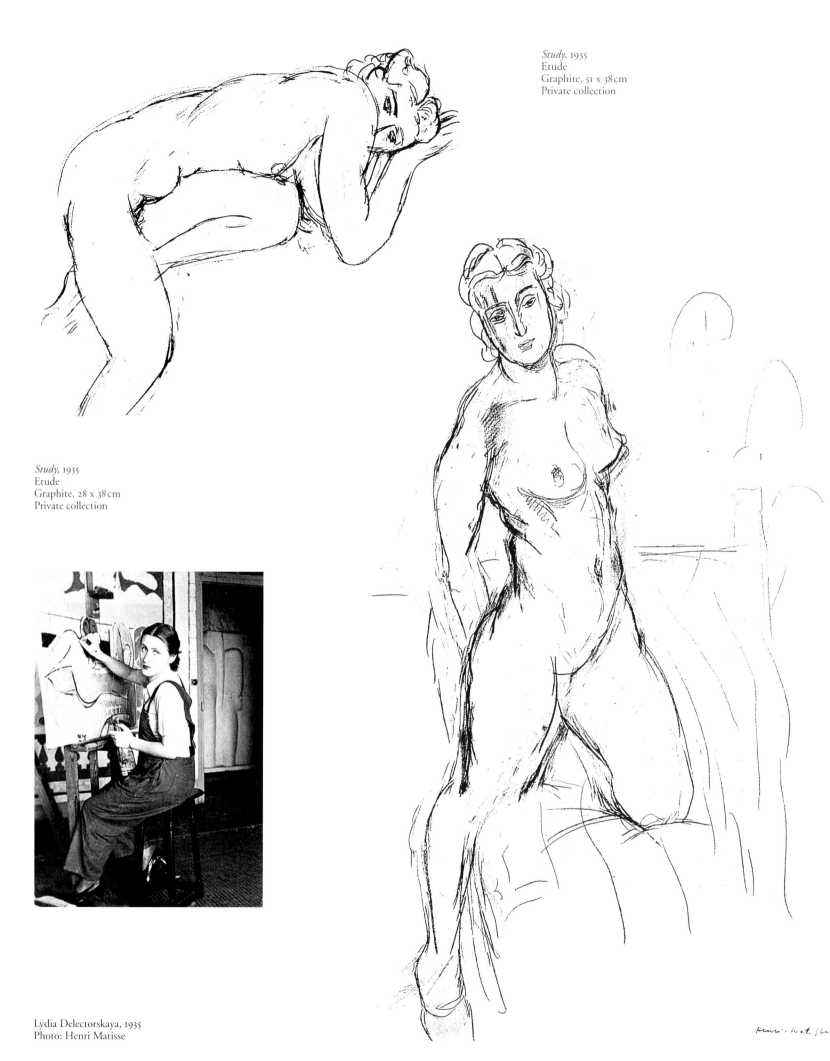

Study, 1935
Etude
Graphite, 51 x 38 cm
Private collection

Study, 1935
Etude
Graphite, 28 x 38 cm
Private collection

Lydia Delectorskaya, 1935
Photo: Henri Matisse

the painting is glimpsed almost as if it were moving into the distance. This observation applies as much to the whole as to the details and to the whole development of a painting or merely to one of its elements: arms, legs, face or even the hair, which was finally depicted as three curls, or to the bouquet in a vase which seems to have been decanted into a sign painted in the same colour as the pink flesh of the nude. But pink at what moment?" In fact, the photographs are in black and white and do not enable us to follow the development of the colour scheme.

The book has the additional merit of noting over time not only Matisse's reactions when talking to himself, of the "What a nasty job this is!" type, or "It's easy to be a critic! Art critics are failed painters: they see the faults but have no idea how to get rid of them." It is also a reply to the naïve questions asked by a young girl who at the time knew nothing about painting. For example, on the subject of *Reclining Nude* of 1936 (p.169): "One ought to be able to produce an impression of monumental size even on a very small canvas because through our tiny little pupil we see objects at their natural size." Or in reply to Lydia, who asked him: "Come on, don't get so upset," he responded: "I am not upset, I have stage-fright." And after a few drawings: "It's a sort of revelation. It isn't me any more. At these moments, I experience a real split personality, I no longer know what I am doing, I identify with my model." Finally, when she asks him if he gets the same stage-fright when he draws a fig leaf as when he is drawing a nude: "Yes, absolutely."

This intimacy, this identification of the painter with his model suggested a trick question to Aragon. "Why does the painter 'have to have' a model if he intends to deviate from it?" Matisse answered mischievously, his eyes screwed up with silent mirth: "If there were no model one would have nothing from which to deviate." Was this a joke? Aragon doubted it. "Over the years, things have

Nude with Heel on her Knee (Reclining Nude), 1936
Nu au talon sur le genou (Nu allongé)
Oil on canvas, 38 x 61 cm
Private collection, Switzerland

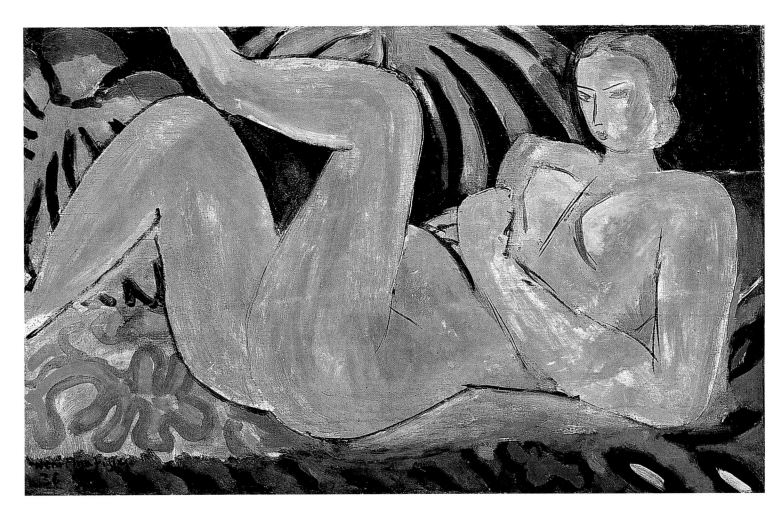

taken a strange course as far as I am concerned; it was this very deviation which I began to like in Matisse, this liberty taken with the model. I understand him and it is I whom I no longer understand." At the very end of his life, Matisse wrote in a preface: "I have studied at length the representation of the human face through pure drawing and in order not to imbue the results of my efforts with my own personality – just as a portrait by Raphael is first and foremost a Raphael – I tried, in about 1900, to copy a face from photographs which kept me within the limitations of apparent nature of the model. Since then, I have used this working method several times. While following the impression produced in me by a face, I have tried not to distance myself from its anatomical construction. I eventually discovered that the likeness in a portrait comes from the contrast between the face of the model and the faces of other people, in a word, its special asymmetry. Each face has a particular style and it is the rhythm which creates the likeness."

In the same preface, Matisse also wrote: "The revelation of life in the study of a portrait came to me when thinking of my mother. I was waiting for a telephone call at a post office in Picardy. To pass the time, I took a telegram form which was lying about on a table and traced the head of a woman with a pen. I drew without thinking, my pen went where it wanted, and I was surprised to recognise the face of my mother with all its delicacy. My mother had a face whose features were distinctive, the strong features of the French inhabitants of Flanders…" It is what Matisse called "the post office revelation" which had a profound effect on all his work. This "revelation" is echoed by Aragon in his quote from Diderot in

Five successive stages of Pink Nude, *1935*

Pink Nude, 1935
Nu rose
Oil on canvas, 66 x 92 cm
The Baltimore Museum of Art, Baltimore (MD)

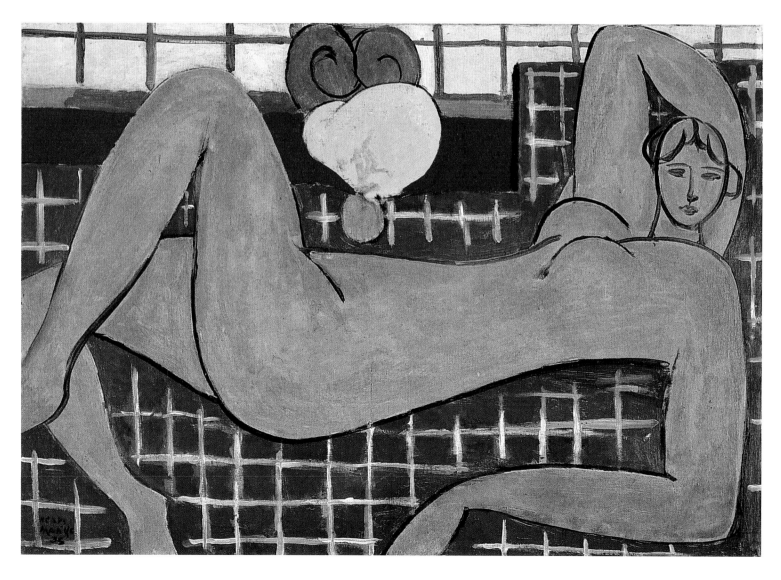

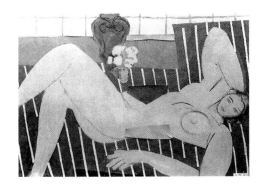

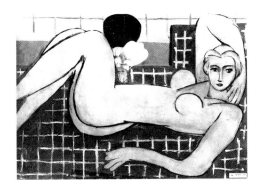

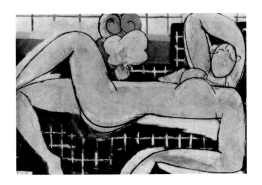

his "Essay on Painting": "I knew a young man of good taste who, before placing the smallest line on his canvas, would go down on his knees and say, 'Dear God, deliver me from the model…'" Matisse could have made this his watchword, since he proclaimed the need for a model while considering it as a point of departure and needed it most in order to "leave it behind".

The painter's feeling was shared by the poet whom we have already quoted. "If Madame Bovary's nose had been shorter," wrote Aragon, "we would think that Flaubert was joking when he said, 'Madame Bovary is me…'' Matisse is not saying that these oriental women who parade and who uncoil themselves in his work like a little ivy frond which he transports with its translucent roots from one vase to another, that these women are him, and they express him… There are portraits and portraits. It is himself which he understands in them, but it should be realised that he understands them as well. There is the story of this American woman whose portrait he was painting. He produced one sketch after another. She wanted to take them all away with her because she saw all the members of her family in them, her mother, an uncle, a female cousin… and I suppose there were also moments of herself of which she was unaware. One day she would look like this drawing, this is how she used to look. Matisse did not see her as she was, no more than he had known her mother, who had stayed behind in Connecticut. He had done better: he had understood her. And through her a great many things. Over and above the portrait."

When Matisse met a new model it would coincide with or even set off a different vision, enabling new developments, as if it were a trigger mechanism.

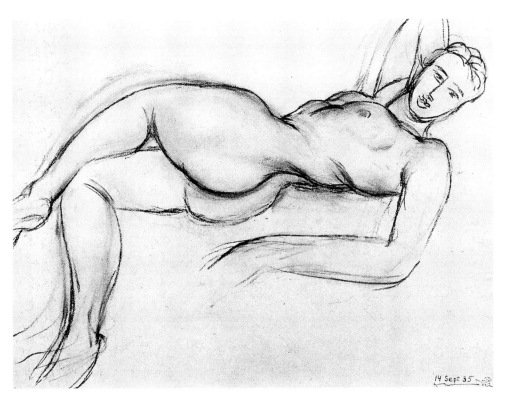

Study for "Pink Nude", 1935
Etude pour le "Nu rose"
Charcoal, 34 x 48 cm
Private collection

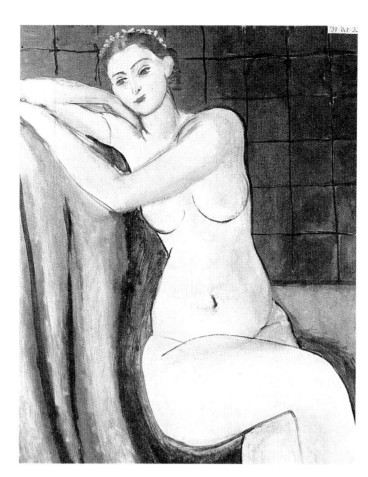

Five successive stages of *Seated Pink Nude*, 1935

PAGE 173:
Seated Pink Nude, 1935
Nu rose assis
Oil on canvas, 92 x 73 cm
Private collection

PAGES 174–175:
Woman in an Armchair, Blue and Yellow Background,
1936
Femme dans un fauteuil, fond bleu et jaune
Oil on canvas, 46 x 38 cm
Private collection

Nude Woman on a Blue Background, 1936
Femme nue sur fond bleu
Oil on canvas, 46 x 38 cm
Private collection

Thus the pose in *The Dream* (p.167) is special to Lydia and was there in the very first drawing Matisse made of her. She recounts the process in detail, which was that of a true crystallisation in Stendhal's sense of the term. "One day he came in and picked up a sketchbook which he placed under his arm and while I was listening absent mindedly to their conversation (the scene took place by the bedside of Madame Matisse who was ill), he suddenly intimated to me: 'Don't move!' Opening the notepad, he began sketching me, deciding on a pose which was familiar to me, my head bent against my arms folded over the chair back. These improvisations occurred more and more frequently. He asked me to pose for him. But it was the very first drawing which was the origin of the painting *The Blue Eyes* (p.166), the first painting he did of me. He used the pose again which he had recorded, a pose to which he was unaccustomed – perhaps because it was one of an employee who may have lacked a certain decorum – but in which he felt me to be completely relaxed and natural. That is what he was seeking in his work, by observing the model when she was relaxed. (He had confirmed in one of his essays that he found working with a model posing in an uncomfortable, tense position tired him, and was even painful to him.) From this moment on, he worked a great deal with me and did so on a regular basis."

The Dream (p.167) constitutes a sort of stage in *Pink Nude* (p.170), there is the same check fabric draped over the divan, the same harmony of blue and pink, the same search for a curve which will cut across the painting and highlight the figure against a unified background and, above all, the total lack of superfluous detail which from one painting to another becomes almost abstract, culminating in *Seated Pink Nude* (p.173). After Dr. Barnes' *The Dance*, Matisse's figures seem to be more restrained and no longer appear to be bursting out of their frames. Even the drawings (*Head (Buddha)* p.178 or the line engraving, p.180) extend beyond the limits of the sheet of paper. Matisse progressively accentuates the use of the close-up.

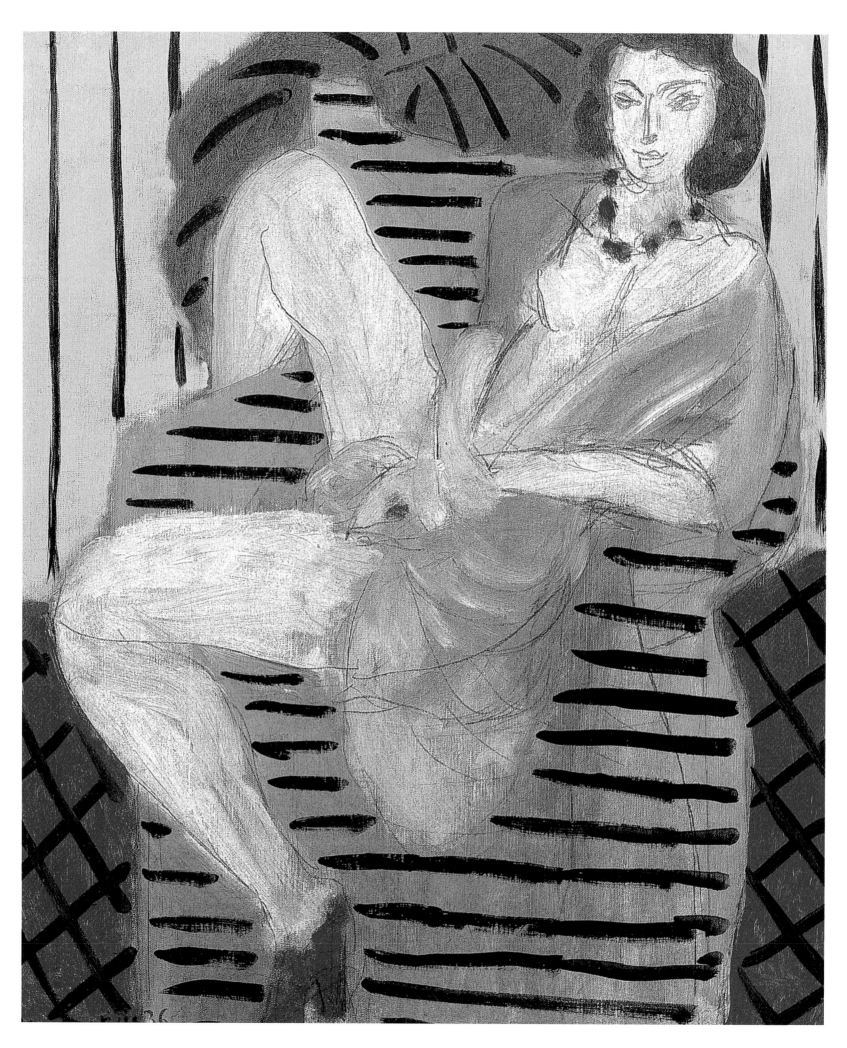

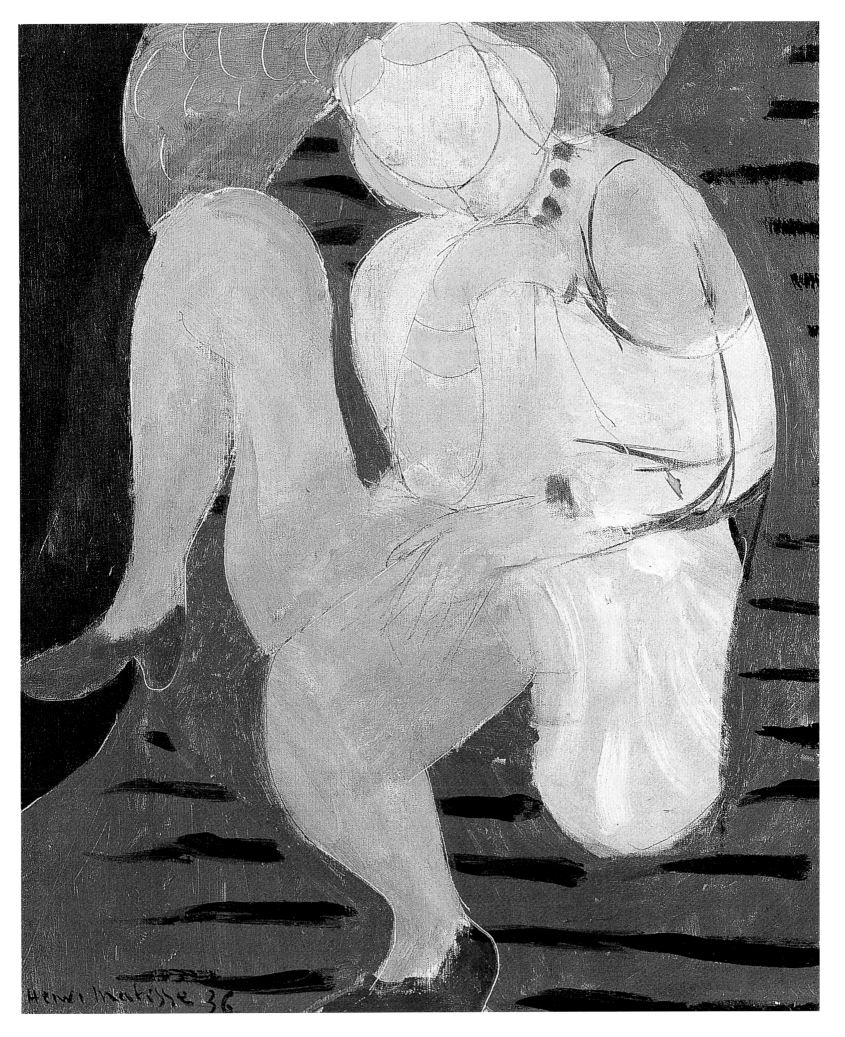

Henri Matisse 36

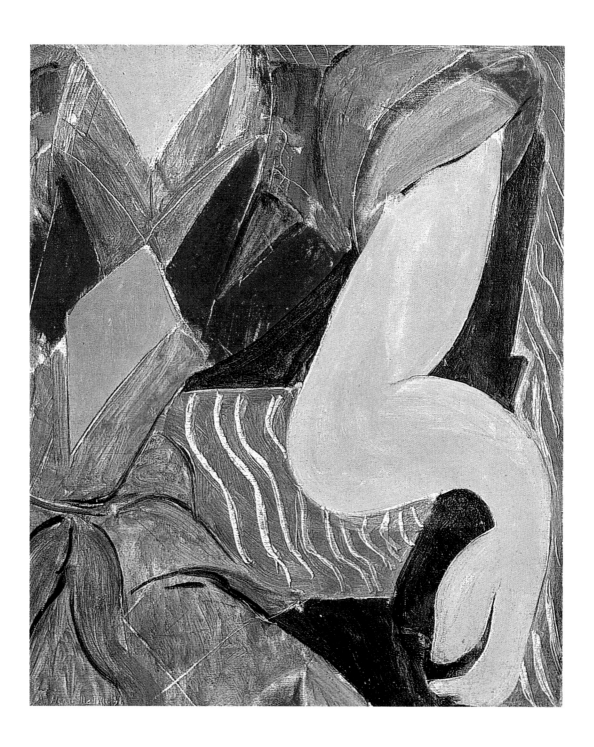

The Arm, 1938
Le bras
Oil on canvas, 46 x 38 cm
Private collection

"In the photographs of successive, rejected stages of the paintings," notes Lydia Delectorskaya, "he could reconsider the course he had taken, the development of the painting, check how right he had been to take certain measures or which errors he had made and could see for himself if, in his desire to achieve perfection, he had inadvertently destroyed something essential or whether, on the contrary, he had taken a step forward in his researches." Thus Matisse was able to see his canvases pass before him as in slow motion. "A good drawing," he said, "should be like a wicker-basket or trug – (I like a trug better because it represents a larger surface in the mind) of which not a twig can be removed without leaving a hole."

In Matisse's work, the "dream" gradually overwhelms the exact likeness. So does fantasy because if the painter had intended to remove the carnal presence of the nudes he depicts so that they were no more than outline and colour and nothing else, one could say that the experiment had failed. But Matisse's subtlety is by now all too well-known, his way of combining a thousand strands of wool

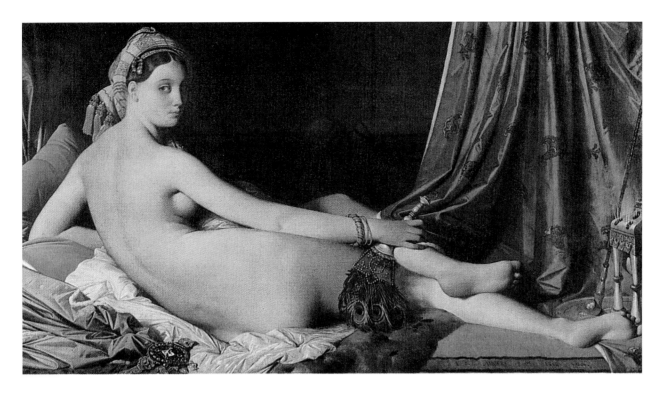

in order to make them into a skein, to think for a moment that eroticism in his work was taboo. On the contrary, it flourishes permanently, not as an end in itself – as it was for the "pompier" painters – but as a bonus. As San Lazzaro notes in a text entitled, *The Feminine Ideal of a Nobleman*, "the face of the woman who inspires a nobleman is not one of Degas' dancers or Renoir's young serving-girls. It is quite simply a sign of the times and of the middle-class circles in which Matisse lives, that of a mannequin whose erotic and social role has just been discovered. Her function is to wear fashionable or childishly outlandish clothes, sometimes also to show off jewellery, against a background of expensive interiors."

For the moment, Matisse wants her undressed and is only interested in her body. He will soon dress her up and paint her in a natural position, as if he were playing with dolls. More precisely, he will no longer need to cover her with frippery as he did with his odalisques or as Rembrandt did, fashion would supply it. Henceforth, no human warmth could be expected from those faces, no more

Jean-Auguste-Dominique Ingres: *The Great Odalisque*, 1814
La grande odalisque
Oil on canvas, 91 x 62 cm
Musée du Louvre, Paris

Paul Cézanne: *The Boy in a Red Waistcoat*, 1894–1895
Garçon au gilet rouge
Oil on canvas, 79.5 x 64 cm
Bührle Collection, Zurich

Dancer and Rocaille Armchair on a Black Background, 1942
Danseuse, fond noir, fauteuil rocaille
Oil on canvas, 50 x 65 cm
Private collection

The Asiatic, 1939
L'asiatique
Charcoal, 61 x 41 cm
Matisse Archives

Drawing (Stage in Head of Buddha), 1939
Dessin (Etat de tête de bouddha)
Charcoal, 61 x 41 cm
Matisse Archives

PAGE 179:
Head (Buddha), 1939
Tête (Bouddha)
Charcoal, 61 x 41 cm
Musée Matisse, Nice

than one finds in the expression of those creatures whose faces haunt the pages of the fashion magazines. As in Ingres' *La Source*, one wonders whether they are even capable of opening their mouths and embarking upon the adventure of speaking. They are simply large moving and emotive flowers, whose presence often has no other purpose than to justify the decor... and vice versa! Yet a certain sensuality emanates from these icons of a new genre, these giantesses; a soft curvaceousness which can become aggressive if the artist imposes a certain type of movement upon them: this movement, as everyone has known since Plato, being love. And Matisse, "the wise old man surrounded by luxury," as Jean Leymarie defined him, repeating the words of Rimbaud, is fully aware of it. The tenacious myth which haunts him, that of earthly paradise, is truly there, under new guises, peopled with creatures who represent a new race, ready for new metamorphoses. The initial drawing represented by the beautiful *Asiatic* progressively distorts in order to eventually transform itself into a colossal and monstrous *Head of Buddha* in its final stage (pp. 178–179).

To achieve his ends, Matisse never hesitated to use and even accentuate beyond what had hitherto been seen – only Picasso could also allow himself to do so without either becoming ridiculous or being critisised – these exaggerations and distortions of which Ingres and Cézanne were past masters. Their contemporaries carefully counted the vertebra in Ingres' *The Great Odalisque* (1814, p. 177). Apparently she has three too many. "A woman's neck can never be too long," said Ingres to his pupils, advocating the exaggeration of line which he

called "correcting nature through itself." To his pupils, again, he professed: "Do not dwell on the dominant features of the model... Emphasise them, if required, until they are caricatured. I say 'caricature' in order to emphasise the importance of such a true principle."

If Ingres has his *Odalisque* of supernumerary vertebrae, Cézanne has his *Boy in a Red Waistcoat* (1894–1895, p.177), a young man whose arms are excessively long in relation to his body. When Cézanne was seeking an ideal and expressive suggestion to accentuate the impression that he had stopped using models entirely, he was not bothered by reality. Once the problem of plasticity was solved, Cézanne was also able to convey, as was Matisse, the empathy which he felt for this young Italian who has posed for him and the psychological uncertainty which emanates from the adolescent model. This is a long way from any kind of realism and is an entry into the world of distortions which, according to Cézanne, can alone render "the virginity of the world". "An acute sense of the nuances is working on me. I feel myself coloured by all the nuances of the infinite. I do not create more than one in my painting. We are in an iridescent chaos." Cézanne also suffered from the Madame Bovary syndrome!

PAGE 180:
Untitled, 1938
Lino-cut for *20th Century*, 31 x 24 cm

LEFT:
The Plant (Pot of Begonias), 1941–1942
La plante (Pot de bégonias)
Lino-cut, 20.1 x 23 cm
Bibliothèque Nationale, Paris

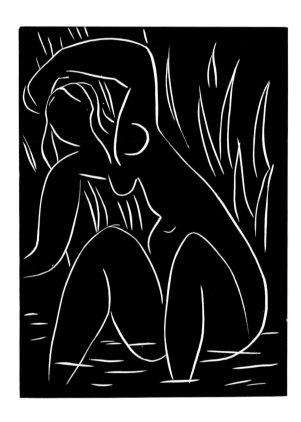

Matisse's painting *The Arm* (p.176) is a supreme example of this world of distortions. It might be compared with the painting entitled *Dancer and Rocaille Armchair on a Black Background* (p.177) and *Rocaille Armchair* (p.207). These two works express all the pleasure which Matisse had taken in playing with the distortions favoured by his illustrious forebears, Ingres and Cézanne, in representing the arm of the chair in the same way that he twisted the woman's arm into a magnificent curve.

Might Matisse have been slightly sadistic? These young girls, these beautiful idlers, these young giantesses at whose feet Baudelaire loved to play, were monsters whom Matisse eventually cut out with scissors from large sheets of coloured paper. It is for them that he tailored the light. After the mirrors and windows he would offer them these great earthly paradises which would emerge from his last collages.

The Afternoon, 1941–1942
L'après-midi
Lino-cut, 24.5 x 17.8 cm
Bibliothèque Nationale, Paris

Matisse's female figures, his "plane-tree women" became bigger and bigger after *The Dance* and appear to be too large for the frames, giving the impression of being on a monumental scale. Thus fantasy and exaggeration were more important to him than accuracy and realism. Fantasy, as well, because the carnal presence of these naked women is almost palpable, so that the "spectator-voyeur" cannot remain indifferent.

The Light of Desire

There is no doubt that in painting *Lady in Blue* (p.182) Matisse showed all the interest which he had in Ingres' *Portrait of Madame Moitessier* (p.183). His reconstituted paradise was thus peopled with giantesses. Aragon observed delightedly: "The woman, according to Matisse, with her neck enlarged at the base where it is encircled by a gold necklace as if by a chain… indicates the languor, if not the strength, or at least the sensitivity which derives from the 'swollen', cylindrical neck inflated at the base. She is that 1937 *Lady in Blue* and is already what he would call fourteen years later, 'a plane-tree'."

Matisse once said of a very beautiful, tall woman: "She has the proportions of a demi-goddess, she is a plane-tree…" Calling a beautiful woman a "plane-tree" is no more surprising than talking of the "arm" of a chair; these are simply reciprocal borrowings from anatomy and vegetation.

The most important link between Ingres and Matisse is that both of them were from an upper middle-class background and thirsted for perfection, yet they were both unable to resist falling, as if despite themselves, in the direction in which they were pulled, that of the sensuality which consistently permeates their work. Each of their various paintings, from which the female form is rarely absent, whether dressed or undressed, is a festival of muffled ambiguity, a controlled audacity, a true anthology. In both of them, the model's dress is more than an ornament, it is more like another skin. The parts of a garment seem to have the same vital functions as the organs of a body; they are organs in themselves. This was not a betrayal of Cézanne, nor even of Manet, from the point of view of the composition of a painting. Matisse once asked Aragon on the subject of *Woman with a Veil* (p.206): "Don't you find it is rather direct? Slightly Manet!" Matisse definitely opted for Ingres as far as subject-matter and expression were concerned. This is the Ingres of whom Baudelaire said: "Monsieur Ingres ought to be at his most successful when painting portraits… Beautiful women, rich natures, tranquil, flourishing health, that is his triumph and his joy!" Could not Baudelaire have said the same about Matisse's work? The work of both men, almost a century apart, have much in common both in the poses of the model as well as in their treatment of the subject, the quest for perfection and the way in which flesh and fabric were rendered.

Who was Gaétan Picon writing about when he said: "There is nothing more acute, more subtle, more 'Ingres-like' than that moment in which a neck rhymes with a necklace, velvet with flesh, a shawl and a hairstyle, than that line where they meet, where a chest and the top of a bodice recognise each other, where an arm meets a long-sleeved glove. If the portraits of women have a special radiance it is because they come like nudes – though with less openness – from the light of desire…"

It is not particularly nationalistic to state that the qualities (and defects) shared by Ingres and Matisse are in a long French tradition. In the case of Ingres, for

Hélène Galitzine. Study for "Lady in Blue", 1937
Hélène Galitzine. Etude pour "La dame en bleu"
Pen and Indian ink, 51.5 x 38 cm
Private collection

Jean-Auguste-Dominique Ingres: *Portrait of Madame Moitessier*, 1856
Oil on canvas, 120 x 92 cm
National Gallery, London

PAGE 182:
Lady in Blue, 1937
La dame en bleu
Oil on canvas, 93 x 73.6 cm
Private collection

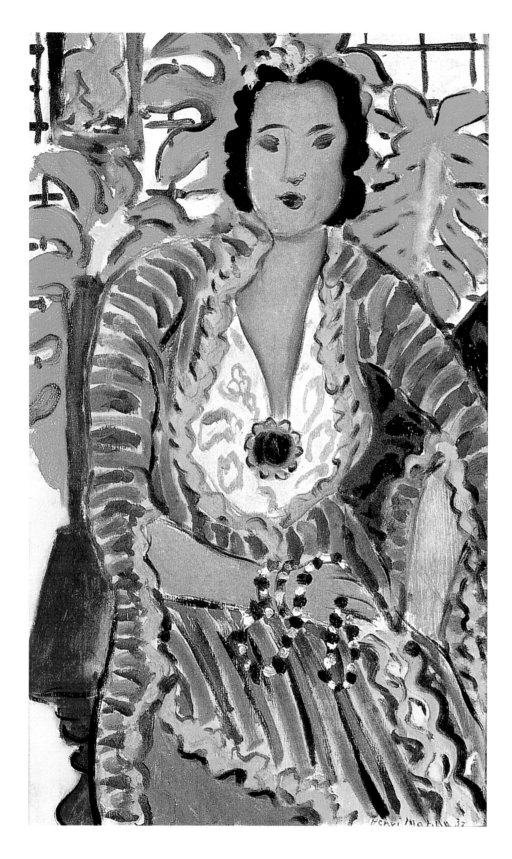

Hélène au cabochon, 1937
Oil on canvas, 55 x 33 cm
Private collection

Small Odalisque in a Violet Dress, 1937
Petite odalisque à la robe violette
Oil on canvas, 38 x 46 cm
Private collection

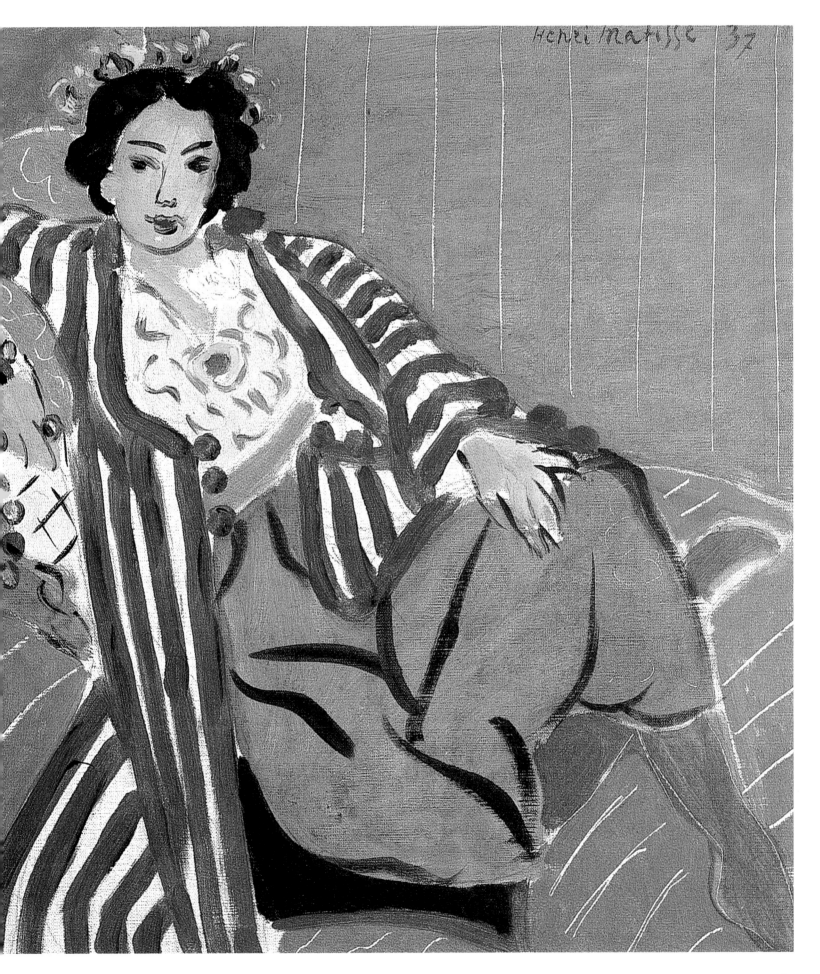

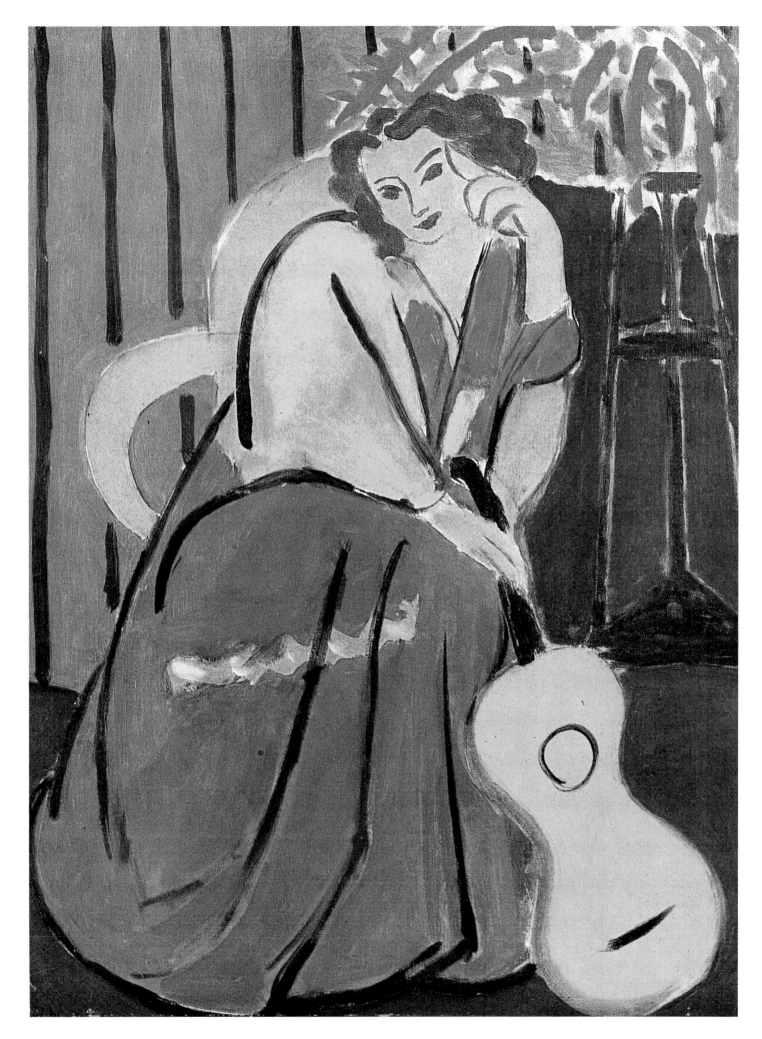

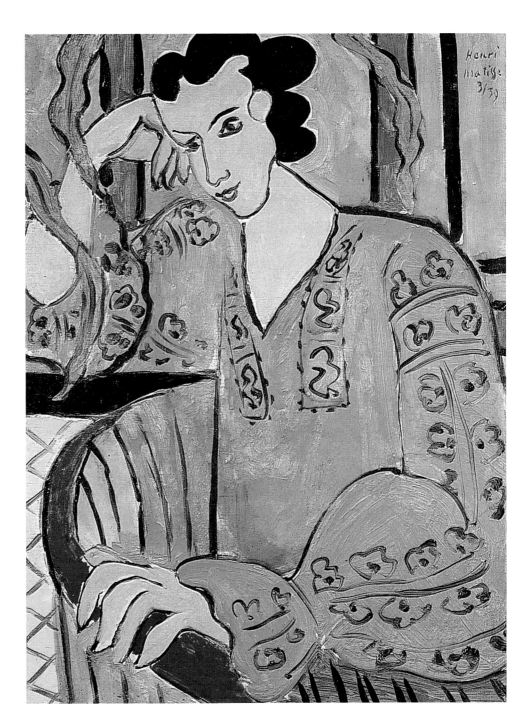

The Green Romanian Blouse, 1939
Blouse roumaine verte
Oil on canvas, 61 x 46 cm
Private collection

Matisse's studio bore an increasing resemblance to a hothouse in which rich flowerings developed and grew, these "plane-tree women" which he so adored and invented. The more these creatures became drawings and expanses of colour, the stronger became their carnal existence. They would gradually lose their hat, their blouse, their accessories and even their face in order to become a long-legged, round-thighed, wasp-waisted Eve, an Eve with prominent breasts which through their curves traced the eternal desire of man.

PAGE 186:
Woman in Yellow and Blue with Guitar, 1939
Femme en jaune et bleu à la guitare
Oil on canvas, 65 x 54 cm
Private collection

example, when he painted the portrait of a woman (*Madame Moitessier* or *Madame de Sennones*), this leading classical painter as he is so often defined, suddenly became a romantic. Eroticism appeared, the fantasies and impulses of the creator of *The Turkish Bath* broke through the traditional framework to which he has been assigned. The flesh and the cloth melt into each other. The dress becomes one with the body. The shoulders and arms are of the same texture as the silk and the velvet, the pleats of the skirt are as the folds of the skin. Now Ingres' shapes seem ready to rise nude from their clothing, now it is the dress which seems to be on the point of falling off, of fading away before the triumphant appearance of the naked body... These portraits, like those of Matisse, all tend towards nudity as the highest expression of graphic art. Yet Ingres, the worthy bourgeois, is not simplistic either. If he eliminates the excess baggage, he attempts to go beyond sensuality and eroticism. What does he want the viewer to see? To contemplate without desire "this obscure object of desire"? Is that hypocritical? No, in Ingres, what is remarkable is that he was firmly attached to "virtuous art",

Nude Kneeling before a Mirror, 1937
Nu agenouillé devant un miroir
Pen and black ink, 38 x 51 cm
Private collection

PAGE 189:
*Untitled (Nude Seated on a Bench in Front of a
Mirror)*, 1937
Sans titre (Nu assis sur une banquette devant une
glace)
Pen and black ink, 38 x 28 cm
Musée National d'Art Moderne, Centre Georges
Pompidou, Paris

Raphaelesque purity, he had a sense of sin and he did his best to overcome the lustful thoughts which images of women were liable to arouse in him. These magnificent bodies were unaware of the desire they provoked. If they invited it, they did so unconsciously. Quite simply, what he wanted to accept as an ethic was above all an aesthetic.

The same applies to some extent to Matisse. The fact that Matisse shares some of Ingres' tastes has just been remarked upon. For example, it is well known that Ingres' models all appeared to be suffering from goitre. These include *Thétis, Angélique, La Fornarina*, the women in *The Golden Age* (a favourite theme of Matisse's), *Saint Symphorien, The Apotheosis of Homer* and *The Turkish Bath*. Doctors have considered the matter and have come up with the conclusion that "the neck of the women in Ingres' paintings represent the first stage in a semiology of the thyroid body" and it is known that hypertrophy of the thyroid gland creates a particular sexual ardour in women who are thus affected…

It has also been written that "Ingres loved beautiful, full lines in women, an opulence of form as well as a rather calm and nonchalant mentality which is often accompanied by a certain plumpness. His feminine ideal was quite oriental (which is also reminiscent of Matisse to a certain extent). He was not one to depict burning, feverish eyes in drawn, bitter faces, the passionate disquiet of Leonardo, nor the hallucinating, dreamy expressions, the ardour of the Botticelli

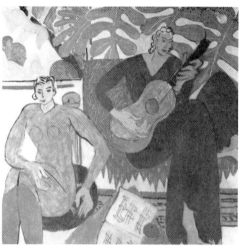
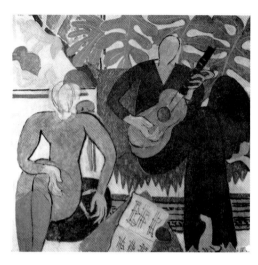

Three stages of *The Music*, 1939

Two Female Figures and a Dog (Blue Dress and Net-patterned Dress), 1938
Deux personnages féminins et le chien (Robe bleue et robe résille)
Oil on canvas, 73 x 60 cm
Private collection

PAGE 191:
The Music, 1939
La musique
Oil on canvas, 115 x 115.1 cm
Albright-Knox Art Gallery, Buffalo (NY)

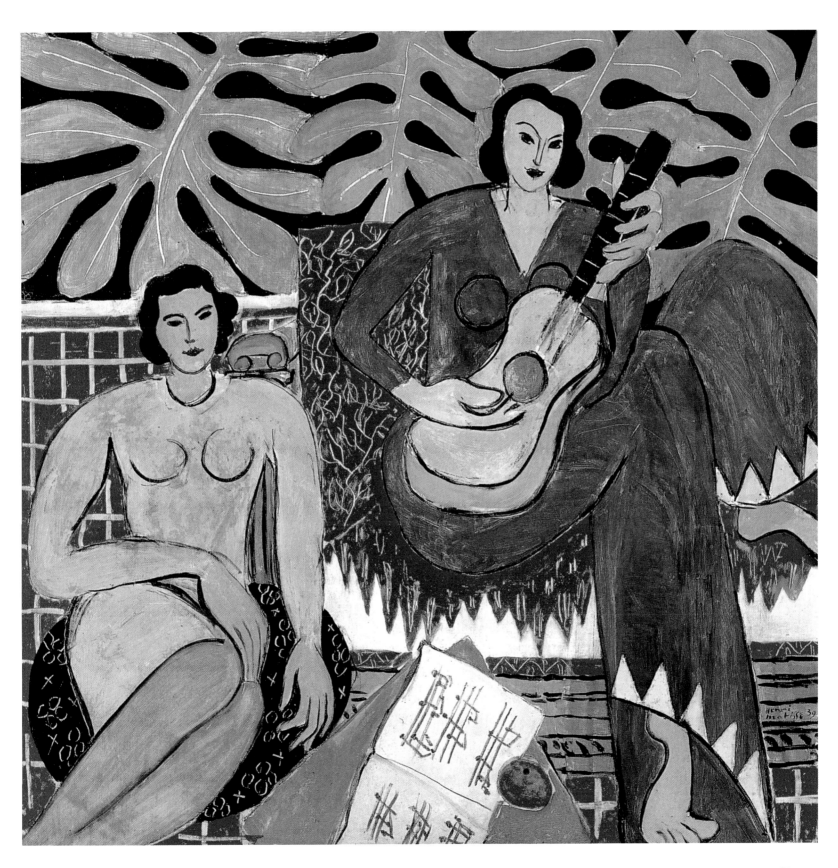

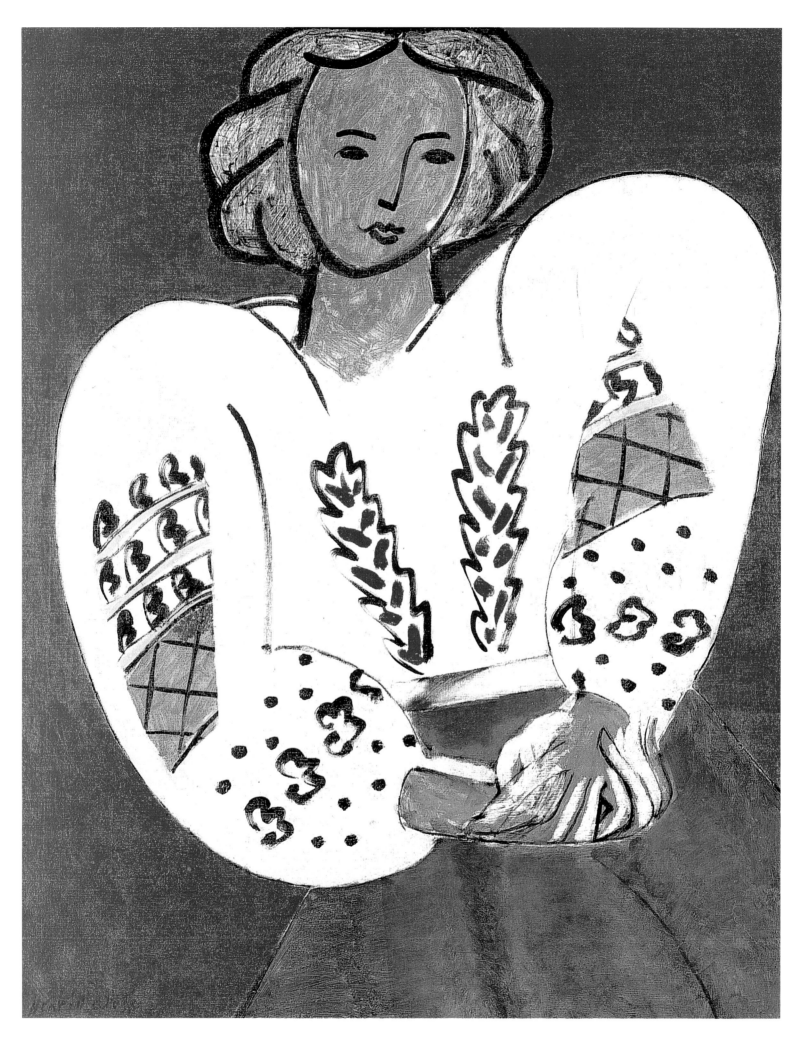

virgins, driven insane by superhuman temptations… Ingres' women are submissive creatures, who do as little thinking as possible, and who are happy to lie about on sofas. Was it chance or his special vision which provided him with models who were so much to his taste?" This medical observation also applies rather surprisingly to Matisse, and that is why we mention it here, as far as Matisse was concerned, Ingres, despite constant criticism, remained his mentor on the road to the odalisques. "The distortions used by Ingres have often been invoked to justify Picasso. In my view, they are closer to the liberties of expression taken by Matisse," notes Aragon.

Aragon devoted a whole chapter of his book *Henri Matisse, a Novel* to this interest which Ingres and Matisse seemed to share, likening the charm of Madame de Sennones to various references in Matisse's work, including women, objects, furnishings, plants, trees and in general anything which he considered or which he suddenly perceived as being related to this "curve" of femininity. He even cited *The Algerian Woman* or *Lady in Green* as early examples of the thyroid type. There is a swelling of the neck in the various versions of *Laurette*, and even *Three Sisters*.

For Aragon, *The White Feathers* is almost a portrait of Madame de Sennones in her first flush of youth. The heavy chin of Antoinette, the model in *The Black Table*, is similar to that in Ingres' models, as if Matisse were disguising Ingres' heroines either in Moorish costume or in feathered hats. Even in *Woman and Goldfish*, the model has bulging eyes and her chin, mouth and the rich curves of her shoulders and arms seem to fall into the same category. It would be useless

Two successive stages of *The Romanian Blouse*, 1940

Dancer Resting, 1939
Danseuse au repos
Charcoal, 64 x 47.7 cm
National Gallery of Canada, Ottawa

PAGE 192:
The Romanian Blouse, 1940
La blouse roumaine
Oil on canvas, 92 x 73 cm
Musée National d'Art Moderne, Centre Georges Pompidou, Paris

to mention the sculpted "large heads"; they also have their place. Aragon asked the question: "Did Matisse realise that for all those years he had been painting Madame de Sennones?… Was it a similarity of physical taste that he was discovering with his illustrious predecessor and which caused him to paint these odalisques, or on the contrary, was it the fact that he had painted odalisques because of Ingres thus causing him to discover the significance of an attraction he already felt, but which he only explained afterwards, or even after the feeling had been revealed to him…" Aragon admitted that he never thought to question Matisse on this point, but he is sure that the painter was aware of the medical analysis of Ingres' work which has just been mentioned.

So Matisse only painted the kind of women he liked. Very few painters have been able to bequeath their feminine ideal to posterity. After Botticelli and Piero della Francesca, this did not happen until Veronese and Tintoretto. Then came Ingres, who kept that old eternal feminine ideal to which he added a goitre and a few vertebrae. Since then, only Matisse has made it possible to discover through his painting the kind of woman who was much more than a personal ideal, in the manner of Renoir's servant-girls and Degas' ballet dancers, but was that of a whole era. Women who in some way were the most magnificent, the most

Themes and Variations, F6, 1941
Thèmes et variations, F6
Pastel, 40 x 52 cm
Musée de Grenoble, Grenoble

Themes and Variations, F10, 1941
Thèmes et variations, F10
Pen and ink, 40 x 52 cm
Musée de Grenoble, Grenoble

Woman Sleeping on a Corner of the Table, 1939
Femme dormant sur un coin de table
Charcoal, 60.4 x 40.7 cm
Private collection

magnified reflection, while attaining the intemporal, in the manner of Proust, a personification of their time. First of all, there was a single ideal, his own wife whom he painted in every possible way, wearing a suit, draped in a Spanish shawl, wearing various outlandish hats. Gradually, pursuing his work of aesthetician, Matisse gave us this new Eve with the long legs, rounded thighs, wasp waist and pronounced bust which through the flat surfaces and curving arabesques betrayed the eternal desire of man. In this respect, are not the two versions of *Dancer Sitting* (pp. 204–205) archetypes rather than dancers?

If Matisse could not conceive of a paradise without goddesses the same applied equally to music, music preferably as a source of tranquillity. In his 1939 version of *The Music* (p.191), Matisse associated two indispensable elements, and took the opportunity to introduce a new theme, the female pair used as a contrast between two models, two poses, two different costumes. It was a sort of female duplication with a flavour of Madame Bovary. The perfectly ordered structure was the result of the personal transformation performed by Matisse on the Ingres-like drawing which he had used more precisely in the *Portrait of Mademoiselle H.D.* and in *Lady in Blue*. In *The Music*, in yet another about-turn, Matisse returned to the well-defined contours of the monumental nudes of the 1907–1917

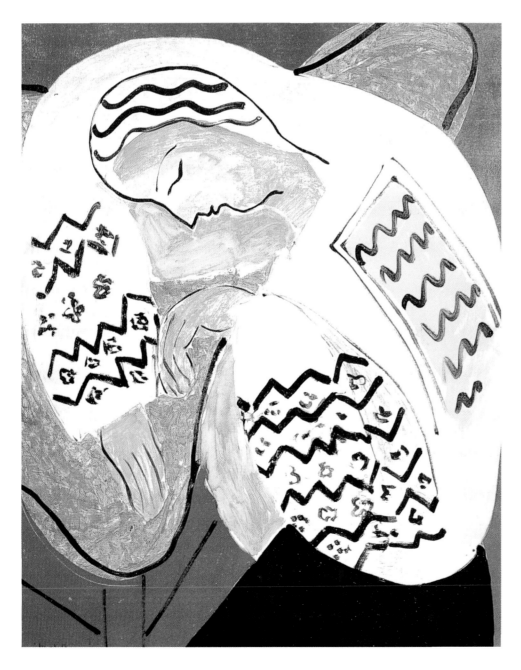

Themes and Variations, F3, 1941
Thèmes et variations, F3
Pen and ink, 52 x 40 cm
Musée de Grenoble, Grenoble

Themes and Variations, F5, 1941
Thèmes et variations, F5
Pen and ink, 52 x 39 cm
Musée de Grenoble, Grenoble

The Dream of 1940, 1940
Le rêve de 1940
Oil on canvas, 81 x 65 cm
Private collection

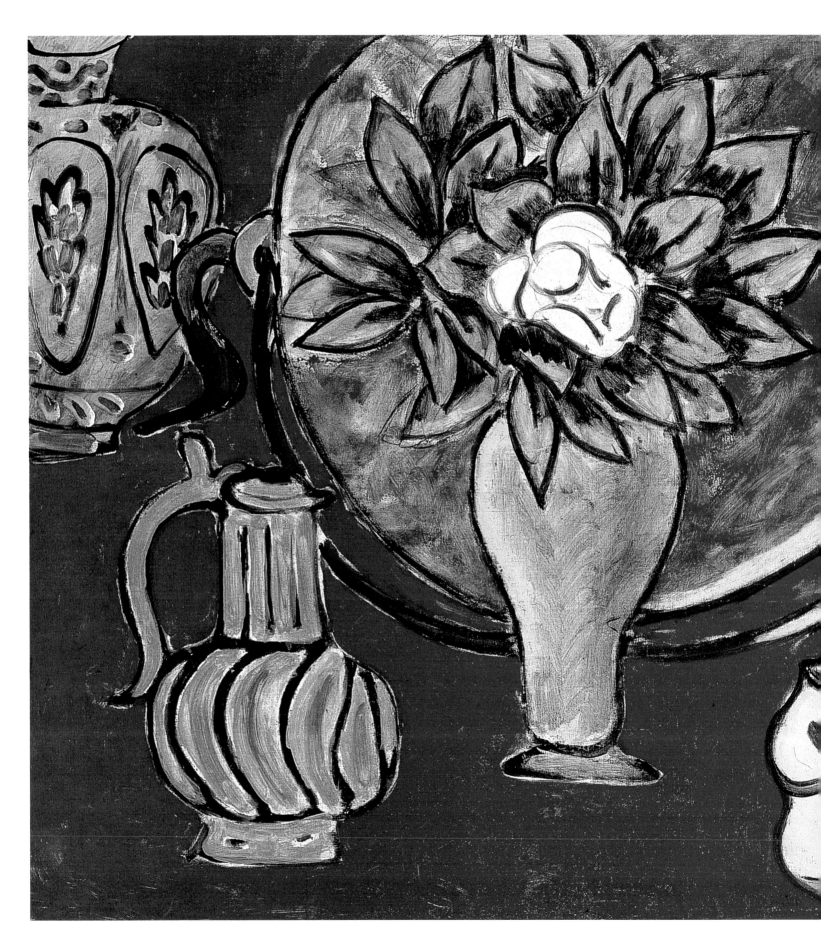

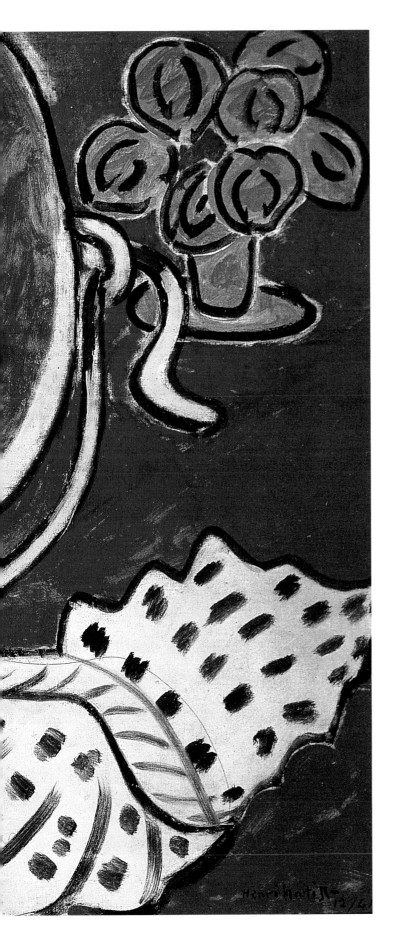

Sketch by Matisse published in *Verve*, 1945
Pen and Indian ink
Private collection

Four stages of *Still Life with a Magnolia*, 1941

Still Life with a Magnolia, 1941
Nature morte au magnolia
Oil on canvas, 74 x 101 cm
Musée National d'Art Moderne, Centre Georges
Pompidou, Paris

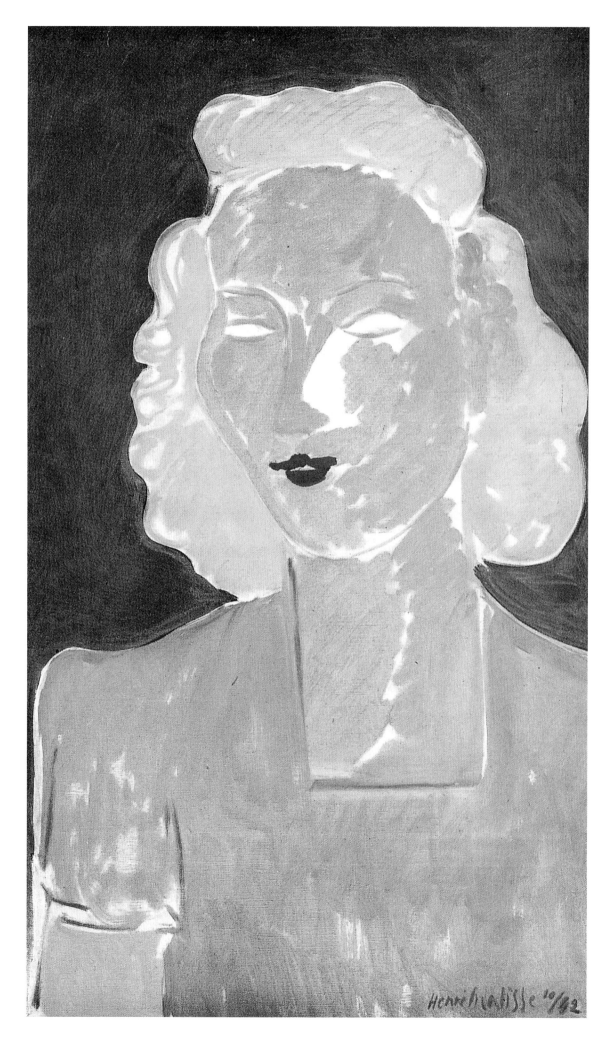

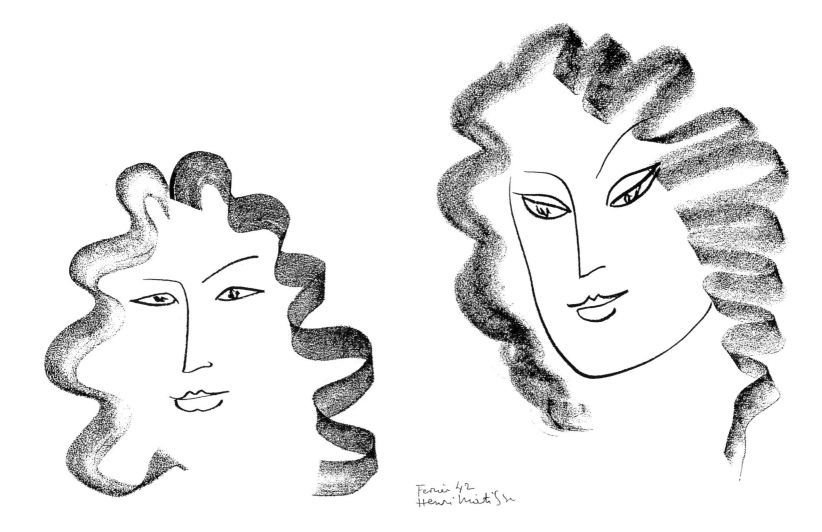

Mélanie 2, 1942
Red crayon, 52.5 x 40.5 cm
Musée Matisse, Nice

Three-quarter Face, 1942
Visage de trois-quarts
Graphite pencil, 52.5 x 40.5 cm
Musée Matisse, Nice

period, which proves, as if proof were needed, that Matisse always linked the past and the present and never ceased to use the same theme in all its forms. Here again, the photographs of the preparatory stages (p. 190) show the composition growing like a plant, the female musicians were pulled upwards and suspended against large floral cut-outs. *Woman in Yellow and Blue with Guitar* (p. 186) combines several habitual poses and reinforces its well-defined outlines in order to produce a meditation on silence which is "Mozart again" even when the orchestra has fallen silent. It would be to wrong Matisse to reproach him for not having painted strings on the guitar. It is a pointless remark if this is a painting which pays homage to silence, one which can be compared to the comment by the Renault car-workers who, when faced with the figures painted by Fernand Léger, asserted that "hands like that could never even hold a hammer!" Of course one cannot play a guitar without strings! Shades of Leonardo da Vinci, souvenirs of the Renaissance, obsession with realism, what stupid judgements have been made in your name!

Matisse made increasing use of photography in order to keep a record of the successive stages of his paintings. At first, only his closest associates had access to these documents, but soon, perhaps for teaching purposes or in order to prove that his masterpieces were the result of a long peregrination or of superhuman effort, Matisse agreed to show them publicly, in the same way that a conjurer might explain how a trick is performed. Thus, in 1945, the Maeght Gallery exhibited six of Matisse's paintings accompanied by their "photographic studies" dated and framed like his canvases. There were three versions of *Still Life with a Magnolia* (p. 197) and thirteen versions of *The Romanian Blouse* (p. 193), proving the importance which Matisse attached to this evidence of his hard work. "I have my idea in my head, and I want to achieve it. I very often want to redesign it... But I know what I want to achieve. Photographs taken while the work is in progress enable me to know whether the last concept is closer than the previous

PAGE 198:
Young Woman in Pink, 1942
Jeune femme en rose
Oil on canvas, 55 x 33 cm
Private collection

ones, whether I have progressed or regressed." (to Léon Degand, *Les Lettres Fran-çaises*, October 1945).

This was a novelty and even a complete innovation which made its mark on the art press. Claude Roger-Marx wrote on this occasion in *Arts et Spectacle*: "For its inauguration, the Maeght Gallery took the happy initiative of hanging, or rather exhibiting on the great day, an exciting conversation piece. It obtained from one of the most refined of all colourists – the fascinator of a younger generation which only has a hazy knowledge of Delacroix, Manet, van Gogh and Gauguin – recent canvasses and their preparatory sketches. These confessions are all the more surprising since Henri Matisse substituting for perspective, for the style of modelling used in the Western world and any literal representation, flat areas of colour filling in shapes, multiplications of cursive transpositions and emphasis of distortions, practising in the eyes of the masses the opposite of what used to be called a 'complete' painting. Four figures and two still lifes – *Young Girl in a Cape, Sleeper at the Violet Table, France, The Peasant Blouse (The Roma-nian Blouse), Still Life with Shells* and *Still Life with a Magnolia* – were collected in the Rue de Téhéran, surrounded by photographic enlargements which were framed like canvases in order to demonstrate the vicissitudes through which they

LEFT:
Reader on a Black Background (The Pink Table), 1939
Liseuse sur fond noir (La table rose)
Oil on canvas, 92 x 73.5 cm
Musée National d'Art Moderne, Centre Georges Pompidou, Paris

Nude (W. J. the Model), 1939
Nu (modèle W. J.)
Charcoal, 48 x 37.5 cm
Private collection

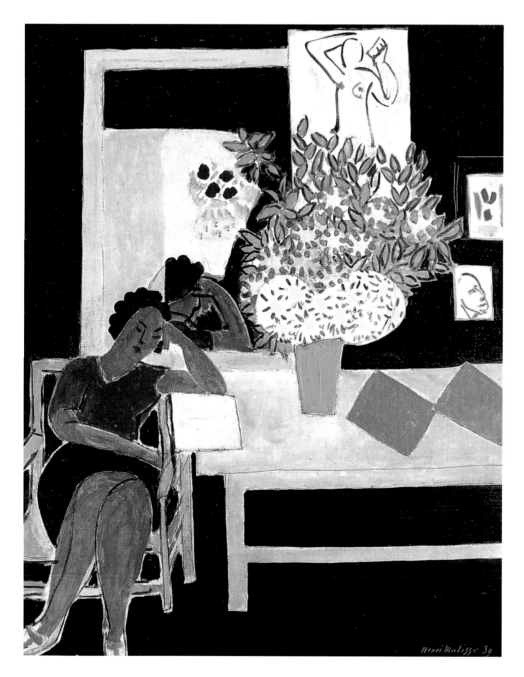

PAGE 201:
Brassaï: Matisse and his model, Wilma Javor, a young Hungarian woman, in the studio in the Rue des Plantes, 1939.

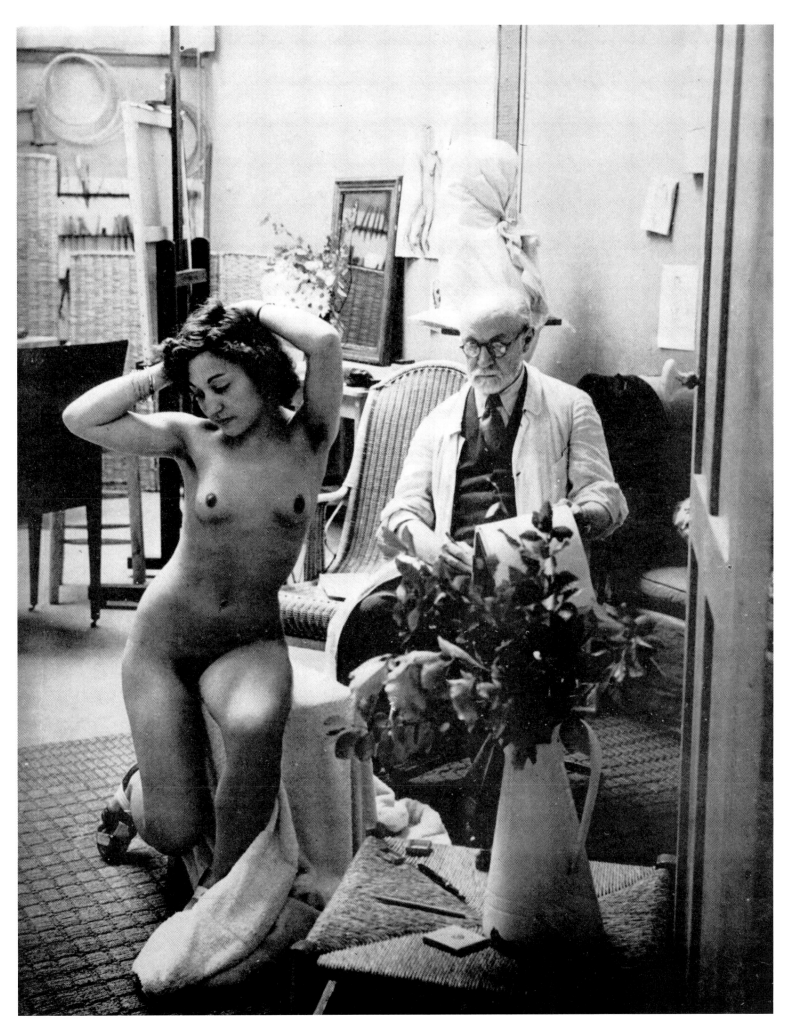

had passed. To borrow the vocabulary of the engraver, these are successive stages. We are witnessing a birth in slow motion and can see how the rhythms and values are gradually changing before our eyes, how the distribution of the occupied and empty spaces has changed, the same quality of space takes on a different density, volumes are reduced or amplified, a particular ornament is better defined or disappears altogether, a particular background is furnished or made plain, a particular dominant is allowed greater effect or is reduced to silence. Matisse, through this method of presentation, wanted, I think, to show that very few paintings are so carefully strived for – and thus so complete – as his own, and that this is achieved by making sacrifices, by amplifications and by the introduc-

Interior with an Etruscan Vase, 1940
Intérieur au vase étrusque
Oil on canvas, 73.6 x 108 cm
The Cleveland Museum of Art, Cleveland (OH)

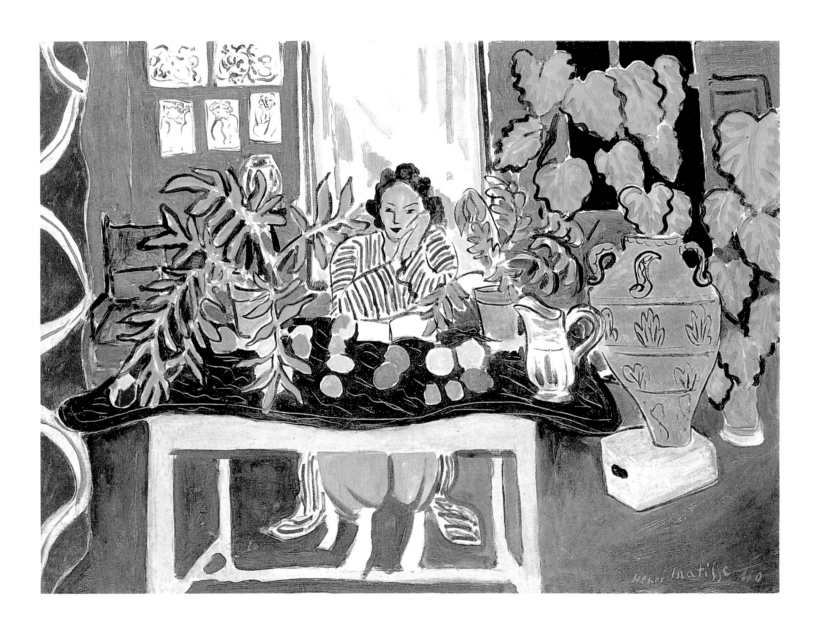

PAGE 203:
Two Young Girls, the Yellow Dress and the Tartan Dress, 1941
Deux jeunes filles, la robe jaune et la robe écossaise
Oil on canvas, 61 x 50 cm
Musée National d'Art Moderne, Centre Georges Pompidou, Paris

tion of new plastic elements, until the result satisfies him. Once again, he insists on proving that he does not need attractive features or easy charms and that the gifts of the harmonist are far less important in his eyes than his abilities as an organiser…"

The Dream of 1940 (p. 195) is an echo of *The Romanian Blouse* (p. 192). In fact, Matisse hung them in his own home on either side of the painting of *The Serf*. The theme of the embroidered blouse, whose patterns were very much to Matisse's taste, had been used for numerous drawings since 1936. As in *French Window in Collioure*, which heralded the start of the 1914–1918 War, these opposing atti-

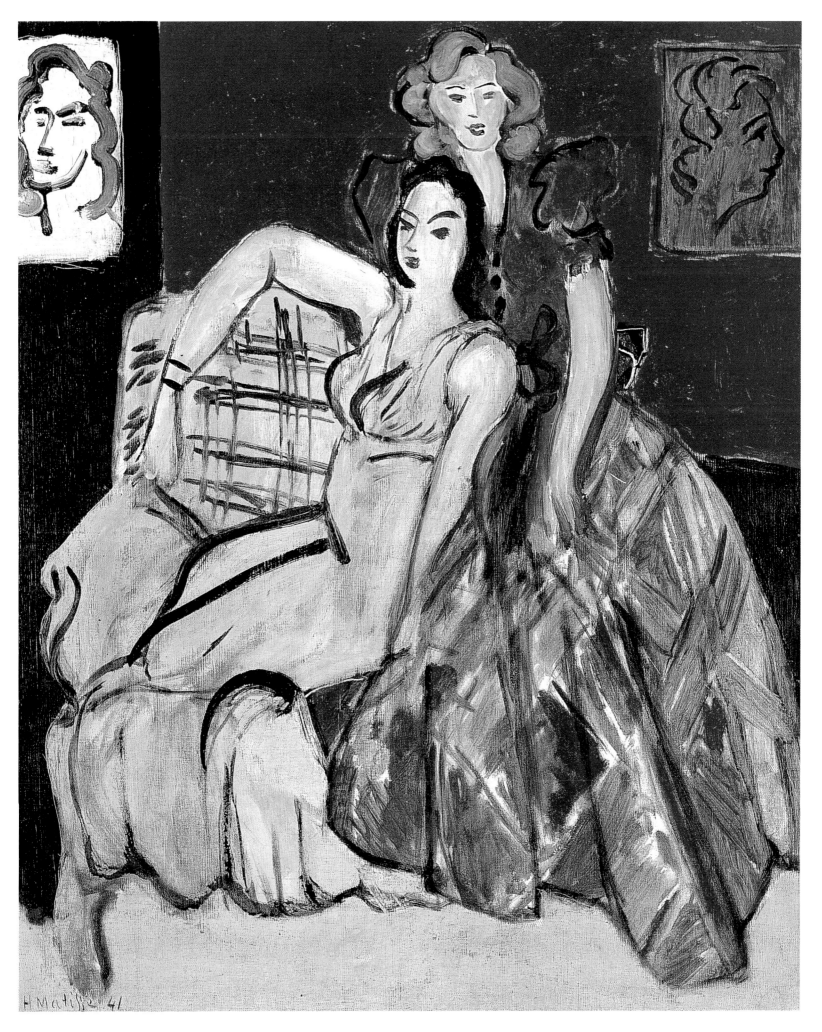

tudes of the open wings of *The Romanian Blouse* and the folded ones of *The Dream of 1940* have been considered as the plastic, unconscious translation of the ambivalence of the feelings aroused in Matisse during those troubled times. As he has written, he was both deeply disturbed by the situation in France and determined to be hopeful, to resist, by continuing to work and choosing to stay there. He had been invited to go to Brazil but he refused to leave. "I would feel as if I were a deserter. If everything of value escapes from France, what will remain of France?" he wrote to his son, Pierre, on 1 September 1940. He also declined an invitation to San Francisco.

His studio contained the elements of the paradise of which he dreamed. There was a huge aviary filled with rare birds including cooing turtle-doves. Familiar objects accumulated on the furniture, favourite ornaments which he enlarged in his paintings, the copper pot which he used in *Still Life with a Magnolia* (pp. 196–197) which was his favourite painting at the time ("I think I have given the maximum of my strength," he said of it), precious vases, African masks and Chinese pottery, tropical shells, lemons, oranges and dried gourds, lush vegetation and the exuberant foliage of massive rubber-plants… But the effect of this troubled period can be felt in the way in which the return of black is organised. Black made its appearance in 1914 as the dominant colour in a whole series of paintings from *Reader on a Black Background* (p. 200) to *Young Woman in Pink* (p. 198). *Two Young Girls, the Yellow Dress and the Tartan Dress* (p. 203) and even in the series to *The Dancers*. In the midst of the reflections, mirrors, paintings within paintings, contrasting dresses, flesh and fabric which match each other,

Dancer Sitting in an Armchair, 1942
Danseuse assise dans un fauteuil
Oil on canvas, 46 x 33cm
Private collection

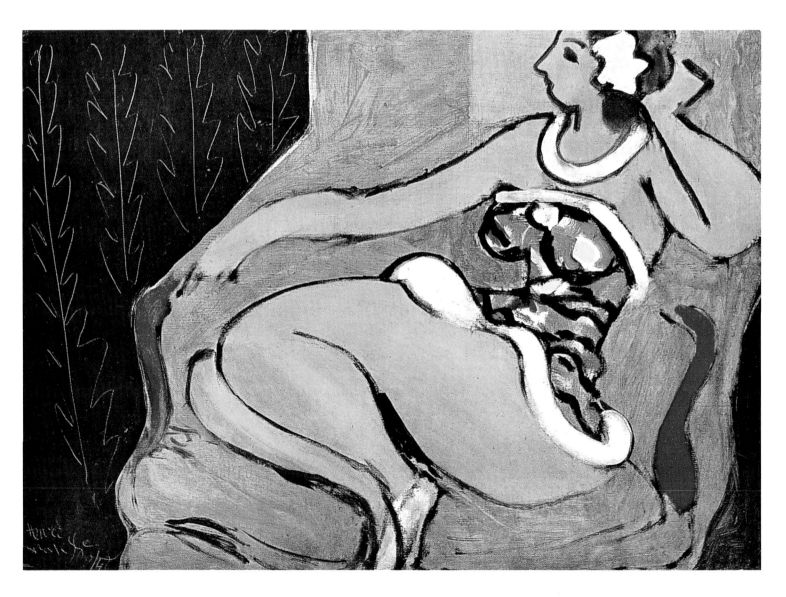

and so on, all of them customary devices, black itself plays a special role. Oriental painters used it, especially the Japanese in their prints. Manet was a master at subjugating it. "It comes back to me," he explained, "that the black velvet waistcoat of the young man in the straw boater is of a frank and luminous black. In the portrait of Zacharie Astruc by Manet, there is another black waistcoat also expressed in a frank, luminous black. Doesn't my panel *The Moroccans* also contain as bright a black as the other colours in the painting?"

This period of Matisse's work begins with Ingres and ends with Manet. "Like every development," explained Manet, "that of black in painting has progressed in fits and starts. Yet ever since the Impressionists, there has seemed to be continuous progress, playing an ever greater part in the orchestration of colour, comparable to that of the double-bases which is finally allowed to perform solos."

"This is how these strange loves have continued from armchair to armchair, the romance continues…," commented Aragon in his *Novel*, commenting this time on "Madame Bovary as armchair…" Is it a woman? An animal? For Aragon-the-poet Matisse's portrait of *The Rocaille Armchair* (p. 207) becomes a sort of obsession. For him it is resolutely masculine. Is it the portrait of Don Juan or at least that of Casanova? In fact this "leading man" or "gigolo" (according to Aragon) is a sequel, with a gap of a few years in between, to *The Arm* (p. 176). It has the same arms as in *Pink Nude* and *The Dancers (Dancer, Rocaille Armchair…)*. Aragon sees it as a partner to Matisse's beauties. But it can also be considered as one of them and forms a sort of female couple with them similar to that in the *Young Girls*. Antonin Artaud, faced with *Gauguin's Armchair* by van

Dancer Sitting on a Table, 1942
Danseuse assise sur une table
Oil on canvas, 46 x 33 cm
Private collection

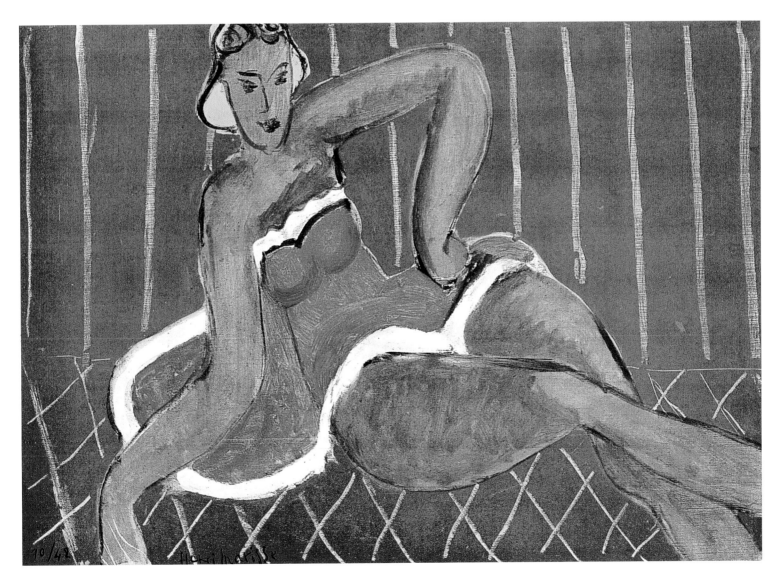

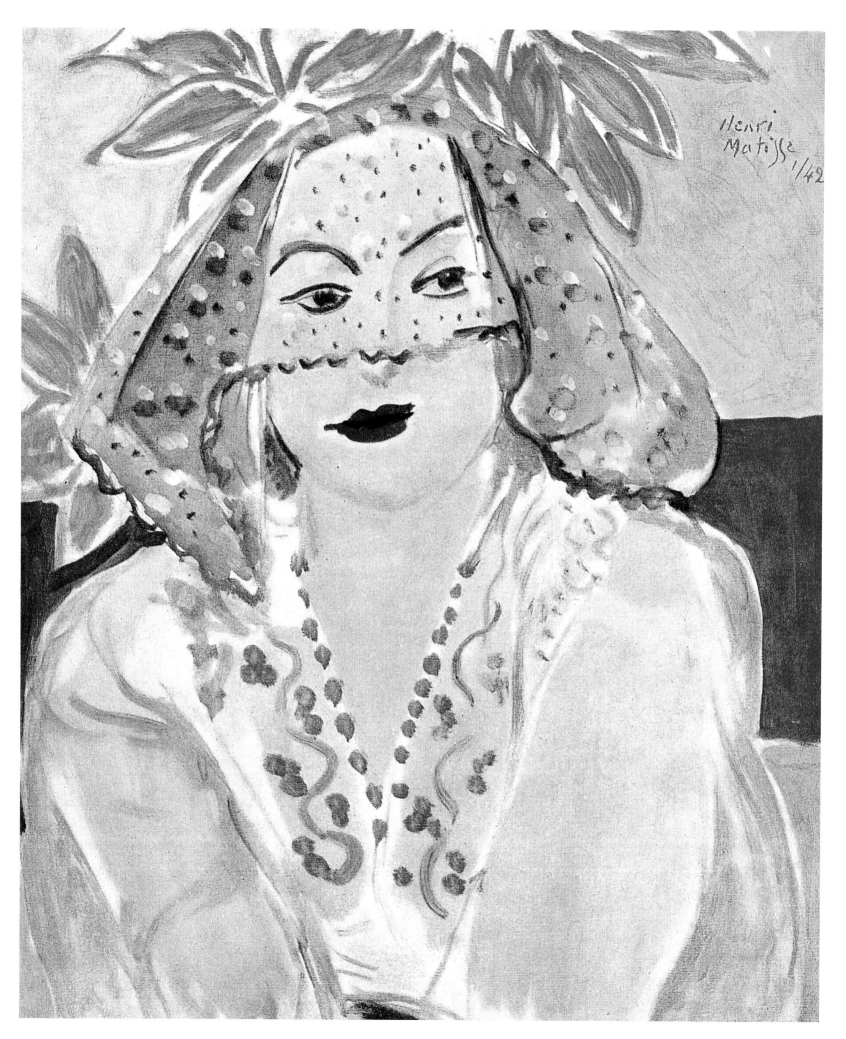

Gogh, saw a drama: "A candleholder on a chair, a rush-seated armchair, a book on the armchair; light is thrown on the drama. Who is about to enter? Will it be Gauguin or some other ghost?" (*Van Gogh, Society's Suicide*). There is nothing dramatic in itself in Matisse's armchair, an animal of reptilian tendency or a sleeping Fauve, apparently inoffensive, with a bouquet of flowers dropped on its knees. It looks rather like a delightful household pet whose mistress, a courtesan no doubt, is stroking... This object appears to contain no sign of metaphysical anguish. Yet a question remains unanswered: will the woman who is going to sit in it be naked or dressed?

The Rocaille Armchair (Sketch), 1942
Le fauteuil rocaille (Esquisse)
Oil on canvas, 61 x 46 cm
Private collection

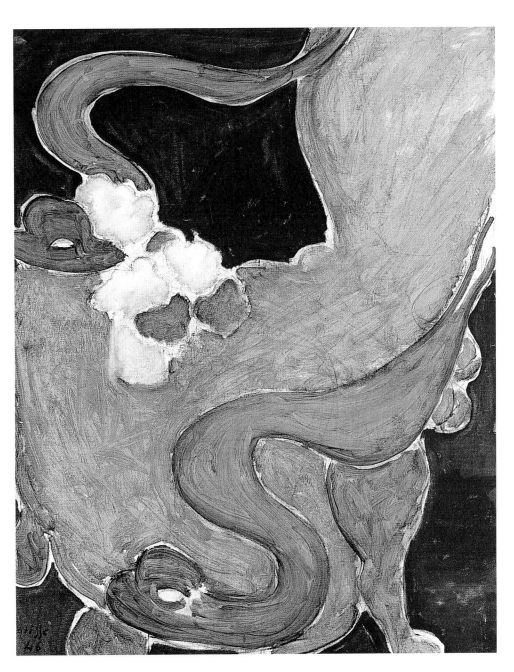

The Rocaille Armchair, 1946
Le fauteuil rocaille
Oil on canvas, 92 x 73 cm
Musée Matisse, Nice

PAGE 206:
Woman with a Veil, 1942
Femme à la voilette
Oil on canvas, 55 x 46 cm
Private collection

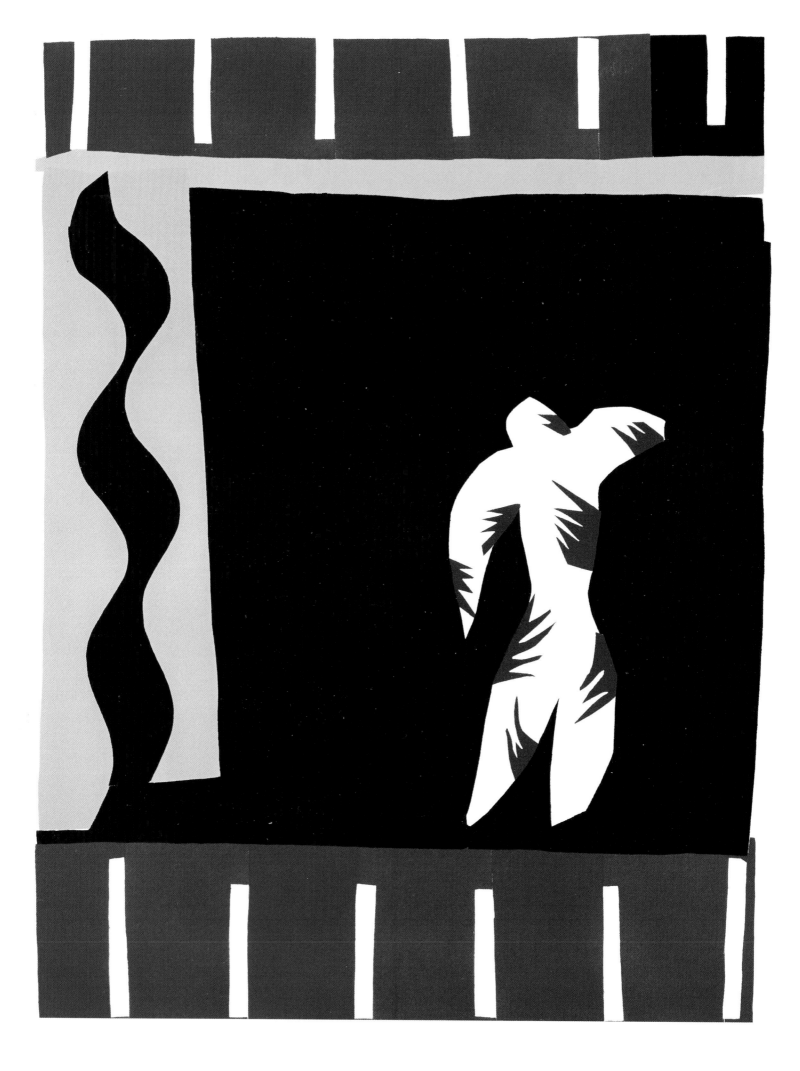

The Testament of Pharaoh

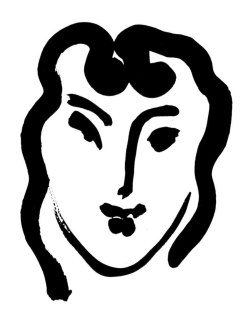

O nly someone like Matisse, who had mastered the arts of both sculpture and painting could dare to apply the technique of statuary to the substance of painting by cutting into a block of pure colour. It was all the more natural for Matisse to draw with a pair of scissors, implying no notable change in his aesthetic. "There is no break," he explained, "between my former paintings and my cut-outs, only more of an absolute, more abstraction. I have obtained the form filtered down to the basics and what I have preserved from the object, which I once presented in the complexity of its space, is the sign which is enough and all that is necessary to enable it to exist in its own form and for the whole of what I have created." In an article written for *Verve* in 1945 and entitled "About Colour", Matisse had written the following about Ingres and Delacroix: "Both of them express themselves in 'the curve' and in 'colour'." He had discerned this common trait, one which was so close to his heart, between two such diverse painters and he perceived it in others as well. "Gauguin and van Gogh at a later stage would appear to have lived at the same time: curves and colour!"

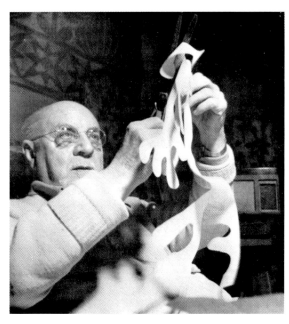

Patitcha Smiling, 1947
Patitcha souriante
Aquatint

Matisse in Vence with scissors and gouache cut-outs, 1947
Cameraphoto, Venice
"Cutting straight into colour reminds me of the direct cut of sculptors" (*Jazz*).

This association of colour with the curve had never been taken to such an extreme prior to Matisse, who used it to reduce a canvas solely to these two modes of expression. Hitherto, drawing and painting complemented each other in almost equal measure; henceforward they would work as equal partners by osmosis, each retaining the autonomy of the master's vision. Matisse could himself have adopted the words of Braque: "Shape and colour cannot be merged, there is simultaneity."

Matisse, it will be remembered, began his career as a result of appendicitis, when his mother gave him his first paint-box. Half a century later, it was another surgical operation that set him on the most glorious phase of his career. This terrible operation which he underwent at Lyons abruptly interrupted the flow of his output. Often obliged to work while lying down, he again began drawing and illustrating, first at Cimiez, then in Vence, where he settled in 1943 in the villa aptly called "La Rêve" ("The Dream"). It was then, when he had difficulty manipulating colour, that he began to resort to paper which had previously been prepared by coating it all over with a colour wash and which he then cut into shapes. This is how the extraordinary picture book called *Jazz* (published in 1947) was born. It consisted of "chromatic, rhythmic improvisations" – such as might have been performed by Louis Armstrong or Charlie Parker – as he transferred to paper his memories of the circus, folktales and his travels, turning them into vivid and violent images. To provide a link between them and make their contrasts less abrupt, Matisse wrote about them in his large, flowing handwriting, finding exciting ways in which to describe them: "Cutting straight into colour reminds me of what a sculptor does... My curves are not crazy..."

PAGE 208:
The Clown (Jazz), 1943
Le clown
Stencil

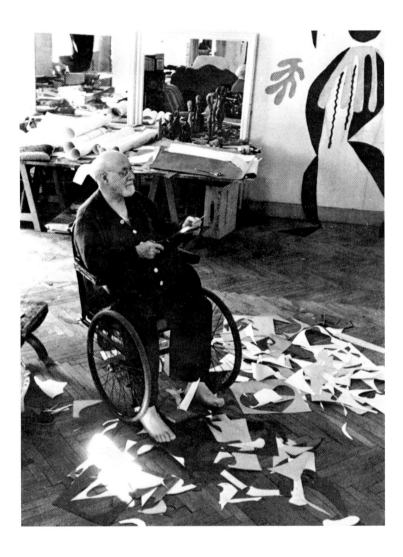

Matisse at work in his studio in Nice, 1952.
The Negress in its first stage hangs on the wall.

Small Torso, 1929
Petit torse
Bronze, height: 9 cm

Small Thin Torso, 1929
Petit torse mince
Bronze, height: 7.8 cm

This extraordinary man, crippled and supposedly lost to painting, yet again found the means of conquering his fate and seized the opportunity to work as he had always wanted in a manner which produced the total synthesis which he himself had invented. Using a simple pair of scissors and paper coloured to the exact shade he required, he solved the problems of form and space, of contour and colour, of structure and orchestration which he had always tried to reconcile, and he did so at a stroke. Better still, this new adventure enabled him to finally attribute their true importance – which he had hitherto sacrificed to colour and relationships of tones – to linear rhythms and shapes. "Paper and scissors," wrote Frank Elgar in *Carrefour* in 1953, "with all that their use requires in terms of frankness and rigour of design and execution, imposed rules, method, a dialectic, a method of creation which constrained him to greater vigilance and thus gave his style this coherence, this purity and austerity which makes us marvel at it today."

Realism and abstraction were finally reconciled at the end of a long development which proceeded from its own logic and not from some sort of laziness or the temptation to ape some contemporary current as some of the defenders of abstract art have had the impudence to claim. Matisse dispelled any equivocation

Shapes. White Torso and Blue Torso (Jazz), 1944
Formes. Torse blanc et torse bleu
Stencil

when he wrote: "I draw in colour," and when he explained to André Lejard: "I am currently turning to materials that are more matt, more immediate, which leads me to seek a new means of expression. Paper cut-outs enable me to draw in colour. This is a simplification for me. Instead of drawing the outline and placing colour within it – one modifying the other – I am drawing directly in colour which is all the more defined since it is not transposed. This simplification guarantees precision in the union of the two methods which become one… It is not a departure but a conclusion."

An Olympian diversion, a flourishing in the twilight years, the frivolity of the sage… Such assessments and hasty judgements were not lacking in the period of coloured paper cut-outs. Georges Duthuit recognised that there might be some truth in them "as applicable to Goethe chatting to Eckermann as to the massive author of *The Magic Mountain,* leaving unfinished a picaresque novel." It does not prevent one from thinking of one of those "great artists turned into old men," recalled by Barrès, "in a hurry to explain, reducing their means of expression as their initials diminish in size and who reach the conciseness of enigmas or epitaphs."

The professional critics were troubled. Here they were confronted with a series of problems which left them stunned. They could not connect this new technique of painting to any which had gone before it as they were wont to do. The technique was completely new. It had never been tried before. One cannot even compare the collages of the Cubists who were merely trying to achieve a geometric effect created from various and unexpected materials. And yet it was enough to remember Matisse at his beginnings, whose teacher predicted that he would want to simplify painting too greatly; Matisse, the Fauve, who wanted "work to be borne of a pure confrontation of colours". *The Dance* and *The Music*, which he had painted for Shchukin all those years ago, may have been the inspiration, as was *The Dance* which he created for Dr. Barnes, those huge surfaces released from their surrounding shades. "Like those gods who point a finger at the sea," wrote Georges Duthuit in a pantheistic flight of fancy, "and a monster emerges or a fully-formed Venus, enclosed in their immaculate perfection, Matisse accomplished the supremely assured gesture – and it matters little that it was made more flexible through so many years of discipline – which released its morphology, that of the very freshness of invulnerable life. There was more material, organic thickness between Pygmalion and Galathea; nothing but the richness given and the arm which directed it. Nothing but this marriage in a moment so vital that it appears to be more eternal, between the soul of colour and the soul of the scissors."

To return to earth, in order to understand what Matisse was trying to achieve by sculpting in colour, one merely has to study the plate in *Jazz* called *Shapes. White Torso and Blue Torso* (p. 211) and compare it with *Small Torso* and *Small Thin Torso* (p. 210), both sculpted in 1929, in order to see how it operates and how, as was his custom, Matisse was able to draw on the past in order to produce his new creations. No doubt the book illustrator also made a contribution, influencing the sculptor in paper, constraining him to balance the two surfaces and juggle with shapes. Matisse said of his illustrations for the *Poems* of Stéphane Mallarmé: "I compare my two sheets to objects chosen by a juggler. Let us suppose, in relation to the problem in hand, one has a white ball and a black ball and on the other hand two pages, the light and the dark, so different yet facing each other. Despite the differences between the two objects, the juggler makes them into a harmonious whole in the eyes of the spectator." Similarly, when writing about *Jazz* he explained that not knowing what to put in between the paintings, he chose to use handwriting in order to "juggle" yet again. "Why after having written, 'Anyone who wants to devote himself to painting must begin by cutting out his tongue', do I need to use means other than those which are my own? This time I have presented my coloured plates under the most favourable conditions. In order to do so, I must separate them using gaps of a different nature. I considered that handwriting would best suit this purpose. The very large size of the writing seemed to me to be obligatory in order to relate decoratively to the nature of the coloured plates. These pages are thus merely used as an accompaniment to my colours, just as asters help in the composition of a bouquet of more prominent flowers. THEIR ROLE IS THUS PURELY VISUAL. What can I write? I cannot fill these pages with the fables of Lafontaine, as I did when I was a lawyer's clerk, when I was engrossing pleadings which no one ever read, not even the judge, and which were created purely so as to use as much stamped paper as was commensurate with the importance of the case. So all I could do was add remarks, notes taken during my existence as a painter. I beg you to grant them, those of you who have the patience to read them, the indulgence which is generally granted to the writings of painters…"

The disconcerted critics would have been even more bewildered if they had been told that in fact *Jazz* had an antecedent dating back to the Middle Ages. Yet that happens to be the case. In fact, apart from the painter's new mode of ex-

PAGE 213:
Icarus (Jazz), 1943. Stencil

The Apocalypse of Saint Severus, eleventh century, Folio 139

Jazz was published by Tériade in Paris in 1947 as a large format portfolio measuring 42 x 32.5 cm. The twenty colour plates were printed as stencils in 170 copies from gouache cut-outs by Matisse, using the same Linel inks as the artist. *Jazz* contains a whole repertoire of specific shapes such as the many-pointed stars, leaves and seaweed with deep cuts which are repeated throughout the plates like a theme. Curiously, these same shapes, or their ancestors, can already be found in an 11th century illuminated manuscript, the *Beatus of Saint Severus*. Matisse was certainly aware of this manuscript, since Mourlot, his printer, had produced a lithograph of it. There is no doubt that *Icarus* and the other plates in *Jazz* owe a great deal to the *Beatus* which in its day was one of the major sources of Romanesque sculpture, just as *Jazz* became one of the major sources of modern art.

PAGES 214–219:
The Circus (Jazz), 1943
Le cirque
Stencil

Some of Matisse's handwritten text for *Jazz*

The Sword-swallower (Jazz), 1943–1946
L'avaleur de sabres (Jazz)
Stencil

The Burial of Pierrot (Jazz), 1943
L'enterrement de Pierrot
Stencil

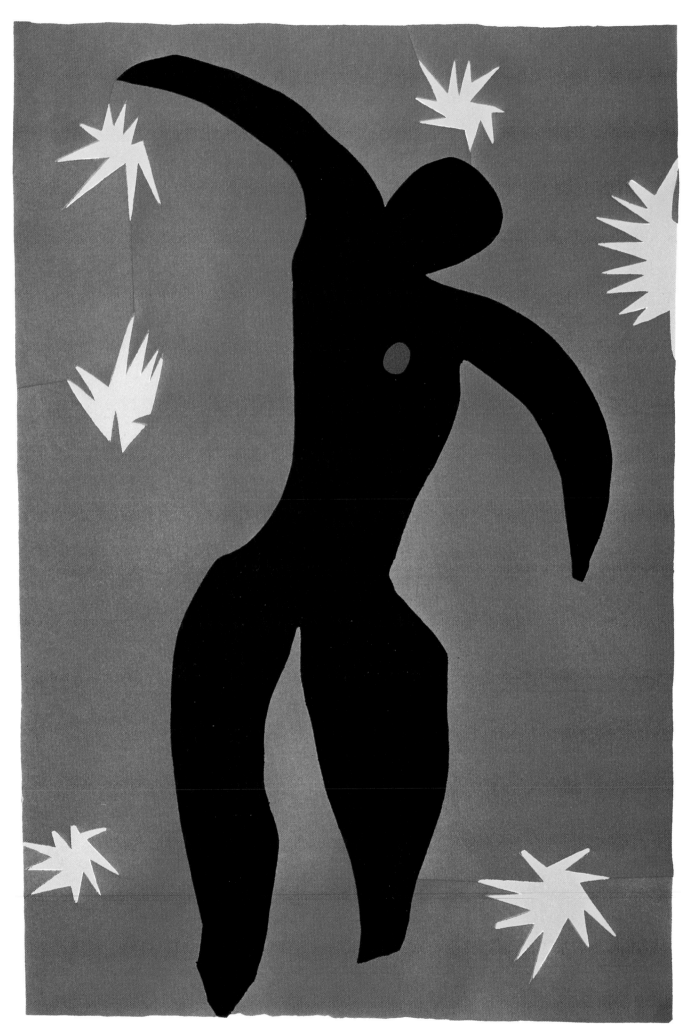

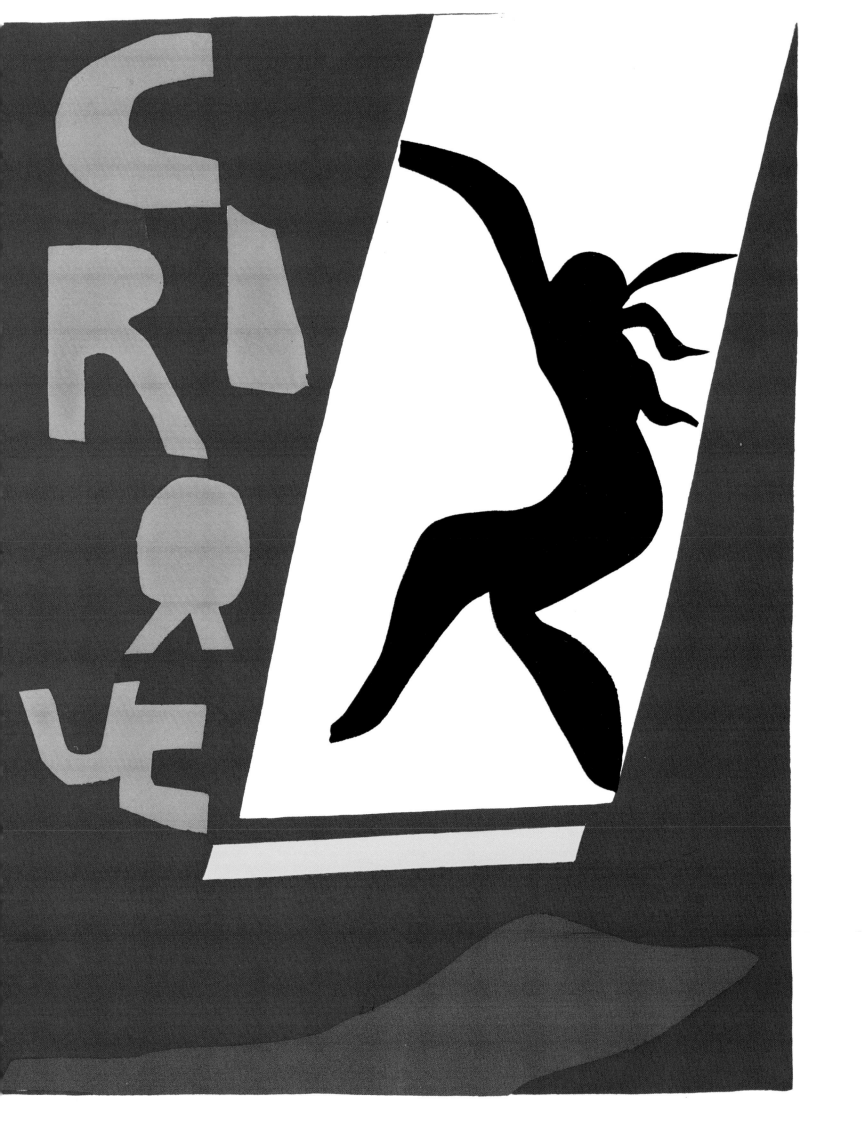

Mes courtes
ne sont pas
folles

Le fil à plomb
en détermi-
nant la direction
verticale forme
avec son opposée,
on
l'horizontale

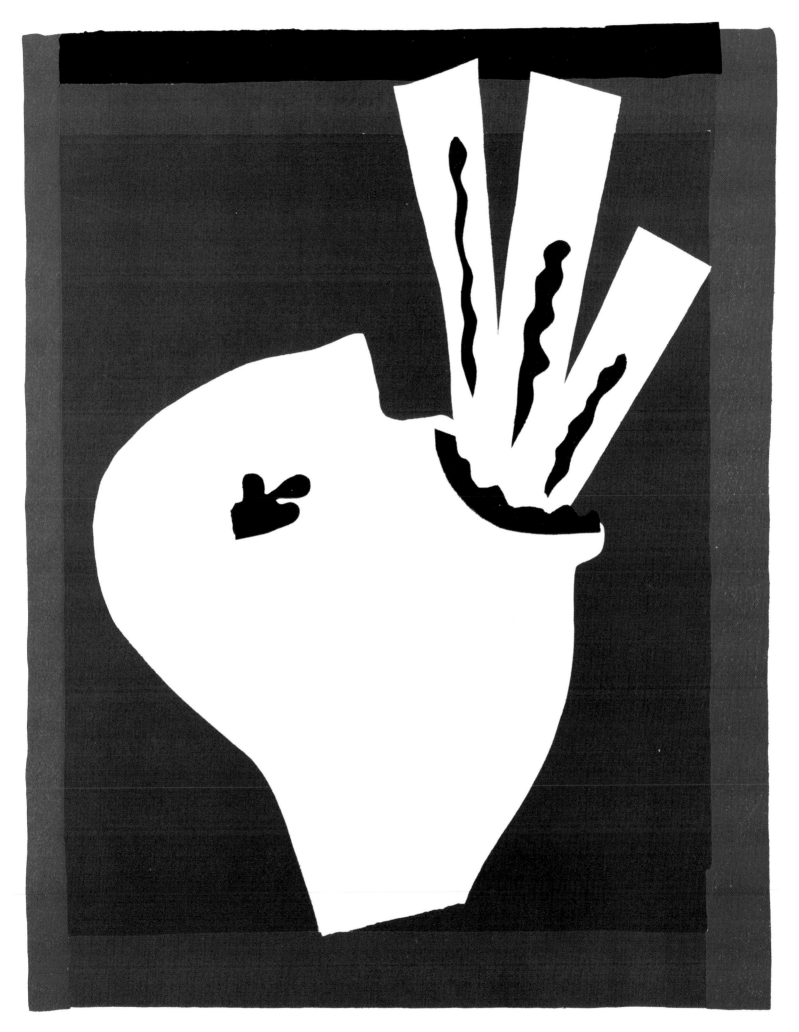

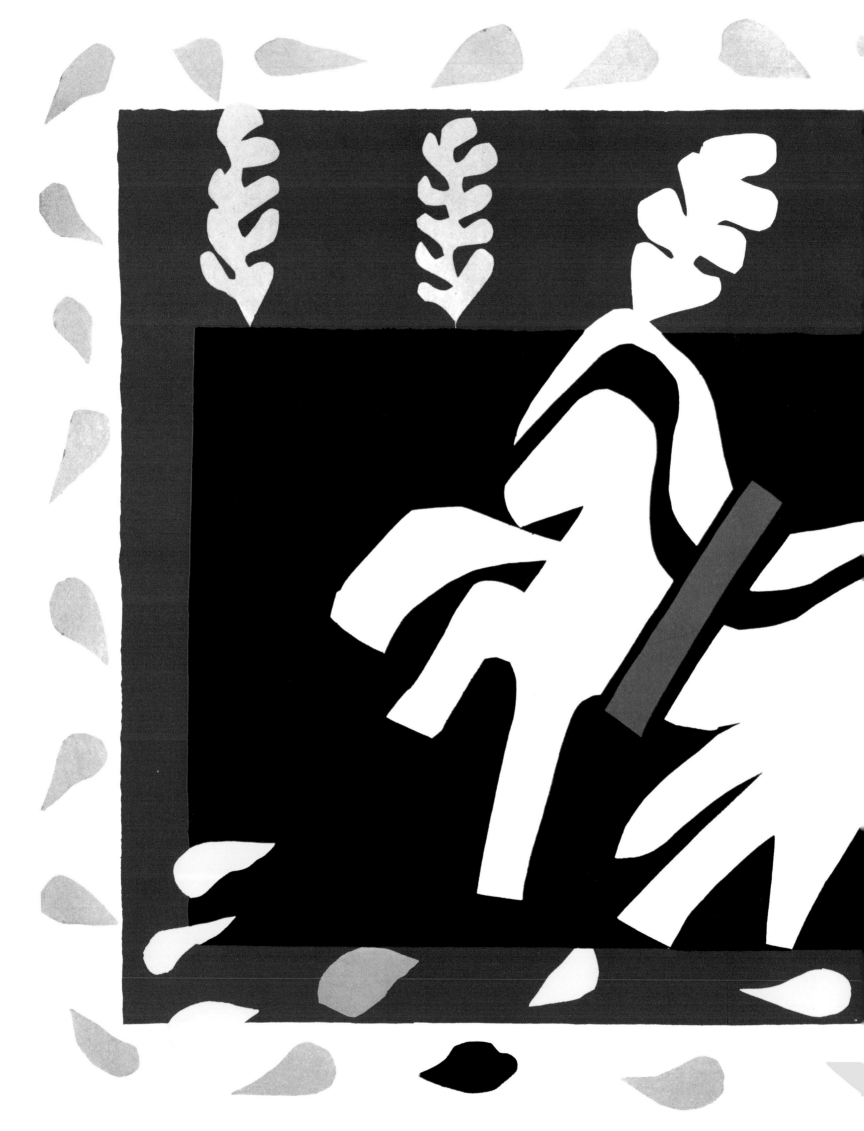

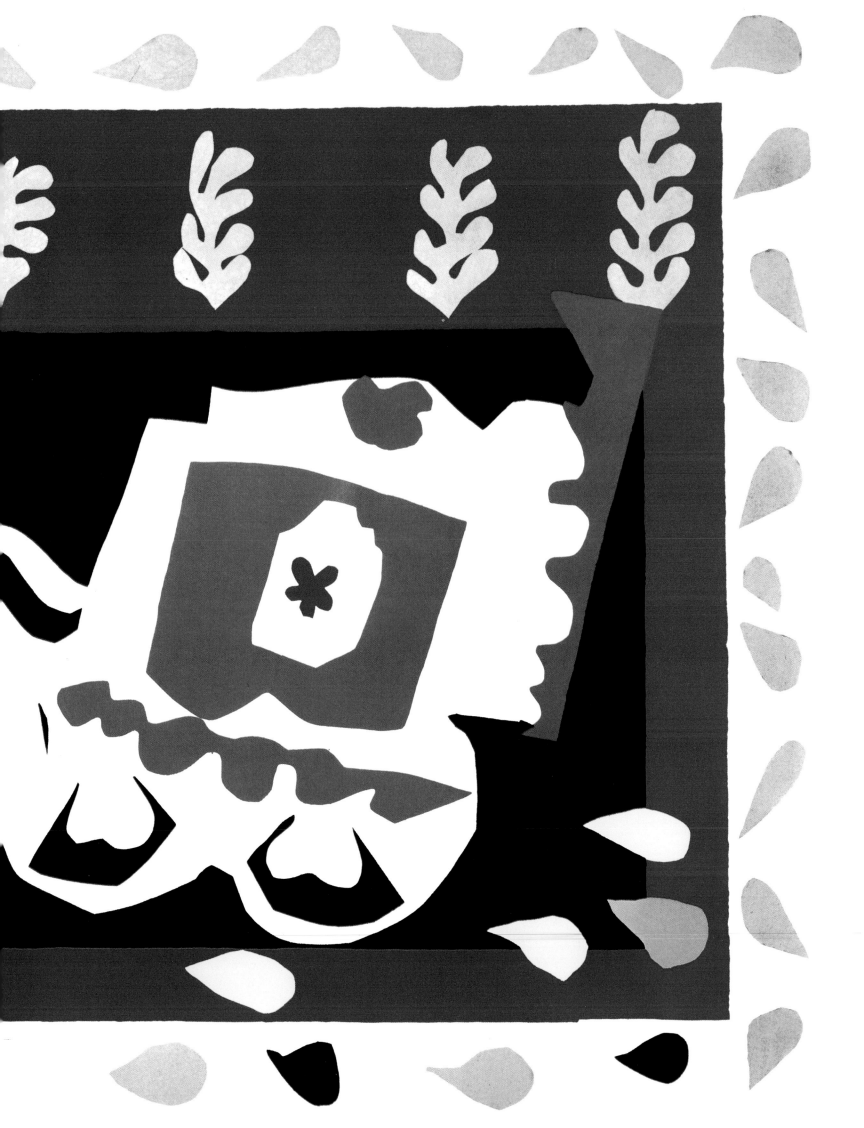

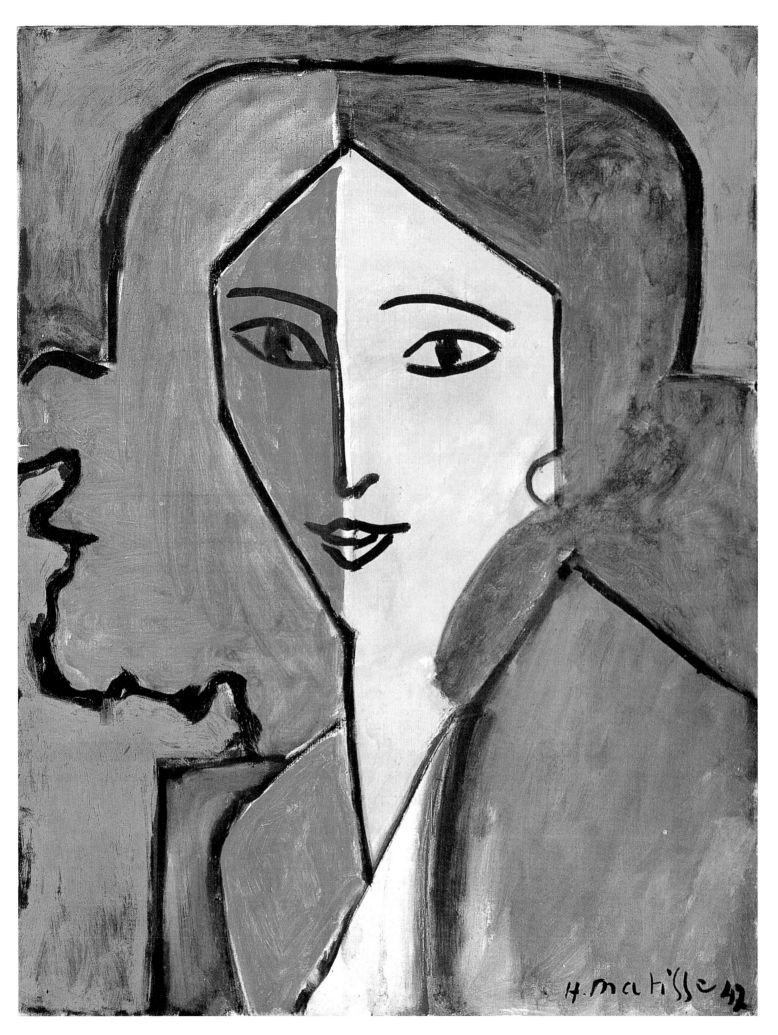

PAGE 220:
Portrait of Lydia Delectorskaya, 1947
Portrait de Lydia Delectorskaya
Oil on canvas, 64.3 x 49.7 cm
Hermitage, St. Petersburg

Jackie, 1947
Charcoal and stumpwork, 56 x 38 cm
Private collection

Composition with Standing Nude and Red Fern, 1948
Composition avec nu debout et fougère noire
Paintbrush and ink, 105 x 75 cm
Musée National d'Art Moderne, Centre Georges
Pompidou, Paris

pression, *Jazz* contains a whole repertoire of specific shapes such many-pointed stars (*Icarus* in particular, p. 213), leaves and seaweed with deep cuts which are repeated in many plates as a sort of theme, yet curiously, these same shapes, or their ancestors, were already to be found in an eleventh-century illuminated manuscript, the *Beatus de Saint Severus* (plate, p. 212). There is no evidence for any link between *Jazz* and the *Beatus*, both of which, 900 years apart, had a considerable influence on their time. The painter, Avigdor Arikha, writing in *Connaissance des Arts* in 1991, draws attention to this meeting. "Matisse's gouache cut-outs are known to have had a profound influence on contemporary art, whereas the *Beatus of Saint Severus* had more of an influence on sculpture. It was even one of the major sources of Roman sculpture, its 'pattern-book'. As Emile Mâle says: 'Sculptors found in these manuscripts both the secret of line and the repository of tradition, that is to say the sacred types and order of religious

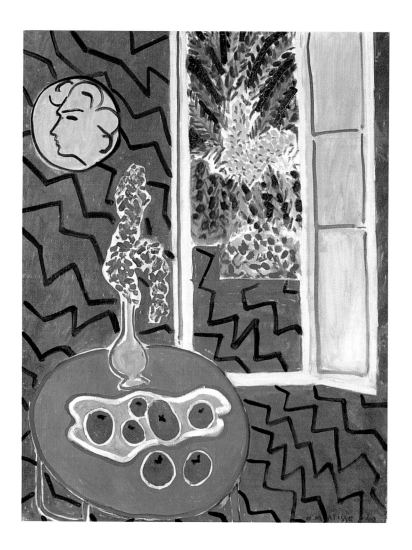

Red Interior: Still Life on a Blue Table, 1947
Intérieur rouge: Nature morte sur table bleue
Oil on canvas, 116 x 89 cm
Kunstsammlung Nordrhein-Westfalen, Düsseldorf

Black Fern, 1948
La fougère noire
Oil on canvas, 116 x 89 cm
Collection Beyeler, Basle

scenes', but only for the outlines, the figures. The coloration fell into oblivion while awaiting the mysteries of the atavistic Henri Matisse." "Cutting straight into colour reminds me of the direct cut made by sculptors," he wrote in *Jazz*, perhaps without considering that he had revealed a beautiful colour from the sleeping stone and brought it to life through painting. It is a long route, from the line to the cut, from the chisel to scissors and from stone to colour… Perhaps it was because colour, like sound, is concrete, that the painter who "decorated" the *Apocalypse of Saint Severus* also managed to substitute beatitude for eschatology. This is what Matisse did in sublimating the terrors of his time, nine centuries later. It is certain that Matisse was aware of the *Beatus* of which Mourlot, its engraver, had made lithographs. He spoke of it, quoting the "Apocalypse" in which the balance of colours which he sought had been sleeping for nine centuries and which he wanted to reveal and amplify. One needs to go back to this pre-Romanesque manuscript in order to find a similar stridency in the order of the book. Later, many other artists remembered the example, in France alone, a Lanskoy or a Nicolas de Staël.

Despite the considerable international furore caused by *Jazz*, Matisse was not satisfied at first and it took him some time to get used to the transposition of the technique of stencilling which the publisher, Tériade, used to reproduce the cut-outs and which cannot be reproduced in any other way, thus giving a result which is only an approximation. Even this approximation is very useful today because the colours of some of the original gouache cut-outs have deteriorated with time and Tériade's stencils have been used to restore the truth of Matisse. Matisse wrote to Tériade in 1944 on the subject of *Jazz*: "This penny toy is tiring me and my whole being revolts against its invasive importance!" Matisse was

nearly 80 years old but he sounds like a young man struggling to live. One might talk about this "old man crazy with drawing" in the manner of Hokusai, who was able to draw the living body of a woman in a single stroke (indeed, "his curves are not crazy") and it was through drawing that he found the means to recover his strength in his old age. In the same way, Matisse, on the point of dying and closeted by illness in his room at Cimiez, found that the ceiling over his bed was a white surface like a huge sheet of paper, so he fixed a piece of charcoal on the end of a fishing-rod and began to trace figures on the ceiling which released him from his suffering and the burden of having nothing to do (photograph p. 248).

Through prodigious energy and method, Matisse managed in fact to turn his life of a recluse into the most fertile and active of his existence. His days were so well filled, his strength so carefully meted out that he would still be able to complete huge projects. A fairly long remission from pain enabled him to resume the great effort of painting. This last royal flush of paintings lasted from 1946 to 1948 in an admirable progression as if Matisse wanted to give the completed version of each of his themes, the culmination of each of his techniques. It is a true pyrotechnic display in which the colours – and especially black – had never been used with such intensity, black not being present in order to darken but to brighten. Light is, in fact, not absorbed by darkness which, on the contrary, reflects it; at the same time, the intensity of the luminosity of the other colours is increased. The pale background of the canvas which shows through in certain places where it is not covered is an integral part of the composition, and there is thus a close connection between the background and the motif. The continuing alternation of negative and positive shades creates an easy interlinking between

The Pineapple, 1948
L'ananas
Oil on canvas, 116 x 89 cm
Collection Alex Hillman Family Foundation

Large Red Interior, 1948
Grand intérieur rouge
Oil on canvas, 146 x 97 cm
Musée National d'Art Moderne, Centre Georges Pompidou, Paris

The Egyptian Curtain, 1948
Intérieur au rideau égyptien
Oil on canvas, 116.2 x 88.9 cm
The Phillips Collection, Washington (D.C.)

PAGE 225:
The Silence Living in Houses, 1947
Le silence habité des maisons
Oil on canvas, 61 x 50 cm
Private collection

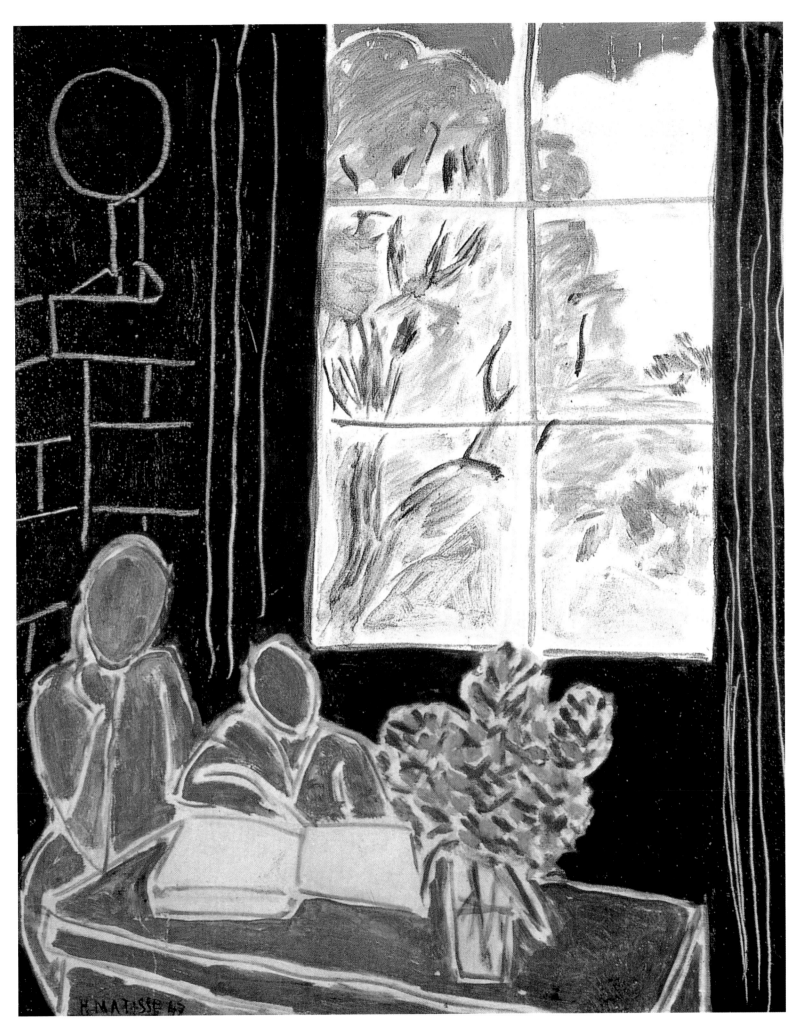

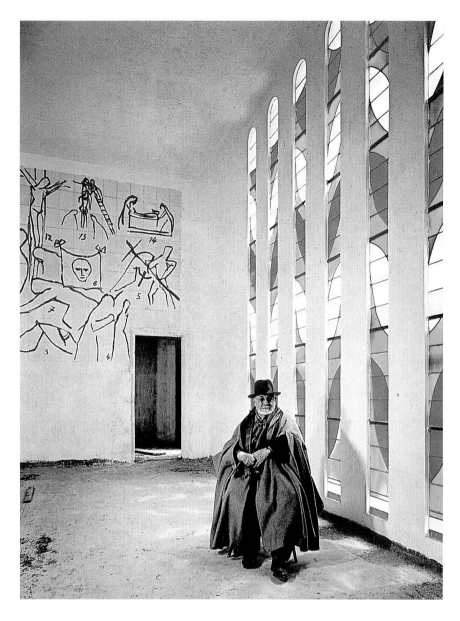

When Matisse was asked about his chapel, he said: "Do I believe in God? Yes, when I work. When I am submissive and modest I feel myself to be greatly helped by someone who makes me do things which are beyond my capability. Yet, I never feel grateful to 'him' because it is as if I were dealing with a conjurer whose tricks I cannot fathom. I find myself frustrated by having benefited from an experience which ought to be the reward for my effort. I am ungrateful yet unrepentant."

Matisse also explained: "My only religion is that of love of the work to be created. I created this chapel with the sole desire of expressing myself to the full. I had the opportunity of expressing myself in the completeness of form and colour. This work was like learning a lesson for me. I brought equivalents into play. I put into it a balance of materials of a humble nature and those of a precious nature. The multiplicity of plans became a unitary plan. One cannot introduce red into this chapel… Yet red is here and it is here through contrast with the colours which are here. It exists as a reaction in the mind of the viewer."

Dimitri Kessel: Matisse in the Chapel of the Rosary, Vence, 1949

Entrance to the Chapel of the Rosary, Vence, dedicated on 25 June 1951 by the Bishop of Nice

Interior of the Chapel of the Rosary, Vence
Left: the *Tree of Life* stained glass window
Right: Altar with Christ in bronze and ceramic dedicated to St. Dominic

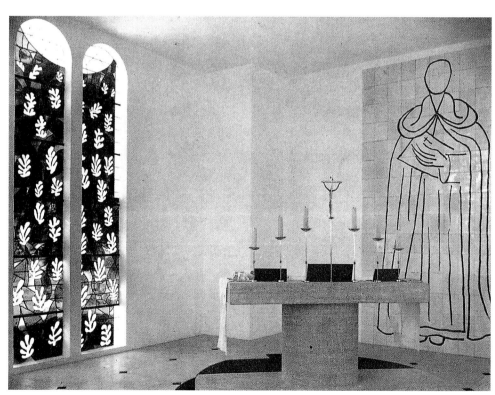

PAGE 227:
Pale Blue Stained Glass Window (Apse Window of the Chapel of the Rosary, Vence), 1948–1949
Paper painted with gouache and cut-out, stuck on brown wrapping paper, then on white cartridge paper, then stretched on canvas, 515 x 252 cm, in two sections
Musée Nationale d'Art Moderne, Centre Georges Pompidou, Paris

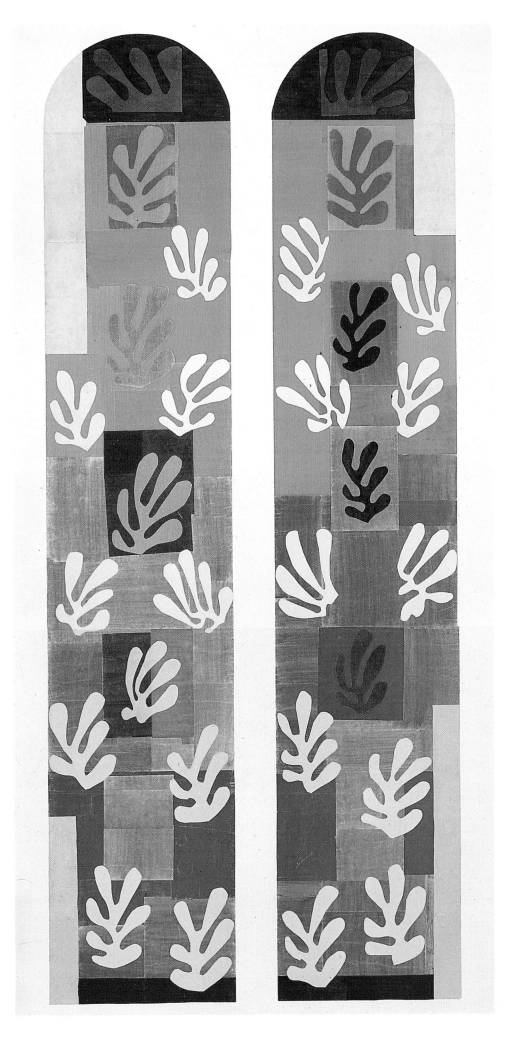

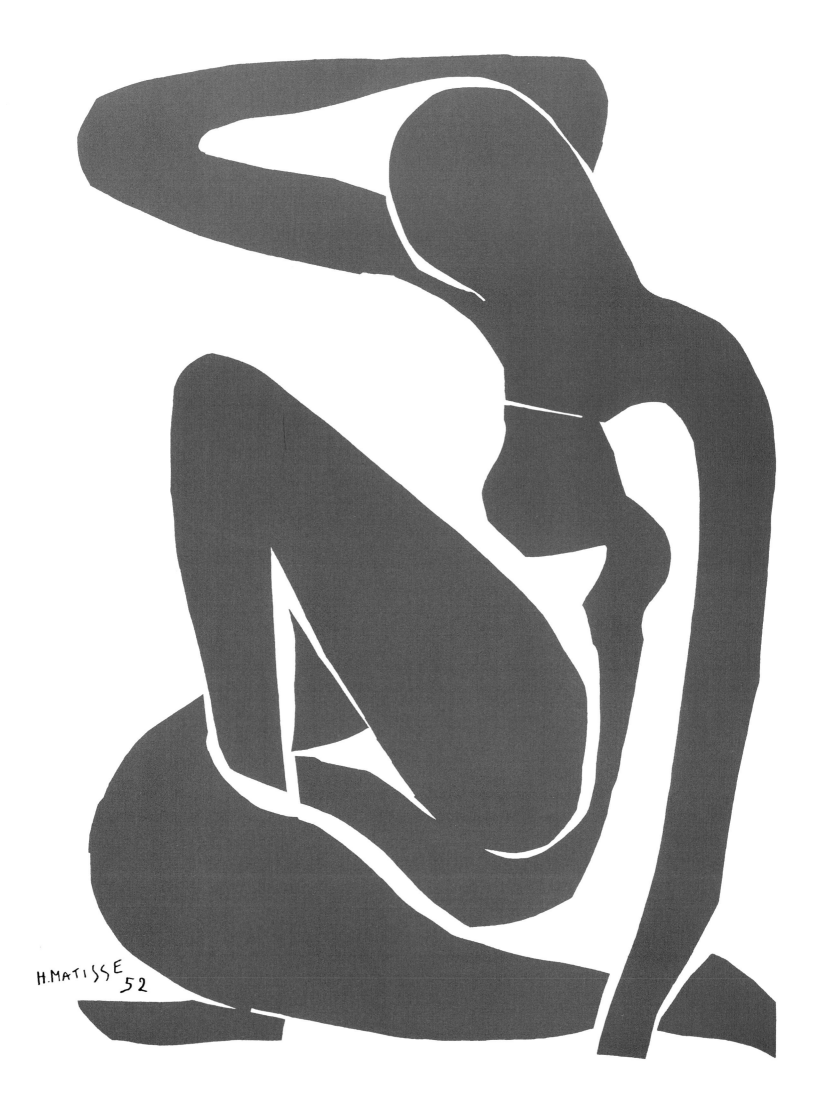

H.MATISSE 52

Venus in the Shell, 1930
Vénus à la coquille
Bronze, height: 31 cm

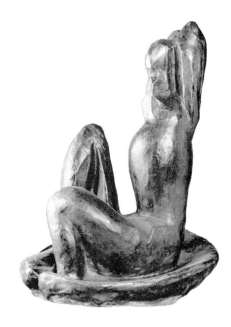

Three studies for *Blue Nude*, 1952
Ink
Private collection

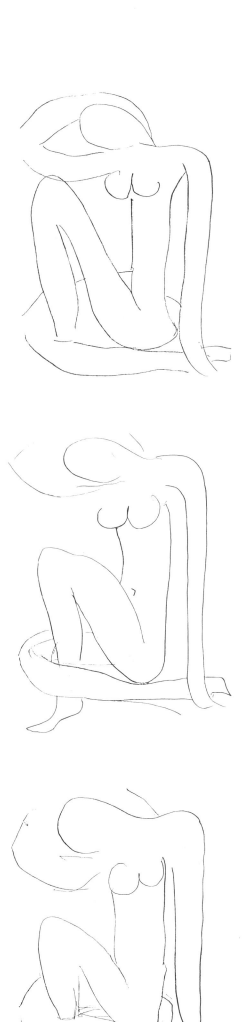

the depth of space and the surfaces. But such is the power of the actual gouache cut-outs themselves that one ends up regretting that a painting such as *Portrait of Lydia Delectorskaya* (p. 220), which is so admirably successful and finished, did not benefit from a second version, this time a cut-out! *The Silence Living in Houses* (p. 225) and the canvas which followed it, *The Egyptian Curtain* (p. 224), are almost the last paintings produced by Matisse who subsequently abandoned his brushes for good in favour of scissors. He returns here yet again to the theme of the window which he had used constantly for fifty years. One is reminded of his interiors of the 1920s. In the first of the two paintings, *The Silence Living in Houses*, paradoxically but easily mastered by Matisse, the intense light of the Midi has invaded everything. It is accentuated by the contrast between the landscape outside, described with precision, and the ghostly forms inside, reduced to bluish shadows. With *The Egyptian Curtain* the same theme is treated the following year, but here it is even more simplified, more stylised and yet very real, especially as regards the fruits which stand out in the foreground. The palm-tree, represented by an assembly of brush strokes, seems to be trying to cross through the window panes. The curved pattern on the curtain, as always, appears to compete with the straight lines to define space. There is such an economy of resources and at the same time such effectiveness in rendering almost palpable the feeling of light, warmth, penumbra and coolness! What more can one do, after one has lined up like beacons, the series of interiors including still lifes, when one has played yet again with all the colours all the possibilities (*Red Interior, Black Fern, The Pineapple, Large Red Interior*, pp. 222–223)? When a de Staël suddenly decides to commit suicide it is because, as he said himself, he has seen all his work in a single sky by Turner; he cannot go any further. Faced with the last canvasses of Matisse, one gets the feeling that he could not go any further using the resources of canvas and brushes. But unlike the Russian, Matisse found a way of reviving his energies through the need to invent something different…

Matisse analysed the state in which he found himself: "A musician said: in art, truth, the real begins when one no longer understands what one is doing and there remains within you an energy which is all the stronger because it is countered, compressed, condensed. It must then be presented with the greatest humility, completely blank, completely pure, candid, the brain seems to be empty, in a state of mind comparable to that of a communicant approaching the Holy Altar. Obviously one needs to have all one's acquired skills behind one and have been able to have retained the freshness of instinct." This new adventure as if it had been designed for a "disingenuous communicant" – Matisse would never have described himself as such – would take the form of a church!

Picasso was furious to find that Matisse was working on a church. "Why don't

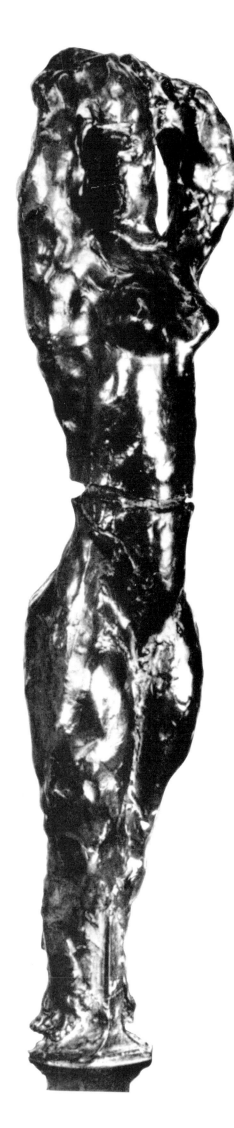

you decorate a market? You would paint fruits and vegetables in it!" And Matisse confided in Marie-Alain Couturier. "But I really don't care. I have greens that are greener than the pears and oranges, more orange than pumpkins. So what does it matter if he was furious?" Françoise Gillot witnessed the showdown between the two painters and reports that Picasso, still furious, insisted: "I would not object if you were a believer. If that is not so, then I do not believe you have the moral right." "For me," retorted Matisse, "all that is essentially a work of art. I meditate and what I undertake penetrates me. I do not know if I have faith or not. Perhaps I am more of a Buddhist. The main thing is to work in a state of mind that is close to that of prayer… I told Picasso: 'Yes, I do pray and you do too, you know it well. When everything is going badly, we throw ourselves into prayer to rediscover the atmosphere of our first communion.' And you do it yourself. He did not say no. These drawings need to come from your heart." "I am again walking on purified ground," Matisse said to the publisher Skira, speaking of the difference between his illustrations of the work of Ronsard and the chapel. Then, Skira remarked maliciously: "So you won't be painting any more little girls?" Matisse hesitated and answered: "I hope that I will…"

Matisse appears to have conceived the idea of embarking on this new venture, of undertaking the decoration of a chapel, when he was in the Clinique du Parc in Lyons when he was tended by a young Dominican nun, Sister Marie-Ange, while another young and beautiful Dominican allowed her pure profile to be used for drawings designed to illustrate *The Portuguese Nun*. Matisse used this new sanctuary to produce a unified work, to create an atmosphere which responded to the very spirit of the religious order for which it was destined. The pure lines of three motifs are outlined against a background of white tiles. There is a monumental *Saint Dominic* reduced to the perfect oval of his face and the folds of his cloak (p. 226), a *Virgin and Child*, a flower among other stylised flowers – a lot better than the carrots and pumpkins which had been suggested by Picasso – and a *Way of the Cross* (p. 226), a combination of the elemental signs which are no longer hidden as they are in the catacombs but exposed to the light of day. This austere Dominican symphony in black and white is only illuminated by

PAGE 230:
Nude Standing (Katia) with Broken Waist, 1950
Nu debout (Katia), la taille cassée
Bronze, height: 45 cm

Blue Nude Standing, 1952
Nu bleu debout
Stencil

Nude with Oranges, 1953
Nu aux oranges
Brush drawing with gouache cut-outs, 155 x 108 cm
Musée Nationale d'Art Moderne, Centre Georges
Pompidou, Paris

THIS PAGE:
Blue Nude with Skipping Rope, 1952
Nu bleu, sauteuse de corde
Stencil

Blue Nude with Green Stockings, 1952
Nu bleu aux bas verts
Stencil

Large Nude, 1952
Grand nu
Paintbrush and Indian ink, 210 x 80 cm
Private collection

The Negress, 1952–1953. Stencil

PAGE 234:
Creole Dancer, 1950
Danseuse créole
Gouache cut-outs, 205 x 120 cm
Musée Matisse, Nice

The Sea Creatures, 1950
Les bêtes de la mer…
Gouache cut-outs, 295.5 x 154 cm
National Gallery of Art, Washington (D.C.)

les bêtes de la mer...
H. Matisse 50

colour, depending on the time of day, through the transparent green and yellow stained glass of the windows. According to Matisse, the best time to visit the chapel is "in winter in late morning, when the light is clean and pure". The preparatory drawings for the stained glass, such as the *Pale Blue Stained Glass Window* (p. 227) were created from cut-outs, in the pure tradition of *Jazz*. In relation to the stained glass of his chapel, Matisse liked to quote *Jazz*. "These are the colours of stained glass. I cut out these painted papers as one would cut glass, except that these are arranged in such a way as to reflect the light, whereas for stained glass one needs to arrange them so that light passes through them."

Two years prior to his death, in 1952, Matisse declared: "It is from the creation of the chapel at Vence that I finally awoke within myself and I understood that all the relentless toil of my life was for the great human family which had to have revealed to it a little of the fresh beauty of the world through me." Compared to Notre-Dame what does this modest chapel represent for Matisse? "It is a flower. It is only a flower, but it is a flower…"

"No painter has ever tickled painting like Matisse until it bursts into such gales of laughter…" Picasso noted on the back of one of his own drawings in December 1951. Six months after the consecration of the chapel at Vence, Matisse was fully occupied in creating his last major monumental and pagan cut-outs, as if

he wanted, for the sake of good form, to balance and counterbalance the designs made for spiritual purposes with the creation of a universe peopled by "female plane-trees, of demi-god proportions". "The designs of this period have a wonderful sensuality," notes Aragon with relief, Aragon the Communist who had found the religious interlude rather disturbing, "of a purity of line and a simplicity which show the persistence, over and above the chapel, of the pagan cult of the woman…" It was towards the end of his life, "hastening like a traveller packing his last suitcases" (to Rouveyre, 1952) that Matisse wanted to communicate to us his last vision of earthly paradise. With his memories of the South Pacific, his languid or athletic giantesses, his floral compositions, like formal gardens, which have the freshness and perfume of "The Song of Songs".

Whatever their size, the last cut-outs are always "large compositions" because Matisse could only express himself through the infinity of shapes, his secret aim from the very outset which almost all were able to match was the layout for a huge composition. One thus stands on the threshold of Matisse's gigantic and heavenly world "which we enter through a magnificent avenue of plane-trees" (Aragon). The plane-trees even have a name – *Katia* (p. 230), the artist's last sculpture, reaches up to the sky like a tree and the model, a large, beautiful blonde, called herself "the plane-tree" for Matisse's sake. There is *Zulma* (p. 77),

A Thousand and One Nights, 1950
Les mille et une nuits
Gouache on cut-outs, 139.1 x 374 cm
The Carnegie Museum of Art, Pittsburgh (PA)

a large figure which is a souvenir of Morocco. *The Negress* (pp. 232–233), a work on which Matisse conferred a particular intensity by the use and presence of black and white gouache in an isolated shape, narrowed by light but animated with such a precise movement that despite the scale of the white background it is important enough to become the focus of an entire wall. The inspiration was the black dancer, Josephine Baker, the queen of "Les Années Folles" – the 1920s and early 1930s in Paris – who was made famous by the string of bananas around the waist which was all she wore and which might have been created by Matisse as if he had wanted to play with banana-like shapes. There are the famous *Blue Nudes* (p. 228), whose bodies are folded over themselves, in the pose which the painter used in his earlier work such as the *Odalisques* and sculptures such as *Venus in the Shell* (p. 229), completely filling the available space. Sometimes they are in movement as with the *Dancers* with their hair streaming out (p. 158), sometimes they are static, geometric, huddled, and these denuded "plane-trees" become part of the curvature in *Blue Nude with Skipping Rope* (p. 231). For one of them, the story goes, Matisse had run out of blue gouache so he extended the length of the leg using paper of another colour and it became the composition of the so-called *Green Stockings* which contains one of the painter's favourite combinations, green and blue. There is the joyful dynamism of *Creole Dancer* (p. 234), inspired by another dancer, Katherine Dunham, which draws its exuberance from the way in which the curves of this leaping plane-tree, this woman-bouquet moves against the background of an irregular chequerboard. And in the meantime, Sheherazade haunts the long horizontal panel of *A Thousand and One Nights* (p. 236–237) for which another of the inexhaustible memories of Matisse supplied the material, experiences registered twenty years or so previously, during a trip to the Pacific in 1930. "I was bathing in the Lagoon. I was swimming around the colours of coral… I plunged my head beneath the water, which was transparent against the absinthe blue of the Lagoon, my eyes wide open… and suddenly I lifted my head out of the water and fixed the whole brightly-lit scene in my memory." No longer able to move, no longer able to swim, he surrounded himself with water and with wonderful gardens by papering the walls of his flat with sketches of his works, and he spent days contemplating them and transforming them, scenes and landscapes which went "beyond" any scene or any landscape and even beyond a "painting".

It is this "beyond" which is evoked in the last works which were to take the form of this poignant yet serene farewell represented in *The Sadness of the King* (p. 240). This painting is the last of Matisse's great pictorial efforts, created with cut-outs and pasted down. It is the final salute of the artist – the artist being represented by the king, dressed in black, a guitar in his hand – to the world which surrounds him, to the themes which are so dear to him. Matisse had gathered them all together, including the dancer, around him, as if to bury himself with them, like a pharaoh of ancient Egypt. It is known that Matisse, without aspiring to make it into a testament but conscious of the scope of the work and the king's "profoundly pathetic expression" considered it to be superior to *Zulma* and the equal of his best work. As he approached death, Matisse was proud of "at last being able to sing like a child to his heart's content from the top of the mountain up which he had struggled". This is what Baudelaire had meant when he wrote: "Genius is merely childhood found again at will."

Henry Miller, in his *Tropic of Cancer* found the words to celebrate Matisse's art which has the same freshness as his writings. "Standing on the threshold of that world which Matisse had created, I re-experienced the power of that revelation which had permitted Proust to so deform the picture of life that only those who, like himself, are sensible to the alchemy of sound and sense, are capable of transforming the negative reality of life into the substantial and significant outlines of art. Only those who can admit the light into their gizzards can translate

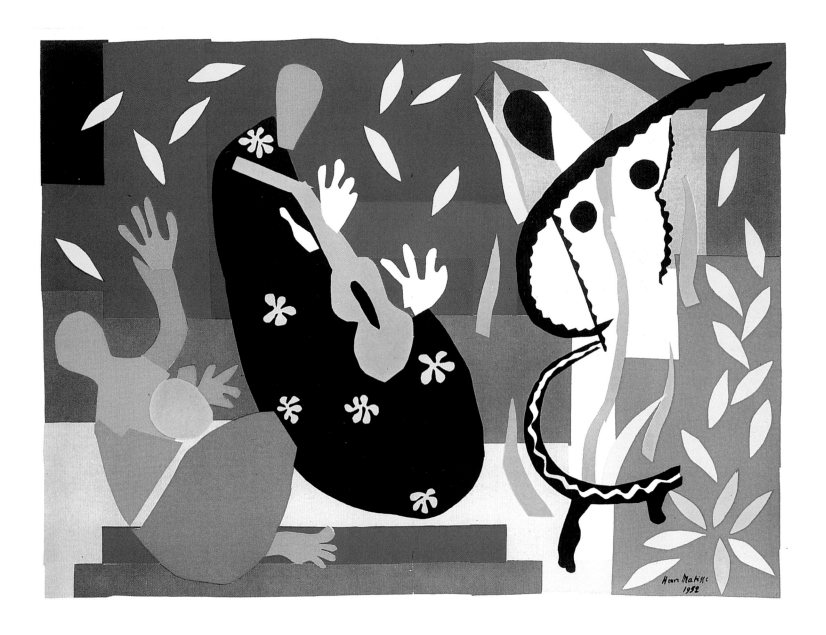

The Sadness of the King, 1952
Tristesse du roi
Gouache cut-outs, 292 x 396 cm
Musée National d'Art Moderne, Centre Georges
Pompidou, Paris

what is there in the heart… In every poem by Matisse there is the history of a particle of human flesh which refused the consummation of death… He it is, if any man today possesses the gift, who knows where to dissolve the human figure, who has the courage to sacrifice a harmonious line in order to detect the rhythm and murmur of the blood, who takes the light that has been refracted inside him and lets it flood the keyboard of colour… Even as the world goes to smash, there is one man who remains at the core, who becomes more solidly fixed and anchored, more centrifugal as the process of dissolution quickens… At the very hub of this wheel which is falling apart, is Matisse… The odalisques he had studded with malachite and jasper, their flesh veiled with a thousand eyes, perfumed eyes dipped in the sperm of whales. Wherever a breeze stirs there are breasts as cool as jelly, white pigeons come to flutter and rut in the ice-blue veins of the Himalayas… The world of Matisse is still beautiful in an old-fashioned bedroom way. There is not a ball-bearing in evidence, nor a boiler plate, nor a piston, nor a monkey wrench. It is the same old world that went gaily to the Bois in the pastoral days of wine and fornication…"

In the words of the two large volumes of *Henri Matisse, a Novel*, Aragon expressed his *mea culpa*: "In this I seem to be truly French. I have written a great

deal about Matisse without ever aspiring to render in words either the form or colour of his paintings and I am aware of having lent dramatic passions to his armchairs, his greenery, the components of his still lifes (or his figures)."

Like Aragon, we abhor the jargon of the art critic just as Stendhal must have done. That is why, while still forcing us to take account of the integral course taken by his work we have left it to Matisse to express, as often as possible, the mastery of the written and spoken word because who better than the artist, even if he had first taken the precaution of "cutting out his tongue", to deliver the key? The words express the feelings but do not imitate the paintings. Let us thus leave the last word to Matisse who wrote at the age of 83 to his dear friend, André Rouveyre, not far from a superbly drawn phallus (p. 241) which is ironically captioned, in a quote from the sermons of Bossuet: "Everything is grand for the kings!" "May the survival of my works of which you give me the assurance, actually happen, I wish it … I never think of it because having thrown the ball as far as I can, I cannot be sure whether it will fall to the ground or in the sea or over the precipices from where nothing returns."

Nude, the Plane-tree, 1951
Nu, le platane
Pastel
Private collection

Daphne. Study for "Ronsard", 1942
Daphné. Etude pour le "Ronsard"
Pastel, 26.5 x 20.5 cm
Private collection

Everything is Grand for the Kings. Letter to André Rouveyre, 1952
Tout est grand chez les rois!
Pen, ink and coloured pencils, 26.7 x 21 cm
Musée National d'Art Moderne, Centre Georges Pompidou, Paris

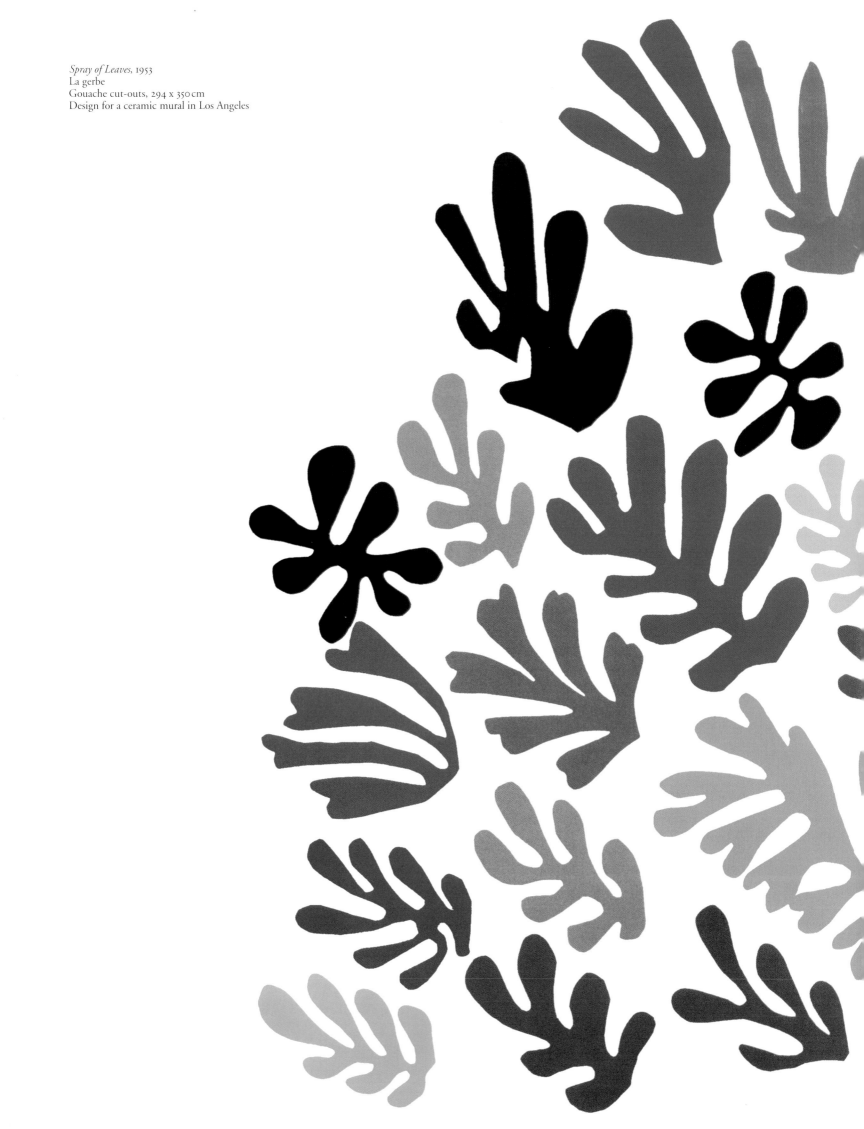

Spray of Leaves, 1953
La gerbe
Gouache cut-outs, 294 x 350 cm
Design for a ceramic mural in Los Angeles

HM 53

mattisse HM.

1869 – Birth of Henri Emile Benoît Matisse at Cateau-Cambrésis (Nord), on 31 December.

1882 – Pupil at the Lycée de Saint-Quentin.

1887 – Studies at the Faculty of Law in Paris.

1889 – Clerk to a solicitor in the firm of Maître Duconseil in Saint-Quentin.

1890 – Appendicitis confines him to bed for a year. His mother gives him a paintbox. First copies of paintings. Takes drawing lessons at the Quentin de la Tour School while continuing to work as a clerk.

1891 – His father regretfully agrees to allow him to pursue his new calling and to register at the Académie Julian in Paris where Bouguereau and Ferrier, the "pompier" painters, are teachers.

1892 – He prefers Gustave Moreau's studio where he meets Albert Marquet, Rouault and a little later, Camoin and Manguin.

1894 – Birth of his daughter, Marguérite, whose mother he does not marry until 1898.

1895 – Copies paintings in the Louvre. Travels to Brittany. Moves to 19, Quai Saint-Michel in Paris.

The Académie Julian where Bouguereau lectured, 1892

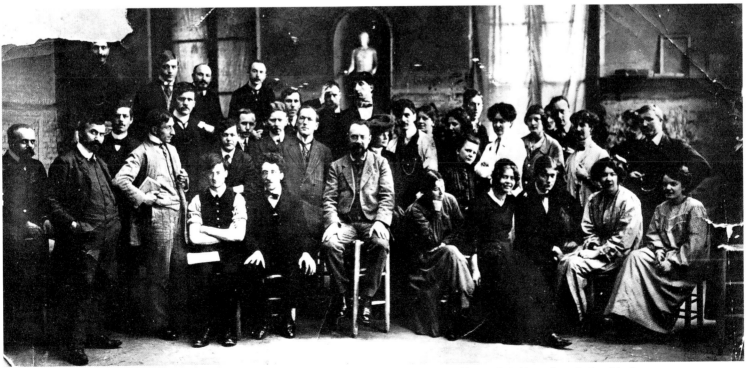

André Derain: *Henri Matisse*, 1905. Oil on canvas, 46 x 34.9 cm
Tate Gallery, London

Matisse and his pupils in his studio at the Invalides in 1909

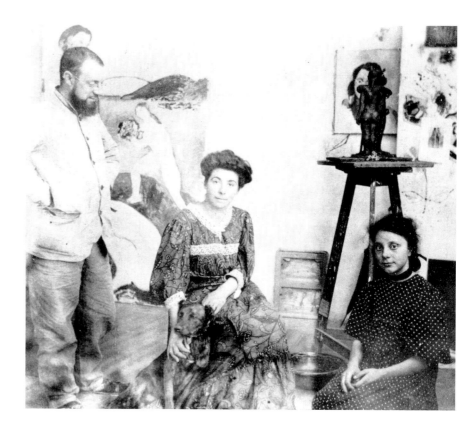

Self-portrait, 1900. Brush drawing

Matisse's studio in Collioure in 1907
From left to right: Matisse, Madame Matisse, their daughter Marguerite.
Behind Matisse *Luxe I*, and behind Marguerite the sculpture *The Two Negresses*

At Renoir's home in Cagnes-sur-mer in 1918
Seated: Greta Prozor and Auguste Renoir. Standing: Claude Renoir, Matisse and Pierre Renoir

1896 – Exhibits successfully in the Salon de la Société Nationale des Beaux-Arts of which he is an associate member. *The Reader* is bought by the State. Travels a second time to Brittany where he meets John Russel, a friend of van Gogh and Monet.

1897 – *The Dining Table* is exhibited at the Salon de la Nationale and is badly received. He meets Pissarro and studies Impressionist painting.

1898 – Marries Amélie-Noémie-Alexandrine Parayre. Honeymoon in London where he discovers Turner. Travels on to Corsica, then to Toulouse, his wife's home town.

1899 – Deaths of Stéphane Mallarmé and of Gustave Moreau. Exhibition of the Nabis painters at Durand-Ruel. Paints on this motif with Marquet. Buys Cézanne's *The Three Bathers*, a Rodin plaster model and a painting by Gauguin from the dealer Ambroise Vollard.

1900 – Great financial difficulties. Works with Marquet on decorating the Grand Palais. His wife opens a milliner's shop. Birth of his son, Pierre.

1901 – Begins to exhibit at the Salon des Indépendants. Derain introduces him to Vlaminck.

1902 – Exhibits at Berthe Weill. Toulouse-Lautrec retrospective at the Salon des Indépendants.

1903 – Founding of the Salon d'Automne where he exhibits with Rouault and Derain. Gauguin dies and there is a retrospective of his work. First etchings.

1904 – First one-man show at Vollard's. Spends the summer at Saint-Tropez with Signac and Cross. Experiments with neo-Impressionist technique.

1905 – Exhibits *Luxe, Calme et Volupté* which is bought by Signac. The Fauves scandal breaks at the Salon d'Automne. *Woman with Hat*, the flagship work, is bought by the Steins.

1906 – *La Joie de Vivre* exhibited at the Salon des Indépendants. Visits Biskra in Algeria. Death of Cézanne. He shows an African sculpture to Picasso. First lithographs and engravings.

1907 – Exchange of paintings with Picasso who is working on *Les Demoiselles d'Avignon*. *Luxe I* is exhibited at the Salon d'Automne. Visits Padua, Florence, Arezzo and Sienna.

1908 – Opening of an Academy at the Invalides in Paris. Travels to Germany. Exhibitions in New York and Moscow (The Golden Fleece) and Berlin. *The Red Dining Table*.

1909 – Buys a house at Issy-les-Moulineaux. Shchukin commissions *The Dance* and *The Music* from him.

1910 – Retrospective at the Bernheim-Jeune Gallery. Visits the exhibition of Moslem Art in Munich. Travels to Andalusia.

1911–1912 – Travels to Moscow to hang *The Dance* and *The Music*. Studies the icons. Several trips to Tangiers with Marquet and Camoin.

1913 – Exhibition of Moroccan paintings at the Bernheim-Jeune Gallery. Participates in the Berlin "Secession", at the Armory Show in New York, and exhibits in Chicago and Boston.

1914 – The works exhibited in Berlin are seized. Meets Juan Gris who has become a refugee in Collioure and assists him financially. Moves to the Quai Saint-Michel in Paris. Paints *View of Notre-Dame* and *French Window at Collioure*.

1916 – Exhibition in London. First winter in Nice.

1918 – Meets Renoir in Cagnes. Exhibition with Picasso at the Paul Guillaume Gallery. Death of Apollinaire.

1919 – *The Black Table* using Antoinette as the model.

1920 – Designs stage sets and costumes for "Song of the Nightingale" for Diaghilev's Ballets Russes. Summer in London, then in Etretat.

1921 – Divides his time between Etretat, Nice and Paris.

1922 – The series of *Odalisques*.

1924 – Exhibition in New York, retrospective in Copenhagen.

Self-portrait, 1944. Pen-and-ink drawing

Self-portrait, 1949. Lithograph

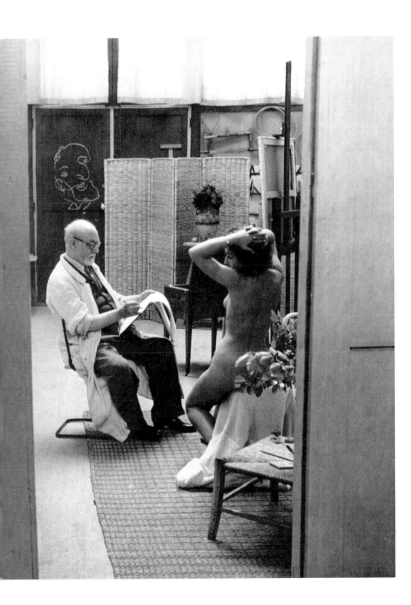

Brassaï: Matisse in his Villa Alesia studio, Paris, drawing his Hungarian model, Wilma Javor, 1939. The drawing he is making will be shown hanging on the wall in the painting he produced in the same year, *Reader on a Black Background (The Pink Table)*, p. 200.

1925 – Travels to Italy. *Decorative Figure on an Ornamental Background.*

1927 – Is awarded the Carnegie Prize in Pittsburgh. An exhibition is organised by his son Pierre Matisse in New York.

1930 – Dr. Barnes commissions *The Dance*. Albert Skira asks him to illustrate a book of poems by Stéphane Mallarmé. Travels to Tahiti via New York and San Francisco. Returns via Suez. Member of the Carnegie Prize jury. Picasso is next awarded the prize.

1932–1933 – Second version of *The Dance* and trip to Merion to install it.

1934–1935 – Lydia Delectorskaya poses for *The Pink Nude*.

1937 – Stages sets for "Red and Black" for the Ballets Russes. Special room at the exhibition of the Maîtres de l'Art Indépendant at the Petit Palais in Paris. Picasso paints *Guernica*.

1938 – Moves to the Hotel Régina at Cimiez. Matisse, Picasso and Braque exhibition in Oslo, Copenhagen and Stockholm.

1940 – Decides to remain in France. Separates from Amélie. Paints *The Romanian Blouse* and *The Dream*.

1941 – Operated on for serious intestinal infection at Professor Leriche's clinic in Lyons. Illustrates Ronsard's *Florilège des Amours* and Henry de Montherlant's *Pasiphae*.

1943 – Installed at Vence in the villa "La Rève" where he would live until 1948.

1944 – Starts the series of painted and glued paper cut-outs which would be used to illustrate *Jazz* published by Tériade in 1947. Works

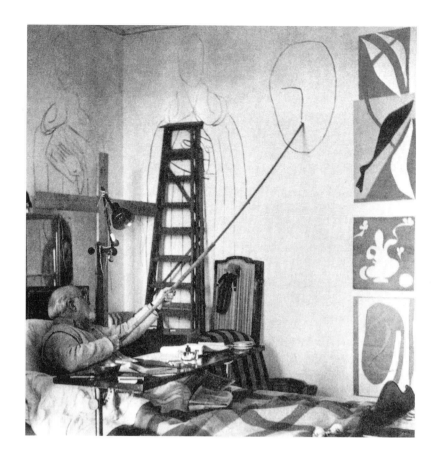

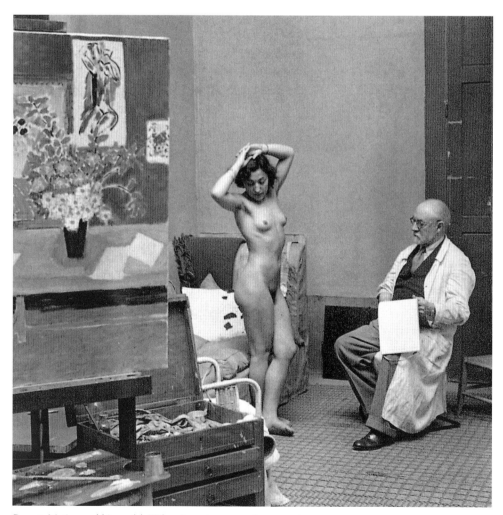

Brassaï: Matisse and his model, Wilma Javor, in 1939, and, next to them, a charcoal nude of the same period

Matisse drawing a head in his room at the Hotel Régina, Nice-Cimiez, 1950. On the left of the wall are drawings for the ceramic tiles depicting St. Dominic. On the right are the gouache cut-outs which would be used in *A Thousand and One Nights* (p. 236–237) and *The Sea Creatures* (p.235)

Pigeons, 1948. Illustration for Ronsard's *Florilège des Amours*

on the illustration of Baudelaire's *Les Fleurs du Mal*. Madame Matisse is imprisoned and her daughter deported for acts of resistance.

1945 – Retrospective at the Salon d'Automne. Exhibits with Picasso at the Victoria and Albert Museum in London. Exhibits recent canvasses at the Maeght Gallery together with the photographs of their successive stages.

1947 – Made a Commander of the Legion of Honour. Death of Bonnard and of Marquet.

1948 – Devotes himself to the decoration of the Rosary Chapel at Vence.

1950 – Grand Prix for painting at the 25th Venice Biennale.

1951 – Dedication of the chapel at Vence. Léger creates the stained glass windows for the church at Audincourt. Exhibitions at the Museum of Modern Art, New York, and in Cleveland, Chicago, San Francisco and Tokyo.

1952 – Inauguration of the Matisse Museum at Cateau-Cambrésis, his birthplace. Series of *Blue Nudes*.

1954 – Dies on 3 November in Nice and laid to rest in the Cimiez cemetery in ground donated by the city of Nice.

Henri Cartier-Bresson: Matisse and his pigeons at the Hotel Régina, Nice-Cimiez, c. 1952

Bibliography

By Matisse

MATISSE Henri: *Ecrits et propos sur l'art*, edited by Dominique Fourcade, Hermann, Paris, 1972

MATISSE Henri: *Matisse on Art*, Oxford, 1973

Works Illustrated by Matisse

REVERDY Pierre: *Les Jockeys camouflés*, drawings, A la Belle Edition, Paris, 1918

VILDRAC Charles: *Cinquante dessins*, published by the artist, Paris, 1920

MALLARMÉ Stéphane: *Poésies*, etchings, Skira, Lausanne, 1932

JOYCE James: *Ulysses*, etchings, New York, 1935

MONTHERLAND Henry de: *Pasiphaé*, lino-cuts, Fabiani, Paris, 1944

Lettres de la religieuse portugaise, lithographs, Tériade, Paris, 1946

REVERDY Pierre: *Visage*, lithographs, Ed. du Chêne, Paris, 1946

ROUVEYRE André: *Repli*, lithographs, Ed. du Bélier, Paris, 1947

BAUDELAIRE Charles: *Les Fleurs du mal*, etchings, wood engravings and photo-lithographs, La Bibliothèque Française, Paris, 1947

MATISSE Henri: *Jazz*, stencil prints of original cut-outs, Tériade, Paris, 1947

Les Miroirs profonds, various poems, drawings, Maeght, Paris, 1947

KOBER Jacques: *Le Vent des épines*, drawings by Matisse, Bonnard and Braque, Maeght, Paris, 1947

RONSARD Pierre de: *Florilège des Amours*, lithographs, Skira, Paris, 1948

TZARA Tristan: *Midis gagnés*, drawings, Denoël, Paris, 1948

D'ORLÉANS Charles: *Poèmes*, colour lithographs, Tériade, Paris, 1950

Main Recent Monographs

GREENBERG Clément: *Henri Matisse*, Abrams, New York, 1953

DIEHL Gaston: *Henri Matisse*, Pierre Tisné, Paris, 1954

REVERDY Pierre, DUTHUIT Georges: *The Last Works of Henri Matisse*, New York, 1958

FERRIER Jean-Louis: *Matisse 1911–1930*, Hazan, Paris, 1961

DUTHUIT Georges: *Le Feu du signe*, Skira, Geneva, 1962

SELZ Jean: *Henri Matisse*, Flammarion, Paris, 1964

LASSAIGNE Jacques: *Matisse*, Skira, Geneva, 1966

Hommage à Henri Matisse, XXe Siècle, Paris, 1970

DIEHL Gaston: *Henri Matisse*, Nouvelles Editions Françaises, Paris, 1970

ARAGON Louis: *Henri Matisse, roman*, Gallimard, Paris, 1971

ELSEN Albert E.: *The Sculpture of Henri Matisse*, Abrams, New York, 1972

BARR Alfred H. Jr.: *Matisse, His Art and His Public*, Secker and Warburg, London, 1975

GUICHARD-MEILI: *Matisse, gouaches découpées*, Hazan, Paris, 1983

DUTHUIT-MATISSE Marguerite, DUTHUIT, Claude: *Henri Matisse, catalogue raisonné de l'œuvre gravé*, edited with the assistance of F. Garnaud, *Paris, 1984*

SCHNEIDER Pierre: *Matisse*, Thames & Hudson, London, 1984

DELECTORSKAYA Lydia: *Henri Matisse, peintures de 1935–1939*, Maeght, Paris, 1986

Matisse at the engraver Mourlot examining the proofs of the Ronsard book, 1948

PAGE 251:
L'Apres-midi d'un Faune: the Faun and the Nymph (rejected plates), 1931–1932 Etching, 32,5 x 25 cm. Baltimore Museum of Art, Baltimore (MD)

Reading or the Burmese Hand. Study, 1944. Crayon. Matisse Archives

MONOD-FONTAINE Isabelle: *Matisse: catalogue des œuvres de Henri Matisse (1869–1954)*, Centre Georges Pompidou, Paris, 1989

ESSERS Volkmar: *Henri Matisse*, Taschen, Cologne, 1989

JACOBUS John: *Matisse*, Cercle d'Art, Paris, 1989

Matisse au Maroc, peintures et dessins, 1912–1913, Adam Biro, Paris, 1990

IZERGHNINA: *Matisse (œuvres des Musées Pouchkine et de l'Eremitage)*, Cercle d'Art, Paris, 1990

ELDERFIELD John: *Henri Matisse: A Retrospective*, The Museum of Modern Art, New York, 1992

NÉRET Gilles: *Henri Matisse Cut-outs*, Cologne, 1994

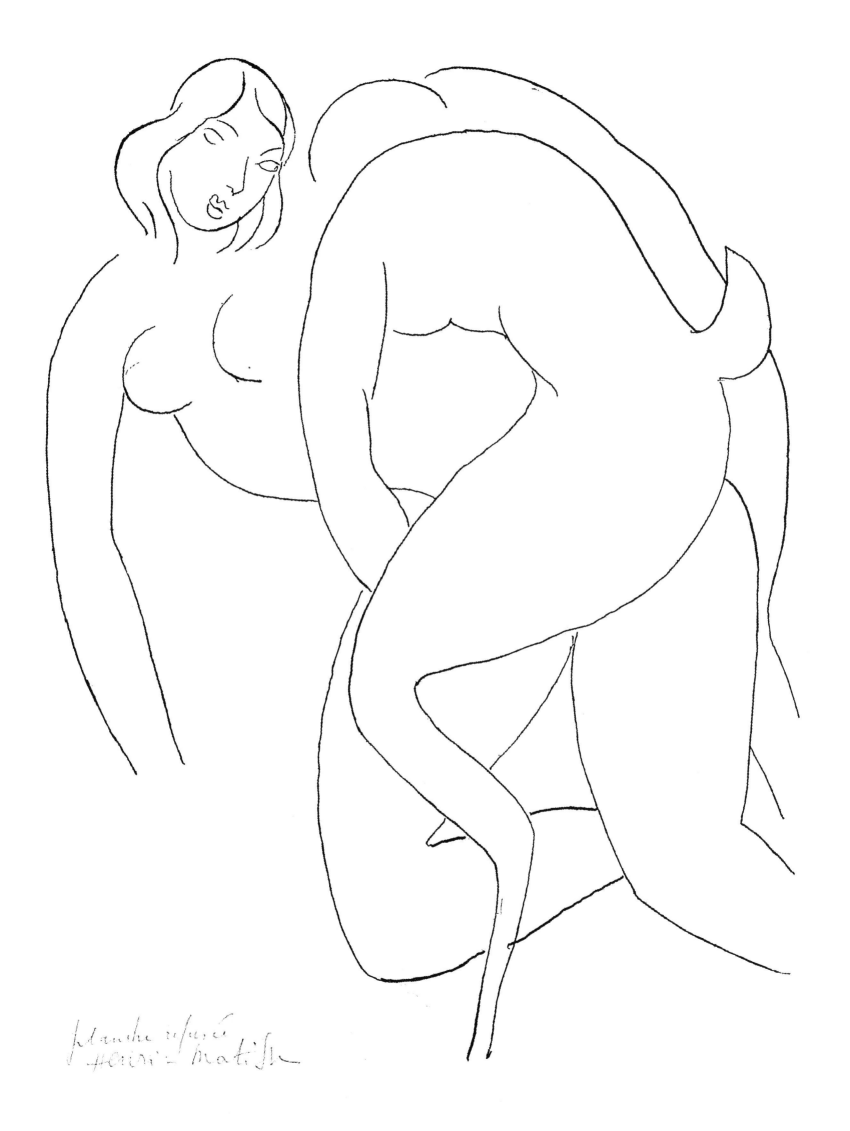

planche refusée
Henri-Matisse

List of Paintings and Sculptures

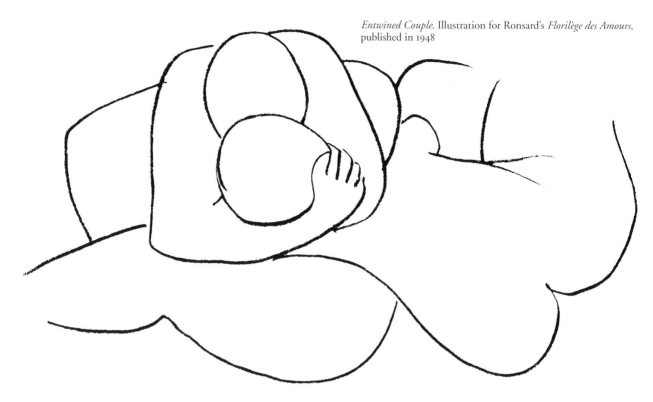

Entwined Couple. Illustration for Ronsard's *Florilège des Amours,* published in 1948

Pen and Indian ink drawing for the series of *Reclining Nudes*, 1935

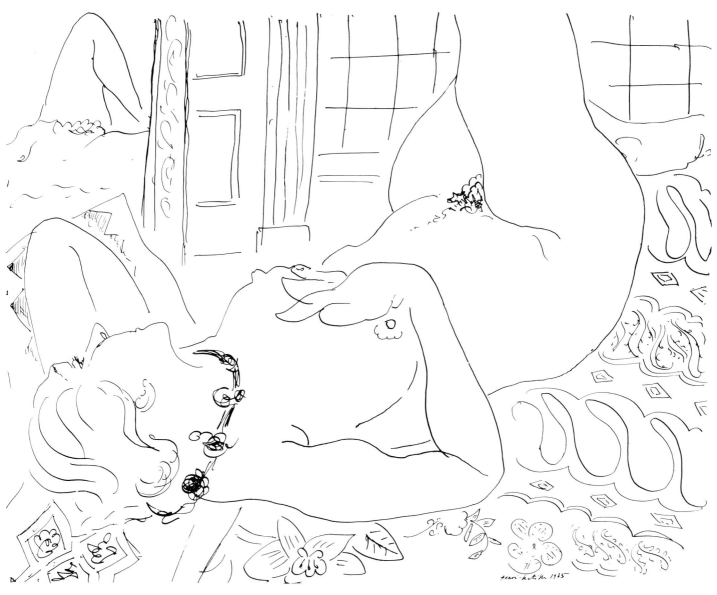

Acknowledgements

The author and editor wish to express their sincere thanks to Mr and Mrs Claude Duthuit and Ms Wanda de Guébriant for their invaluable assistance. They contributed towards a deeper understanding of the œuvre of Matisse, helped to ensure that the colour reproductions in this publication are as faithful as possible to the original works and, last but not least, generously provided access to the archives of the estate of Henri Matisse.

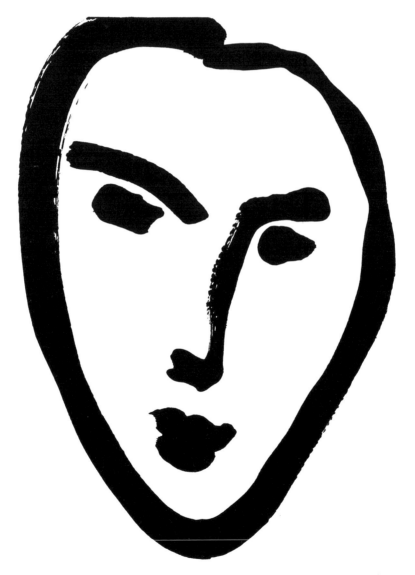

Face, 1952. Indian ink and paintbrush, 75,3 x 64.6 cm. Private collection